Images of a Golden Past

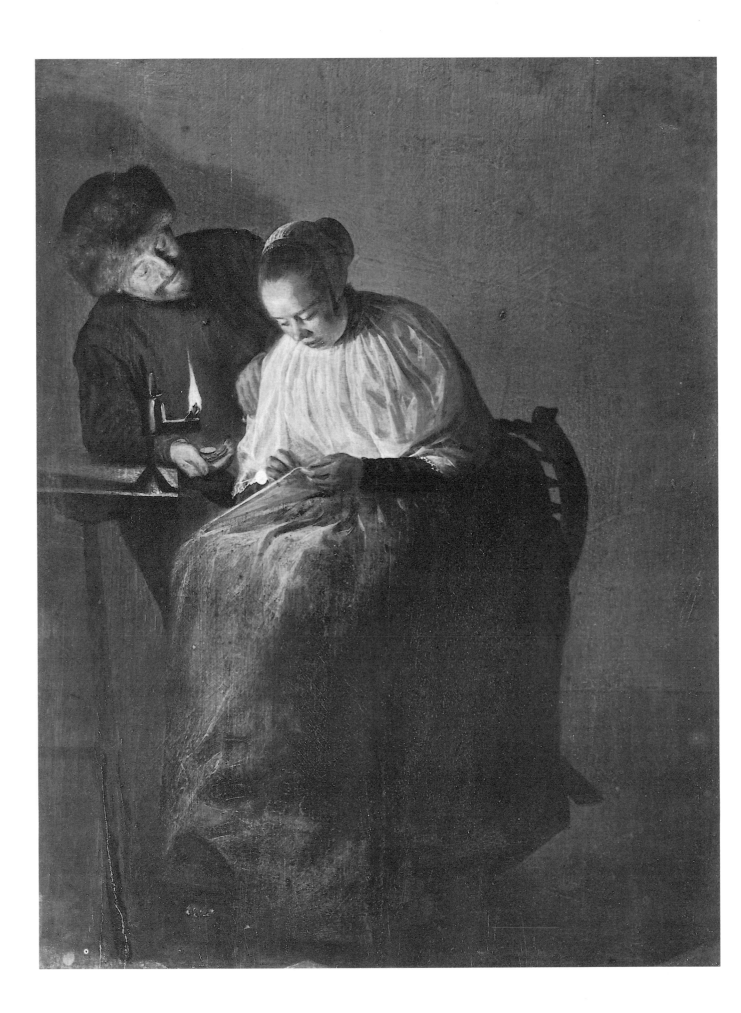

Images of a Golden Past

Dutch Genre Painting of the 17th Century

CHRISTOPHER BROWN

ABBEVILLE PRESS · PUBLISHERS · NEW YORK

COVER: *Woman Reading a Letter*, Johannes Vermeer, The Rijksmuseum, Amsterdam.

BACK COVER: *Man Offering an Oyster to a Woman*, Jan Steen, National Gallery, London.

FRONTISPIECE: *A Man Offering Gold to a Young Woman*, Judith Leyster, Mauritshuis, The Hague.

Library of Congress Cataloging in Publication Data

Brown, Christopher, 1948–
 Images of a golden past.

 Bibliography: p.
 Includes index.
 1. Genre painting, Dutch. 2. Genre painting—17th century—Netherlands. I. Title.
ND1452.N43B77 1984 754'.09492 84-6257
ISBN 0-89659-439-4

FIRST EDITION

Contents

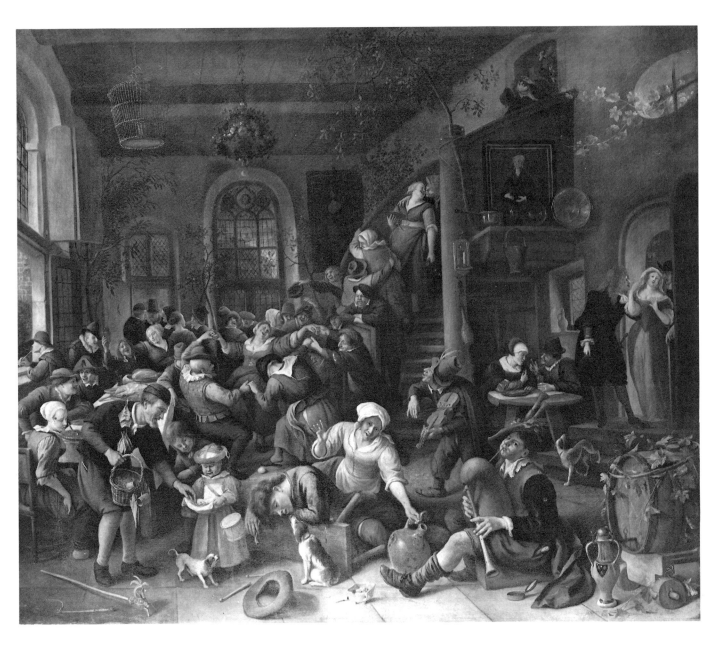

Jan Steen. *The Egg Dance*. Canvas, 112 × 133 cm
Wellington Museum, Apsley House, London
[page 186]

Preface

Six years ago, in 1978, I organized a small travelling exhibition of twenty-eight Dutch genre paintings from the collection of the National Gallery in London. It was shown at four provincial galleries in England and then at the National Gallery itself. In the exhibition and in the catalogue which accompanied it, the paintings were grouped by subject; the catalogue tried to present in a concise and straightforward manner ideas about the meaning and significance of genre paintings which had previously been discussed principally in Dutch and for the most part in scholarly journals. A particular source of inspiration was the exhibition *Tot Lering en Vermaak*, held at the Rijksmuseum in 1976, which was organized by Professor de Jongh and his students at the University of Utrecht. The catalogue of my exhibition was printed in a small edition and sold out before the exhibition reached London. Since then, I have hoped that the opportunity would arise to prepare a second, revised edition and so, when approached to write a book on Dutch genre painting, this is what I suggested. In the event, this is an almost entirely new book. It does however, retain the general arrangement of the catalogue – a lengthy introduction followed by short chapters on particular subjects treated by genre painters – and it inevitably uses some of the same examples. The introduction is made up of five essays on aspects of genre painting and the individual chapters deal with more subjects at greater length and with many more examples than the catalogue was able to do. The book is addressed to the same audience as my exhibition catalogue: the interested museum visitor who wishes to know more about how and why certain types of subject-matter were treated by Dutch artists in the seventeenth century. For those who wish to pursue particular topics touched upon but not explored at length, notes and a bibliography have been provided. My intention has been to provide a clear, informative text not overburdened with abstruse references.

The subjects of the chapters have been chosen not for their iconographic complexity or their references to recondite contemporary ideas but simply because in my experience they are the ones which occur most often in Dutch genre paintings. The range of subject-matter treated by these artists was, however, so wide that my choice is of necessity rather arbitrary. Genre painting concerns itself with public and private life, with work and with recreation, and individual themes have been arranged under those general headings. The chapters inevitably vary in length: some subjects, such as 'Street Scenes', require little explanation and those sections provide little more than extended captions to the plates; others, such as 'The Professions', call for discussion of the way in which the paintings reveal contemporary attitudes towards doctors, dentists and lawyers. The illustrations have been selected to sustain the argument as much as the text. However, there were so many Dutch genre painters and their output was so vast that there are literally thousands of examples of each subject to choose from in making the selection: quality has naturally been the first criterion, and I have drawn heavily upon the two collections which I know best – and which also happen to be the two greatest collections of seventeenth-century Dutch painting – those of the National Gallery in London and the Rijksmuseum in Amsterdam.

Some recent accounts of Dutch genre painting have shown a tendency to become intellectually pretentious in their arguments and unnecessarily recondite in their references. While it is true that seventeenth-century Dutch emblem books and proverb collections are relatively little known today, critical discussion of them need not in this context become an excuse for obscurity – or obscurantism. The art of Rubens, for example, is intellectually demanding to a very high degree and should be approached as such. Dutch genre painting calls for a different approach. It was essentially a simple, popular art-form catering for a large, comparatively unsophisticated, public; and I have always tried to keep this in mind. Although the retrieval of the contemporary significance of Dutch genre painting often means the recovery of ideas which were commonplace in the seventeenth century, this does not of course make it easy. Indeed, involving as it does the identification of popular prejudices, folk practices and traditional beliefs, it becomes an exercise in cultural anthropology and may be far more difficult than, for example, the tracing of Rubens' literary sources.

As the bibliography at the end of this book makes clear, I am very greatly indebted to the work of Jan Emmens and Eddy de Jongh who pioneered new approaches to the study of Dutch genre painting.

Figures in square brackets after plate references in the text refer to the page on which the picture falls.

London, 1984 C.B.

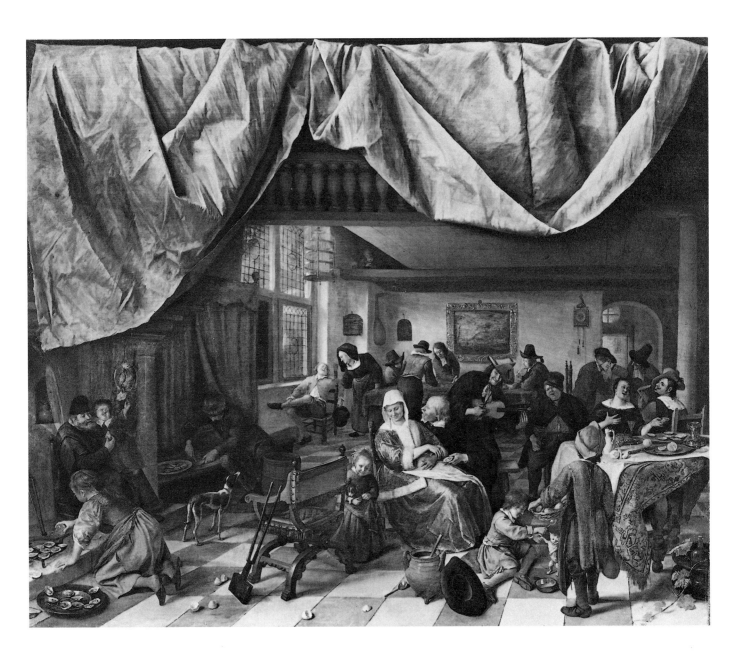

Jan Steen. *The Life of Man*. Canvas, 68.2 × 82 cm
Mauritshuis, The Hague [page 40, 41]

1. Introduction

Genre is one of the secular types of painting – group portraits, town views and church interiors are others – which set the work of seventeenth-century artists in the north Netherlands apart from that of their contemporaries elsewhere in Europe. French, Italian and Spanish artists all painted genre scenes – the peasants of the Lenain brothers and of Velasquez, the musicians of Caravaggio, the butchers of Annibale Carracci – but such subjects were rarely those painters' chief preoccupation and when compared with the great mass of religious, mythological and classical pictures painted in those countries during the seventeenth century, they are numerically few. In the north Netherlands, by contrast, the quantity of genre paintings and their range, both of style and subject-matter, was immense.

The reasons for the popularity of genre painting in the Dutch Republic are complex. While it does, of course, reflect the ideas of Dutch Protestantism, which banished religious images from the churches and encouraged certain types of secular paintings, it is also a consequence of an art market which permitted relatively humble people to buy paintings. When compared with the aristocratic and *haut bourgeois* art of much of the rest of Europe, Dutch genre painting is a genuinely popular form of art – which, however, in the hands of a Vermeer or a Terborch, was capable of the very highest achievement. Although at first glance it may seem simply to provide a pictorial record of life in the Dutch Republic during the seventeenth century, in fact it does far more. It lets us enter the mental world – recreate the world picture, it might be said – of the Dutch during a fascinating and turbulent age. More than an art of mere reportage, it comments, whether obliquely, directly, approvingly or critically, on attitudes towards all aspects of private and public life – festivals and sports, the home and the family, work and relaxation.

I. THEMES AND INTERPRETATIONS

As a glance through the illustrations in this book will reveal, genre is a broad term. It takes in the rowdy peasant scenes of Adriaen van Ostade and the elegant interiors of Gerard Terborch, the poor tailors of Quiringh van Brekelenkam and the overdressed soldiers of Willem Duyster, as well as street scenes in Amsterdam and Rome. It is a term which imposes unnecessary and meaningless restrictions on the richly varied subjects of Dutch painting – when, for instance, does a scene of figures in a landscape, or seated around a still-life, fall within the category of genre?

It is not surprising to discover, therefore, that the term was unknown in the seventeenth century. Instead, there are contemporary references to many particular subjects which today are subsumed within the catch-all of genre. A so-called 'merry company' scene, showing elegantly dressed young men and women in an interior, eating, drinking and playing musical instruments, was known by contemporaries as a *geselschapje* or a *conversatie*, while an outdoor scene of a similar type was a *buitenpartij*. A brothel scene was a *bordeeltjen* and a scene of soldiers in their guardroom a *cortegaerdje* or a *soldaets kroeghie*. Scenes of meals were known as *tafereeltjes* and Italian street scenes as *bambocciate*, a term which came to have a wider use early in the eighteenth century. Each of these subjects had its own pictorial tradition and the term which came closest to covering them all was *beeldeken*, which simply means a painting with small figures, and is often found in inventories drawn up by notaries who felt no need to make more detailed descriptions.

More useful broad categories were constructed: Gerard de Lairesse, for example, in his *Het Groot Schilderboek* (translated into English as *The Art of Painting*), first published in Amsterdam in 1707, distinguished between *burgerlyk* and *geringe* (which might roughly be characterized as bourgeois and low-life) subjects. He wished to distinguish the work of artists like Gerrit Dou and Frans van Mieris, painters of 'modern' subjects whom he admired, from that of Adriaen Brouwer and Pieter van Laer, two of the artists he placed in the second, despised category.

It was not, however, until the end of the eighteenth century that the French word *genre*, literally meaning a 'kind' or 'sort', was first used to describe the wide range of paintings which all apparently represented scenes from every-

day life. Earlier it had been used by, for example, Denis Diderot in his *Essais sur la Peinture* (written in 1766 but not published until 1795) to describe all the minor categories of painting. Landscapes, still-life, scenes from peasant life, were *peinture de genre* as opposed to *peinture d'histoire* which included religious, mythological and classical subjects. 'Painters who concern themselves with flowers, fruits, animals, woods, forests, mountains, as well as those who take their scenes from ordinary and domestic life are called, without distinction, genre painters', wrote Diderot. 'Teniers, Wouwermans, Greuze, Chardin, Loutherbourg and even Vernet are genre painters.' This definition was too broad for the critic Quatremère de Quincy who wrote in 1791 that the paintings properly described as genre are those representing *des scènes bourgeoises*. However, this usage – and de Quincy had in mind Greuze and Fragonard as well as Dou and van Mieris – proved, by contrast, too restricted. The modern definition is unequivocally stated in Franz Kugler's influential *Handbuch der Geschichte der Malerei* of 1837: 'Genre paintings (in the sense which it is normal to attach to these words) are representations of everyday life.' The term has been in constant use with this meaning ever since, and although it imposes artificial restrictions and its use ignores the independent pictorial traditions of the various subjects it subsumes, it remains a convenient and effective term, the use of which has the effect of stressing the single, crucial feature which all these paintings have in common – the representation of observed reality.

Classical antecedents have been sought for genre painting. In the sixteenth century Hadrianus Junius compared the Antwerp artist Pieter Aertsen, who painted market scenes and kitchen interiors, with Perreicos, a painter of antiquity mentioned by Pliny who depicted cobblers' and barbers' shops. The same comparison was used by Bellori in his account of Pieter van Laer. Perreicos' pictures survive only in Pliny's description; the more direct ancestry of Dutch genre painting can be traced in the calendar illustrations of late medieval Books of Hours. In the opening section of these private books of devotion, saints' days and other feasts of the church were listed by month and on the facing page the artist had a rare chance to paint a secular subject – each month was illustrated by an appropriate activity.

The iconography of the activities of the twelve months of the year had been well established by the twelfth century and can be seen on the capitals of Saint-Denis, Chartres and Amiens: it showed the tasks of the countryman, the planting of crops, tending of the vineyard and the harvest. It also showed the pursuits of leisure, and in particular those of the nobles, banqueting and hunting. One of the remarkable aspects of the evolving iconography of the Books of Hours is the gradual appearance of women, at first the idealized lady of courtly love and the peasant woman working beside the men, and of street scenes. In the April scene of the Hours of Charles d'Angoulême, the lady and her lover appear according to the conventions of courtly love within a walled garden, but later, in the Turin-Milan Hours, she is seen supervising work in the garden. She is not invariably alone, but is seen elsewhere with her husband and children grape-picking or overseeing the harvest. These are not strictly, of course, domestic scenes of the kind depicted in Dutch genre paintings, and firm social divisions are always maintained. In the August page of the *Très Riches Heures* [17], illustrated for the Duc de Berry by the Limbourg brothers, an aristocratic hawking party occupies the foreground while behind are peasants, some bringing in the harvest, others swimming. Their nudity is a deliberate contrast to the rich clothes of the nobles. In December the Limbourgs show a ferocious boar hunt in the forest of Vincennes. Peasant life, by contrast, is the principal subject of the February page [18]: they are shown chopping trees, trekking through the snow and indoors, warming themselves indecorously before a blazing fire. The November and December scenes in the Turin-Milan Hours show the traditional sacrifice of the pig but they take place in the street, unusually for depictions of the months whose iconography is traditionally related to the country calendar. In the Hours of Adelaide of Savoy there is a market scene with a motif which was to have a long history in the genre painting of the seventeenth century – young boy pickpockets cutting the purse-strings of busy housewives. The new realism to be found in such illustrations, although

within such essentially personal items as private books of devotion, did not go without comment. In the February page of the Grimani Breviary the artist showed a boy urinating in the snow, a detail which caught the attention of the Venetian Marcantonio Michiel: 'I saw there the twelve months, and amongst them February in which a boy was urinating in the snow turning it yellow and the landscape was snowy and flat.'

The depiction of the months of the year continued, of course, throughout the late Middle Ages and into the sixteenth and seventeenth centuries, in other forms than the calendar pages of Books of Hours. Bernard van Orley, for example, designed a tapestry series showing the months in the form of the hunts of the Emperor Maximilian; and in the seventeenth century Pieter Molijn, the Haarlem landscape painter, made a series of drawings showing the changing countryside beneath the astrological sign for each month.

Fifteenth-century Flemish painters tucked meticulously described scenes from contemporary life into the background of religious works. An outstanding example is Robert Campin's Merode Altarpiece of about 1426 [19]. The central panel shows *The Annunciation*: on the right wing [20] and so physically separated from the Annunciation itself St Joseph is shown carving a mousetrap in his shop overlooking the central square of a Flemish town. On the street side, another mousetrap is displayed for sale. In this context the mousetrap possesses a particular religious significance – it refers to St Augustine's concept that the Incarnation was a trap set by God to catch the Devil. A sophisticated theological idea was in this way presented in the guise of a scene from everyday life. This tradition of 'disguised symbolism' continues into the seventeenth century, although by now the ideas contained within genre scenes are for the most part warnings, examples or choices rather than recondite theological notions.

St Joseph, although shown at work in a contemporary Flemish shop, and on a subsidiary part of the altarpiece, remains a religious personage. The emancipation of genre from a religious context, like the similar emancipation of landscape, took place in the sixteenth century and early examples of genre subjects treated independently are found in the graphic arts.

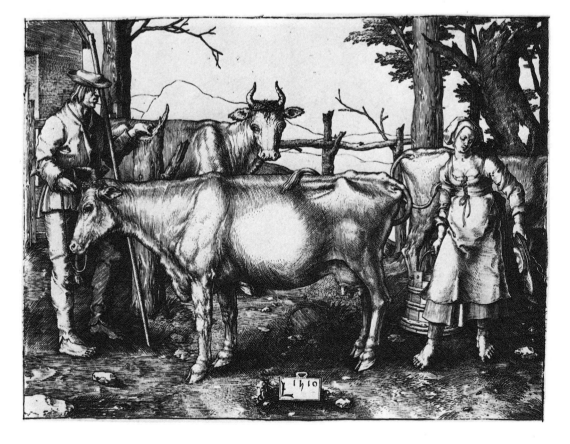

Lucas van Leyden
(1494-1533). *The Milkmaid*, 1510.
Engraving
Rijksprentenkabinet,
Rijksmuseum,
Amsterdam
[page 12]

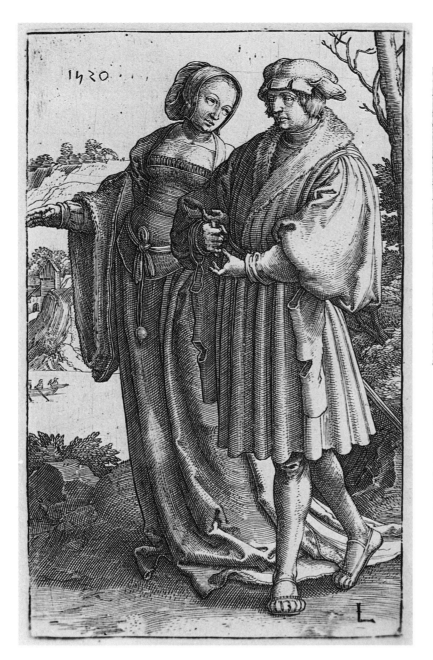

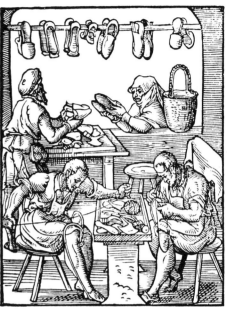

Herein/wer Stiffl vnd Schuh bedarff/
Die kan ich machen gut vnd scharff/
Büchsn / Armbrosthalffter vñ Wahtseck/
Feuwr Eymer vnd Reyßtruhen Deck/
Gewachtelt Reitstieffl / Kürißschuch/
Pantoffel / gefütert mit Thuch/
Wasserstiffl vnd Schuch außgeschnittn/
Frauwenschuch / nach Höflichen sittn.
 D ij Der

Lucas van Leyden. *A Young Couple Walking*, 1520. Engraving Rijksprentenkabinet, Rijksmuseum, Amsterdam [page 12]

Print-making, being a relatively new medium, was, in terms of its subject-matter, far more experimental than the long-established medium of painting with its traditional iconography. This is a feature of Netherlandish art throughout the sixteenth and seventeenth centuries: one has only to compare Rembrandt's painted and etched landscapes to see how much more innovative he allowed himself to be in the latter. Genre subjects appear in prints early in the sixteenth century, long before they are found in paintings. The most important and influential Netherlandish print-maker in this respect was Lucas van Leyden, in whose graphic work are to be found a number of the themes which preoccupied Dutch genre painters of the seventeenth century, among them *The Surgeon, The Dentist, The Milkmaid with her Cattle* [11], *The Beggar's Family, A Young Man cheated in an Inn* [183], *A Young Couple walking* [12] and *An Elderly Couple playing Musical Instruments*. Other print-makers in the north developed these and other genre themes: Jost Amman of Nuremberg, for example, designed a famous series of men at work, the *Eygentliche Beschreibung Aller Stände auff Erden*, popularly known as the *Ständebuch* or *Book of Trades*, first published in 1568 [13]. The verses which accompany the woodcuts are by Hans Sachs: they make it clear that the intention of the series is to provide *exempla* of the virtuous, God-fearing and hard-working lives of artisans. Very few types are condemned; among them are Jews (for usury) [13] and lawyers (for dishonesty) [13]. Doctors, who had been consistently mocked in earlier German epic verse such as Hugo van Trimberg's *Renner*, were by contrast praised

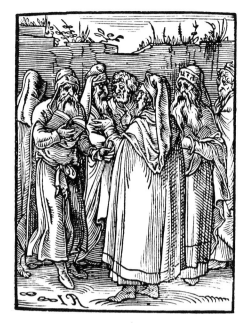

Der Jüd.

Bin nicht vmb sonst ein Jüd genannt/
Ich leih nur halb Gelt an ein Pfandt/
Löst mans nit zu gesetztem Ziel/
So gilt es mir dennoch so viel/
Darmit verderb ich den losen hauffn/
Der nur wil Feyern / Fressn vnd Sauffn/
Doch nimpt mein Handel gar nit ab/
Weil ich meins gleich viel Brüder hab.

J ij Der

Der Procurator.

Ich procurir vor dem Gericht/
Vnd offt ein böse sach versicht/
Durch Loie falsche list vnd renck
Durch auffzug auffsatz vnd einflenck/
Darmit ichs Recht auffziehen thu:
Schlecht aber zuletzt vnglück zu
Daß mein Parthey ligt vnterm gaul
Hab ich doch offt gfüllt beutl vnd maul.

E ij Der

PAGE 12, RIGHT:
Jost Amman (1539–91).
The Shoemaker from
*Eygentliche Beschreibung
Aller Stände auff Erden*
(the Ständebuch),
Nuremberg, 1568
[page 12]

LEFT:
Jost Amman. *The Jew*
from the Ständebuch
[page 12]

RIGHT:
Jost Amman. *The
Lawyer* from the Stände-
buch
[page 12]

[14]. Such prints, and series of prints, circulated very widely in northern Europe and were well known to Dutch painters who were influenced by them, not only in their subject-matter, but also formally, as sources for compositions and individual figures.

A crucial artist in the emergence of genre as an independent category of painting during the sixteenth century was Pieter Bruegel the Elder, whose treatments of the life of peasants were of the greatest importance in the development of this major theme. His paintings were engraved, copied and imitated, in the first place by his son Pieter the Younger, and the prints made after his designs were still more influential. The engravings of *Spring* [15], which shows a formal garden being planted, and *Summer* [15], in which the harvest is being gathered, are in the tradition of the illuminated calendar pages in Books of Hours. The real subject is the work of the muscular gardeners and self-consciously posed harvesters and not, as in Bruegel's painted series of the months, the changing landscape. Pieter Bruegel designed prints of *Skaters on the Ice before the Gate of St George in Antwerp* [192], the ancestor of many ice scenes of the seventeenth century, notably those of Hendrick Avercamp; *The Fair of St George's Day* [190], and *The Fair at Hoboken* [188], scenes of peasant revels; *The Peasant Dance* [189]; and two scenes from popular dramas acted at village kermesses (or fairs) by travelling actors and local amateur literary associations (the so-called *rederijkers* or rhetoricians), *The Masquerade of Orson and Valentine* [16] and *The Dirty Bride*.

The Fair at Hoboken [188], which dates from around 1559, carries a mocking inscription: 'Die boeren verblijen hun in sulken feesten / te dansen springhen en dronckendrincken als beesten. / Sij moeten die kermissen onderhou-

Der Doctor.

Jch bin ein Doctor der Artzney/
An dem Harn kan ich sehen frey
Was kranckheit ein Menschn thut beladn
Dem kan ich helffen mit Gotts gnadn
Durch ein Syrup oder Recept
Das seiner kranckheit widerstrebt/
Daß der Mensch wider werd gesund/
Arabo die Artzney erfund.

D iij Der

Jost Amman. *The Doctor*
from the Ständebuch
[page 12, 13]

wen / Al souwen sij vasten en sterven van kau-
wen.' ('The peasants delight in such feasts, /
To dance, caper and get as drunk as beasts. /
They would go without food or die of cold, / As
long as they could have their kermesses.') The
mockery is robust yet good-humoured: does
it represent Bruegel's attitude towards such
scenes or was it added subsequently by the
publisher of the print's first state, Bartholo-
meus de Momper? There is no way of know-
ing, but perhaps in the context of a discussion
of genre painting it is more important to note
that it does represent the way in which a signifi-
cant number of contemporaries would have re-
sponded to the image. To a modern audience
Bruegel's accounts of the life of peasants seem
to be the work of an amused observer rather
than a stern moralist. The inscription beneath
The Wedding Dance [159] makes fun of the
clumsy-footed country bumpkins and tells us
that the bride is unable to join in because she is

'full and sweet', a euphemism for pregnant:
the point of view is one of patronizing, vulgar
humour, not puritanical revulsion or sour con-
demnation. In dealing with other subjects
which recur during the seventeenth century,
Bruegel's attitude is, however, quite clear: in
The Alchemist [33], for example, there can be
no doubt that his intention is to mock the
man's foolish quest. The scholar on the right
gestures towards the alchemist with one hand
while pointing with the other to the open book
in front of him. The punning words, *Alghe
Mist*, literally 'All Rubbish', can be clearly
made out. In the background, the alchemist's
foolish attempts to transform base metals into
gold have brought him and his family to the
gates of the poorhouse. The alchemist is a fool
but his real sin is avarice. When, however,
Bruegel represented Avarice in his series of the
Seven Deadly Sins, he did so in an entirely
non-realistic manner, placing a female person-
ification of the sin in a landscape peopled by
Boschian monsters. Bruegel also used female
personifications for the Virtues, in a later
series, but surrounded them with a number of
appropriate scenes from everyday life: in *Jus-
tice* [34], for example, the figure of Justicia is
placed amongst scribbling clerks, disputing
lawyers, magistrates sitting in judgement and
scenes of punishment, torture and execution.
In this print Bruegel brings together individ-
ual realistic scenes of the prosecution of justice
to form a non-realistic whole dominated by
an allegorical figure. The Latin text beneath
leaves us in no doubt of the moral: 'The aim of
law is to correct by punishment, to improve by
the example of punishment, and to protect all
by overcoming evil.' In the following century
ideas such as these were to be expressed in a
more coherently realistic guise.

Two subjects painted by Pieter Bruegel were
to prove enormously influential in the seven-
teenth century: Netherlandish Proverbs [30]
and Children's Games [154]. Once again,
Bruegel's mode is realistic yet both paintings
are compendia and the total effect is non-real-
istic. In the next century individual proverbs
and games, and groups of proverbs and games,
were to be shown realistically, although Brue-
gel's use of children to stand for the folly of
their elders continued within such apparently
purely descriptive images.

14

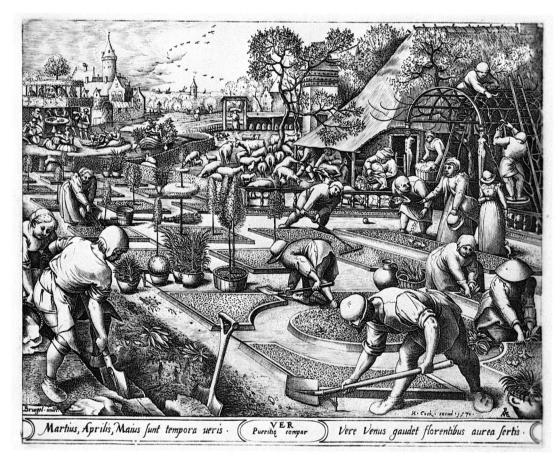

Martius, Aprilis, Maius sunt tempora ueris. VER Puerihę compar Vere Venus gaudet florentibus aurea sertis.

After Pieter Bruegel the Elder (c. 1525–69). *Spring*. Engraving, probably by Pieter van der Heyden Rijksprentenkabinet, Rijksmuseum, Amsterdam The print is based on a drawing of 1565 by Bruegel which is in the Albertina, Vienna. [page 13]

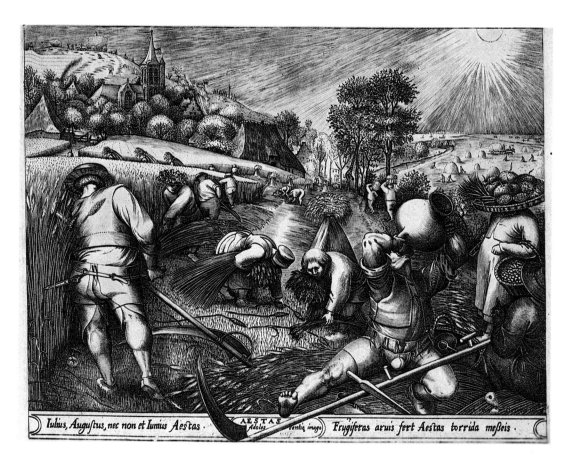

Iulius, Augustus, nec non et Iunius Aestas. AESTAS Adoles fentię imago Frugiferas aruis fert Aestas torrida meßeis.

After Pieter Bruegel the Elder. *Summer*. Engraving, engraver unknown Rijksprentenkabinet, Rijksmuseum, Amsterdam The print is based on a drawing of 1568 by Bruegel which is in the Kunsthalle, Hamburg. [page 13]

After Pieter Bruegel the Elder. *The Masquerade of Orson and Valentine*, 1566. Woodcut Rijksprentenkabinet, Rijksmuseum, Amsterdam
The popular play *Orson and Valentine* was based on a French romance which was first published in Lyon in 1489. It was widely translated and adapted: versions appeared in English, Icelandic, Italian, German and Dutch. The story tells of twins, abandoned soon after birth: one, Orson, is reared by a bear, while his brother, Valentine, is brought up at the court of King Pippin. They are reunited and together rescue their mother, Bellisant, who has been captured by a giant. In this woodcut it seems that Valentine is the figure with orb and sceptre on the far left; Orson points the crossbow; the giant, bearded and scaled, carries a spiked club; and Bellisant holds out the ring which identifies her to her sons. In the background of this performance of the play by a troupe of travelling actors, women are holding out gourds to the audience to collect their coins.
[page 13]

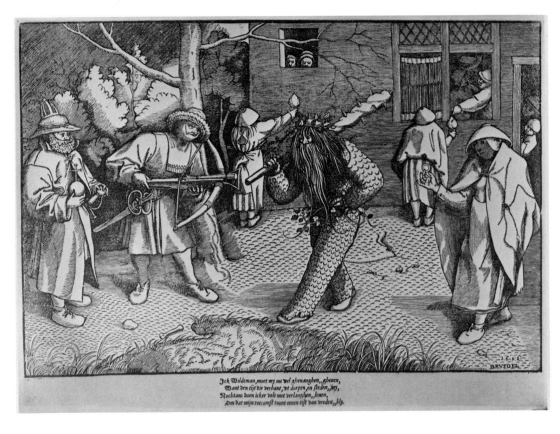

Bruegel's influence on the development of genre painting in the north Netherlands was enormous. Not only did his prints and copies after his paintings reach the north in great quantities, but a number of Antwerp painters familiar with his innovations travelled to the north as a direct consequence of the dislocation caused by the war between Spain and the United Provinces. Gillis van Coninxloo and Roelant Savery both settled in Amsterdam and Adriaen Brouwer, the great Flemish painter of peasant scenes, spent part of his apprenticeship in Haarlem. The importation of Flemish ideas to the north, whether in the form of works of art or of the artists themselves, is central to the evolution of Dutch genre painting, as it is to that of landscape and other secular categories of painting. Ideas which originated in Flanders took firm root and were developed in the north.

David Vinckboons, who holds a key position in the transfer of Flemish peasant scenes from Antwerp to Amsterdam and Haarlem, was only ten when his family settled in Amsterdam in 1586. His father was an Antwerp painter and trained his son in the Flemish tradition. Vinckboons' peasant dancers and festivals are based on those of Pieter Bruegel, although the

scale of his figures tends to be smaller. In addition, he is, with Willem Buytewech and Dirk Hals, a major figure in the development of the 'merry company' scene in the first years of the seventeenth century. He also painted what appears to be the first treatment of a subject which had been engraved by Lucas van Leyden and was to become extremely popular among genre painters, *The Village Dentist* (1614). Another familiar genre subject, the *Blind Hurdy-Gurdy Player* [19], was apparently painted for the first time in the north by Vinckboons, among whose pupils seem to have been the prodigiously talented artist Esaias van de Velde as well as Hendrick Avercamp.

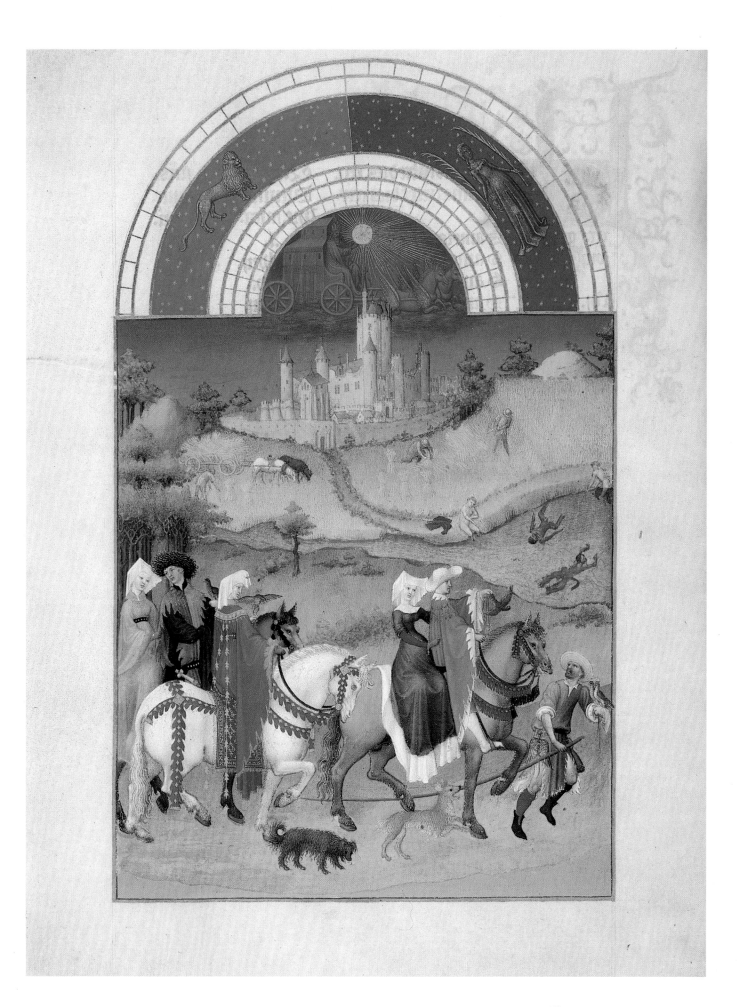

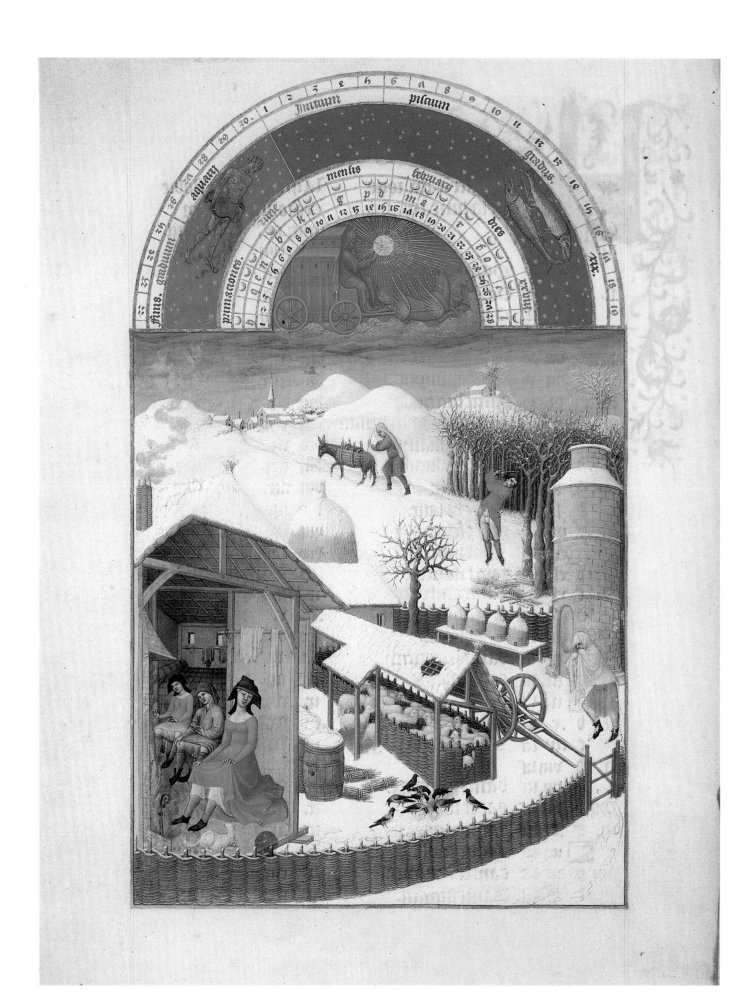

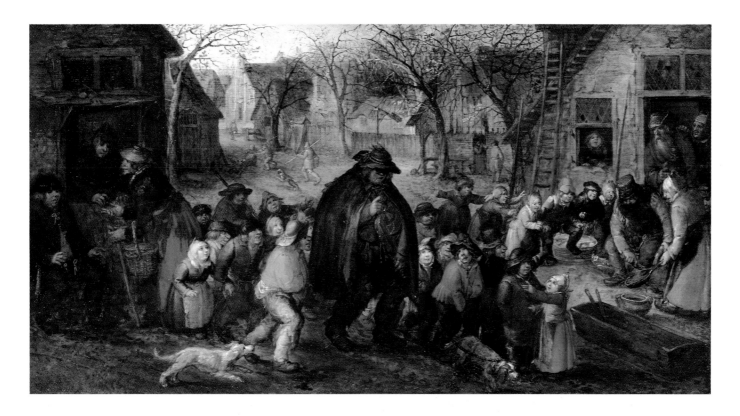

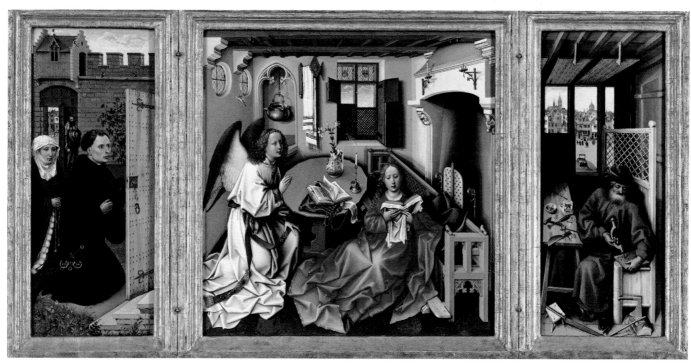

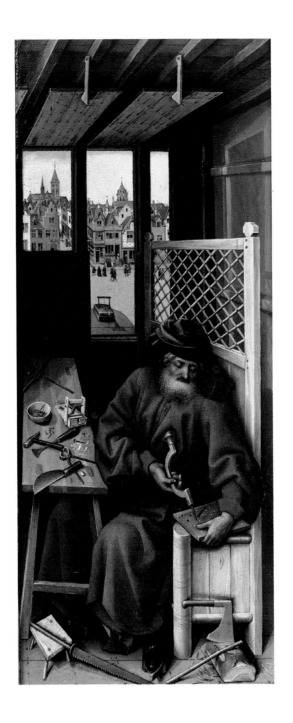

Robert Campin (The 'Maître de Flémalle'). *St Joseph* (right wing of the Merode Altarpiece) [page 11]

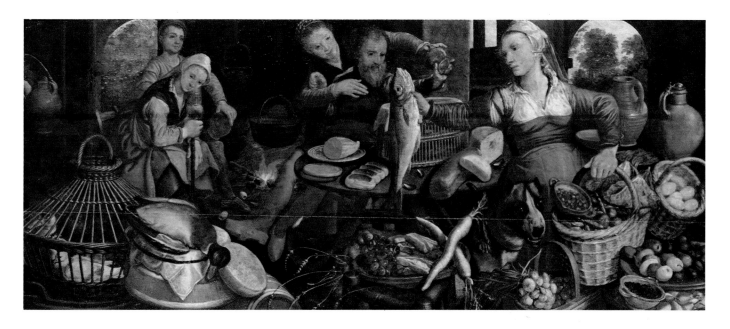

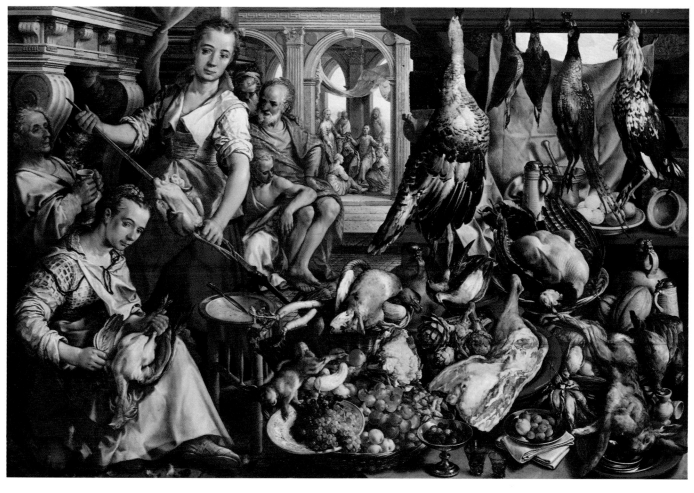

Pieter Aertsen (1509-75). *Kitchen Scene*. Panel, 92 × 215 cm. Rijksmuseum, Amsterdam. [page 33]

Joachim Beuckelaer (c. 1530-73). *Kitchen Scene, with Jesus in the House of Martha and Mary*, 1566. Panel, 171 × 250 cm. Rijksmuseum, Amsterdam. [page 33]

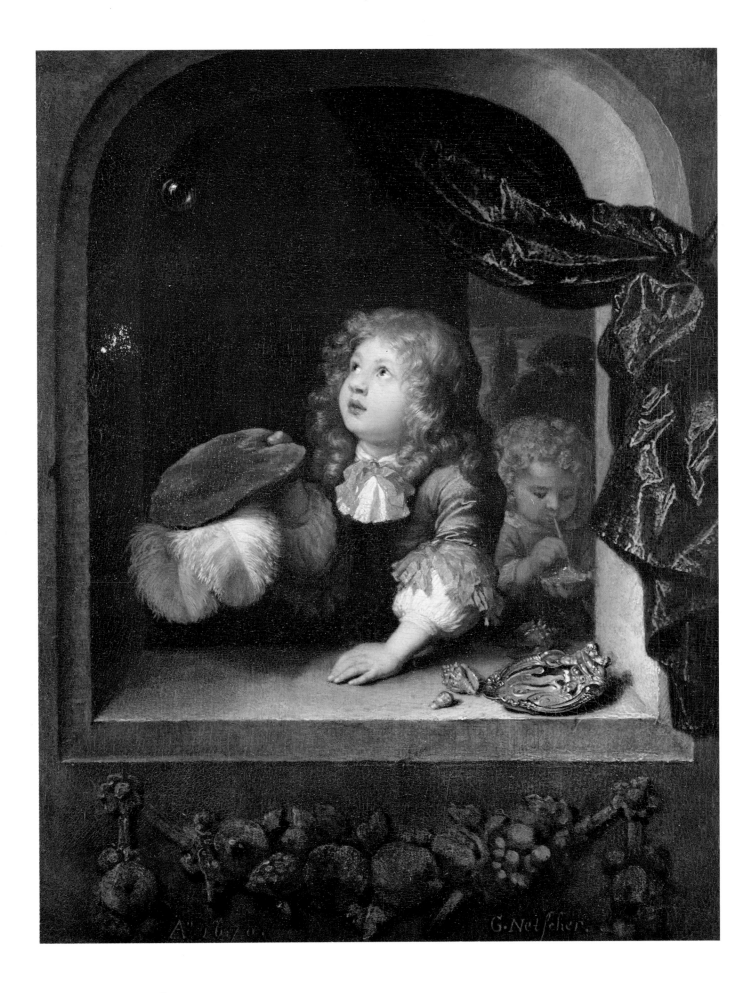

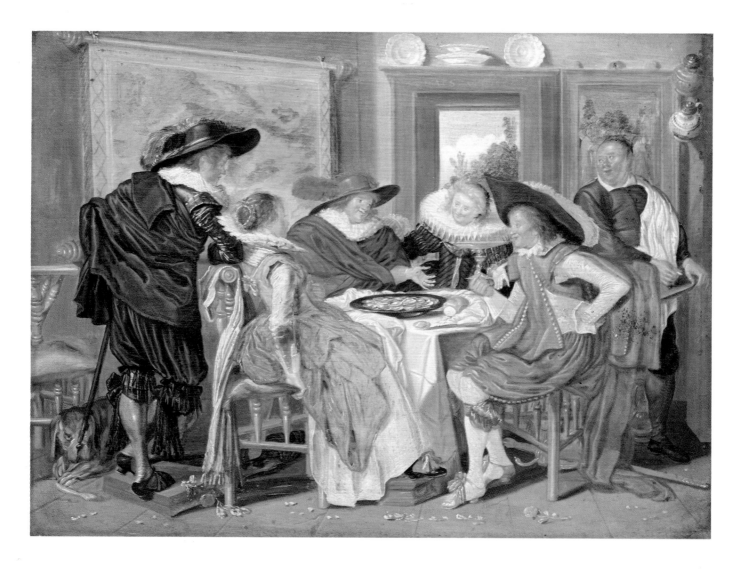

Dirk Hals (1591-1656). *Merry Company*, 1626. Panel, 28 × 38.8 cm.
Reproduced by courtesy of the Trustees, National Gallery, London.
[page 41, 42]

PAGE 24:
Gerrit Dou (1613-75). *The Quack Doctor*, 1652. Panel, 112 × 83 cm.
Museum Boymans-van Beuningen, Rotterdam.
[page 43, 44, 45, 47]

PAGE 25:
Nicolaes Maes (1634-93). *The Sleeping Kitchenmaid*, 1655. Panel, 70 × 53.3 cm.
Reproduced by courtesy of the Trustees, National Gallery, London.
[page 48]

OPPOSITE:
Caspar Netscher (c. 1635-84). *Two Boys Blowing Bubbles*, 1670. Panel, 31.2 × 24.6 cm.
Reproduced by courtesy of the Trustees, National Gallery, London.
[page 40]

24

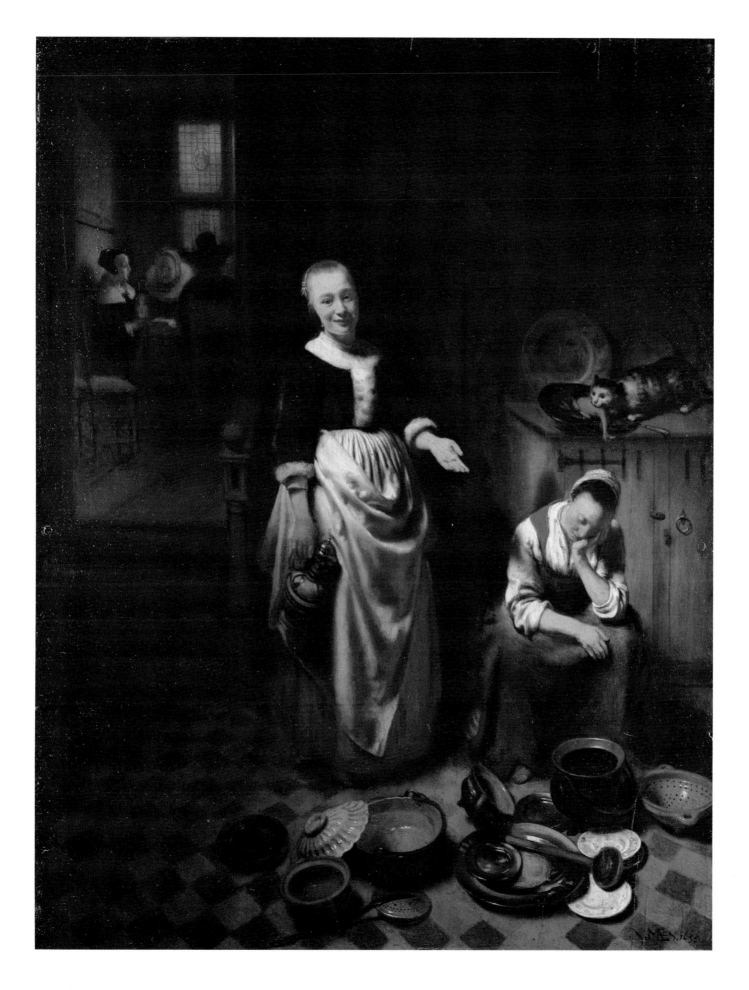

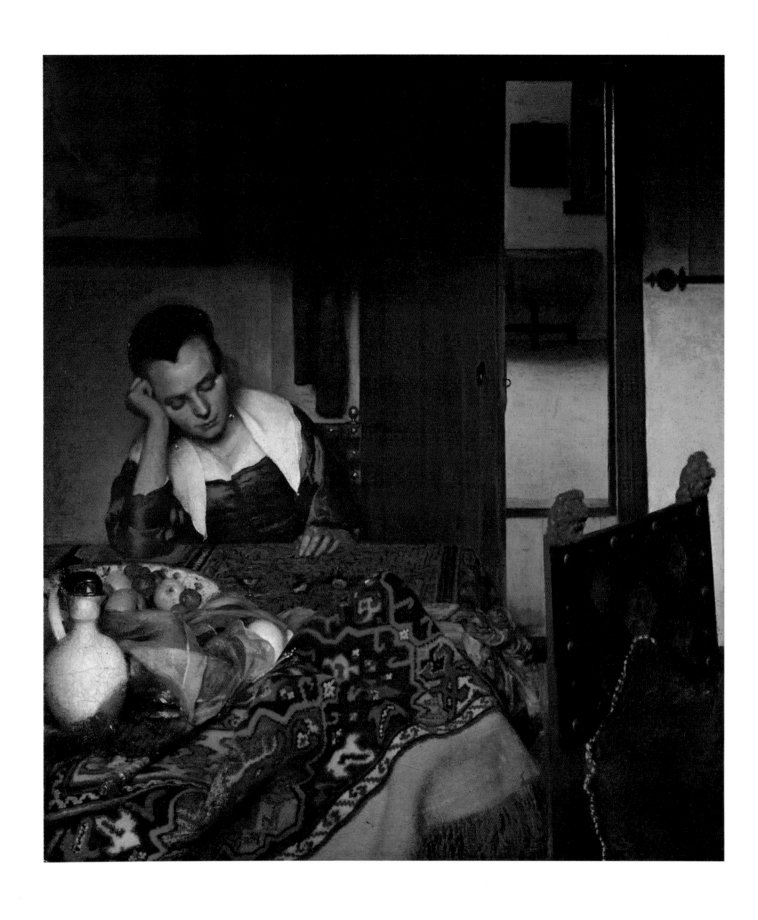

Jan Vermeer (1632–75). *Girl Asleep at a Table*, c. 1657. Canvas, 86.5 × 76 cm.
Metropolitan Museum of Art, bequest of Benjamin Altman (1913), New York. [page 48]

26

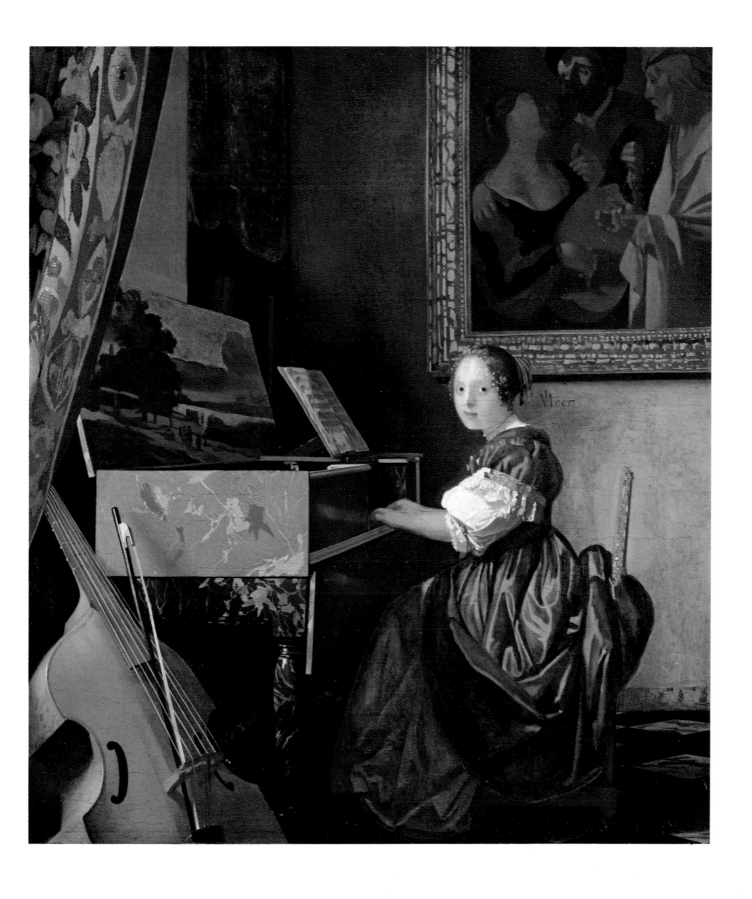

Jan Vermeer. *A Young Woman seated at a Virginal*, c. 1672. Canvas, 51.7 × 45.2 cm.
Reproduced by courtesy of the Trustees, National Gallery, London. [page 49]

27

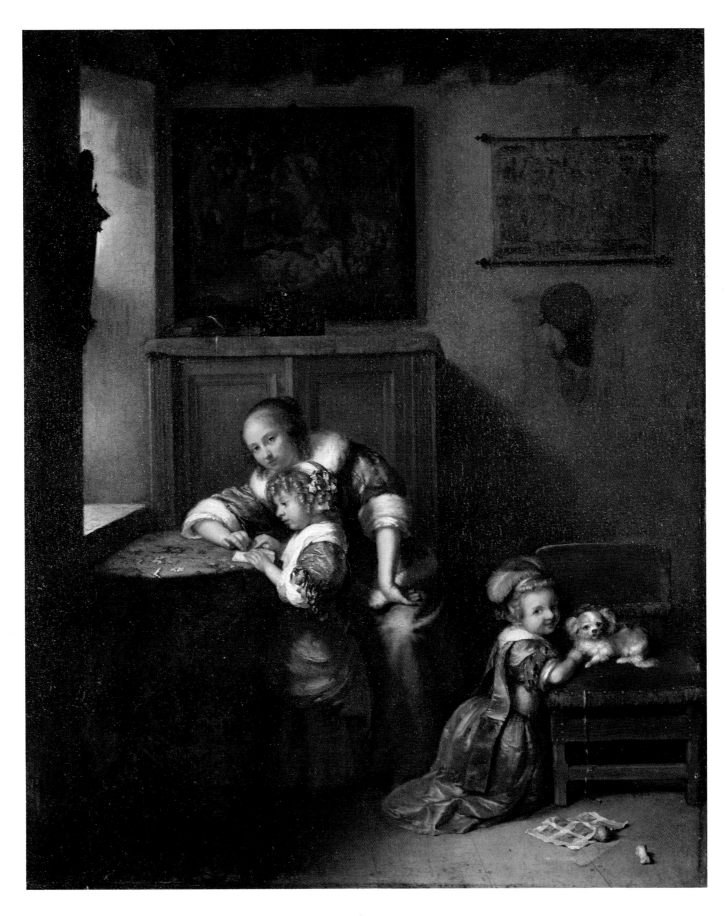

Caspar Netscher. *A Lady teaching a Child to read*. Panel, 45.1 × 32 cm
Reproduced by courtesy of the Trustees, National Gallery, London.
[page 49]

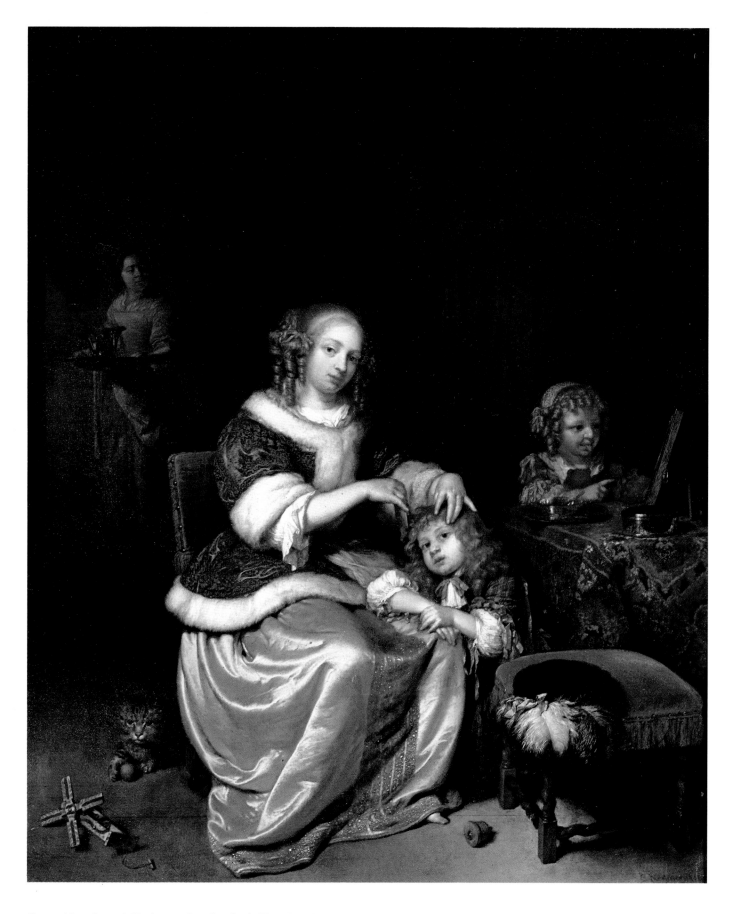

Caspar Netscher. *A Mother combing her Son's Hair*. Panel, 44.5 × 38 cm
Rijksmuseum, Amsterdam
[page 49]

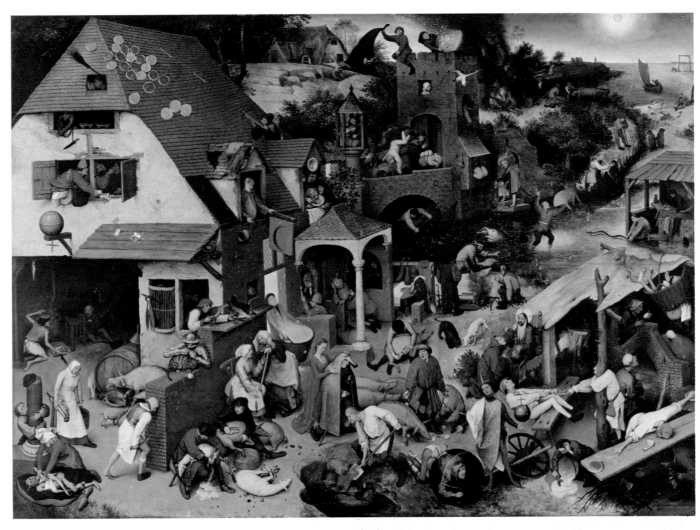

Pieter Bruegel the Elder.
Netherlandish Proverbs,
1559. Panel, 117 × 163
cm
Staatliche Museen
Preussischer Kultur-
besitz, Berlin-Dahlem
[page 84]

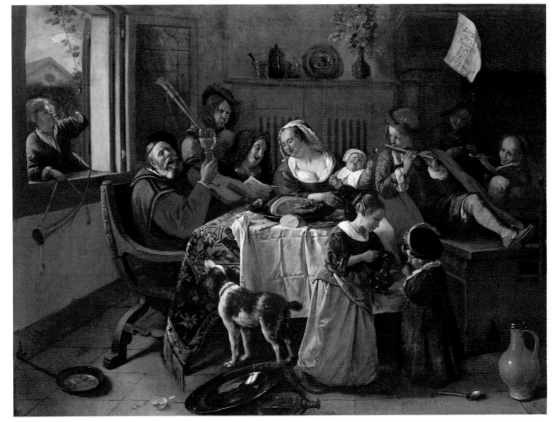

Jan Steen (1625/6-79).
*Soo de ouden songen, so
pypen de jongen*, 1669.
Canvas, 110.5 × 141 cm
Rijksmuseum,
Amsterdam
[page 86]

Jan Steen. *Soo de ouden songen, so pypen de jongen*. Canvas, 83 × 99 cm
Staatliche Museen Preussischer Kultur-besitz, Berlin-Dahlem
[page 86, 88]

Jan Steen. *The Effects of Intemperance*. Panel, 76 × 106.5 cm
Reproduced by courtesy of the Trustees, National Gallery, London
[page 88]

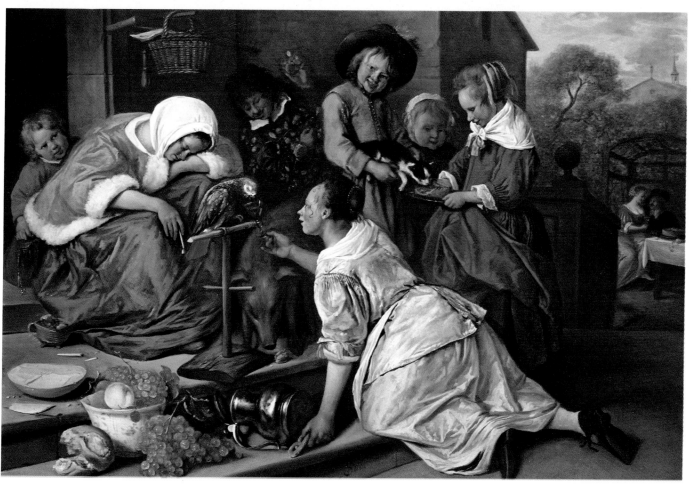

31

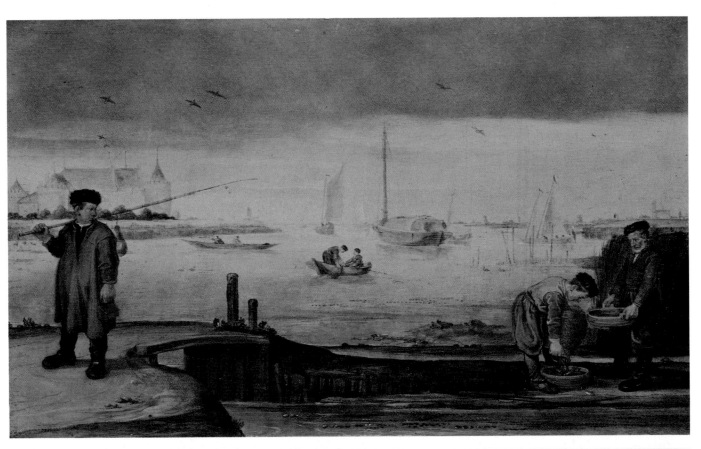

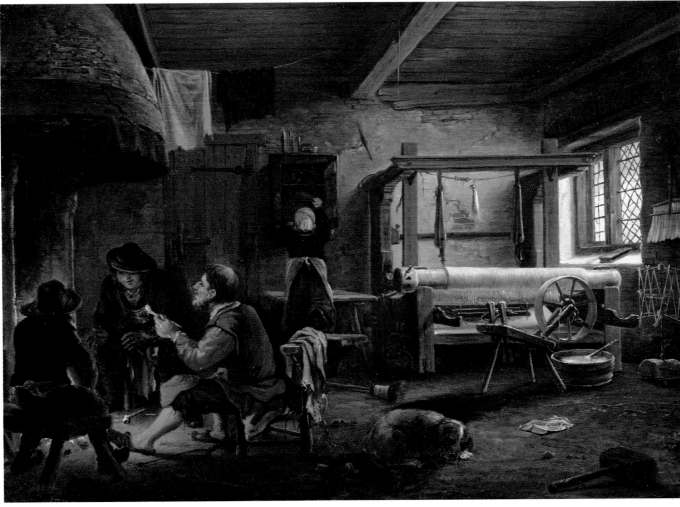

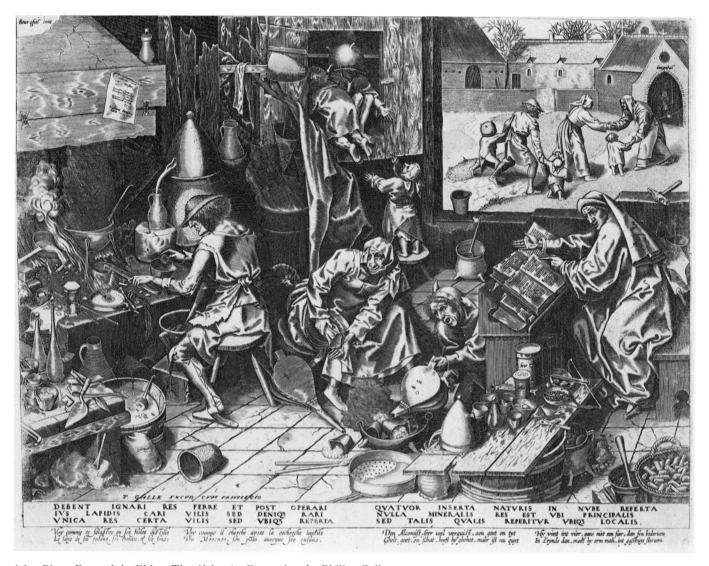

DEBENT IGNARI RES FERRE ET POST OPERARI QVATVOR INSERTA NATVRIS IN NVBE REFERTA
IVS LAPIDIS CARI VILIS SED DENIQ RARI NVLLA MINERALIS RES EST VBI PRINCIPALIS
VNICA RES CERTA VILIS SED VBIQ REPERTA SED TALIS QVALIS REPERITVR VBIQ LOCALIS.

Vay comme ce solasfee en fes biens des Fille *Vay comme il cherche apres la recherche inutile* *Den Alcumist ser veel verquist, aen goet en tyt* *Hy vint int vier, eans niet een vier, dan syn bederuen*
Le sang de ses enfans, (ses Treseurs, & ses sens) *Du Meesuse, son pain auerque ses enfans.* *Gbelt, goet, en schat, heeft hy ghehat, maer ist nu quyt* *In d'eynde dan, moet hy erm man, int gasthues steruen.*

After Pieter Bruegel the Elder. *The Alchemist*. Engraving, by Philips Galle.
Rijksprentenkabinet, Rijksmuseum, Amsterdam.
The print is based on a drawing of 1558 by Bruegel which is in the Kupferstichkabinet at Berlin-
Dahlem. On the paper pinned up above the alchemist's head the word *misero* can be made out. In the
background the alchemist and his family are being received into a poorhouse. [page 14]

Other types of Flemish genre painting which took root in the north, although in a significantly adapted form, were the market and kitchen scenes of Pieter Aertsen [21] and his nephew Joachim Beuckelaer [21], both of whom worked in Antwerp in the 1560s. In the backgrounds of several of their paintings of women preparing food and market stalls, are small-scale religious scenes, intended to create a deliberate contrast between the temporal and the spiritual, the secular and the religious. In the north Netherlands, the great majority of kitchen and market scenes lack such direct references to the Christian life, although this is not to say that they are entirely without moral significance. An exception is found in the work of the Haarlem painter Pieter van Rijck, a close follower of the Aertsen tradition, some of whose paintings do include subsidiary religious scenes.

Early in the seventeenth century, certain traditional subjects, long familiar in the art both of Flanders and the north Netherlands, came to be treated as genre scenes or to have genre elements included in them. In this way a particular moral sense, or even a specific religious meaning, began to attach itself to particular scenes or types of scenes. The process is one of the carrying over or transfer of meaning from a clearly allegorical representation to a realistic one. It is a process which can be paralleled in

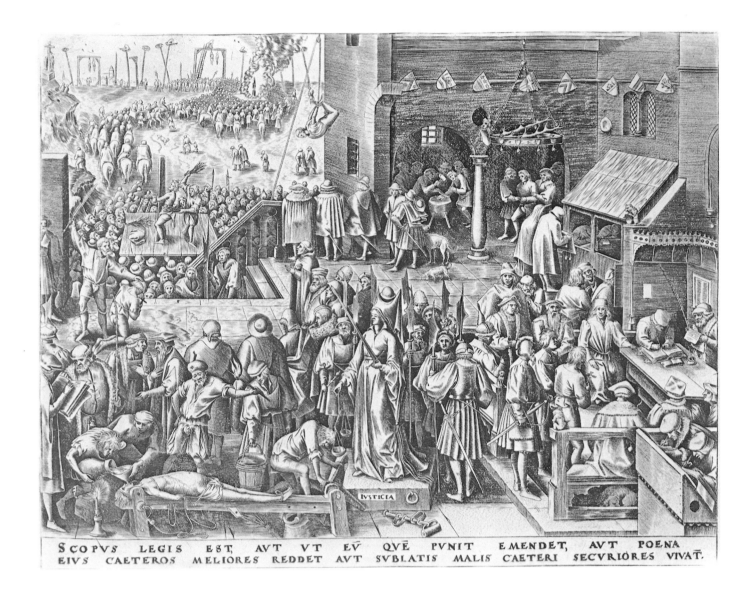

SCOPVS LEGIS EST, AVT VT EV QVĒ PVNIT EMENDET, AVT POENA
EIVS CAETEROS MELIORES REDDET AVT SVBLATIS MALIS CAETERI SECVRIORES VIVAT.

After Pieter Bruegel the Elder. *Justice*. Engraving, probably engraved by Philips Galle. One of a series of the Seven Virtues. Rijksprentenkabinet, Rijksmuseum, Amsterdam
The print is based on a drawing of 1559 by Bruegel which is in the Royal Library, Brussels. [page 14]

literature: a study of the plays performed by the Eglantine, the older of Amsterdam's two *rederijkers kamers* shows a distinct move from the personification of ideas (the figure of Justice, for example) to a more realistic mode (a lawyer). In the visual arts the subject of the Four Elements, for example, was no longer represented by traditional allegorical personifications, whose iconography had been established since the Middle Ages, but by a figure taken from contemporary life. In a series designed by Claes Jansz. Clock in 1597, a fisherman in modern dress stands for the element of Water [35], a harvester for Earth [35], a blacksmith for Fire [35] and an aristocratic huntsman with a hawk on his wrist for Air [35]. Even more striking in this respect is the series of the Four Elements designed by Willem Buytewech and engraved by Jan van der Velde, in which Earth [36] is a market-place, Water [36]

a sea-shore, Fire [37] a battle at night with roaring cannons lighting up the sky, and Air [37] a hunt. In the case of prints containing explanatory inscriptions there is, of course, no difficulty in discovering the intended meaning. However, in the case of series of paintings without such inscriptions, which in many cases may have been dispersed, it is easy to see that the original meanings may have been lost sight of. A second traditional subject newly interpreted in the seventeenth century was that of the Five Senses. In the series designed by Frans Floris and published by Hieronymus Cock in Antwerp in 1561 the Senses are shown as allegorical female personifications [38]. Forty years later in Haarlem, Hendrick Goltzius showed them as half-length amorous couples [38] and forty years after that Jan Both and his brother Andries [39] interpreted the theme with illustrations from peasant life.

34

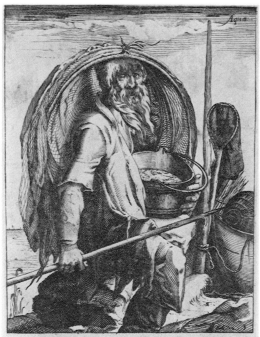

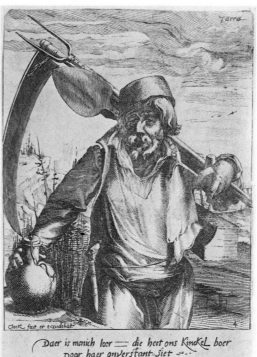

LEFT:
Claes Jansz. Clock
(c. 1576–active until
1602). *Water*, 1597.
Engraving, one of a
series of engravings of
the Elements
Rijksprentenkabinet,
Rijksmuseum,
Amsterdam
[page 34]

RIGHT:
Claes Jansz. Clock.
Earth, 1597. Engraving
Rijksprentenkabinet,
Rijksmuseum,
Amsterdam
[page 34]

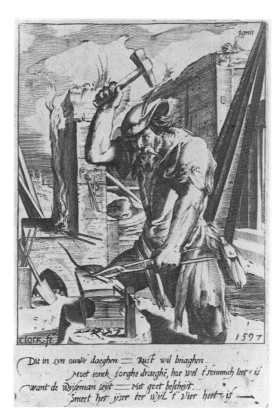

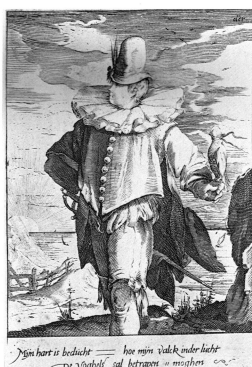

LEFT:
Claes Jansz. Clock. *Fire*,
1597. Engraving
Rijksprentenkabinet,
Rijksmuseum,
Amsterdam
[page 34]

RIGHT:
Claes Jansz. Clock. *Air*,
1597. Engraving
Rijksprentenkabinet,
Rijksmuseum,
Amsterdam
[page 34]

After Willem Buytewech
the Elder (1591-1624).
Earth. Engraving, one of
a series of engravings by
Jan van de Velde (1593-
1641) of the Elements
based on designs by
Buytewech
Rijksprentenkabinet,
Rijksmuseum,
Amsterdam
[page 34]

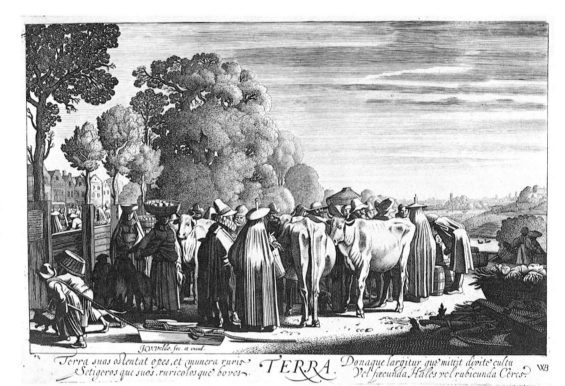

After Willem Buytewech
the Elder. *Water*.
Engraving, one of a
series of engravings by
Jan van de Velde of the
Elements based on
designs by Buytewech
Rijksprentenkabinet,
Rijksmuseum,
Amsterdam
[page 34]

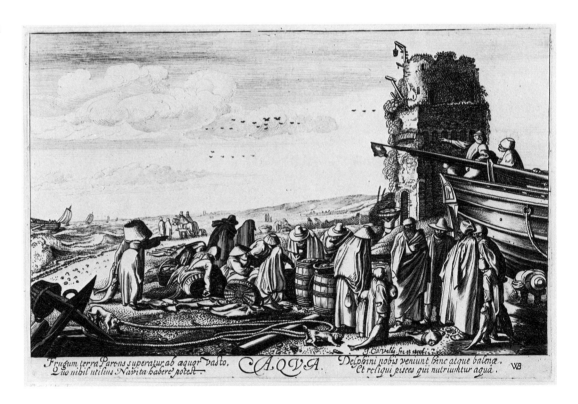

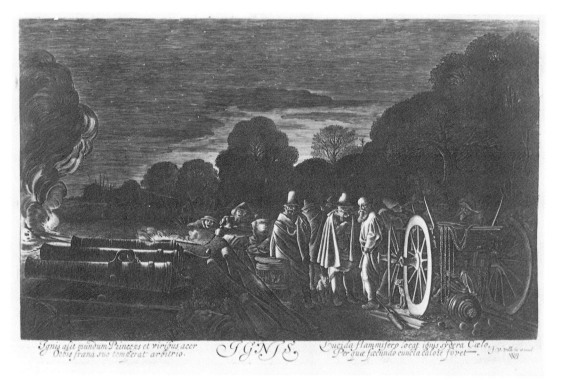

After Willem Buytewech the Elder. *Fire*. Engraving, one of a series of engravings by Jan van de Velde of the Elements based on designs by Buytewech Rijksprentenkabinet, Rijksmuseum, Amsterdam [page 34]

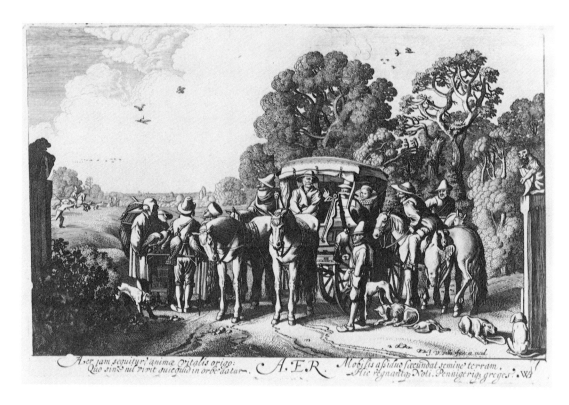

After Willem Buytewech the Elder. *Air*. Engraving, one of a series of engravings by Jan van de Velde of the Elements based on designs by Buytewech Rijksprentenkabinet, Rijksmuseum, Amsterdam [page 34]

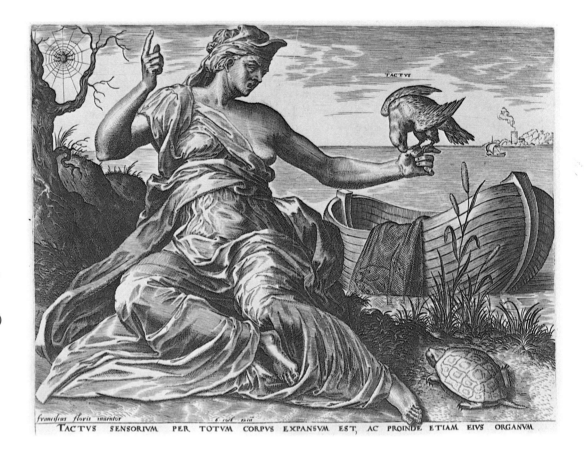

After Frans Floris
(1516-70). *Touch*, 1561.
Engraving, one of a
series of engravings by
Cornelis Cort (1533-78)
of the Five Senses.
Published by
Hieronymus Cock
Rijksprentenkabinet,
Rijksmuseum,
Amsterdam
[page 34]

TACTVS SENSORIVM PER TOTVM CORPVS EXPANSVM EST, AC PROINDE ETIAM EIVS ORGANVM

After Hendrick Goltzius
(1558-1617). *Touch*.
Engraving, one of a
series of engravings by
Jan Saenredam (1565-
1607) of the Five Senses
Rijksprentenkabinet,
Rijksmuseum,
Amsterdam
[page 34]

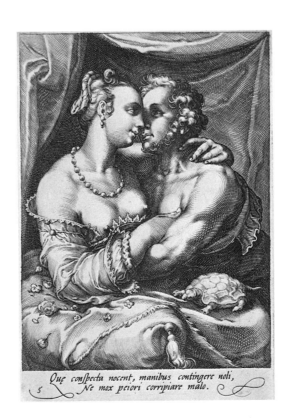

The transformation from the allegorical to the
realistic representation of a traditional subject
can also be seen in the so-called *homo bulla*
theme, in which from classical times the fragil-
ity of man's life has been compared to a soap
bubble. In the Netherlands in the fifteenth
and sixteenth centuries the subject was shown
in a purely symbolic manner – a *putto* seated
on a skull blowing bubbles – as, for example,
in a print by Christoffel van Sichem [40] in
which the bubble is, with pedantic literalness,
inscribed '*Homo*'. In an engraving of 1594 by
Hendrick Goltzius [40], a *putto* rests on a
skull and blows his bubbles from an ornate
tazza; behind him are flowers, fading fast, and
a vase from which smoke rises and then dis-
perses into the air. Both flowers and smoke are
well-worn symbols of human mortality. The
motto below is quite explicit: '*Quis evadet?*'
('Who can escape?'). When, however, Caspar
Netscher came to paint the same subject in

After Andries Both (c. 1608–41). *Touch*. Etching, one of a series of etchings by Jan Both (1610–52) of the Five Senses. Rijksprentenkabinet, Rijksmuseum, Amsterdam. [page 34, 98]

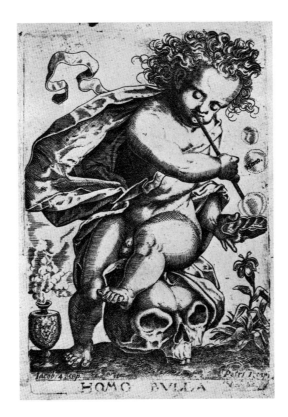

1670, he chose a realistic mode: two children in contemporary dress take the place of Goltzius' naked *putto* [22]. One of the children blows bubbles, as the *putto* had done, from an ornate silver *tazza*, while the child in the foreground is about to burst a floating bubble in a vain attempt to catch it in his plumed velvet hat. The whole scene takes place within a stone niche decorated by a garland of flowers and fruit in bas-relief, of a type used by the Leiden painter Gerrit Dou and his followers. On the sill is a second *tazza*, almost identical to one designed by Adam van Vianen in 1618, which today is in the Rijksmuseum. Such elaborately chased *tazze*, like the rare shells beside it, were enthusiastically collected in Holland in the seventeenth century and their presence here underlines the sense of the futility of worldly possessions in view of life's fragility. Snoep-Reitsma has skilfully traced the tradition of the *homo bulla* in realistic guise into the eighteenth century in the work of Chardin and Lancret (whose interpretations were engraved with appropriate inscriptions) and into the nineteenth century in versions by Manet (*Léon Leenhoff Blowing Bubbles*: a painting of 1867 in the Gulbenkian Foundation in Lisbon from which Manet made a print) and Millais. For all its sentimentality, Millais' *Bubbles* [41] belongs to the tradition: the broken flowerpot adds to the sense of fragility. Other nineteenth-century examples could be added. Among the most effective are a painting of 1859 by Thomas Couture in the Metropolitan Museum, in which a boy has abandoned his homework in order to watch the bubbles float slowly away, and a lithograph by Daumier. De Jongh discovered a particularly amusing example of the survival of the *homo bulla* tradition in an English children's book, *Afternoon Tea: Rhymes for Children* by J.G.Sowerby and H.H.Emmerson, published in London in 1880 [42]. Beneath an illustration of children blowing bubbles is the verse:

> Man's life is a bubble as light as air,
> Floating away now here, now there,
> The bubble looks likely to float all day,
> But man's life sooner doth fade away.

In other paintings the *homo bulla* theme can be just one element in a more complex whole. There is, for example, a rowdy interior scene by Jan Steen in the Mauritshuis, with figures eating, drinking, singing and, in the background, playing backgammon [8]. Despite the realistic setting – the large room with its chequered tiles, small-paned windows, table covered with a Turkish carpet and so on – this huge crowded scene can hardly be taking place in a domestic sitting-room. Nor does it seem to be meant for the interior of a tavern. Steen has crammed his canvas with a wealth of inci-

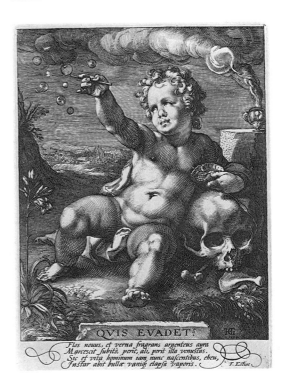

dent – the couple singing, the child playing with a cat, the old man offering an oyster – a well-known aphrodisiac – to a young woman, the maid warming the oysters and pouring vinegar on them, and in the background men smoking, drinking and gambling, while an old woman (of the 'procuress' type) offers a tall glass of beer to a seated man. What Steen is doing is lifting a curtain – literally, as well as figuratively, because the top third of the painting is covered by an illusionistic curtain – on the world of pleasure lived only through the senses, life lived purely for pleasure. It could carry above it the motto which the poet Vondel had devised for the Amsterdam theatre: inscribed above the proscenium arch were the words 'De wereld is een speeltoneel, Elck speelt zijn rol en krijght zijn deel' ('The world is a play, and everyone plays his role and is given his part'). However, a part in the world's play does not last forever and to make this point – and so cast a thoroughly sombre mood over the proceedings – Steen tucked away in the rafters a small boy who is blowing bubbles which drift down on to the figures below. At his shoulder is a skull. Here the *homo bulla* figure adds an additional layer of meaning to a genre scene.

When, as with Caspar Netscher's *homo bulla* painting [22], a realistic mode is employed to convey a particular idea, it is often difficult for a modern spectator to recognize its true subject. In the case of the *homo bulla*, and in those of the Five Senses and the Four Elements, there is a long-established traditional iconography to which it can be related, but in other paintings the artist's references may be contemporary. He may be combining elements from everyday life in a way intended to convey a particular idea, or a number of ideas, in an entirely original manner. The interpretation of such paintings is naturally far more problematic than it is with those employing traditional symbols, but there is evidence other than that of our eyes which we can call upon in attempting to understand them. In the first place, some such paintings were engraved soon after they were painted in order to make them available to a wider public, and when they were engraved a legend would be printed beneath them to point up the moral. An example is an engraving by Cornelis Kittensteyn after a

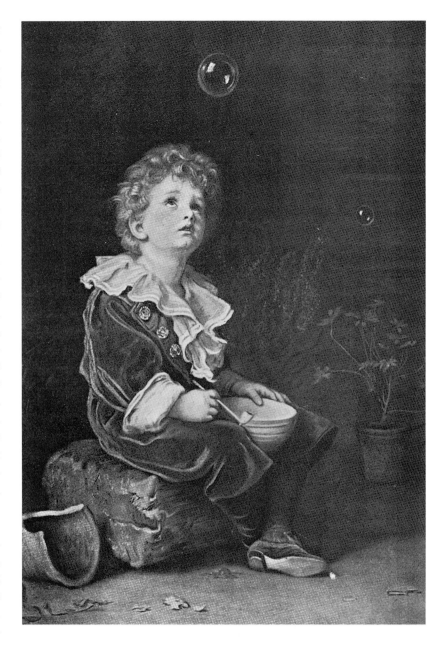

design by Dirk Hals of a 'merry company' scene which shows a group of young people enjoying lively conversation after a meal [160]. The engraving is presumably after a particular painting and although this painting is not known today, a number of very similar ones, such as that of 1626 in the National Gallery, London, are [23]. The verses beneath Kittensteyn's print make it quite clear that the spectator is being called upon to condemn the young people's appearance and behaviour. The author mocks them for their extravagant dress, their self-indulgence and their frivolity, and warns them that their pleasures will be short-lived. An interpretation of the painting in this sense raises the same problems which have already been encountered with prints

After Sir John Everett Millais (1829-96). *Bubbles*. Mezzotint by G.H.Every, 1887 British Museum, London [page 40]

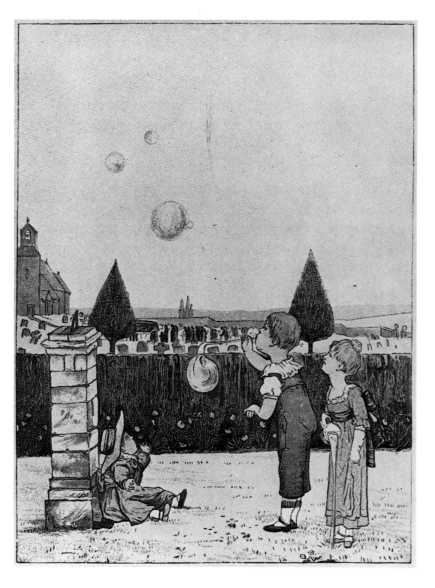

Illustration from
J. G. Sowerby and
H. H. Emmerson.
*Afternoon Tea: Rhymes
for Children*, London,
1880, p. 36
British Library, London
[page 40]

viewers' responses, certainty is rarely possible. All we can say is that the moral associations of the verses would have been suggested to some contemporaries by the paintings themselves.

In addition to single prints, an invaluable source for the interpretation of Dutch genre paintings is to be found in that now almost forgotten form of popular literature, the emblem book. An emblem book is a collection of illustrated sayings or proverbs, often with a moralistic sense. There are three parts to an emblem: a motto, an illustration and an explanation. Emblems had first been devised in Italy and Alciati's *Emblemata* of 1531 was the first printed emblem book to be widely known. They could be highly sophisticated and allusive, with double entendres and teasing symbols, which the reader would enjoy puzzling out. This is what the English emblem writer Henry Peacham had in mind when in his emblem book *Minerva Britannica*, published in 1612, he described the purpose of an emblem as 'to seede at once both the mind and the eie by expressing mystically and doubtfully our disposition... which perhaps could not have been openly, but to our praejudice, revealed'. In other, less sophisticated, hands, emblems could be little more than illustrated popular proverbs. The Dutch were particularly enthusiastic about emblems and large numbers of emblem books were published in the north Netherlands in the seventeenth century. Dutch emblem books tend to be far more down-to-earth than Italian ones. Their authors prefer the homely truth, the illustration from everyday rather than the arcane puzzle. They also often tend, hardly surprisingly in that place at that time, to adopt a highly moral tone. Jacob Cats, the most popular Dutch author of the seventeenth century, wrote a number of best-selling emblem books, notably *Sinne- en Minne-Beelden* (literally, *Images of the Mind and of Love*) of 1618 and *Spigel van den Ouden ende Nieuwen Tijdt* (*Mirror of the Old and New Time*) of 1632. They were illustrated by the artist Adriaen van de Venne In the introduction to the *Spigel*, Cats characterized the attraction of emblems: 'Proverbs [by which he meant proverbs or sayings in emblem form] are particularly attractive, because of a certain mysterious quality, for while they appear to be one thing, in fact they are

after Bruegel's peasant scenes: are we justified in believing that Hals had these sentiments in mind when he was painting his picture, or did the publisher believe it was necessary to include such moralizing sentiments in order to 'explain' a secular painting of this type? It is hard to know, but it is worth noting that Hals included a number of symbolic elements in his painting – the fast-fading roses strewn on the floor, the aphrodisiac oysters on the table and the religious painting, probably *The Taking of Christ*, hanging on the wall behind the innkeeper – which would reinforce a reading such as that given in the verses beneath Kittensteyn's print. If this interpretation is accepted, can we then consider all the many 'merry company' scenes in this way? It would seem likely, since they are all, in purely formal terms, closely related. However, in such matters, involving artists' intentions and contemporary

another, so that when in time the reader grasps the exact meaning and intention, he experiences great pleasure in the discovery – not unlike someone who, after a search, finds a beautiful bunch of grapes under thick leaves. Experience teaches us that many things gain by not being completely seen, but veiled and concealed.' In his emblem books Cats, in leaden verse, pointed to simple religious morals, although it is a particular feature of his early book, the *Sinne- en Minne-Beelden*, that two alternative explanations of each emblem are provided, one spiritual (that is, concerned with the *sinne*, the spirit or the mind) and the second worldly (concerned with *minne*, love). Commenting on this calculated ambiguity in the preface, Cats quotes the precedent of the Bible in which 'it is not rare to find one and the same thing considered sometimes as good, sometimes as bad'. While Cats may not have been a great writer, he was very widely read – his books went into enormous editions and were constantly reprinted – and his work does seem to have reflected closely the attitudes and aspirations of many Dutchmen, in a country where by contemporary European standards the level of literacy was exceptionally high.

There are two particular reasons for the importance of emblem books in a discussion of Dutch genre painting. In the first place, these books were made use of by painters – indeed, some books were specifically directed towards artists, as they explain on their title pages. When, for example, Dirck Pietersz Pers translated one of the best known of Italian emblem books, Cesare Ripa's *Iconologia*, into Dutch in 1644, he stated on the second title page that it was 'een werck dat dienstigh is, allen Reedenaers, Poeten, Schilders, Beeldhouwers, Teyckenaers, en alle andere Konstbeminders en Liefhebbers der Geleerheyt en eerlijcke Wetenschappen' ('a work that is useful to all orators, poets, painters, sculptors, draughtsmen, and all other art lovers and devotees of learning and true knowledge'). In the second place, certain emblem books, notably those of Jacob Cats, were very widely read and are a genuinely popular form of literature. They can therefore serve to introduce us to certain ideas which were in common currency at the time and which are referred to by genre painters in their very different medium. In general, analogies between painting and contemporary literature should be made with the greatest care; for example, the parallels between Dutch Arcadian poetry, which had a restricted upper-class readership, and the development of Dutch landscape painting, are difficult to substantiate. However, in the case of popular emblem books and genre painting, there is a world of shared ideas. In certain cases, a knowledge of emblems can be used to interpret individual elements and motifs which are incorporated in order to underline the general sense, often quite evident, of a painting. An example is Jan Steen's painting, *Grace before Meat*, in the Philadelphia Museum of Art. A peasant family are giving thanks for their humble meal: the mood of the painting is one of Christian devotion. The meal is taking place outside and prominent among a number of plants on the left is a sunflower. At first this might seem simply to be a naturalistic element of the composition: although eye-catching, the bright yellow circle of the sunflower is not out of place. However, a knowledge of emblems enables us to realize that Steen placed the sunflower in this scene with the deliberate intention of underlining or reinforcing the sense of the whole. The sunflower turns towards the sun for its sustenance and so had in emblematic literature become a symbol for the Christian who turned towards God for spiritual sustenance. For example, in Zacharias Heyns' *Emblemata*, published in Amsterdam in 1625, the sunflower is used to illustrate Christ's words in the Gospel of St John (8:12): 'I am the light of the world.' Although recognizing the significance of Steen's use of the sunflower in his painting enriches our appreciation and understanding of it, it does not basically change our view of its general sense.

An example of the way in which our entire response to a painting can be enhanced by a knowledge of the community of ideas shared between emblem books and genre painting is provided by Gerrit Dou's *Quack Doctor* [24] in the Museum Boymans-van Beuningen in Rotterdam, whose meaning was so brilliantly reconstructed by Emmens. The subject of the *Kwakzalver* was already well established by the time Dou painted it in 1652. The quack who deceived his listeners by his smooth salesmanship, persuading them to buy his worth-

less patent medicines, was a stock character. He stood for deceit and his victims for gullibility. For example, in a print by Jan van de Velde after Willem Buytewech, it is the audience which is castigated in the inscription: '*Populus vult decipi*' ('The people want to be deceived'). However, Dou's interpretation of this standard subject imbues it with many rich layers of additional meaning. He has placed the scene in Leiden, his home town: the town wall and the Blauwpoort can be seen in the background on the left. The quack has set up his stall selling patent remedies outside the window of an artist's studio. The painter, a self-portrait of Dou, brushes and palette in hand, leans out, taking no interest in the proceedings but looking directly out of the painting. A crowd has gathered around the quack's stall which is covered by a rich Turkish carpet and surmounted by what more or less amounted to the quack's shop-sign, the circular Chinese umbrella. A huntsman who carries a dead hare over his shoulder has stopped, as have a man wheeling a barrow full of vegetables, a maid with a dish covered by a cloth, and a young mother with her baby. The latter is wiping her baby's bottom: looking more closely we see that she is a pancake-seller, with her portable griddle and a large bowl of pancake mixture beside her. To her right an old woman, her mouth open, is so intent upon the words of the quack that she fails to notice that her pocket is being picked. The quack doctor was a familiar figure at markets and fairs in seventeenth-century Holland, just as he was in the American West a century ago, if Hollywood is to be believed. He deceived with his performance, his fast talk and his worthless testimonials. Dou has used the figure of the quack as the central feature of what may at first glance appear to be a slice of everyday life in Leiden but is in fact an elaborate and immensely sophisticated allegory of the nature of deception.

The modern spectator can unravel the allegory with the help of contemporary emblem books, although he may still miss certain nuances of meaning. This is not to say that Dou necessarily made use of these particular emblem books in devising his allegory, but rather that the ideas expressed in Dou's painting were in current circulation and found alternative vis-

Dat Cera Fidem.
Emblem from Roemer Visscher, *Sinnepoppen*, Amsterdam, 1614 [page 44]

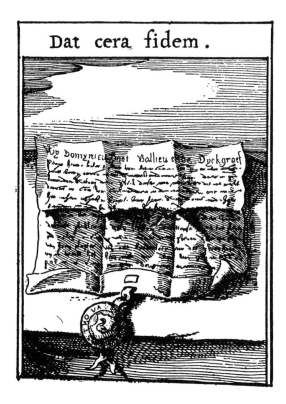

ual expression in the emblems. For example, the document (with its heavy, impressive-looking seal) which lies so prominently on the quack's table can be paralleled in an emblem in Roemer Visscher's book *Sinnepoppen* (literally, *Dolls of the Spirit*), published in Amsterdam in 1614. Above an illustration of a similar document is the Latin motto, '*Dat cera fidem*', meaning that the seal gives confidence [44]. The text explains that the gullible are easily deceived by official-looking documents, which is clearly the meaning that Dou also intends. Such a meaning would, however, probably be obvious to a modern spectator even without the help of a comparable emblem. Far more difficult to recognize, however, is the contrast intended by Dou between the dead tree shown prominently on the left and the flourishing tree in the centre of the composition. This can be compared to another emblem in Visscher's book, showing a live tree and a dead tree [45]. The motto is '*Keur baert angst*', meaning that choice gives rise to fear or uneasiness, while the text beneath concerns the difficulty of making choices and the dangers of choosing the superficially more attractive option which, like the tree which withers and dies, proves to be the wrong one. It is advice which the quack's audience would be well advised to heed.

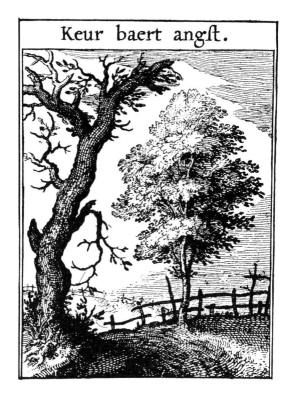

The image of the pancake-woman [45] can be found in another emblem book, *Zinnebeelden oft Adams appel* (*Images of the spirit, or Adam's Apple*) by Jan van der Veen, published in Amsterdam in 1642. The woman cooking pancakes illustrates a lengthy motto which can be literally translated: 'The prattle of ill-considered talk is the cause of the undoing of many good intentions.' The commentary draws an analogy between a pancake which has not been properly cooked and ideas which are unsound or have not been fully thought out. Dou makes use of this metaphor, deliberately placing the uncooked pancakes which are not being carefully watched (as they are in the emblem) directly below the figure of the quack whose words are 'uncooked' and untruthful. A third book, Johan de Brune's *Emblemata*, published in Amsterdam in 1624, is of help when we turn to the action of the woman in cleaning her child. This image was often used to illustrate the sense of Smell in series of the Five Senses but de Brune extends its meaning. He uses it to illustrate a *vanitas* motto: '*Dit lijf, wat ist, als stanck en mist?*' ('What is life if not stench and excrement?'), and Dou employs it in a similar manner to condemn the quack for his part in adding to the evil of the world and the harshness of life. Elsewhere in the painting the quack's deceit is echoed by the actions of the children, an example of the frequent use of

children to point up adult weakness (in the tradition of Pieter Bruegel) in Dutch genre painting. The boy at the huntsman's feet is trapping a bird with a bait, just as the quack is trapping his audience with the bait of his words and 'testimonials'. A second boy is picking the old woman's pocket as she gives all her attention to the quack. There are many additional elements which deepen the meaning of the whole: the ape on the quack's table is, for example, a traditional symbol of deceit.

By including his own self-portrait, Dou introduces an important additional dimension to a traditional subject. The quack and the painter, shown more or less side-by-side, are clearly intended to be compared: both deceive, one the mind and the other the eye. Both, Dou is saying, are in the same business, that of creating illusions. Just as the quack's audience believes his coloured waters to be healing medicines, so the painter's audience sees in his two-dimensional panel a recognizable and apparently real part of the everyday world. The painter's illusions are, naturally, preferable to

Keur Baert Angst.
Emblem from Roemer Visscher, *Sinnepoppen*, Amsterdam, 1614 [page 44]

Emblem from Jan van der Veen, *Zinnebeelden oft Adams appel*, Amsterdam, 1642 [page 45]

Het ongerijmt geklap of reedenlooſe reeden,
Verderven ſoet verbaal en alle goeds zeeden.

XXIV.

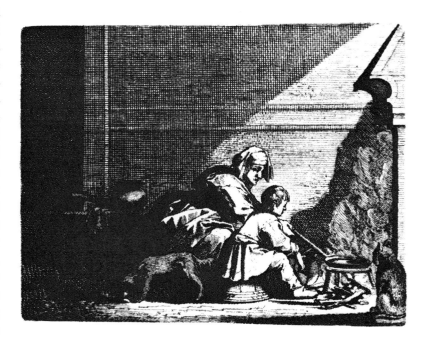

Du ſage eſt, l entretien tres-doulx & agreable,
Contraire eſt le babil du fol. Inſupportable.

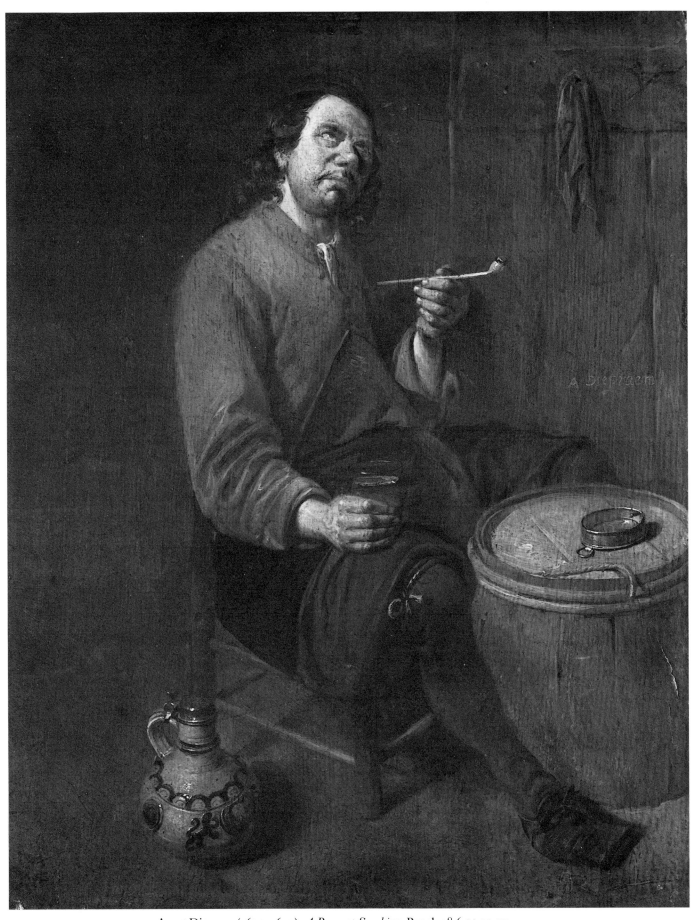

Arent Diepram (1622–1670). *A Peasant Smoking*. Panel, 28.6 × 23 cm.
Reproduced by courtesy of the Trustees, National Gallery, London. [page 47]

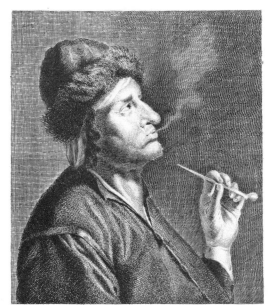

Terwyl ik yvrig rook verinis, kleyn gesneen,
Denk ik vast by my self; Soo vliegt de Weerelt heen.
AE. pinx. · H. Bary fc.

Gallery, London) [46] calls to mind the passage in Eugène Fromentin's *Les Maîtres d'Autrefois* (Paris, 1876) which until relatively recently typified the usual approach to much Dutch genre painting: 'Why does a Dutch artist paint a picture? For no good reason at all; and no one asked him for one. A drunken peasant with a red nose fixes you with his eye and, showing his teeth, laughs at you while he raises a jug; if it is well painted, it has its price.' However, if we compare Diepram's painting with a contemporary engraving by Hendrick Bary [47] of a strikingly similar figure, we may suspect that Fromentin has simplified the Dutch artist's motives. The inscription beneath the smoking peasant reads: 'When I smoke *verinis* [a type of tobacco] cut up fine, I think to myself all the time, so the world flies away.' If we carry this sense over to the paint-

Hendrick Bary (after AE). *The Smoker*. Engraving Rijksprentenkabinet, Rijksmuseum, Amsterdam [page 47]

Philips Galle (1537-1612). *Acedia*. Engraving Rijksprentenkabinet, Rijksmuseum, Amsterdam [page 48]

the quack's, but the intention of both is to mislead their audience. Here Dou introduces a vitally important element not only of this particular painting, but of Dutch genre painting as a whole – humour. Whether as in Dou's case it takes the form of cleverly allusive wit, or, as in the case of some of his contemporaries, of coarse and vulgar joking, it is very often present in genre paintings, and its importance has been insufficiently recognized. Emmens' interpretation of Dou's *Quack Doctor* has further, profoundly serious, ramifications. He believed it to be concerned with the nature of good and evil in an abstract, philosophical sense, a contemporary equivalent of the classical subject of the Choice of Hercules (a choice between vice and virtue) with a further layer of meaning in that the labourer, huntsman and painter stand for the *vita activa* and the *vita contemplativa*. I cannot follow him in this interpretation, which turns the painting into a heavy-handed moral tract, a piece of clumsy sermonizing. Rather it is a witty, self-consciously clever allegory about the nature of deception which would have been enjoyed and appreciated by the well-educated clientele for whom Dou worked.

By no means all Dutch genre paintings attain this level of sophisticated allusiveness. Arent Diepram's *Peasant Seated Smoking* (National

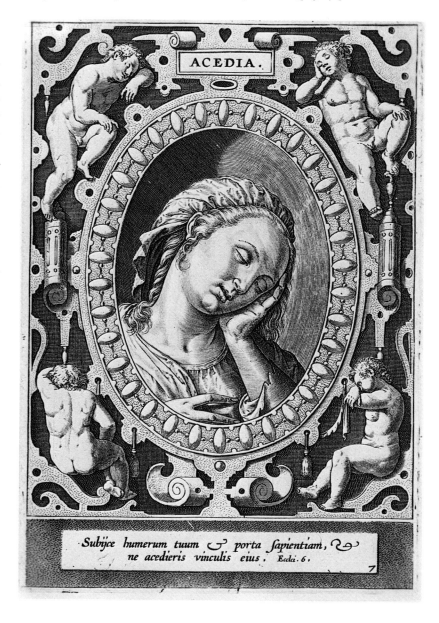

ACEDIA.

Subijce humerum tuum *&* porta sapientiam, ne acedieris vinculis eius. Eccli. 6.

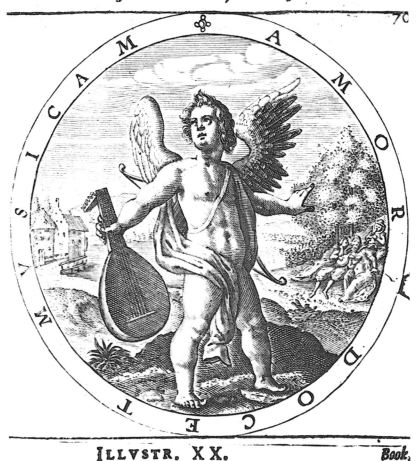

Love, a Musician is profest,
And, of all Musicke, is the best.

ILLVSTR. XX.

Amor Docet Musicam.
Emblem from Gabriel
Rollenhagen, *Nucleus
Emblematum*, Cologne,
1611
[page 48]

ing, it assumes a *vanitas* significance. Smoking was, of course, a contentious issue at the time: it was a relatively new phenomenon associated with rowdy lower-class behaviour and often provoked extreme disapproval. Diepram, however, is not entering this debate. His aims are far more modest: he is apparently aware of the *vanitas* implications of his subject and at the same time is making fun of the peasant slumped in his chair, whose life is slipping purposelessly away, just as his tobacco smoke disperses in the air.

In Nicolaes Maes' *The Sleeping Kitchenmaid* (National Gallery, London) of 1655, we are surely invited to share the smiling housewife's indulgence of the maid who has fallen asleep over the unwashed dishes [25]. And yet, as can be seen by comparison with a print by Philips Galle, Maes has taken her pose from the traditional representation of *Acedia* [47] or Idleness, one of the Seven Deadly Sins.

This is, however, no stern Calvinist tract, but rather an amused visual comment on a saying like that in Johan de Brune's *Emblemata*: '*Een keucken-meyt moet d'eene ooghe naer de panne en d'ander naer de katte hebben*' ('A kitchen maid must keep one eye on the pan and the other on the cat.') The allusion to Acedia is itself an aspect of the painting's wit. It must also always be kept in mind that contemporaries would not have valued a painting such as this in the first place for its success in conveying such a commonplace idea, but rather for its apparent truth to nature: the lifelike figures and the cunning cat, the still-life of pots and pans on which Maes has lavished such evident care and the so-called *doorkijkje*, the view through at the left to the room in which the meal is being served. This is an early use of a visually intriguing recessional device later employed to great effect by Pieter de Hooch and others. Vermeer also painted a maid sleeping in a posture of *Acedia* (Metropolitan Museum, New York), but here there is no amused observer to point her out to the spectator [26]. It is fascinating to discover that the earliest mention of Vermeer's painting, in an Amsterdam inventory of 1696, describes it as showing '*een dronkende slapende Meyd*' ('a drunken, sleeping maidservant'). At least one contemporary must have made an association between the presence of a white porcelain wine-jug and the maid's slumped posture. Did Vermeer intend us to understand that the maid was drunk or idle or indeed both? Did he intend to condemn her, or was his attitude one of amusement? Or is the painting in fact entirely lacking in any moral sense? Is its real 'meaning' contained in the superlative still-life, the elegant spatial relationships and the remarkable treatment of the fall of light on differing textures?

Certain themes constantly recur in Dutch genre painting of the seventeenth century and the form of this book is largely determined by them. Love is a pervasive theme. It is often associated with music, and this is made explicit by Gabriel Rollenhagen in his emblem *Amor docet musicam* [48] which shows a cupid holding up a lute and pointing towards music-making lovers in the background. An emblem by Jacob Cats [49] shows a man playing a lute while in front of him another lies on a table. The motto is '*Quid non sentit amor?*' ('What

does love not feel?') and in the text the lute-player invites women to pick up the second lute and join him in a love duet. Can this then be the meaning of the prominently displayed viola da gamba in Vermeer's *Young Woman seated at a Virginal* (National Gallery, London) [27]? Is it to be taken up by a man who would then perform a love duet with the young woman? If this is the case, what are we to make of Dirck van Baburen's scene of mercenary love, *The Procuress* [175], hanging on the back wall? Is mercenary love the painting's true subject? And it is not only music-making that is associated with love in Dutch genre paintings. Letter-writing and letter-reading are also subjects which contain unmistakable references to love.

The education of children was another favourite subject. In his *Lady teaching a Child to read and a Child playing with a Dog* (National Gallery, London), Caspar Netscher intends us to recognize a deliberate contrast between the child, a girl, who is being helped with her reading by her mother, and the other child, a boy, who prefers to play [28]. A knucklebone, a top and a illustrated broadsheet, lie beside him. The two children stand for industry and idleness. There is a similar painting of the same size by Netscher in the Rijksmuseum [29] which may be a pair to the picture in London. It shows a mother combing the hair of her son while her daughter admires herself in a mirror. Again, of course, a contrast between obedience and disobedience (compounded in this case by vanity) is intended. (This tradition is continued into the nineteenth century in a pair of similarly contrasted scenes by Abraham van Strij in the Dordrechts Museum.)

Prominent on the floor in the foreground of both of Netscher's paintings is a top. In Visscher's *Sinnepoppen* is an emblem showing a top being whipped [49]. The motto is: '*Soo langh de Roe wanckt*' ('As long as the whip beats'). The text expands on this – 'The further the whip is from the backside, the lazier they grow in the service of God' – and Visscher makes it clear that he is not simply referring to the discipline of children but also to the relationship between Man and God. That this more general implication was also in Netscher's mind is made clear by his inclusion on

Quid non sentit Amor? Emblem from Jacob Cats, *Sinne- en Minne-beelden*, Amsterdam, 1664. [page 48]

So langh de Roe wanckt. Emblem from Roemer Visscher, *Sinnepoppen*, Amsterdam, 1614 [page 49]

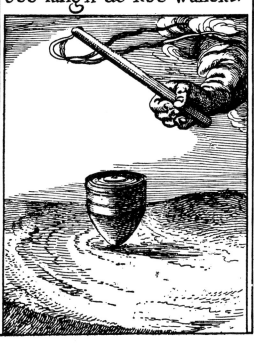

Peter Paul Rubens
(1577-1640). *The Brazen
Serpent*. Canvas,
186.4 × 264.5 cm
Reproduced by courtesy
of the Trustees, National
Gallery, London.
[page 50]

the back wall of the room in the London paint-
ing of a small copy of Rubens' painting of *The
Brazen Serpent* [50]. The placing of paintings
within paintings in order to explain, underline
or add further significance to a particular scene
is a device often used by Dutch genre painters.
It is the realistic equivalent of the earlier prac-
tice – common in Flemish painting of the fif-
teenth and sixteenth centuries – of placing a
subsidiary, explanatory scene in the back-
ground, or on the wing of an altarpiece. *The
Brazen Serpent* is an illustration of the Old
Testament story of the plague of serpents
which God visited upon the Israelites when
they forsook Him. A similar idea to that of
Visscher and Netscher can be found in a com-
mentary by Jacob Cats on a print showing
children's games. Of the top, he wrote: 'The
top spins merrily on the floor, whipped by a
biting cord, and the harder it is hit the better it
spins. But stop beating for just a moment and
it falls in the dust. From then on it won't spin
at all but will lie forever like a block. The top is

never better watched than in times of sorrow
and unhappiness. For if anyone lives without
pain, he rusts from idleness. When man has
too much leisure, then the heart yearns for
Lust.' If we read Netscher's painting with this
sense – and there is much support for such a
reading – it shows in the first place a deliberate
moral contrast between industry and idleness,
learning and play. The presence of the top in
so prominent a position adds an extra element:
children should be beaten like the top lest they
'rust from idleness'. *The Brazen Serpent* in-
troduces a further layer of meaning – just as
children have to be beaten in order to learn, so
man's devotion to God is strongest when he is
lashed by misfortune.

The method of interpretation of Dutch genre
paintings with the help of contemporary prints
as well as emblem books and other popular
literature which has been outlined here and is
used elsewhere in this book must be employed
with the greatest care. The dangers inherent in

50

such an approach are all too obvious. It is easy enough for the twentieth-century art historian with prints and emblem books at his elbow to construct elaborate interpretations for apparently simple paintings, giving them an intellectual sophistication they do not inherently possess. Similarly, it is possible to turn them into sour moralizing tracts by not taking account of the humour which often constitutes an important part of their appeal. It has always to be kept in mind that a genre painting is a *painting*, not an illustrated book, a painted emblem or the visual equivalent of a Calvinist sermon. To a contemporary audience it was first and foremost an almost miraculous exercise in illusionism, in the recognizably accurate representation of people, situations and objects familiar from everyday life. The ideas that could be expressed might be truisms, clichés or the most hackneyed of popular proverbs and yet presented in this form would seem fresh and exciting. And in the hands of intellectually gifted artists like Dou and Netscher the ideas themselves could be original and provocative.

II. THE TRANSFORMATION OF DUTCH SOCIETY

All art, even that which derives many of its elements from observed reality, possesses its own self-referring history and resists simplistic interpretations of its development in terms of social change. Yet if there is one type of art which will gain in comprehensibility and significance from an understanding of its social and historical background, it surely is genre painting and perhaps Dutch genre painting most of all. By its very nature Dutch genre painting represents, reflects and comments on contemporary life in the north Netherlands. It is an art that was responsive to contemporary discussion and debate, to changes in social organization and in patterns of private and public behaviour. Although certain themes recur throughout the seventeenth century, others enjoyed a brief vogue which can sometimes be related to current events and preoccupations: an obvious example is the *cortegaerdjes*, scenes of soldiers resting, gambling and drinking in guardrooms, which were popular in Amsterdam in the 1620s and 1630s, and are clearly related to events in the long war with Spain.

In Dutch genre painting there are no canonical scenes, as there are in religious art, to be endlessly repeated within the often constricting limits of a long-established iconographic tradition. In this sense it is a constantly changing and developing art, with relatively loose formal traditions, and for these reasons it is inappropriate to analyse these traditions on the model, for example, of Italian or French religious painting. There was a lively exchange of ideas between genre painters (and between painters and print-makers) but the tracing of particular motifs and spatial or compositional devices from one artist to another – as has been done with the so-called *doorkijkje*, the view from a foreground room through a door into a second room, for example – is a largely futile exercise, presuming as it does the rigid constraints of an iconographical tradition which are, in fact, largely absent. Two genre painters with a particular problem of the depiction of their everyday environment (rather than that of Heaven, or of first-century Palestine) to solve may well have come up quite independently with the same idea, rather than have borrowed one from the other.

Although in formal or compositional terms, Dutch genre painting was responsive and innovative, that is not to say it was progressive in its treatment of social change and intellectual and scientific development. Indeed, it was quite often exactly the opposite, making use, for example, of traditional characters such as the alchemist who belong to a sixteenth-century graphic tradition rather than to the observed life of the seventeenth century in order to poke fun. The attitudes of genre painters towards doctors, dentists and, for that matter, scientists in general are, for the most part, permeated with a typically late medieval amalgam of fear, distrust and suspicion. The doctor is depicted as a conventional stereotype, a quack or a brute, and there is little real reflection of any of the remarkable medical and scientific discoveries of the seventeenth century. Maps, one of the great Dutch achievements of the century, are sometimes glimpsed in domestic interiors, notably in those of Vermeer, and cartography was cherished by genre painters for its inherent beauty, its power of description and its evocation of distant lands. However, while Vermeer's *Astronomer* [72] and

Geographer [73] may seem to be shown by the artist as contemporary heroes, Adriaen van Ostade's preposterous *Alchemist* [101], Jan Steen's comic doctor [97] and Jan Molenaer's brutish *Dentist* [67] better typify the attitudes of genre painters towards scientists and the medical profession.

To say that Dutch society was changing during the seventeenth century is an understatement. It would be more accurate to say that the last quarter of the sixteenth century and the first half of the seventeenth saw it transformed. The pace and the extent of this process naturally varied greatly within the north Netherlands: in the province of Holland it was at its most dramatic and complete and it is with Holland that this account will largely be concerned. In the eastern provinces of Gelderland and Overijssel, by contrast, the tenor of rural life continued much as it had done since the Middle Ages, although they were not, of course, untouched by bitter religious conflict. The principal factors which brought about this transformation, more radical than anywhere else in western Europe, were the long war with Spain and, in particular, the consequent shift of population to the north; the permeation of Calvinism into every aspect of the life of the Republic and its establishment as the State religion; the recurrent political conflict between the urban regent class and the House of Orange; and the country's phenomenal economic success.

The Dutch Republic was at war with the Spanish Empire, of which prior to the outbreak of the Revolt in 1567 it had been a relatively insignificant distant part, until 1648, when her independence was recognized under the terms of the Treaty of Münster. After the recommencement of hostilities in 1621, following the breakdown of the Twelve Years' Truce, the war was largely fought in Flanders and the armies of the Republic were almost entirely made up of foreign mercenaries. The financial commitment to the war, however, remained immense and was met by heavy direct and indirect taxation: in 1628 there were 120,000 men under arms, including all the *waardgelders* (members of the town militias), mercenaries and sailors, equivalent to the total population of Amsterdam.

The long war not only had financial and military consequences for the Republic; it also brought about a major shift of population within the Netherlands. In 1500 the province of Holland contained a quarter of the Republic's population; by 1650 it was two-fifths. In that year Holland provided two-thirds of the Republic's total revenue, a clear indication of its economic domination. Emigration from Flanders to the north, particularly after the reconquest of Antwerp by the Spaniards in 1584, was on a very large scale. These emigrants were not only the politically active, who feared Spanish retribution, and Protestants, unable to practise their religion in Flanders, but also many with less idealistic motives, those who had lost their jobs in the severe economic dislocation caused by the war which had ravaged the south. Antwerp's position as a great trading port had been usurped by Amsterdam and the long-established textile industries of Flanders had been displaced by those of Leiden, Haarlem and other northern towns. There was, for example, a huge influx of weavers into the rapidly expanding industrial centre of Leiden from the cloth-weaving towns of Flanders such as Houdschoote and Ypres at the end of the sixteenth century and in the early years of the seventeenth. Amsterdam experienced phenomenal population growth from 30,000 in 1530 to around 105,000 in 1622 and more than 150,000 by the end of the century: so many were from the south that Jacques della Faille commented in 1594, 'Here is Antwerp itself changed into Amsterdam.' A third of all citizens in 1622 were immigrants from the southern Netherlands or their first generation descendants. Tensions between the immigrants, with their Spanish manners and clothes and their high-flown patterns of speech, and the more down-to-earth natives, was the subject of the great Amsterdam playwright Gerbrand Bredero's last play, *Jerolimo or the Spanish Brabanter* of 1618, in which the principal characters are a flamboyant southerner, with no money but great pretensions, and his Amsterdam servant. There was a second wave of immigration later in the century when many French Huguenots settled in Holland after Louis XIV revoked the Edict of Nantes in 1685 but this was not on the same scale and it did not have the profound social consequences of the Flemish immigration.

52

During the war of liberation from Spain, Calvinism was a powerful inspiration. However, the triumph of the Calvinist Church in the north Netherlands was gradual and never absolute. The theocracy of which devout Calvinists dreamt was never established because the new-found political liberties of the Republic and her economic development worked against it. In the early years of the century Holland's urban regent class, which exercised great political authority in the States General, the United Provinces' parliament, was indifferent or even hostile to Calvinism, favouring more tolerant forms of Protestantism. Confrontation came in 1618 when the Calvinist Church called upon what was in effect its secular arm, the House of Orange, to bring down the Advocate of Holland, the effective political leader of the Republic, Johan van Oldenbarnevelt. Subsequently, there were fierce religious disputes, which occasionally led to rioting, with Gomarus' strict Calvinism attracting mass support among the artisan and working classes while Arminius' more liberal Protestantism found its principal supporters among the richer and more influential sections of Dutch society. This tension continued in one form or another throughout the century. Calvinism was implacably opposed to humanism: it opposed all extravagance and self-indulgence, advocating sobriety, simplicity and reserve. In these respects, it was profoundly influential on the development of all echelons of Dutch society; even among the Republic's richest citizens there were many devout Calvinists. Calvinist teaching naturally informed attitudes towards social behaviour and the family as well as patterns of worship.

Only after the Great Assembly of 1651 did the Reformed Calvinist Church (*Hervormde Kerk*) achieve the status and power of a State Church. Its catechism was taught compulsorily in all schools and its ministers were paid by the State. Since 1637 the Church had had its own translation of the Bible, the Bible of the States, authorized by the Synod of Dordrecht. The Church's liturgy was conducted in buildings which had been stripped of any suggestion of Popish luxury, and there was even opposition to organ music although by 1640 pressure of public opinion had forced its reintroduction. Only psalms were sung, hymns

were not permitted. The most important part of the two- or three-hour long Sunday service was the sermon. Certain preachers had a great popular following: when a sermon by Borstius of Dordrecht was announced for nine o'clock, queues would form outside the church at five. After a passage from the Bible had been read the preacher (*predikant*) would climb into the pulpit, which was placed on one side of the body of the nave, and deliver his sermon, often in a highly coloured language which made frequent use of puns and proverbs. Many sermons dealt with the conduct of individuals and criticized prominent people by name. Luxury and the love of pleasure were constantly condemned from the pulpit. Long hair worn by men, jewellery worn by women, the theatre, dancing, tobacco, coffee, alcohol, the celebration of traditional festivals like St Nicolas and Twelfth Night, were all the subjects of impassioned denunciation in sermons.

For much of the rest of Europe the seventeenth century was a period of economic stagnation and crisis but for the north Netherlands it was a time of remarkable growth, particularly in the province of Holland and its leading city, Amsterdam. The success of Holland was based in the first place on the Baltic grain trade, 'the soul of trade' as it was described by one Amsterdam merchant: it involved the transport of grain from Danzig and other Baltic ports to Amsterdam where it was traded on the city's grain exchange and then re-exported to the rest of Europe. This carrying trade was expanded to every other conceivable commodity until by 1670 the Dutch merchant marine was larger than that of England, France, Spain and Portugal combined. Hendrick Laurensz. Spieghel, who was a successful merchant as well as a poet, composed an ode to the *Zeevaart*, cataloguing in iambics the city's trade: cheese and butter from Friesland, furs and hides from Russia, cattle from Denmark, timber and fish from Norway, beer and cloth from England, wine from France, pepper from India, cork and figs from Spain, in exchange for dairy products, herring, salted fish and linen from Holland. This world-wide trade was underpinned by the Amsterdam Bank and Exchange which made the city the financial capital of Europe, and defended by the fearsome Dutch navy.

53

The success of Amsterdam, Leiden and the other towns of Holland attracted not only immigrants from the south but also from the rural areas of the north Netherlands. As a consequence a large proportion of Dutchmen lived in towns: in the province of Holland in 1622 two-thirds of the population lived in towns of over 3,000 inhabitants and almost half in towns of over 10,000. The rapid growth of the towns led to increased demands on the rural areas for the provision of food and these were met by a revolution in agrarian techniques with larger farm animals, new crops (notably maize, buckwheat and potatoes) and better yields. Dutch agriculture, no less than Dutch commerce, was remarkably efficient and successful in the seventeenth century. In the United Provinces as a whole, but especially in the western provinces of Zeeland, Holland and Friesland, the dramatic political and social change brought about by the Reformation movement and the war with Spain had seen the end of seigneurial rights and the consequent division of land into smaller units which were intensively cultivated. In place of the vast estates of France and England, often owned by absentee landlords, Dutch agriculture was characterized by small farms owned by the farmers themselves or leased to them by wealthy town-dwellers. It was also free of the customs of rural communities elsewhere in Europe: common fields had disappeared from Holland by 1500 and, with them, many of the difficulties associated with common husbandry and grazing. Efficiently farmed, agricultural produce was easily transported the relatively short distances to the towns along the extremely effective network of canals. Urban demand for food also encouraged the programme of land reclamation which was at its height between 1590 and 1639, between which dates 80,000 hectares of lake and marsh were drained to provide fertile polder.

The country's economic success particularly benefited the regent class, the often intermarried but, at least in the first half of the century, not yet socially exclusive, group of merchant families who controlled the towns. Many individuals accumulated enormous fortunes but there was little desire for lavish display on the French or Italian model. The prosperity did to some extent percolate through to the lower reaches of Dutch society. Real wages rose from 1625 onwards, so that by the middle of the century Dutch labourers and artisans were the best paid in Europe. On average, wages were twenty per cent higher than in England. When in 1696 Gregory King made the first estimate of national incomes for some European countries, the Dutch were the richest people in Europe. Taxation, however, was high: a comparative analysis of consumption, taxation and saving in England, France and the United Provinces in 1688 and 1695 reveals that the Dutch had the highest incomes, the highest taxes, the highest level of savings and a relatively low level of consumption. While grain prices rose more slowly during the seventeenth century than in the rest of Europe because of the importation and efficient distribution of cheap grain from Prussia and Estonia, there remained widespread poverty among the exploited industrial class (notably in the Leiden textile industry) and, most strikingly, among a large drifting population of seasonal labourers.

In the insanitary conditions of the seventeenth century, the urbanization of the Dutch Republic brought with it the rapid spread of disease. Amsterdam, which was severely overcrowded, suffered nine major outbreaks of plague between 1617 and 1664. In the latter year, according to the city's historian Caspar Commelin, 24,000 died but as the city was so crowded 'in the streets this extraordinary loss was not noticeable'. Dutch mortality rates, for both children and adults, were very high by European standards. Life expectancy was rarely over thirty and the average age at marriage gradually rose during the century, to around twenty-five. Marriage entered into at that age could expect an average duration of fifteen years, with four or five children. Of every hundred children born, half died before marriageable age. At all ages there was a higher masculine mortality rate, thus upsetting the balance of the sexes. The general demographic pattern was one of virtual equilibrium in the towns and small increase in rural areas. The small rural increase was accounted for by emigration to the towns and to the 'new lands' overseas, which half a million Dutchmen colonized during the course of the century. Parival uncharitably described the East Indies as 'a real sewer of a country into which flows all the garbage of Holland'.

The Dutch in the seventeenth century were not only prosperous, they were also remarkably literate. At the end of the century the Dutch and the English enjoyed the highest literacy rates in Europe, the invention of printing and the preaching of the Reformed religion being the two most important contributory factors. In the Dutch Republic this was a direct consequence of the Reformed Church's drive for universal education: the Synod of Dordrecht in 1574 had urged the establishment of schools throughout the United Provinces. At the lowest level of the ambitious educational system were the common schools which Schotanus, a professor at the University of Franeker, called 'the foundation of the Republic and the Church'. In 1667 he claimed that all the villages of Friesland 'are adorned with small schools for educating the children in reading, writing and arithmetic and the catechism'. The situation was the same elsewhere in the United Provinces: local historians almost invariably record the arrival of the first schoolmaster soon after that of the first *predikant*. (A good example is provided by Pieter Carelsz. Fabritius, father of the painters Carel and Barent, who went in 1616 at the age of about eighteen to the village of Midden-Beemster on the Beemster polder, which had been reclaimed only four years earlier: he was also sacristan and precentor of the church, which was served by the *predikant* of Monnikendam until 1622, when it received its own *predikant*.) Above the common schools – and complaints are often heard of the quality of the teachers in those schools – were (by the mid-seventeenth century) ten *gymnasien* and sixty-two Latin schools which gave more advanced instruction in virtually all the towns of the Republic. In addition there were the five universities, staffed by seventy-seven professors and enrolling six hundred students every year. This educational system (as well as the incomes of Reformed ministers and the provision of charitable institutions such as poorhouses) was largely supported by the efficient administration of former church lands.

The economic success of the Dutch Republic went hand-in-hand with a decentralized political system and a remarkable degree of toleration. The political theme which runs through the century is the continuing struggle between the urban regents whose administrations wished to facilitate trade and business and so were tolerant, moderate and peaceable, and the party of the Prince of Orange, the hereditary Stadholder of Holland, which attracted a more extreme, exclusive brand of Calvinism and sought power through military success. In 1650 Prince Willem II laid siege to Amsterdam and the crisis precipitated a pamphlet war between the parties, the *prinsgezinden*, who favoured a more centralized system of government under the prince, and the *staatsgezinden*, who supported the oligarchic rule of the regents, which allowed considerable independence for the individual provinces. The House of Orange, according to the Calvinist preacher Jacob Stermont, was 'a secure compass, by which the ship of Our Republic has safely sailed past many a dangerous rock' whereas the regents' party was made up of Hispanophile libertarians and Arminians possessed by the Devil's spirit. They were worse, he alleged, than the 'bitterest Jesuits'. By contrast the Bicker family, who led the regents' party, were praised by Vondel for their selflessness; they were, he wrote, 'concerned more with the citizens' needs than with their own honour, state or gain'. The crisis passed with the death of Prince Willem a few months later and the subsequent abolition of the title of Stadholder, but the same passions and parties resurfaced in the *rampjaar* of 1672, when the armies of Louis XIV invaded from the south.

The toleration of Dutch society was admired by foreign visitors to Amsterdam. In 1619 James Howell wrote that 'in this street, where I lodge, there be well near as many Religions as there be Houses, for one Neighbour knows not nor cares not much what Religion the other is of'. Sir William Brereton, in the city in 1634, was also struck by the fragmentation of religious life: he noted thirty sects within the Baptist Church alone. The principal split within the Reformed Church itself was that of the Remonstrants who left the main body of the Church after the Synod of Dordrecht, unable to accept the dogma of predestination. They were named after their statement of faith, the *Remonstratie* of 1610, drawn up by Johannes Uytenbogaert. In 1629 they were permitted to build their own church and some time later to establish a seminary. Among the diverse Prot-

estant sects there was constant and often fierce debate carried on in sermons, books, pamphlets, broadsheets and newspapers. Catholics were tolerated, though excluded from public office. They worshipped at their secret shelter-churches such as Our Lord in the Attic in Amsterdam, which survives today, and the *beguines* were left alone to perform their acts of charity in the city's *Begijnhof*. The Lutherans were granted permission to build a church in Amsterdam in 1632 and there were churches in the city catering for French Protestants, German Calvinists and British Protestants. A French official estimated in 1672 that a third of the Dutch population was attached to the Reformed Church, a third to the various dissident Protestant sects and the remaining third were Catholics. In 1675 Elias Bouman's great Portuguese synagogue in Amsterdam was dedicated: Romeyn de Hooghe's commemorative engraving carries the inscription: '*Libertas conscientia incrementum republicae*' ('Freedom of worship is the mainspring of the Republic').

Many political and religious exiles settled in Amsterdam, of whom the best known is the French philosopher René Descartes, who wrote to his friend Balzac in Italy in May 1631: 'What other place in the world would one choose, where all the commodities of life and all the curiosities to be desired are as easy to come by as here? What other land, where one could enjoy such a complete freedom?'

Another aspect of Dutch life admired by visitors was the provision of public charity. Both public and private charity was a major concern of the Republic's Calvinist society, its provision the duty of the rich to help the poor and of the state to help those unable to help themselves. The running of poorhouses and orphanages had been taken over from the Catholic Church and while the Reformed Church and all the other major denominations had their own charitable foundations, public charity was principally a civic responsibility. The administration was entrusted to boards of regents and regentesses, who were drawn from among the richer citizens. John Evelyn particularly admired the Amsterdam *Gasthuys*, 'an Hospital for their lame and decrepit soldiers and seamen, where the accommodations are very great': as with many such institutions, the

buildings had been confiscated from the Catholic Church. Even in the Amsterdam houses of correction, the *Rasphuis* for men and the *Spinhuis* for women, where petty criminals, vagrants and prostitutes were put to work, there was a characteristically Calvinist combination of punishment and charity: above the *Spinhuis* door was inscribed a poem by Hooft: 'Fear not, I do not desire to take revenge on wickedness, but to force you to the Good. My hand is punishment, but my intentions are loving.'

III. THE FAMILY AND THE HOME

Dutch genre painting, while it reflects and often depicts public life, is particularly concerned with the lives of individuals and with the family. In recent years the history of the family has become the subject of intense study in its own right and historians, led by Philippe Ariès, Lawrence Stone, Peter Laslett and others, have outlined shifts in its composition and nature. From their work it has become clear that in the Protestant societies of northern Europe there was in the seventeenth century a continuing move from the extended family, with several generations living beneath the same roof, towards what has been characterized as the modern, affective family – that is, parents and children bound tightly together as a single social unit by ties of love, responsibility and duty. In the north Netherlands this restricted family was thought of as the basic building block of its new, Calvinist, republican society: it was, in the words of Johan van Beverwijk, 'the fountain and source of republics', and was seen by both the State and the Church as the most important means of 'social control', in Foucault's sinister phrase.

All forms of Protestantism placed great emphasis on the instruction of children within the home. Regular readings from the Bible, the singing of hymns and the saying of prayers before meals were daily features of domestic life in Protestant households. *Grace before Meat* (*Gebed voor de Maaltijd*) is an important theme treated by many Dutch genre painters, showing – not always without sentimentality – communal prayer in both rich and poor homes.

A print by Claes Jansz. Visscher of 1609 shows a wealthy family, mother, father and children,

HOUWELICK,
DAT IS,
Het gantfche Beleyt des
ECHTEN-STAETS;

Afgedeylt in fes Hooft-ftucken,
Te weten

MAEGHT,	VROUWE,
VRYSTER,	MOEDER,
BRUYT,	WEDUWE.

Behelfende mede de
MANNELICKE TEGENPLICHTEN;

Door
JACOB CATS.

HOVWELICK.
DAT IS
Het ganfch Beleyt des
ECHTEN STAETS
afgedeylt
in fes Hooft Stucken
door
IACOB CATS.

t'AMSTERDAM,
By I. I. SCHIPPER, op de Keyfers-gracht, 1664.

Met Privilegie voor 16. Jaren.

Frontispiece of Jacob
Cats, *Houwelick*.
Amsterdam, 1664
[page 58]

saying grace: beneath in Dutch and French is a passage from Psalm 128: 'Blessed is he that feareth the Lord; that walketh in his ways. For thou shalt eat the labour of thy hands: happy shalt thou be, and it shall be well with thee. Thy wife shall be as a fruitful vine: thy children like olive plants round about thy table. Behold, that thus shall be blessed the man that feareth the Lord.' Family worship and instruction, while not of course replacing public worship, assumed a far greater impor-tance in Protestant than in Catholic societies. It was the duty of parents to instruct their children in the teachings of the Bible and the catechism. The scriptures were read, studied and discussed in every household and as a complement to them, children were taught the catechism. There were a number of such state-ments of doctrine, the Heidelberg catechism being the most widely used. It consisted of fifty-two sets of questions and answers, one for each week of the year. This domestic in-

struction would be reinforced by the pastor's weekly sermon, which would be attended by the whole family. Before the sermon, the *voorlezer* read passages from the Bible for about half an hour from his own lectern beneath the pulpit. The pastor would then deliver his sermon, expounding a biblical text, which would be followed by the singing of versified psalms. The pastor's role in the community was as *herder en leeraar*, shepherd and teacher. He taught and explained the *leer*, the central body of doctrine by the observance of which the devout would attain the path to salvation.

Within the family, the father, its head, was the provider. The mother's role was the upbringing of the children and the maintenance of the home. There was no lack of advice as to how best she should carry out her duties and it came not only from the pulpit. Jacob Cats wrote a number of books intended to instruct young women in their responsibilities: *Maagdeplicht* (*The Duties of a Young Woman*), *Verstandige Kok of Zorgvuldige Huishouder* (*The Wise Cook or Careful Householder*), and *Houwelick* (*Marriage*). The last, first published in 1625, was written in the form of rhyming dialogues between young women and older friends or married women. Illustrated by Adriaen van de Venne, it was intended as a handbook for the contemporary family [57]. Cats divided a woman's life into six stages: Maid, Sweetheart, Bride, Wife, Mother [59] and Widow (*Maecht, Vuyster, Bruyt, Vrouwe,*

Moeder, Weduwe). A young woman should show the 'virgin virtues': she should be modest, quiet and correct and wait patiently until God brings her her partner. He should be approved by her parents but of her own choosing: forced marriages are wrong because love is free. Within marriage both men and women should be virtuous: the woman should submit to her husband whose duty it was to instruct her. 'Men should obey the law and women their husbands', he writes. *Vrouw* [58] is the longest section of the poem and Cats describes the wife's duties in detail: the supervising of the kitchen (as Cats envisages it, much of the menial work is done by maids) and the rearing of the children 'at least until the child is seven years old'. The maids cook, clean and shop but the wife prepares the menus, tells them what to buy at the market and chastises them when necessary. Cats' model is clearly a wealthy family but the reading of his works was not restricted to a small social group. His books went through innumerable editions and it has been estimated that by 1655 50,000 copies of *Houwelick* were in circulation.

Cats was, of course, a traditionalist and there is a good deal of evidence to suggest that the rigidly patriarchal family he describes was itself changing during the century. Sir John Reresby, in Holland in 1656, found Dutch women remarkable for the way in which they maintained order in the house and dominated their husbands. Beverwijk advocated that women should extend their activities beyond the home: 'To those who argue that women are fit only to manage the household and no more, I say that many women go from the home and practise trade and the arts and learning. Only let a woman come to the exercise of other matters and she will show herself capable of all things.' Such a view was extreme, but it seems likely that in many households husband and wife were equals in authority and responsibility. Similarly, the relationship between children and their parents seems often to have been less authoritarian than that described by Cats. Indeed, the French traveller Jean-Nicolas Parival, whose fascinating account of his stay in Holland *Les Délices de la Hollande* was published in 1678, wrote that 'it is partly from this excessive indulgence towards their children that there results the disorder which

is often to be seen in their conduct. It is nevertheless surprising that there is not more disorder than there is, and there is perhaps no better proof of the natural goodness of the inhabitants of this country and the excellence of their disposition.' This observation of overindulgence towards children is also made by other visitors to the north Netherlands.

Parival commented, as did many other foreign visitors, on the cleanliness of Dutch homes: 'The women pride themselves on the cleanliness of their houses and rooms to a degree which it is hard to believe. They wash and scrub ceaselessly.' Owen Feltham remarked ironically on Dutch *deugdzaam*, the notion of public and private virtue, that 'the houses they keep cleaner than their bodies, their bodies than their souls', and the philosopher John Locke, visiting a farm outside Amsterdam in 1685, noted in his journal that it was 'much cleaner than one should see any kitchen, nay most of the finest parlours in England'. The Dutch were aware of this reputation and even told stories about fanatical cleanliness at their own expense. One such story was recounted to Sir William Temple by the Secretary of the City of Amsterdam: 'There is the house where one of our magistrates was going to visit the mistress of it, and knocking at the door, a strapping north Holland lass came and opened it; he asked, whether her mistress was at home, she said yes: and with that he offered to go in: but the wench marking his shoes were not very clean, took him by both arms, threw him upon her back, carried him across two rooms, set him down at the bottom of the stairs, pulled off his shoes, put him in a pair of slippers that stood there, all this without saying a word; but when she had done, told him, he might go up to see her mistress who was in her chamber.' Gerard de Lairesse, in an aside in his *Het Groot Schilderboek*, which contains more than an echo of Temple's ancedote, mocked 'such women as make idols of their houses, and chuse rather to go barefoot on their floors than bedaub them, though they have maids always at their elbows with woollen clothes to clean after them. But since this sacrifice to neatness of houses is here, in Holland, too obvious, we shall urge not further, but, for peace sake, silently reflect Oh! the vanity of a too spruce Dutch woman.'

After Adriaen van de Venne, *Moeder*. From *Houwelick*. 2nd edition, The Hague, 1632 [page 58]

Meals were eaten together in the home, in some households (as can be seen, for example, in an interior by Gabriel Metsu) with the maid also at the table. This familiarity with the servants is the subject of an amusing anecdote recounted by a puzzled Frenchmen, de la Barre: 'The hostess seated herself first without any ceremony; the servant sat down familiarly next to her mistress; the master uncomplainingly took one of the two remaining places, and the manservant seized the other. The mistress and the maidservant served themselves first, and took the best portions. We felt that longstanding habit had arranged this order of seating in the household, and all went well until the master was rash enough to tell the maidservant to go and fetch something for him. The mistress told her husband to fetch it himself, as she wanted her servant to rest. Then harsh words began to fly. The servant supported her mistress enthusiastically and the husband and wife glared at one another until the husband, acknowledging his error, apologized to his wife and stole a kiss from her.' Afterwards the wife justified her behaviour to her guest, saying that the servant was 'affectionate and hardworking', particularly careful with the dishes, and that she looked after the chimneys.

In artisan households the principal meal was at midday and in the evening only broth, porridge or *rijstenbrei* (rice cooked in milk with butter, sugar or stewed prunes) were served. The family retired to bed early, around nine.

Vertoond,in.roo.Verbeeldingen: van:Ambachten, Konften,Hanteeringen enBedryven;met Versen.

†AMSTERDAM. *Gedaan, door, Johannes, en, Cospaares Luiken.* 1 6 9 4.

Frontispiece of Jan and Caspar Luicken, *Het Menselyk Bedryf*, Amsterdam, 1694 [page 61, 89]

would wish to include his children (sometimes even the dead ones, in the guise of angels) in a domestic or rural setting. Family portraits change during the course of the century from stiff rows of figures to the family grouped together in the living-room with the children playing, or making music, compositions which have a good deal in common with certain genre paintings. Portraits of children alone, very rare before the seventeenth century except for the grandest aristocratic children in whom rested dynastic hopes, signify the new importance of the child, the recognition of his individuality and even a degree of independence. So too do certain genre paintings: above, the *homo bulla* tradition, from Goltzius to Netscher, has been traced in terms of the development of a realistic mode of representation. Equally it could be traced to show changing attitudes to the depiction (and so the social position) of the child: from the idealized, classical *putto* to the modern child, with his satin ribbons and velvet cap, playing self-absorbedly. Some people found these changes confusing: in Jan Boltingh's play *Mr Tiribus*, Jan Muurtjes, a barber's assistant, compares modern Amsterdam to the city he had known thirty years before. In the old days, he says, older people were respected as founts of wisdom and authority but today 'one has to ask the children what virtue and vice is ... the children know more. The world is changing day by day.'

Music-making was part of the life of many families. Hundreds of collections of popular songs have survived, among them songbooks compiled by distinguished poets like Gerbrand Bredero and Jan Hermansz. Krul. Many are amorous serenades for lovers, but others – collections such as Valerius' *Gedenck Clanck* and Starter's *Friesche Lusthof* – were suitable to be sung by the family gathered in the evening around the harpsicord played by the mother or eldest daughter, or simply bellowed without accompaniment.

The increasing importance of the family as a social group is attested by the growing numbers of family portraits commissioned during the seventeenth century. Rather than a pair of single portraits of himself and his wife, a father

To the degree to which genre painting represents the contented, well-ordered family, the virtuous housewife and devout father, and their obedient children, it can almost be equated with certain kinds of religious art – a secular, Protestant equivalent of the Holy Family. Indeed, close parallels (which sometimes suggest common sources) can be made with biblical scenes such as the Rest on the Flight to Egypt and Christ in the Workshop of St Joseph. In this sense genre painting can be thought of as a new, Protestant type of art reflecting the ideas and circumstances of the young and devout Dutch Republic. In treating with great seriousness (though not without humour), and even sanctifying, the everyday and in presenting to its public exemplary representations of family life, it closely echoes the ideals of that society. In this way genre painting can be thought of as on the one hand an art of reassur-

ance and on the other as the representation of a social ideal which was to be strived for – and both of these notions naturally challenge its claims to be taken at face value. A comparable phenomenon can be seen in an extreme form in Jan Luicken's remarkable book *Het Leerzam Huisraad*. Luicken, a poet and printmaker, had in 1675 been converted to the pietism of Jacob Böhme and in his book he invests the simplest utilitarian objects with a transcendental value. In a later book, *Het Menselyk Bedryf*, he applies the same pietistic approach to everyday occupations [60]. There is no reason to believe that Pieter de Hooch or Gabriel Metsu, for example, shared Luicken's view of the world in detail, yet there is in their work, and in that of many genre painters, a similar, though less intense, sense of the immanence of the familiar and of the morally improving value of scenes of domestic life.

IV. THEORY: GERARD DE LAIRESSE ON 'MODERN' PAINTING

There is very little contemporary discussion of what we know today as genre painting in the north Netherlands in the seventeenth century. None of the theoretical treatises about painting published in the seventeenth century – the principal ones are those by Carel van Mander (1604) and Samuel van Hoogstraten (1678) – specifically advocates the depiction of scenes from domestic and working life. They urge the artist to study from nature, to draw what he sees about him (though in this context they have landscape painting principally in mind); yet, being steeped in an Italianate theoretical tradition, they go on to advocate that nature be transformed into art in the studio, that simple appearances be ennobled by the exercise of the artist's imagination and that sketches from life (*naer het leven*) be rendered ideal when transferred to canvas or panel via the crucible of the painter's mind (*uyt de geest*). To the extent that some genre paintings are idealizations of the everyday world, combinations of observed elements intended to create a particular effect or put across a particular idea, they might be thought to be responding to such notions. However, there is nothing to suggest that any theorist in the seventeenth century was concerned with constructing an aesthetic for genre painting.

Van Mander grouped all scenes which included figures under the heading *historien*, by which he meant scenes from mythology and classical history, as well as allegorical representations. He makes no specific references to scenes from domestic life or peasant life. Hoogstraten acknowledges the existence of such scenes but does not discuss them in any detail. He devises three grades (*graden*) of painting, on classical models: the lowest includes *grotissen* (caves or grottoes), flowerpieces, kitchen scenes and other still-lifes (including *vanitas* still-lifes which he specifically mentions); the second, intermediate category is broad, including 'satyrs, wood-gods and Thessalonian shepherds' ('*Satyrs, Bosgoden en Thessalische Harders in het lustige Tempe*') as well as animals in paradise, night scenes, fires, *bambootserytjes* (street scenes of the *bamboccianti* type), *kluchten* (literally, farces: presumably paintings with a humorous intent) and barbers' and cobblers' shops (*Barbiers- en Schoenmakerswinkels*). Of these, the last three certainly fall within the modern umbrella term of genre. Finally, the highest category is, of course, history painting – lofty subjects from mythology and classical history and literature. So, apart from informing us that he rates some genre paintings above still-life, whose painters he describes elsewhere as 'humble foot-soldiers in the army of art', Hoogstraten provides few clues to contemporary attitudes towards genre painting. This is particularly frustrating as Hoogstraten painted a number of genre scenes himself. His general comments on painting are no more revealing in the context of genre: a painting should be a mirror of nature (*een spiegel van de Natuer*) which should deceive the eye in a pleasing and satisfying manner (*op een geoorlofde vermakelijke en prijslijke wijze bedriegt*).

In other seventeenth-century theoretical writings there are occasional passing references to genre paintings: for example, Philips Angel, in his *Lof der Schilderkonst* (1642), a published address to the Leiden guild of St Luke, is complimentary about *cortegaerdjes*, barrack-room scenes.

By the time, however, that Gerard de Lairesse came to write his *Het Groot Schilderboek* (Amsterdam, 1707), genre was such an important

aspect of Dutch painting that he could not ignore. His diatribe against genre painting is interesting not only because it is a reflection of its popular success but also because Lairesse recognizes the theoretical dilemma of art imitating nature, but not all nature. 'How are the beauties and probable uses of painting either sunk, obscured or slighted, since the *Bambocciades* are multiplied in this country', he wails. (This translation is from the first English edition of Lairesse, published in 1778: *Bambocciades* is explained in a marginal note, 'The followers of Bamboccio, a celebrated painter of mean subjects.') 'We scarce see a beautiful hall or fine apartment of any cost, that is not set out with pictures of beggars, obscenities, a Geneva-stall, tobacco-smokers, fiddlers, nasty children easing nature, and other things more filthy. Who can entertain his friend or a person of repute in an apartment lying thus in litter, or where a child is bawling, or wiping clean? We grant that these things are only represented in pictures: but is not the art of painting an imitation of life; which can either please or loath? If then we make such things like the life, they must needs raise an aversion. They are therefore too low and unbecoming subjects for ornament, especially for people of fashion, whose conception ought to surpass the vulgar. We admit indeed that all this is art or at least called so, when the life is thereby naturally expressed; but how much the beautiful life, skilfully handled, differs from the defective life of modern painters, let the curious determine.'

Lairesse describes genre as 'modern painting' as opposed to antique painting – 'noble or ignoble, antique and modern' – and constantly stresses its inferiority, principally on the grounds of its limitations for the display of noble ideas and emotions: 'Although modern things seem to have some prettiness, yet they are only to be esteemed as diversions of the art. I moreover maintain that such painters as never produce more than one choice of subjects, may truly be rated among tradesmen; since such representations cannot be called an exercise of the mind, but a handicraft trade.'

One of Lairesse's principal criticisms of genre painters was their use of humble models: 'Such is their zeal and extraordinary pains, that one paints for that end the air of his wife,

though ever so ugly, with all her freckles and pimples very exactly; whereby the agreableness of a beautiful woman's face is quite lost: Another chuses his clownish unmannerly maid-servant for his model, and makes her a lady in a saloon: Another will put a lord's dress on a schoolboy, or his own son, though continually stroaking his hair behind his ears, scratching his head or having a down-look: thinking it sufficient to have followed nature, without regard to grace, which ought to be represented; or having recourse to fine plaister-faces [by which he means casts after the antique] which are to be had in abundance.' 'We even see them', Lairesse continues, 'make life more deformed than nature ever produces; for the mis-shapen faces Bamboccio, Ostade, Brouwer, Moller [Molenaer], and many others made, the more they were esteemed by the ignorants: By which low choices we can easily judge, that they were strangers to beauty, and admirers of deformity.' Here Lairesse reveals his considerable acquaintance with the painters of peasant life. He finds no virtue in their 'low and deformed' subjects but there are genre painters whom he admires: 'Francis Mieris has not only curiously followed his master Gerard Dou, in the elegant modern manner, but is, in some things, his superior. ...It is more commendable to be like a good Mieris in the modern manner, than a bad Raphael in the antique.' So in order to encourage the development of the 'elegant modern manner' Lairesse suggests some appropriate subjects for such as painter to tackle: 'parents permitting their children to take some diversions in bathing' and 'city-like subjects; which daily afford plentiful matter for a modern Painter' such as 'two virgins... seen at a table drinking tea'. This latter subject is chosen by Lairesse as 'an example In treating and Refusing' – one tries to press a cup of tea on the other who has had enough. This is conceived as a domestic drama: 'these two passions cause two contrary motions in the whole body, hands, feet and face'. It is therefore as a vivid enactment of a scene involving various passions that Lairesse justifies such subjects within his classicistic theory of art; it was advice which Willem van Mieris apparently took quite literally in a painting of a tea-party (Paris, Louvre). 'Such subjects as these', Lairesse continued, 'are very commendable, and may be nobly dis-

posed, to the credit of the artist: But he must avoid handling cottages, brandy-shops, ale-houses, bawdy-houses, corps-degard, and the like.'

Lairesse's is the first extended account of genre painting by a Dutch writer on art. He contrives a way of reconciling it with classicistic theory and outlines a number of appropriate subjects. Ironically, the great age of Dutch genre painting was long over by the time Lairesse provided it with a theoretical justification. Only derivative artists like Richard Brakenburgh, Willem van Mieris and Matthys Naiveu survived to continue the tradition of genre painting into the eighteenth century. Their illustrious predecessors, Jan Steen, Frans van Mieris and Gerard Terborch, had required no theory to justify their vigorous, beautiful and richly inventive practice.

V. PRACTICE: TOWNS AND THEIR PAINTERS

The Dutch hunger for paintings astonished visitors. Visiting the Rotterdam fair in 1641 John Evelyn found it 'so furnished with pictures (especially landscips and drolleries [by which he meant genre paintings], as they call these clownish representations) as I was amaz'd ... 'tis an ordinary thing to find, a common farmer lay out two or three thousand pounds in this commodity, their houses are full of them, and they vend them at their kermesses to very great gains.' Others also commented on the remarkable phenomenon of quite humble people owning paintings. The English traveller, Peter Mundy, noted 'all in general striving to adorn their houses, especially the outer or street room, with costly pieces, butchers and bakers not much inferior in their shops which are fairly set forth, yea many times blacksmiths, cobblers etc. will have some picture or other by their forge and in their stalls.'

With such intense demand for paintings, it is not perhaps surprising that there was an active group of painters in almost every small town. In addition to the well-known centres such as Amsterdam, Leiden, Delft, Haarlem and The Hague, there were painters working for the local market in Deventer, Leeuwarden, Enkhuizen, Zwolle, Middelburg and other small towns. Each town had its own genre painters working in a variety of styles on a variety of subjects and often moving from town to town so that a survey of genre painting by style and place is an almost impossible undertaking. It is presumably for this reason that there is no detailed study of genre painting as there is, for example, of landscape painting and architectural painting. It may be useful, therefore, in the context of an account of genre painting by subject, to sketch in the broadest terms the activity of the principal artists in the towns in which they worked as a background to the similarities of style and subject matter, and exchanges of ideas, which will be discussed in the chapters which follow. Further biographical details about individual artists can be found in the Appendix.

Amsterdam occupies a central place in the history of Dutch genre painting: it provided much of the initial impetus and subsequently acted as a magnet for talented provincial artists anxious to exploit its large market. It was in Amsterdam that the painter father of David Vinckboons settled and, as has already been remarked, Vinckboons occupies a key role in the transfer of Flemish subjects such as the peasant kermis to the north. He also developed new subjects, previously known only in graphic art, which were to have a long life in genre painting. Pieter Codde and Willem Duyster both lived and worked in Amsterdam. Codde was a portraitist as well as a painter of small, highly finished genre scenes, which often show elegantly dressed figures in an architectually restrained interior, eating, drinking, card-playing and so on. Duyster had a particular interest in barrack-room scenes and also painted interiors similar to those of Codde and of his brother-in-law Simon Kick, who lived in Amsterdam. This group of painters of *cortegaerdjes* and interiors was principally active in the 1620s and 1630s: Duyster died in 1635 but although Codde survived until 1678, he turned increasingly to portraiture. His small-scale portraits showing sitters amidst the carefully chosen clutter of their lives were highly successful. Also at work in Amsterdam early in the century was Arent Arentsz., whose landscapes, with their strongly characterized and

OPPOSITE, TOP:
Arent Arentsz. *Fishermen
and Hunters*. Panel, 27 ×
52 cm
Rijksmuseum,
Amsterdam
[page 90]

OPPOSITE, BOTTOM:
Adriaen van Ostade
(1610-85) and Cornelis
Decker (before 1625-
78). *Interior of a
Weaver's Cottage*.
Panel, 46 × 57 cm
Musées Royaux des
Beaux-Arts, Brussels
[page 92]

prominent figures, are heavily dependent on those of Hendrick Avercamp. Avercamp himself may well have been a pupil of Vinckboons in Amsterdam but by 1618 had returned to the small town of Kampen in the province of Overijssel where he spent the remainder of his working life.

Amsterdam attracted provincial painters throughout the seventeenth century, the best known, of course, being Rembrandt who had moved there from his native Leiden by 1632. Amsterdam was by far the largest city in the Netherlands and possessed a public wealthier and more adventurous in its tastes than elsewhere. By virtue of its world-wide trade it was also the most cosmopolitan of Dutch cities. There was a large, active art market with enterprising dealers and frequent auctions of Italian, French and Flemish, as well as Dutch paintings. The importance of Amsterdam as a commercial and artistic centre continued to grow during the seventeenth century and a particularly important group of genre painters was working there in the thirty years after 1650. Gabriel Metsu moved there from Leiden in the 1650s; Pieter de Hooch had arrived from Delft by 1661; and Jacob Ochtervelt who came from Rotterdam had settled in Amsterdam by 1674. A native genre painter was Carel Dujardin who lived in great style on the fashionable Heerengracht and painted Italianate scenes.

Haarlem, being a relatively small, inward-looking provincial town with a population of only 40,000 in 1622, had a quite different character. Brewing and weaving were its principal industries. It possessed, however, a prosperous regent class (who can be seen in Frans Hals' group portraits) and a large community of Flemish immigrants. Haarlem is particularly associated in the early years of the seventeenth century with the development of the 'merry company' scene. Among its most accomplished practictioners were Dirk Hals, the younger brother of the portrait painter Frans, and Esaias van de Velde. Van de Velde was a native of Amsterdam, where he may well have been a pupil of the Flemish landscape painter Gillis van Coninxloo; Esaias was in Haarlem at least by 1610 and remained there for a further eight years. His principal activity is as a landscape painter and, with Hercules Segers and Cornelis Vroom, he occupies an important place in the development of realistic landscape painting; however, he also painted 'merry companies', cavalry battles and scenes of travellers ambushed. In 1618 Esaias moved to The Hague, attracted there by the possibilities of patronage from members of the Orange court. A third Haarlem painter, Hendrick Pot, painted merry company scenes, *cortegaerdjes*, and *bordeeltjes* as well as small-scale portraits. Pot moved to Amsterdam around 1650. Jan Molenaer and his wife the painter Judith Leyster, who married in 1636, both reveal the clear influence of Frans Hals in their slashing brushstrokes and bright palettes. They painted genre scenes almost exclusively: Molenaer specialized in interiors with young people and children. Frans Hals, who painted only a handful of genre subjects, is also said to have been the master of Adriaen Brouwer from Antwerp and Adriaen van Ostade, both painters of peasant life. Brouwer returned to Flanders but Adriaen van Ostade enjoyed a long and prolific career in Haarlem. Scenes from peasant life are particularly associated with Haarlem in the work not only of Adriaen van Ostade but also of his short-lived brother Isack and his pupil Cornelis Dusart. It was also from Haarlem that Pieter van Laer set out for Rome, where he gave his nickname *il Bamboccio* to an entirely new type of genre painting, the Roman street scene.

The most original of 'merry company' painters, Willem Buytewech the Elder, was in Haarlem in 1612 but five years later returned to his native Rotterdam. The port of Rotterdam was rapidly expanding during this century. In 1635 the English Merchant Adventurers had moved there from Delft, a measure of the city's increasing importance as a centre for international trade. It was a relatively small artistic centre but one which was to boast a number of other important genre painters, among them the underestimated Hendrick Sorgh (according to Houbraken, a pupil of Buytewech) who specialized in market scenes; the peasant painter Cornelis Saftleven; Ludolf de Jongh; Jacob Ochtervelt, who is said to have been a pupil of Nicolaes Berchem at the same time as Pieter de Hooch and, like de Hooch, specialized in domestic interiors; and

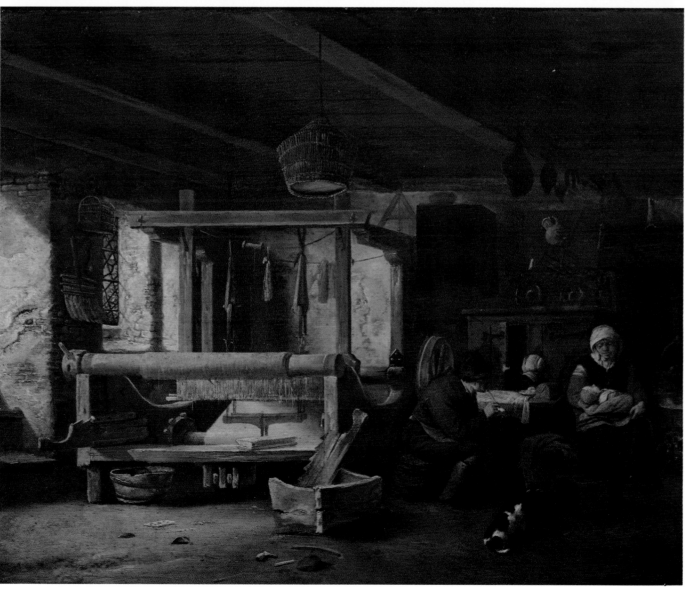

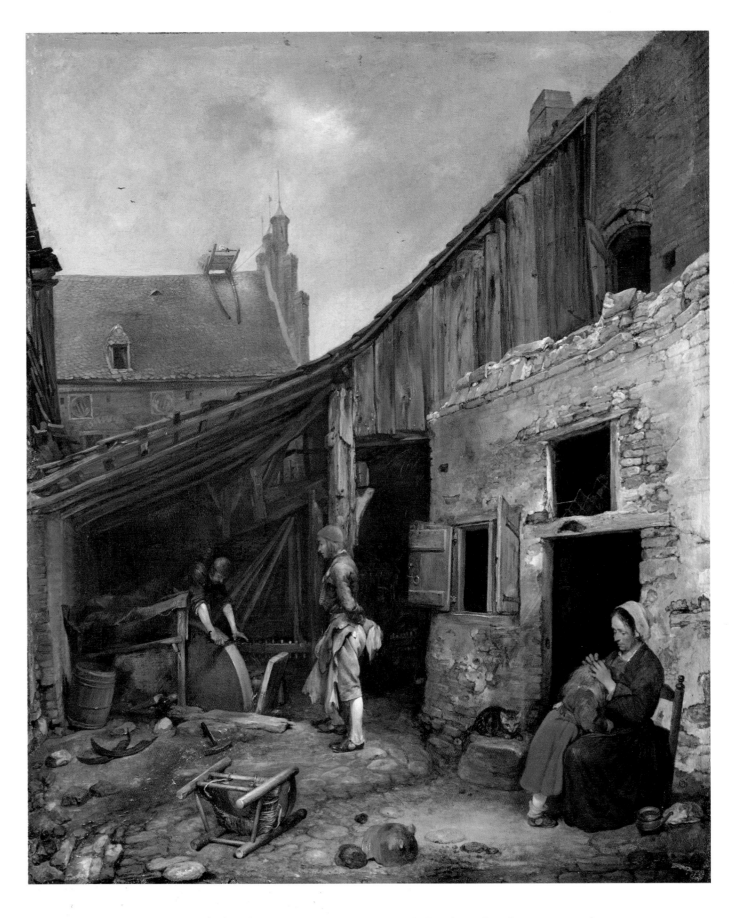

Gerard Terborch (1617–81). *The Knife-grinder's Family*, c. 1653. Canvas, 73.5 × 60.5 cm
Staatliche Museen Preussischer Kulturbesitz, Berlin-Dahlem
[page 91]

66

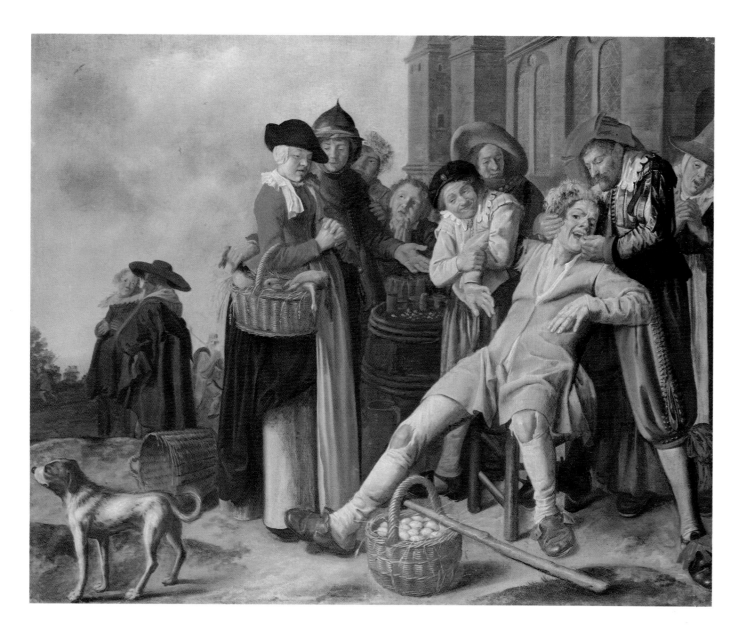

Jan Molenaer (1609/10-68). *The Dentist*, 1630. Canvas, 65.9 × 81 cm
Herzog Anton Ulrich-Museum, Brunswick
Photo: Museumfoto B.P.Keiser. [page 52, 94, 98]

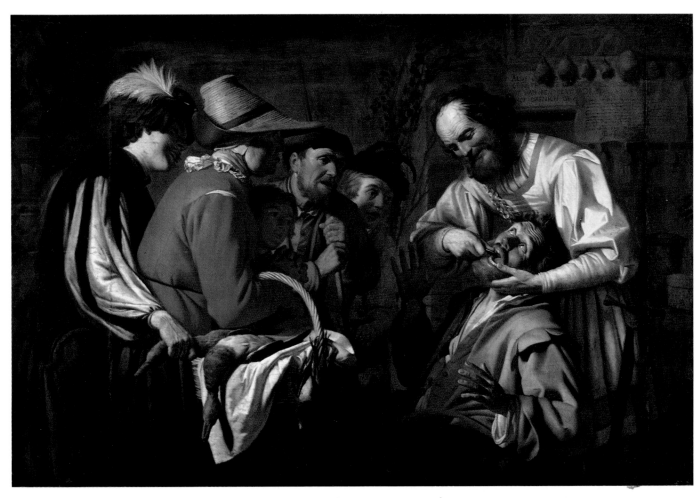

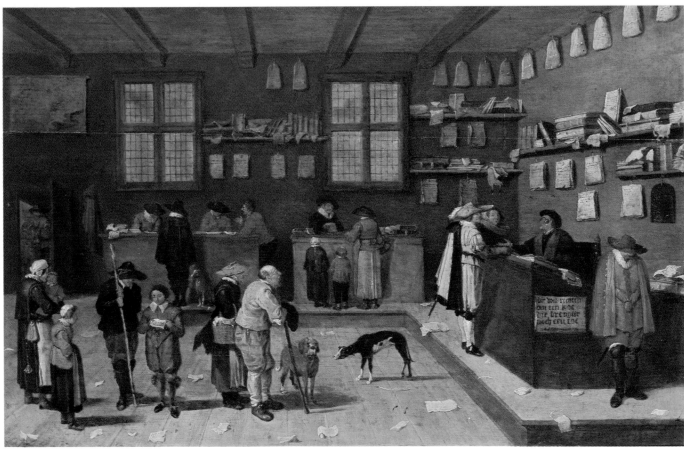

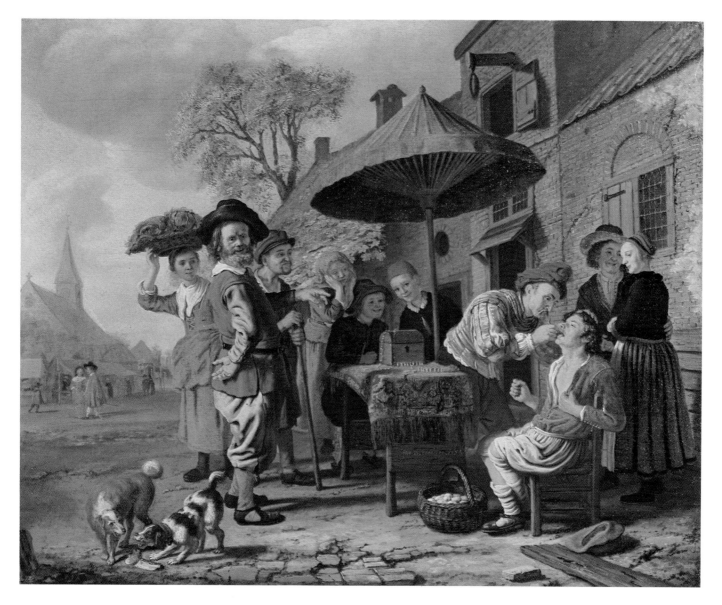

Jan Victors. *The Dentist*, 1654. Canvas, 76 × 94.5 cm. Rijksmuseum, Amsterdam.
[page 98]

OPPOSITE, TOP:
Gerard van Honthorst (1590-1656). *The Dentist*, 1628. Canvas, 137 × 200 cm. Musée du Louvre, Paris.
[page 98]

OPPOSITE, BOTTOM:
Pieter de Bloot (1601-58). *The Lawyer's Office*, 1628. Panel, 57 × 83 cm
Rijksmuseum, Amsterdam. [page 99]

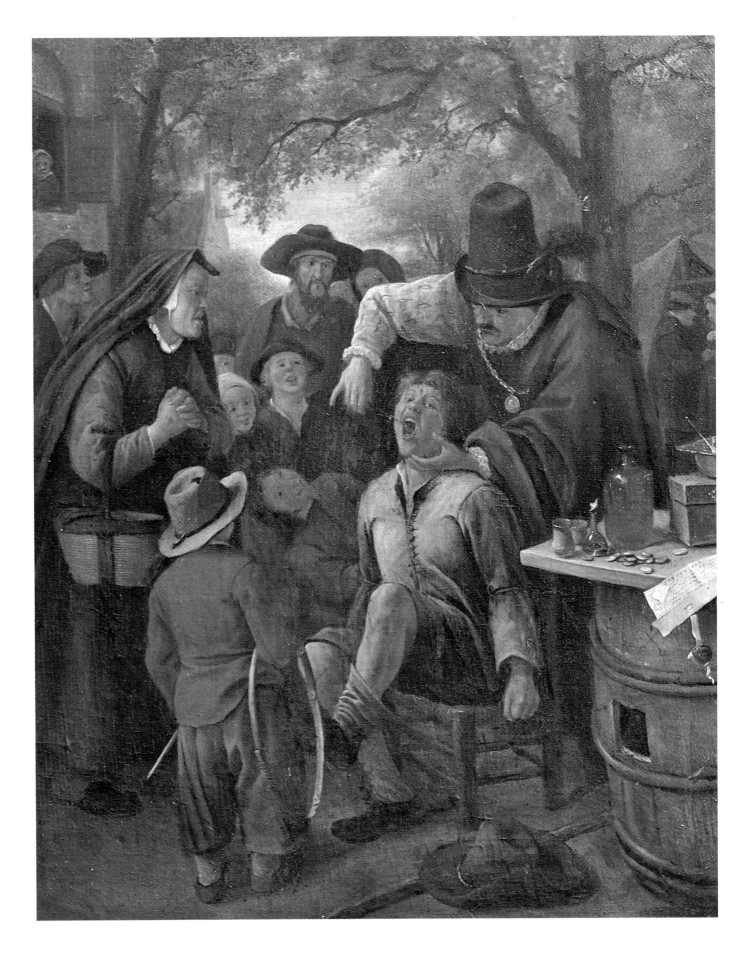

Jan Steen. *The Dentist*, 1651. Canvas, 32.5 × 26.7 cm. Mauritshuis, The Hague. [page 98]

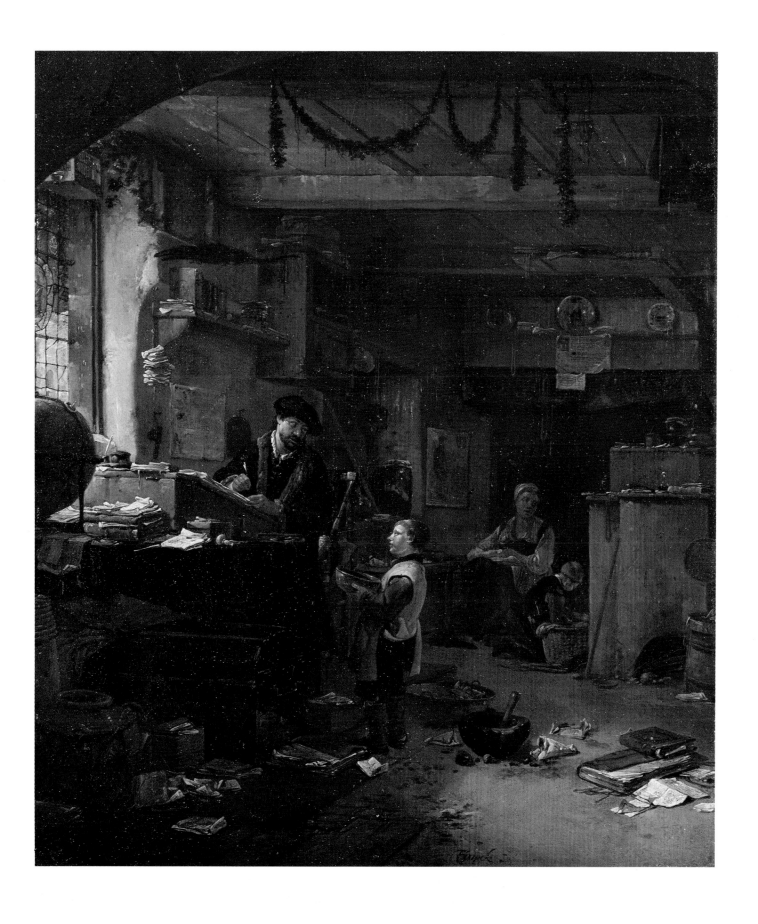

Thomas Wijck (c. 1616-77). *The Alchemist*. Panel, 43 × 37.5 cm. Rijksmuseum, Amsterdam. [page 100]

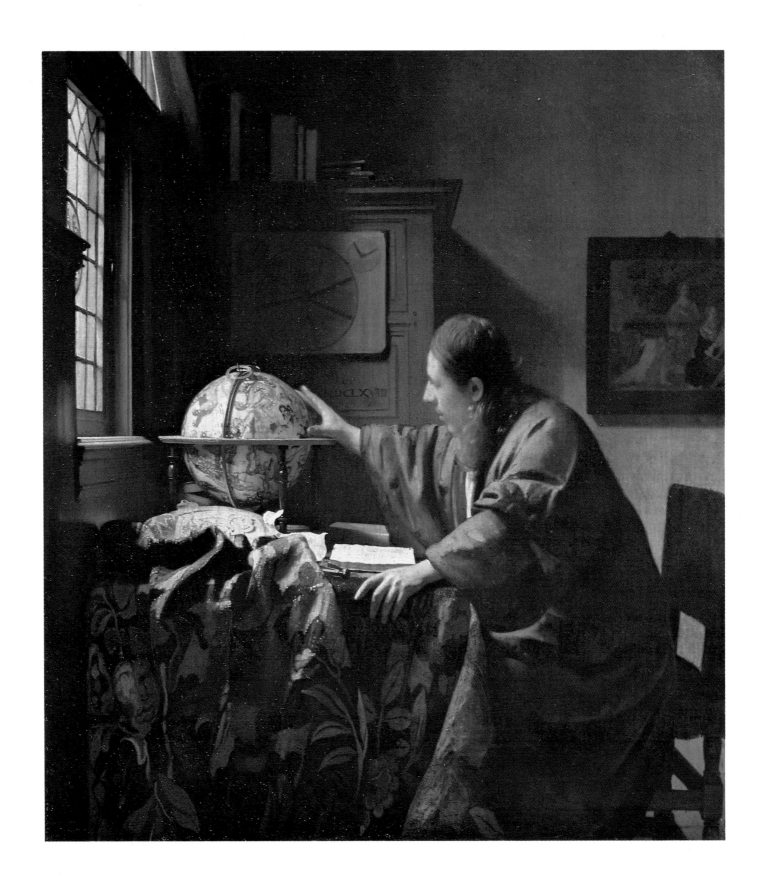

Jan Vermeer. *The Astronomer*, ?1668. Canvas, 50 × 45 cm. Musée du Louvre, Paris.
[page 102]

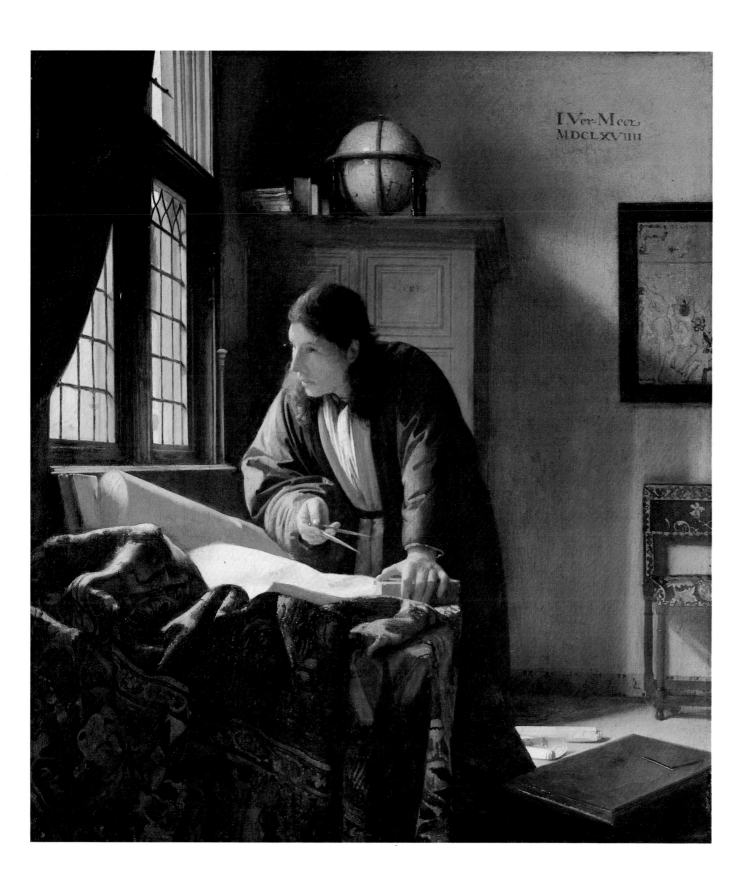

Jan Vermeer. *The Geographer*, 1669. Canvas, 53 × 46.6 cm. Stadelsches Kunstinstitut, Frankfurt.
Photo: Kunstdia Archiv Jürgen Hinrichs. [page 102]

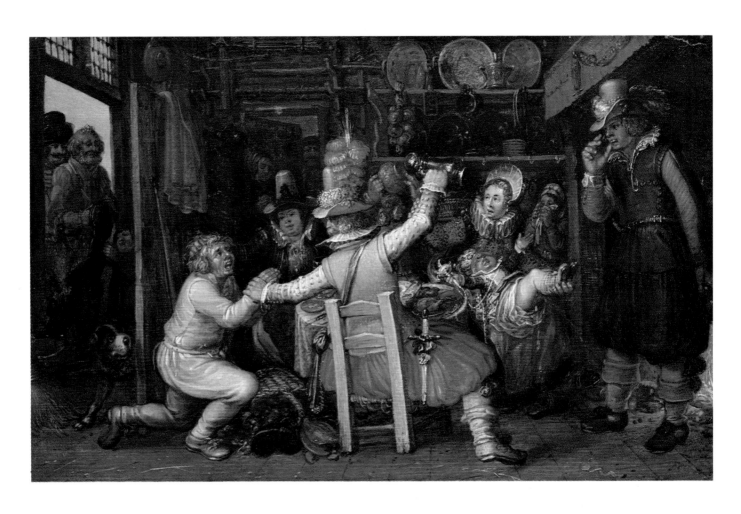

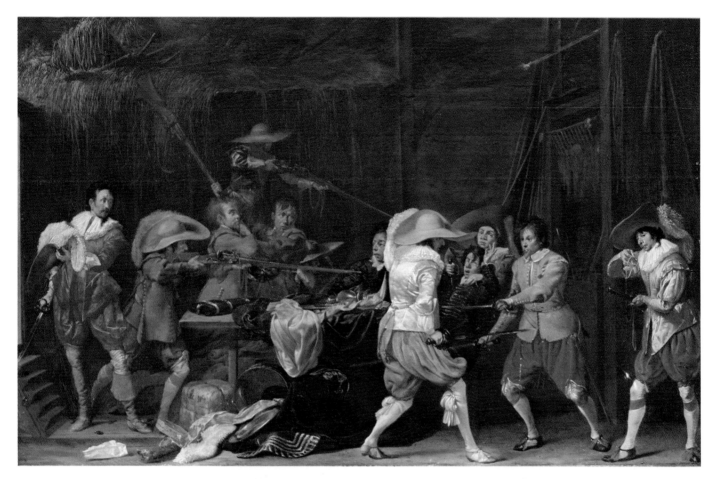

OPPOSITE, TOP:
David Vinckboons
(1576-1632). *The
Peasants' Grief*
(Boerenverdriet). Panel,
26.5 × 42 cm. A pair to
the painting below.
Rijksmuseum,
Amsterdam
[page 108]

OPPOSITE, BOTTOM:
David Vinckboons. *The
Peasant's Joy*
(Boerenvreugd). Panel,
26.5 × 42 cm. A pair to
the painting above.
Rijksmuseum,
Amsterdam
[page 108]

Willem Duyster
(c. 1599-1635). *Soldiers
fighting over Booty*.
Panel, 37.6 × 57 cm
Reproduced by courtesy
of the Trustees, National
Gallery, London
[page 106]

Carel Fabritius (1622-
54). *The Sentry*, 1654.
Canvas, 68 × 58 cm
Staatliches Museum,
Schwerin
[page 111]

Gerard Terborch. *A Soldier and a Messenger*, 1653. Panel, 66.7 × 59.5 cm
Mauritshuis, The Hague
[page 111]

76

Carel Dujardin (c. 1623-78). *The Soldier's Tale*. Canvas, 89 × 80 cm
Yale University Art Gallery, New Haven.
Leonard C. Hanna, Jr. Fund. [page 111]

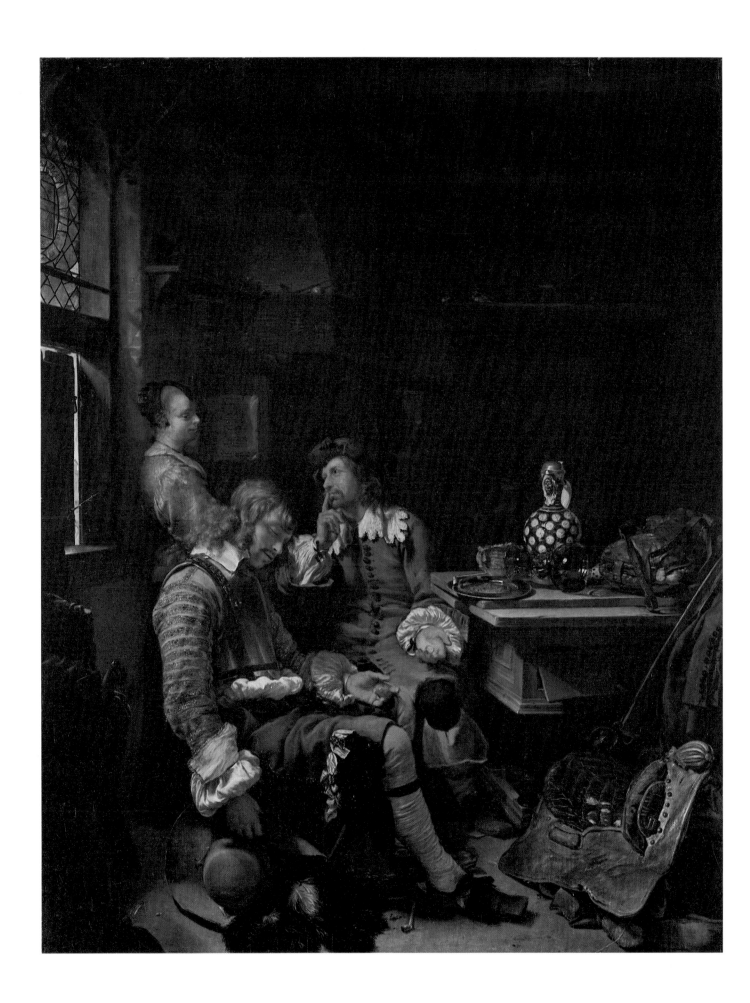

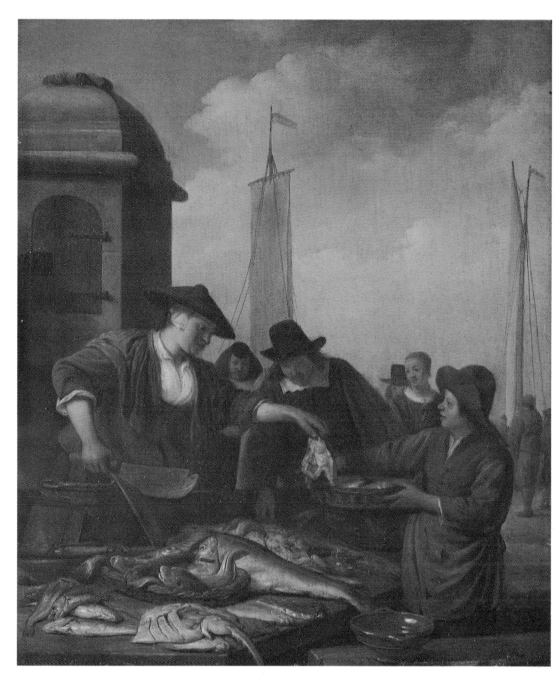

Hendrick Sorgh (1610-70). *Fish Market*. Panel, 31.2 × 26.2 cm
City of Manchester Art Gallery.
[page 111]

OPPOSITE:
Frans van Mieris (1635-81). *The Sleeping Soldier*. Panel, 41.5 × 33 cm
Alte Pinakothek, Munich
Photo: Kunstdia-Archiv Jürgen Hinrichs
[page 111]

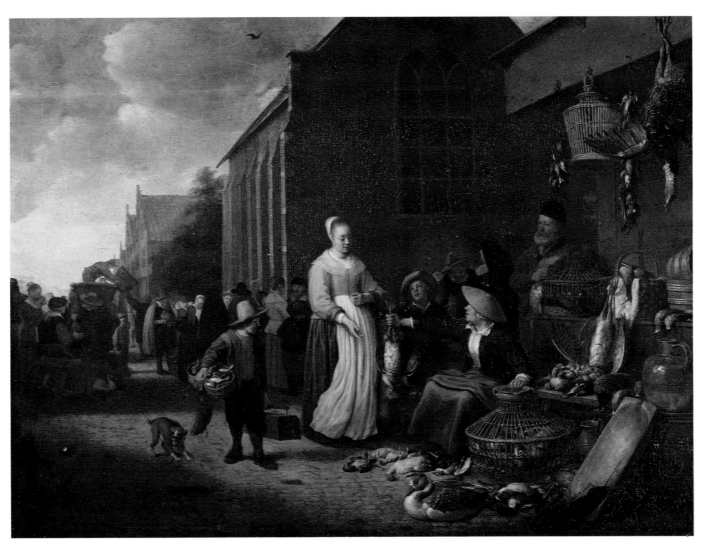

Hendrick Sorgh. *Poultry Market at Rotterdam*. Panel, 49.5 × 65 cm
Öffentliche Kunstsammlung, Basle.
[page 111]

the enormously successful Adriaen van der Werff, admired for his smooth and highly finished technique, and named by Houbraken as the greatest Dutch artist of his day.

With its huge textile manufacture, Leiden was the largest industrial centre in the Republic and boasted its oldest and most distinguished university. In terms of its genre painting Leiden's distinct personality was created by the town's leading painter, Gerrit Dou. The range of his original and often highly sophisticated subject-matter is wide: complicated allegories like the *Quack Doctor* [24] and the *Lying-in Room* triptych [165], interiors with musicians and mothers and children, single figures and the so-called 'niche' paintings in which domestic interiors, shops, etc., are glimpsed through an open window. Dou's highly finished technique was adopted by his pupils, notably Frans van Mieris, whom he is said to have called 'the Prince of my pupils', and Godfried Schalcken. From this meticulous style they are collectively known as *fijnschilders* (fine painters). Both van Mieris and Schalcken were, like Dou, highly successful artists with a Europe-wide clientele: van Mieris received commissions from the Medici, and Schalcken, who painted a large number of night scenes, worked in London and Düsseldorf. The *fijnschilder* tradition in Leiden was continued into the eighteenth century by Frans van Mieris' sons, Jan and Willem, and by his grandson, Frans the Younger (died 1763). Gabriel Metsu is said to have been a pupil of Dou but he had left Leiden for Amsterdam by 1657 and his work does not belong to the *fijnschilder* tradition: his open brushwork suggests instead a Flemish influence. Metsu's subject-matter is eclectic (borrowings from many of his contemporaries have been identified) but his style, especially his melting rendition of texture, is entirely original. It has been suggested that certain of the subjects treated by Dou and his followers reflect the influence exerted on the artistic and intellectual life of the town by the university. There is little direct evidence of this, although François Sylvius, professor of chemistry and medical science, was an important patron of Frans van Mieris.

The sixteenth century had been a golden age for Delft. Its industries of brewing and textile manufacture brought great prosperity to the town and before the fire of 1536 it paid the highest taxes of any city in Holland. As William the Silent's base it played a political role out of all proportion to its relatively small size during the early stages of the war with Spain. The seventeenth century saw the gradual decline of the city's old industries (although porcelain manufacture flourished) and of its political importance. Wealth and civic power came to rest in the hands of a small, profoundly conservative and impeccably Calvinist regent class. Up until 1650 Delft was a small centre, best known for the portraits of Mierevelt and the history paintings of Leonaert Bramer. In that year Carel Fabritius, from the small town of Midden-Beemster, just north of Amsterdam, settled there; two years later Pieter de Hooch, from Rotterdam, is first recorded there and 1656 is the earliest date on a painting by Jan Vermeer who had been born in the town. Jan Steen and Gerard Terborch both visited Delft during that eventful decade. The 'Delft School' is a misnomer for this group of enormously gifted genre painters: they do not possess the coherence of a 'school' in the Italian sense and yet they did undoubtedly share certain preoccupations – the rendition of light and its daytime effects, the expressive possibilities of space, and certain simple, domestic subjects. Three painters of church interiors, Emanuel de Witte (who also painted a few genre scenes), Gerard Houckgeest and Hendrick van Vliet, were also active in the town in the 1650s exploring related problems of the convincing depiction of enclosed architectural space.

Samuel van Hoogstraten, who had been in Rembrandt's Amsterdam studio at the same time as Fabritius, and Nicolaes Maes, who was there a few years later, both returned to work in their native Dordrecht, a busy port at the mouth of the River Maas, one of the Rhine's tributaries. After 1660 Maes confined himself to portraiture but in the second half of the 1650s he painted a number of small domestic interiors which though employing a dark palette, share many of the characteristics of Delft paintings. Hoogstraten, who was also a poet and is best remembered today for his theoretical treatise on painting, made a few rather tentative excursions into genre painting as well as

experimenting with perspective in the form of a peep-show of a house interior with intriguing glimpses into far rooms and through the windows.

The Hague took its lead from the patronage of the Orange court. A number of artists were attracted there including Caspar Netscher, who had been a pupil of Terborch, and Adriaen van de Venne. Van de Venne's career provides one of the most direct and fascinating links between art and moralistic literature. Born in Delft but trained in a severe Calvinist environment in Middelburg, he was a poet, and a prolific illustrator, notably of the works of Jacob Cats, as well as a painter. He enjoyed a long, active and varied career (until 1662), and developed a new type of painting, the grisaille illustrating a proverb or popular saying with the text in a banderole, in addition to painting portraits, complex allegories and public events (involving the Prince of Orange) in The Hague.

Utrecht, isolated both geographically and by reason of its large Catholic population, was in genre, as in other aspects of painting, exceptional. It was by tradition a fervently Catholic city, the seat of an archbishopric, and had remained so despite the progress of Protestantism elsewhere in the north Netherlands. A sixteenth-century Pope, Adrian VI, had come from Utrecht and his favoured painter, Jan van Scorel, was from his native city. Painters in Utrecht, unlike their contemporaries elsewhere in the Republic, still received commissions to paint large-scale religious works and were trained in history painting in the town's leading workship, that of Abraham Bloemaert. The Caravaggesque painters of the early years of the century – Dirck van Baburen, Hendrick Terbrugghen and Gerard van Honthorst, all pupils of Bloemaert – had spent several years in Rome where they had been particularly impressed by the work of Caravaggio himself and his immediate Roman followers such as Bartolommeo Manfredi and Orazio Gentileschi. On their return they painted musical parties and single musicians and drinkers on a large scale, with half-length figures illuminated by strong contrasts of light and dark. They are dressed in the striped jerkins with slashed sleeves of Italian *bravi*. Although the Utrecht

painters, and Terbrugghen above all, treated these subjects with their own richly evocative palette and subtle technique, they remain outside the main currents of Dutch genre painting and have their principal impact, in terms of the influence they exerted, on the development of history painting in the Republic. Both Terbrugghen and Baburen died during the 1620s and Honthorst turned increasingly towards classicizing history painting and portraiture in his later, and highly successful, years, some of which were spent in The Hague, where he was court painter to the Prince of Orange. Genre was never to be an important concern with later generations of Utrecht painters, although the Leipzig-born Nicolaus Knüpfer, who was principally a history painter but painted a number of highly original genre scenes, settled there.

Many Dutch genre painters moved from town to town for a variety of personal and financial reasons. Jan Steen seems to have been constantly on the move: born in Leiden, he is known to have lived in Haarlem, The Hague, Warmond, and was also briefly in Delft. Perhaps some of the fascinating variety of Steen's subject-matter and styles are a consequence of the apparently unsettled pattern of his life. Gerard Terborch, after extensive travels throughout Europe and stays in Amsterdam and Kampen, settled in the small provincial town of Deventer in his native Overijssel and was soon assimilated into its regent class, painting portraits of his fellow regents and himself serving on the town council. It was in Deventer that he developed his small-scale genre scenes which are so rich in descriptive detail and psychological nuance.

POSTSCRIPT

Even a survey of Dutch genre painting as cursory as the one presented in this Introduction will give the reader some sense of its diversity – geographical, stylistic and thematic. The web of influence and borrowing – and no line was drawn between simple plagiarism and the classically respectable *aemulatio* (emulation) advocated by Hoogstraten and other theorists – is of infinite complexity. Not only did artists in a particular town, brought together in one workshop or within the local Guild of

St Luke, exchange ideas, but those towns were geographically very close, communications were (by seventeenth-century standards) excellent and artists often moved from one to the other. Engravings made after genre paintings were relatively rare (before the eighteenth century) but many independent prints of genre subjects were made. Sources for painters included such prints as well as illustrations in emblem books, plays, poems and moralistic tracts.

With such a rich multiplicity of influences and sources, a general account of stylistic development or thematic change is very difficult to construct and is beyond the scope of this book. From Jan Molenaer to Frans van Mieris, Willem Duyster to Caspar Netscher, or Willem Buytewech to Adriaen van der Werff, we can observe a move during the course of the seventeenth century towards higher finish, greater elaboration of detail as well as a new interest in the meticulous depiction of interiors and accurate descriptions of domestic settings and social mores. And yet this is no natural or inevitable progression, no gradual evolution toward greater technical and social sophistication in the service of realism. Among the many elements which such a pattern fails to take account of is fantasy, inspired by the fashion for things French and seen, for example, in the borrowings by many Dutch genre painters from the prints of Abraham Bosse, in the second half of the century; the high degree of finish already present in the earlier works of Dou; the spatial sophistication of Isaac Koedijk's interiors; and the constant shifts of style within the work of the mercurial Jan Steen.

A similar pattern of a gradual development, in this case away from specific meaning, has recently been imposed on the content of Dutch genre painting. In reaction to what he considers over-elaborate interpretations, Lyckle de Vries has recently argued that there was an 'iconographic erosion', that is to say, a falling-away of meaning during the century so that by around 1650 genre painting had largely shed its symbolic and allegorical aspects. Thereafter, he argued, genre painters were more concerned with formal problems. He characterizes this process as one of 'aestheticization'. There can be no denying that over the course

of the century there was a movement away from the symbolic and allegorical modes of the sixteenth century. In particular, certain traditional subjects such as the Four Elements and the Five Senses do lose favour. However, the concept of a gradual erosion of meaning, while valuable in the context of an artist as little interested in symbolic elements as de Hooch, fails to take account of the many genre painters – the list is very long and includes Dou, Netscher, Schalcken, Frans and Willem van Mieris, Vermeer, van der Werff and Steen – who continue to give their paintings many layers of symbolic meaning throughout the second half of the seventeenth century and into the eighteenth. While Willem Buytewech, for example, preferred an exemplary scene from daily life to an allegory, Vermeer remained faithful to the mode of allegory at a much later date. Rather than a falling-away or erosion of meaning, the process is one of change in the types of meaning which artists were trying to communicate. Moralizing allegories may be fewer but the tradition of an emblematic mode of thought in Dutch genre painting is, as de Jongh has maintained, a continuing one throughout the seventeenth century and beyond.

2. Proverbs

Dutch genre painting is closely related to popular literature, indeed to popular culture as a whole, of which proverbs form a very important element. The definition of what constitutes a proverb has often been attempted, rarely successfully. The seventeenth-century English author Howell's 'shortness, sense and salt' leaves out a crucial ingredient – widespread popularity. Erasmus' often reprinted *Adages* (1500) are a compilation of Greek and Latin proverbs with extensive commentaries: his definition, '*Celebre dictum scita quapiam novitate insigne*' ('A saying is famous insofar as it has the distinction of novelty'), sets far too high a standard for proverbs as a whole. However defined, we can all recognize proverbs as enshrining popular wisdom. Although no longer – at least in western Europe – a living form of popular literature, in the sixteenth and seventeenth centuries proverbs were cherished and collected for the first time: the ear-

liest collection of Netherlandish proverbs was published in Antwerp in 1549. This was by no means the first compilation, of course – the biblical Book of Proverbs was such a collection – but its publication does bear witness to a new interest in the preservation of a folk heritage. It was followed by a spate of Netherlandish and German proverb collections illustrated with woodcuts, and the whole literature of emblem books is a very closely related phenomenon. Roemer Visscher's *Sinnepoppen*, published in Amsterdam in 1614, for example illustrated the proverb '*Een dwaes en zijn gelt zijn haest ghescheijden*' ('A fool and his money are easily parted') topically, with two tulips: at that time Dutchmen were willing to part with fortunes to obtain rare bulbs. Many emblem books were in fact little more than illustrated collections of traditional proverbs. A notable literary example of the contemporary interest in the recording of folk sayings is Rabelais' hilarious piling them up for a deliberately comic effect in Book 5 of *Gargantua and Pantagruel* (1564).

The best-known visual compilation is Pieter Bruegel's *Netherlandish Proverbs* of 1559 [30], which shows about one hundred proverbs. It may well have been inspired by a print by Frans Hogenberg published shortly before [84]. The title of the print reads: *Die Blau Huicke is dit meest ghenaemt / maer des weerelts abvisen he beter betaempt* (*This is generally called the Blue Cloak, but it would better be called the world's follies*). The common theme of the proverbs chosen by Hogenberg is men's foolishness and deceitfulness: prominent in the left foreground is the scene of a woman hanging a blue cloak on her husband, a sign that she is cuckolding him. Bruegel's proverbs, many of which had been illustrated by Hogenberg, are also concerned with human weakness and stupidity. In his case, however, they are acted out by the inhabitants of a realistically depicted Flemish village. The house on the left with the inverted orb as its sign stands for the World Turned Upside Down, a symbol of human folly. As well as the *Blue Cloak*, other prominently shown proverbs include: 'One shears the sheep, the other the pig', 'One holds

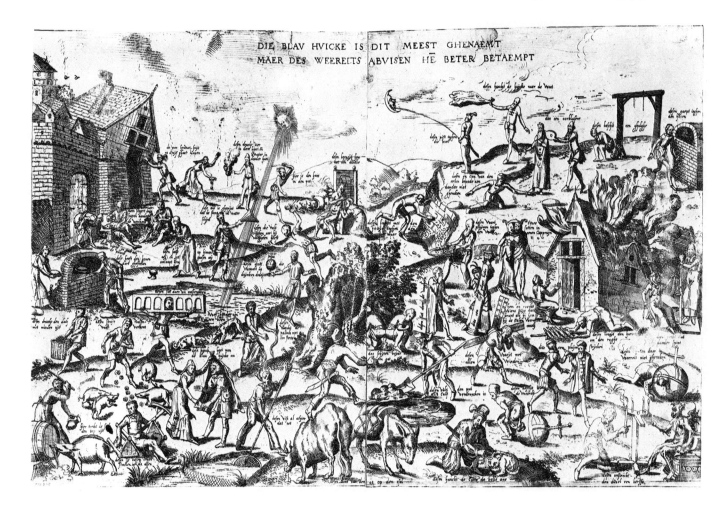

the distaff while the other spins', 'He brings baskets of light out into the daylight', 'The pig has been stuck through the belly', and 'He throws roses before swine'.

Bruegel also painted a number of individual proverbs and sayings. *The Misanthrope* of 1568 [85] is the only one to carry an inscription: '*Om dat de werelt is soe ongetru | daer om gha je in den ru*' ('Because the world is so unfaithful, I will go into mourning'). This is illustrated by an elderly cowled figure who, absorbed in his own thoughts, is about to walk into a scattering of mantraps and whose purse is being stolen at the same time. The moral is that it is no good retiring from the world and trying to bury your head in the sand; the only way to deal with life's difficulties and disappointments is to face up to them.

The depiction of individual proverbs, and groups of proverbs, continued into the seventeenth century in new, more realistic guises. In about 1620, for example, Joachim Wtewael of

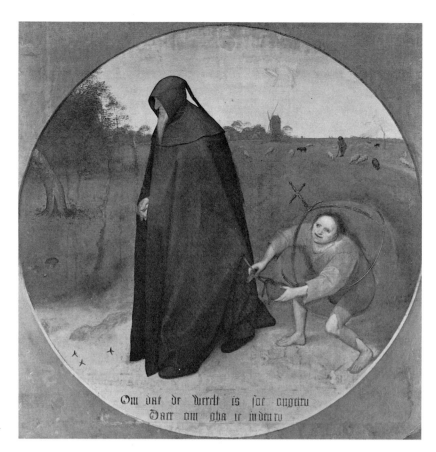

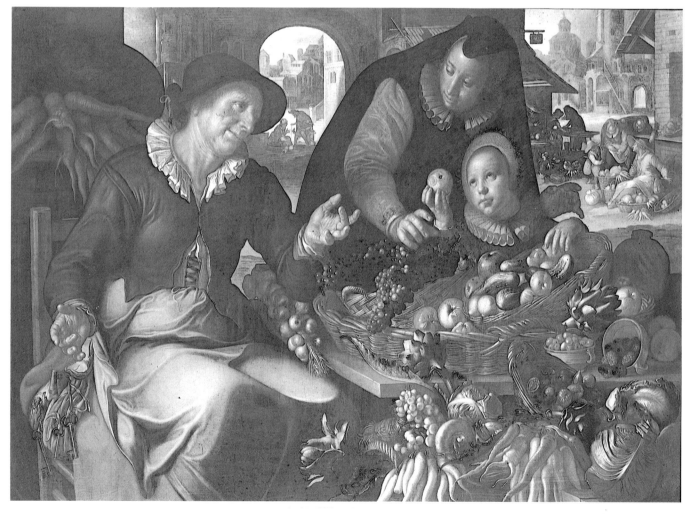

In the image, a sign reads:

Wat maeckme
al om gelt !

Adriaen van de Venne.
'*Wat maeckme al om
gelt*', 1625. Panel 34.2 ×
53 cm
Museum of Fine Arts,
Budapest
Photo: Károly Szelényi,
Corvina Archiv
[page 86]

Utrecht illustrated the proverb '*Een rotte appel in de mand maakt al het gave fruit te schand*' ('One rotten apple ruins the barrel'), in the form of a scene of a woman selling vegetables and fruit at a market [85].

Adriaen van de Venne painted a large number of grisailles carrying inscriptions which are proverbs or popular sayings. A particularly lively one is now in Budapest [86]. The text, pinned to the wall, reads '*Wat maeckme al om gelt*' ('What people will do for money'). The saying in full is: "What people will do for money", said the farmer, when he saw a monkey sitting on the window sill.' Van de Venne has wittily reserved the roles: the monkey, normally seen performing tricks before a paying audience, here points at the farmer who has clambered up onto the window sill and is the object of general amusement. The eggs which he is taking to market spill from his basket as he makes a fool of himself. The richly dressed couple on the left are detached observers of the scene: the woman directs our attention to the farmer.

The seventeenth-century Dutch painter most concerned with the representation of proverbs and sayings was Jan Steen. He often makes his subject quite explicit by incorporating the text within the composition. One saying which he illustrated a number of times and which touches on a matter of particular concern to him, the proper upbringing of children within the family, is '*Soo de ouden songen / soo pypen de jongen*' ('As the old sing, so the young chirp'). The meaning is, of course, that the young will imitate their elders and so must be set a good example. The paintings show rowdy, drunken households in which the children are learning rowdy, drunken ways. In the Rijksmuseum painting of 1669 the text of the saying is displayed on a paper pinned to the mantelpiece [30]. Many of the children's activities are intended as puns on the word *pypen*, meaning 'pipe' as well as 'to chirp': not only is there a variety of musical pipes – a curved horn, bagpipes and a flute – but the children are also smoking pipes and the small child in the foreground is about to drink from the long, thin spout of a vessel known as a *pyp*. In the version

86

Jan Steen. *Soo gewonnen,
so verteert*, 1661. Canvas,
79 × 104 cm
Museum Boymans-van
Beuningen, Rotterdam
[page 88]

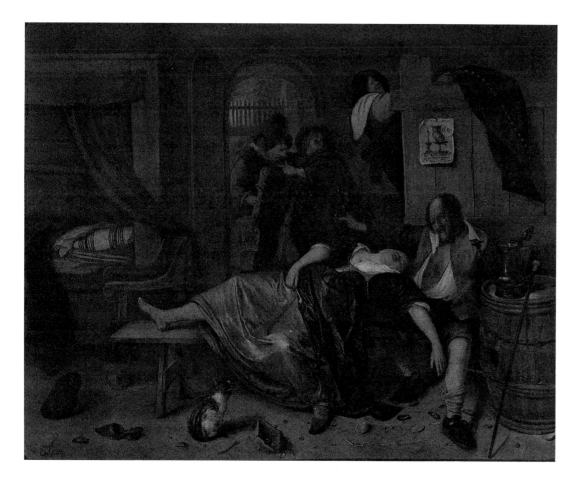

Jan Steen. *The Drunken
Couple*. Panel, 52.5 × 64
cm
Rijksmuseum,
Amsterdam
[page 88]

in Berlin [31] Steen sets the scene at a christening: the motto is on a paper lying in front of the cradle. Hanging on the back wall are two paintings by Frans Hals, *Malle Babbe as Smoker* and *Pickelharing as Drinker*, which underline the moral that the children will pick up bad habits such as smoking and drinking if they see them practised by their elders.

Steen's inspiration was Flemish. He was clearly aware of paintings of this subject by Jacob Jordaens, of which the earliest dated example, in the Museum at Antwerp, is from 1638. Steen's purpose, however, is more didactic: there can be no doubt that he intends to critize the poor example set by the adults in showing children smoking, drinking and behaving so mischievously.

Another saying illustrated by Steen is '*Soo gewonnen, soo verteert*' ('Easy come, easy go'). In the painting of 1661 in the Boymans-van Beuningen Museum in Rotterdam, the words are inscribed in gold letters on the bas-relief decoration of the fireplace [87]. The seated man has just won money at backgammon; two other men can be seen playing in a far room, glimpsed on the left. The fickle goddess Fortuna, whose traditional pose has been amusingly adapted by Steen so that she rests her right foot on a dice, has smiled on him. He is spending his winnings, however, as quickly as he got them, on wine, oysters and – we may surmise from the juxtaposition of an elderly crone and a young woman, the traditional procuress-prostitute combination – women.

Pinned up behind a drunken couple in a tavern scene by Jan Steen in the Rijksmuseum [87] is a print which illustrated the saying '*Wat baet er kaers en Bril als den Uyl niet sien en wil*' ('What is the use of candles and spectacles if the owl cannot and will not see?'). The elderly drunkard whose coat is being stolen from under – or, more literally, above – his nose illustrates the truth of this popular proverb, that some people will never learn. This was a favourite saying of Steen's: it is found in many of his paintings with various subjects, among them *The Schoolmaster* (Edinburgh, National Gallery of Scotland) [153] and *The Alchemist* (private collection, New York).

In the *Effects of Intemperance* (National Gallery, London) [31] Steen incorporates a number of proverbs into a single realistic setting: the drunken mother refers to the biblical proverb 'Wine is a mocker', while to the right a boy throws roses before swine, one of the proverbs which Bruegel had illustrated. The children, lacking the watchful eye of a parent, steal, feed a pie to the cat and give wine to the parrot. In the background an old man is seducing a young girl, another of the potential pitfalls of alcohol. Steen, like Bruegel, is a moralist and above the head of the drunken woman hangs a basket in which can be seen reminders of the fate which awaits those who lack self-discipline – the crutch and clapper of the beggar and the birch of judicial punishment. It is only by actively resisting the temptations of excessive indulgence in sensual pleasure that poverty and degradation can be avoided. Steen's constant theme, always wittily presented, is the havoc wrought on the proper conduct of the family and of society as a whole by self-indulgence, and he chose familiar sayings in order to make his point.

3. The World of Work

I. THE WORK OF MEN

Seventeenth-century Dutch society, permeated by the ethics of Calvinism, placed a high value on the virtues of hard work and honesty, and scenes showing men at work were thought of as illustrations – almost glorifications – of those virtues. It was, in addition, a society which, particularly in the first half of the century, enjoyed a high degree of social mobility, so that hard work could bring rewards of wealth and improved social status. In early seventeenth-century Amsterdam a man's place in society depended not necessarily on his parentage or his profession but rather upon his wealth; and there were many examples of men who had made their fortunes by industry and determination.

An economy as sophisticated and prosperous as that of Holland at the time depended upon a large working class, both skilled and unskilled. Sailors, fishermen, dockers, net- and sail-makers, ship-builders, dyers and weavers,

88

brewers, sugar-boilers, tobacco cutters and packers, farmworkers in a highly commercialized and specialized agriculture, made up a fragmented yet articulate group. The artisan class included shopkeepers, tailors, cobblers and that socially indeterminate group, the artists: all served the affluent consumer society of the United Provinces. Calvinism, with its sympathy towards democracy and social emancipation, had its deepest roots in the artisan and working classes.

In these circumstances – and many genre paintings, it must be remembered, were relatively cheap, within the means of working people – it is not surprising that the occupations of men became a popular subject, treated in numerous paintings, and even more prints. Such prints were often issued in series or bound in a single volume. They carried moralizing legends, praising the industry and skill of the individual artisan. A direct heir to Jost Amman's *Ständebuch* was Jan and Caspar Luicken's very popular *Het Menselyk Bedryf* (*The Work of Man*) [60], published in Amsterdam in 1694, which contained one hundred prints of occupations with religious verses below. The Luickens were religious enthusiasts who

AQUA
met Privil:

viewed all wordly activity in terms of service to God; as such they cannot be taken as in any way typical of contemporary artists, although their ideas were shared by a substantial section of the Dutch public who must have viewed paintings and prints showing the work of men in a similar light.

After Abraham Bloemaert (1564-1651). *Water*. Engraving, one of a series of engravings by Frederick Bloemaert (c.1610-69) of the Elements after designs by his father Rijksprentenkabinet, Rijksmuseum, Amsterdam
[page 90]

Hendrick Avercamp (1585-1634). *Fishermen*. Panel, 24 × 39.2 cm Fondation Custodia (Coll. F.Lugt), Institut Néerlandais, Paris
[page 90]

Fishermen

Early in the century fishermen had been real-istically represented as illustrations of the ele-ment of Water in series of prints of the Four Elements – as, for example, in that by Frederik Bloemaert after his father Abraham's designs [89]. It is unlikely, however, that Arent Arentsz. had this allegorical meaning in mind – or indeed the Luickens' identification of the fisherman with the Fisher of Souls [91] – when he painted fishermen at work near Mui-den Castle [32]. He also showed fishermen at their work with two related occupations, those of hunters and farmers, in a pair of small paint-ings. Hendrick Avercamp, on whose subtle, understated style that of Arentsz. depends, had also depicted fishermen with rods and nets as well as a duckshooter, with, in the distance, a view of the town of Kampen: the flat river landscape is relieved only by the grim vertical lines of the gallows [89].

Arentsz.'s experience seems to have extended only to freshwater fishing in the rivers close to his native Amsterdam. Sea-fishing was treated by a number of marine artists such as Simon de Vlieger. The rare scene of the catch being laid out on the beach and bought from the fisher-men by a merchant who painstakingly records the transactions in a ledger is shown by Willem van Diest in a painting of 1638: the setting is the beach at Scheveningen, near The Hague [90].

Tailors

Quiringh van Brekelenkam's *Interior of a Tail-or's Shop* [92] seems to have been a particu-larly successful composition, since he repeated it, with slight variations, more than a dozen times. All the versions show the tailor and his young apprentices sitting cross-legged on a table by a window in order to get the best of the daylight. The various tools of their trade – chalk, scissors and needles – are on the table beside them. The work-room is also the living-room of the tailor's house, facing onto the street; his wife sits on a low stool beside the fireplace feeding her baby. (On the back wall

De Visser.
Ghy al, die swemd, in's weerels Stroomen,
'tGroot Visnet kund ghy niet ontkoomen.

Gelyk een Visnet aan de Strand,
Soo, secht de Wysheid, sal't ook weesen,
Wanneer des grooten Vissers hand,
Den Vangst der Mensen uit sal leesen;
Het goede in het heemels Vat,
En't quaade in een leelyk Gat.

De Kleermaaker.
ôMens besteed, , Uw beste kleed.

Het Kleed is noodig in der Tijdt ,
Maar beide, Kleed en Vlees verslijt :
En daarom Zijnder groote reeden ,
Om uit te sien met, ons Gemoed,
Naa Heemels Stof en heilig goed ,
Dat ons voor ewig mocht bekleeden.

hangs a still-life of a type painted by Brekelen-
kam himself.) Brekelenkam's painting dates
from about 1660. Jan Luicken's *Tailor*, of
thirty years later, also shows this arrangement
[91]. For Luicken, however, the tailor provides
a reminder that the flesh, like clothes, wears
out and so we should 'fix our minds upon the
material of heaven and holy good, that may
clothe us for all eternity'.

Cobblers

Jan Victors' *Village Scene with a Cobbler* [93]
dates from about 1650. The cobbler himself is
seated in a village street and a woman, dressed
in traditional West Frisian costume, points out
the hole in her shoe. On the bridge in the back-
ground a quack doctor has set up his stall (with
the distinctive circular Chinese umbrella, as in
Dou's *Quack Doctor*) [24]; and Victors, whom
we know to have been very devout, may be in-
tending a deliberate contrast between the hon-
est labour of the cobbler and the dishonest
trade of the quack.

Knife-grinders

The itinerant knife-grinder, going from house
to house, was once a familiar sight in Dutch
towns and villages. He is shown, for example,
in an etching by Adriaen van Ostade, one of a
number he made whose subjects were occupa-
tions. With the exception of his early *corte-
gaerdjes*, Gerard Terborch's genre scenes
show prosperous interiors, with card-players,
musicians and well-dressed drinkers. His
Knife-grinder's Family (Berlin-Dahlem) is a
remarkable contrast to these, a moving study
of urban poverty [66]. The house is in a state
of virtual collapse, the family dressed in rags,
the courtyard strewn with rubbish, and yet the
father is working hard at the wheel and the
mother carefully inspects the child's hair for
fleas, a familiar illustration of maternal de-
votion. The scene is one of virtuous poverty,
and Terborch brought to the coarse linen and
crumbling brick all the skill in the rendition of
texture which he more usually expended on
silks and satins.

91

Weavers

In the Dutch Republic in the seventeenth cen-
tury weaving was largely a cottage industry.
Weavers owned their own looms which were
set up in the principal room of their houses,
and so they worked amidst the confusion of
domestic life. Haarlem was an important cen-
tre for weaving and two Haarlem painters,
Adriaen van Ostade and Cornelis Decker, col-
laborated on a painting of a weaver's cottage:
Ostade painted an interior of a type very famil-
iar from his peasant scenes and Decker added
the figures [65]. It was a subject to which
Decker, best known as a landscape painter in
the tradition of Jacob van Ruisdael, returned
in a painting of 1659 in the Rijksmuseum
[93]. Johannes van Oudenrogge, who also

worked in Haarlem, in a picture of 1652 shows
the loom (placed close to the window to get
good light) idle, and the weaver and his ap-
prentices or assistants smoking around the
hearth, while his wife prepares their meal
[32].

92

Jan Victors (1619/20-
?76). *A Village Scene
with a Cobbler*. Canvas,
63 × 78.5 cm
Reproduced by courtesy
of the Trustees, National
Gallery, London
[page 91]

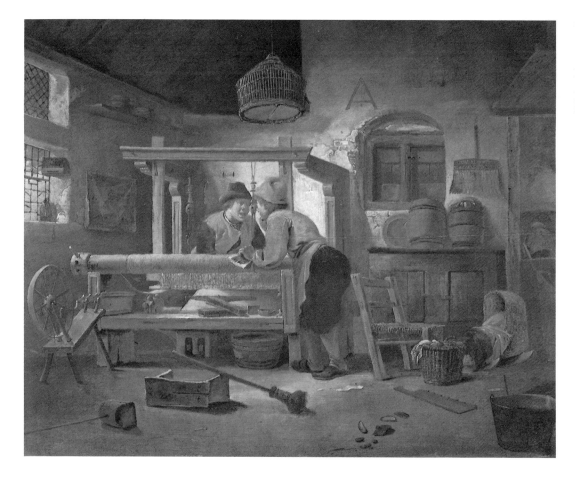

Cornelis Decker. *A
Weaver's Workshop*,
1659. Panel, 45 × 57 cm
Rijksmuseum,
Amsterdam
[page 92]

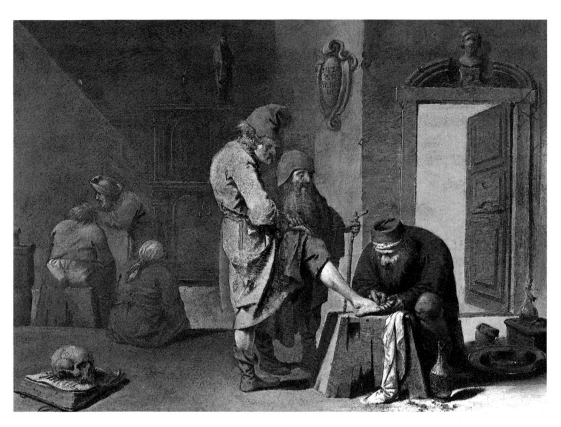

Pieter Quast (1606-47). *The Foot Operation.* Panel, 30 × 41 cm. Rijksmuseum, Amsterdam.
[page 94]

II. THE PROFESSIONS

It is a remarkable feature of Dutch genre painting that the professional classes in Dutch society – doctors, dentists and lawyers in particular – are treated almost entirely in a mocking spirit. They are also often made fun of in popular literature, especially in plays, and we may imagine that these attitudes reflect widely-held prejudices. It is ironic that while Dr. Tulp, a member of Amsterdam's regent class who relished his reputation as the Vesalius of the North, and his colleagues in the city's Surgeons' Guild, commissioned Rembrandt to immortalize them as devoted scientists in a passionate search for anatomical exactitude, the popular conception of the doctor was of a fraudulent quack or brutal butcher. Major advances in medical science were made by Dutch physicians during the seventeenth century but they do not seem to have affected the popular notion of the doctor. The physician who treated most Dutchmen, and particularly those who lived in the country, was more likely to have been a travelling barber-surgeon whose skills were of the most primitive kind.

Doctors: the Quack Doctor and 'The Doctor's Visit'

The Quack Doctor was a popular figure in Dutch genre painting. He was treated in a variety of ways – as a cruel deceiver, a figure of fun, or a symbol of duplicity. (This is by no means an exclusively Dutch phenomenon: there are contemporary Italian, French and English representations of the Quack Doctor as an image of deceit.) Gerrit Dou's sophisticated use of the quack as an allegory of deceit has been discussed in detail (see pages 43, 44). Adriaen van de Venne, in a grisaille of 1631, adopted a far more overtly moralizing tone, while other artists, like Molenaer and Steen, treated the subject in a light-hearted, even knockabout, way.

For Jan Steen the medical profession was an irresistible butt for satire. His quack is a hunchback with an exaggeratedly long jaw and a tall black hat; he is so theatrical in his gestures that we might be present at a play in which his assistants hold down the peasant who is about to undergo an appalling operation. Pieter Quast shows an aged surgeon performing a

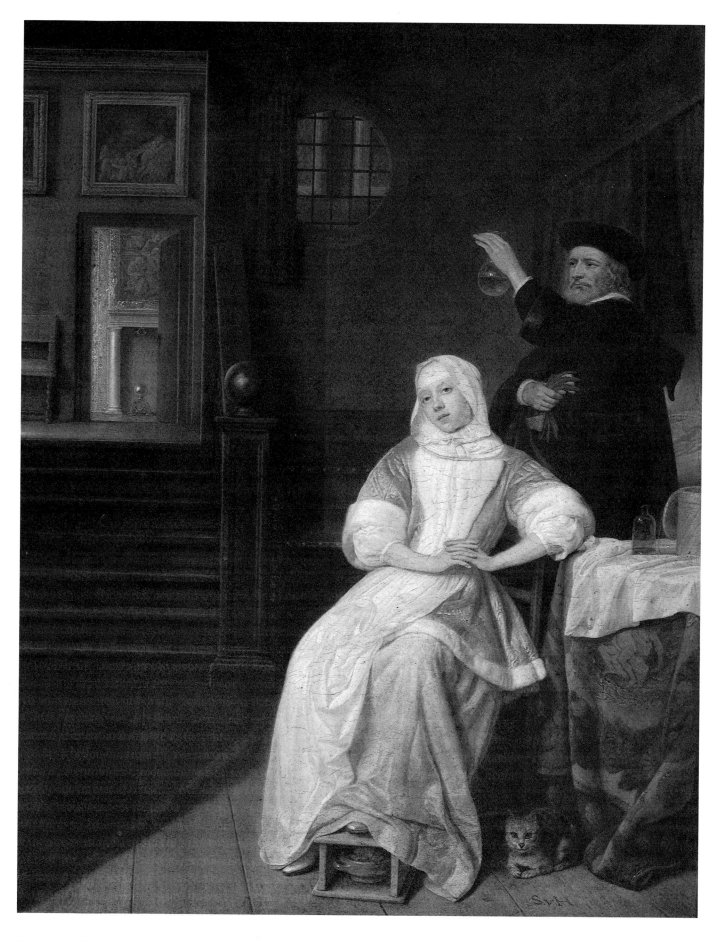

Samuel van Hoogstraten (1626-78). *The Doctor's Visit*. Canvas, 69.5 × 55 cm Rijksmuseum, Amsterdam. [page 98]

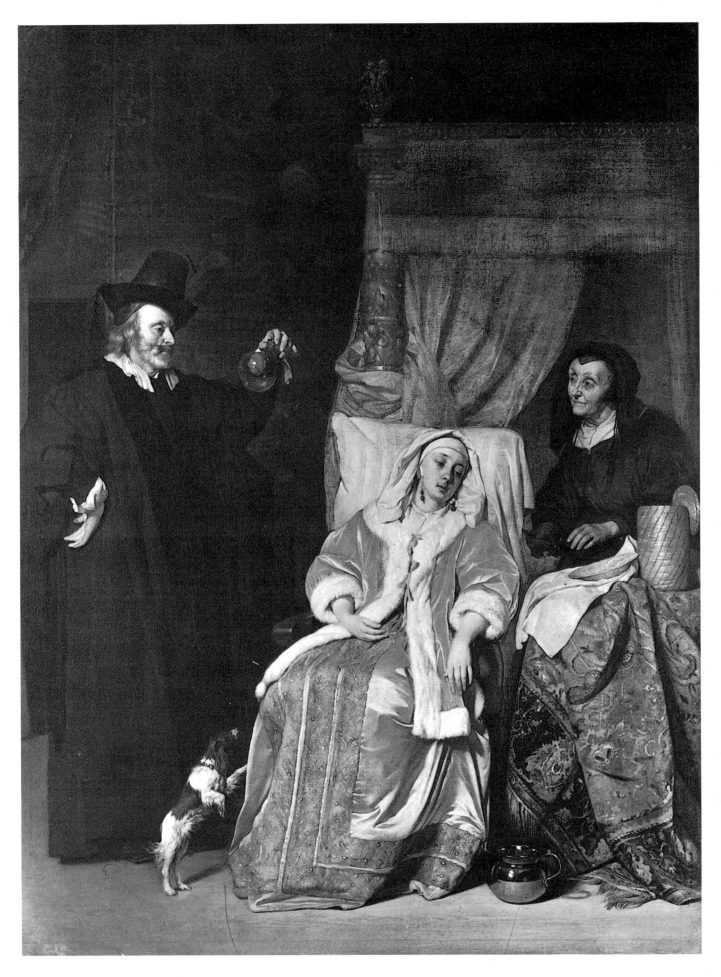

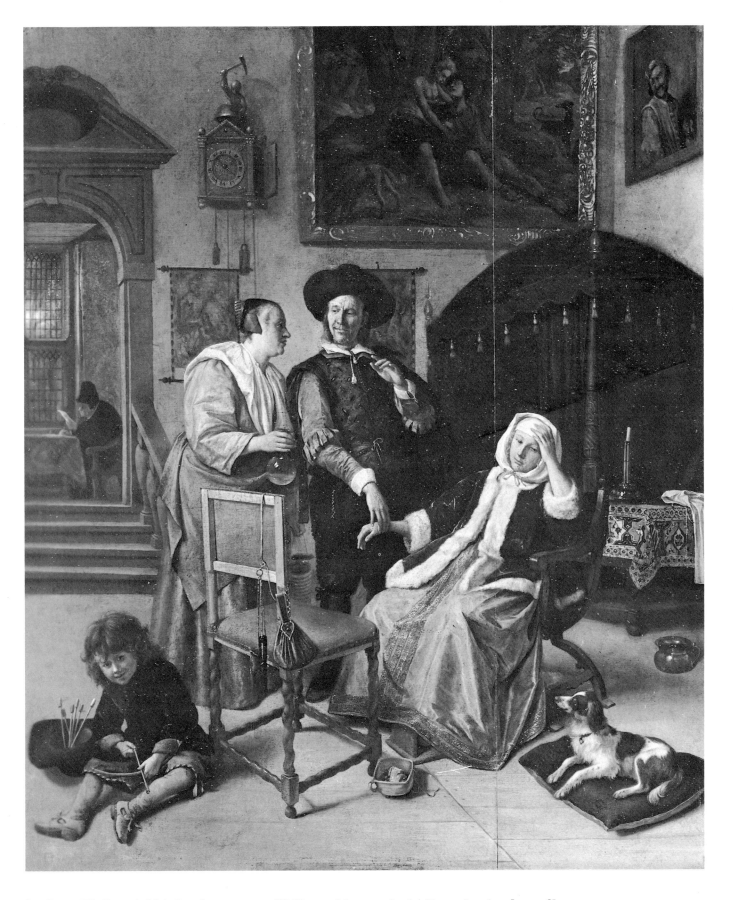

Jan Steen. *The Doctor's Visit*. Panel, 49 × 42 cm. Wellington Museum, Apsley House, London. [page 98]

OPPOSITE:
Gabriel Metsu (1629–67). *The Doctor's Visit*. Canvas, 60 × 47 cm. Hermitage, Leningrad. [page 98]

foot operation while other anxious patients wait their turn [94]. The presence of a skull resting on an open book at the left is hardly an encouraging omen.

The single most popular genre scene involving a doctor is the so-called 'Doctor's Visit', in which an elderly physician is shown examining a glass phial of urine provided by the patient, a young woman who is seen languishing in bed or propped up on cushions in a chair. It is a subject particularly associated with Jan Steen – who painted more than forty different versions – but it was also painted by Samuel van Hoogstraten [95], Gabriel Metsu [96], Gerrit Dou, Frans van Mieris and others. Examination of urine colour was a popular form of diagnosis but the joke is that the young woman is beyond the doctor's help; she is suffering from no ordinary complaint but from 'love's sickness', pregnancy. One of Steen's paintings carries the explicit inscription, '*Als ik my niet verzind, is deze meid met kind*' ('If I am not mistaken, this girl is with child'). Other elements within the painting underline this implication – in the version in the Wellington Museum, for example, there is a picture of Venus and Adonis on the back wall, while the boy in the foreground with his bow and arrow is a contemporary Cupid [97]. The ribbon burning in the earthenware dish at the girl's feet refers to a traditional folk practice for determining pregnancy: it was thought that if a girl was made sick by the fumes of a burning ribbon she was pregnant. In this case it is the girl's mother who holds the urine bottle while the doctor, who looks knowingly at her, takes her pulse. It has been suggested that the leering doctor in this and other representations of the subject by Steen is based, particularly in the details of his costume with its wide-brimmed hat and slashed sleeves, on the figure of the doctor in the *commedia dell'arte*. While there is undoubtedly more than a little theatricality in Steen's depiction of the scene, the doctor's dress is, if exaggerated, consistent with that of professional men in the seventeenth century.

Dentists

Dentists were shown in no more sympathetic a light than their professional colleagues, the doctors. Before the invention of anaesthetic, dentistry was of necessity a painful, even brutal, business. In the series of the Five Senses by Andries Both, *Touch* shows a dentist performing a clumsy extraction [39]: in the inscription he is identified as Doctor Lubbert, a name given to particularly stupid characters in Dutch popular literature. In Honthorst's painting of 1628 [68], an extraction is being performed by a genial dentist: his patient is terrified and the whole performance, not unlike a public execution, has caused a crowd to gather. A pickpocket is able to take advantage of one woman's horrified fascination by stealing from her basket. In Molenaer's painting of 1630 [67] and Steen's painting of 1651 [70] the patient's agony and the dentist's clumsiness are exaggerated to the point of caricature.

Victors, in 1654, shows an itinerant dentist who has set up his circular Chinese umbrella (like that of the quack), his table and a chair in a village street [69]. Once again, his patient is shown in agony, although in this case the dentist appears to be as conscientious as his limited skills allow. A crowd has gathered to gaze upon this gruesome event. One old woman raises her hands to the sides of her face in sympathetic distress while the man on the left directs our attention to the operation.

Lambert Doomer's *Dentist* [99] is a species of quack doctor. He is evidently prosperous, well dressed, and wears a sword; he has a glamorous female assistant and all the attributes of quackery – a bogus diagram pinned to the fence behind him, jars of potions and a monkey, who amuses (and so distracts) the crowd by searching for fleas in a boy's hair. Doomer also emphasizes the relish of the spectator in the patient's all-too-evident agony: a particularly ghoulish pleasure is being taken in the proceedings by the old woman on crutches.

Lawyers

Like doctors, lawyers had a very different conception of themselves from that which we find in genre painting. There are many Dutch portraits of lawyers as upright citizens, pillars of the community, clutching documents, looking up from a volume in their book-lined studies. In a painting of 1628 in the Rijksmuseum, the Rotterdam genre painter Pieter de Bloot [68]

98

showed law being dispensed to well-dressed townspeople and peasants alike. Pieter Bruegel the Younger had painted satirical scenes of gullible peasants swindled by grasping lawyers, and de Bloot's painting is similar in composition. His treatment of the scene is, however, not obviously satirical but realistic. The queue of those seeking help is patient, waiting to be called up to the lawyers' desks – and the painting's bitter message is thereby all the more effective. It is contained in the motto on the right: '*Die wil rechten om een koe die brengter noch een toe*' ('If you go to a lawyer to get back your cow, you will have to bring another to pay him').

III. ALCHEMISTS, ASTROLOGERS AND ASTRONOMERS

The seventeenth century in Holland has justly been called the Age of Observation: it witnessed many major discoveries in cartography, optics and astronomy. All these sciences were particularly valuable in navigation and since the basis of the flourishing economy of the Republic was its seaborne trade, their study was enthusiastically encouraged. The crucial instrument was the lens, which might be taken as the scientific symbol of the age. Three Dutch scientists who enjoyed a European reputation in the seventeenth century – they were all early members of the Royal Society – could grind their own lenses. Christiaan Huygens, a brilliant physicist, was also a mathematician and astronomer who wrote a paper on the polishing of lenses. He discovered Saturn's rings and one of the planet's satellites; however, his best-known work was on the wave theory of light (known as Huygens' Principle) and the

Lambert Doomer (1622–1700). *The Dentist*. Drawing, Pen and wash, 28.7 × 40.2 cm Ashmolean Museum, Oxford
[page 98]

theory of the polarization of light. Anthoni van Leeuwenhoek of Delft was an anatomist and an entomologist, but is best remembered for his microscopy: he made the first accurate description of red blood corpuscles in 1674. (Incidentally, van Leeuwenhoek was one of Vermeer's executors and therefore must have been a friend of the artist, who painted two studies of scientists at work.) The third, Herman Boerhaave, known throughout Europe simply as 'the great Boerhaave', was professor of medicine at Leiden University, and was equally distinguished as a chemist, botanist and mathematician.

In addition to such renowned 'modern' figures as Huygens, van Leeuwenhoek and Boerhaave, there were a number of scientists, expecially in the early years of the century, in whose work the boundary between science and magic was by no means clear. Such a figure was Cornelis Drebbel, from Alkmaar; he came to England in 1604 and worked at the court of James I, who had a weakness for sorcerers. He gained a reputation as an inventor and claimed to have devised a perpetual motion machine as well as a submarine and a rain-making contraption; and he also assisted in the staging of court masques. Some of his experiments were undoubtedly alchemical, and yet he has serious claims to be remembered as a scientist: he was a military engineer of great talent and discovered a new process for the dyeing of wool, which was taken up at the Bow textile works.

In an age which could contain characters as different as Huygens and Drebbel – and a whole range of scientists and pseudo-scientists of far less talent – there was naturally great popular interest in, and much popular misconception about, science and scientists. The large number of paintings and prints which show scientists at work reflects this interest. The predestinarian Calvinists opposed much scientific research, particularly astronomy, on the grounds that such knowledge was not intended for man. However, in other quarters, including some theological ones, it was fiercely defended. And it is against this background of a lively contemporary debate about science and its uses that we should view Dutch genre paintings of scientists.

Alchemists

The alchemist's belief that base metals could be transformed into gold is often used in sixteenth-century art and literature as a paradigm of human folly; Pieter Bruegel shows an alchemist ruining his family in his hopeless quest for gold [33]. It is a subject which was treated by a number of seventeenth-century genre painters in a more realistic manner. Adriaen van Ostade places his alchemist, who is working the bellows to fan the fire beneath a cauldron, within a dark, cavern-like barn [101]. It is unlikely that Ostade knew any alchemists and even less likely that they worked in laboratories like this one. What he has done is to take the figure of the alchemist from an existing pictorial tradition and place him within his own convention for the depiction of peasant life. The left-hand side of the painting, with the boy gnawing hungrily on a bone and the mother cleaning her child, could come from any of a large number of Ostade's scenes from peasant life. That Ostade was conscious of the convention of the alchemist as a symbol of human foolishness is made clear by the Latin inscription on the paper that lies beside the alchemist's foot. (The inclusion of an inscription, familiar in the work of Jan Steen, is otherwise unknown in Ostade's.) It reads 'oleum et operam perdis', meaning that his work is a complete waste of time and effort. The saying is from the Roman comic dramatist Plautus, although Ostade may have known it from the sixteenth-century German humanist Agricola's *De Re Metallica* (1556).

Ostade's use in 1661 of what was in effect an earlier convention, his choice of a target for his satire which had been comprehensively attacked if not entirely demolished in the sixteenth century, is an aspect of the conservatism of some Dutch genre painting. The foolish alchemist was by that date the most threadbare of visual clichés. It is also a valuable reminder of how existing pictorial traditions could take priority over the observation of contemporary life. Ostade was not alone in his continuation of this tired theme: Thomas Wijck painted a number of scenes of alchemists in their laboratories crammed with bubbling cauldrons, glass phials and other sinister tools of their trade [71].

Astrologers and astronomers

The line between astrology, the study of the effects of the stars on human behaviour, and astronomy, the scientific study of heavenly bodies, was rarely drawn with any clarity in the seventeenth century. For example, the Luickens, in *Het Menselyk Bedryf*, showed an astronomer in his study but described him as *De Astrologist*. In the accompanying verses, they predictably took the Calvinist line that such studies were irrelevant to man's predicament: '*De Astrologist. | Daar 't meest aan is geleegen, Staat meest te overweegen | Soo laag in 't stof te zyn geseeten, | En 's hoogen heemels loop te meeten, | Schyntveel: Maar 't is van veel meer nut, | Den loop des leevens naa te speuren, | En wat er Eindling staat te beuren, | Op dat men 't Eeuwich Onheil schut.*' ('The Astrologist. That which is most important needs the most consideration. | Sitting so low in the dust | And measuring the high course of heaven | Seems a

great enterprise; but it's of much more use | to investigate the course of life | And what will eventually happen | in order to prevent Eternal Damnation.') Calvinists condemned astronomy because of its associations with astrology, which was dangerous superstition, and also because knowledge of the heavens is not the concern of men. The biblical text used to support this view was Moses' exhortation in Deuteronomy 4:19: 'And lest thou lift up thine eyes unto heaven, and when thou seest the sun, and the moon, and the stars, even all the host of heaven, shouldst thou be driven to worship them, and serve them, which the Lord thy God hath divided unto all nations under the whole heaven.' Calvin himself had written against astrology in his *Admonitio adversus astrologiam*, published in Geneva in 1549, and there were numerous sixteenth-century satires on astrologers, notably that contained in Sebastian Brant's *Ship of Fools* [102]. The text reads '*Die op de planeten haer gheloove stellen, |*

Adriaen van Ostade. *The Alchemist*, 1661. Panel, 34 × 45.2 cm
Reproduced by courtesy of the Trustees, National Gallery, London
[page 100]

Die op de Planeten haer gheloove ftellen,
Moghen vvel coopen een cleet met bellen.

Illustration from
Sebastian Brant, *Aff-
ghebeelde narren
speelschuyt*, Leiden, 1610
[page 101]

Moghen wel coopen een cleet met bellen.' ('He
who puts faith in the planets / May as well buy
a [fool's] cap and bells').

It was difficult, as Kepler found, to reconcile
the discoveries of astronomy with Christian
belief. The idea that the sun and not the earth
was at the centre of the universe caused out-
rage in conservative theological circles. Else-
where, however, astronomy had its defenders.
In Amsterdam in 1634 Willem Blaeu pub-
lished his influential and scholarly *Institutio
Astronomica*. Even some theologians rallied to
its defence: the popular Dirck Rembrantsz.
van Nierop published a treatise in support of
astronomy in 1661.

The large number of representations of astrol-
ogers and astronomers by Dutch artists can be
seen as a consequence of the great public in-
terest in the study of the heavens and the
debate about its significance. In a painting in
the National Gallery by the Leiden painter
Olivier van Deuren, the young astronomer
studies a celestial globe on which the constel-
lations are shown in the form of animals and
figures. So precisely detailed is van Deuren's

technique – in the Leiden tradition of Dou –
that some of the Northern and Zodiacal con-
stellations can be made out: on the left Ursa
Major and, below this, Leo; on the right, be-
neath the encircling brass ring, Bubuleus
(Bootes). The curtain on the right is intended
as a *trompe-l'œil* of the curtain which was often
hung over paintings by the Dutch to preserve
them from sunlight and dust. Simulated cur-
tains of this type were painted by a number of
Leiden artists and are an aspect of their fasci-
nation with tricks of illusion. Van Deuren's
painting does not satirize or condemn the stu-
dent: indeed, his application appears to be
held up as an example of devotion to study.

Vermeer's *Astronomer* of 1668 [72] spins a
globe which is described in equal detail: it can
be identified as Hondius' globe of 1600. Again,
there is no sense of criticism, but rather of the
subject's admirable devotion to his work. It
has been suggested that the painting hanging
on the back wall, which apparently shows *The
Finding of Moses*, is a reference to the biblical
condemnation of astronomy but this is a dis-
tinctly far-fetched idea. The painting has a
pendant, a *Geographer* [73], of the following
year with precisely the same compositional
format: Vermeer intended to present a con-
trast between the study of the celestial and the
earthly, though there is nothing in the paint-
ings to suggest that he did not consider them
to be of equal importance.

The circle of Rembrandt was particularly in-
terested in the subject of a scholar in his study.
Joris van Vliet, for example, who was closely
associated with Rembrandt in his early years
in Leiden, mocks scholarly pedantry in a print
of *c.* 1630 [103]. The booklined study is domi-
nated by a globe. So too is that of Dr Faustus
[103] in Rembrandt's puzzling etching of the
early 1650s, which has been shown to be the
reworking of a composition by Lucas Cranach
of *Luther as St Matthew*. While these scholars
display an interest in astronomy, it was prob-
ably not their prime concern: it is, however,
the principal interest of the seated scholar in
a painting of 1652 (National Gallery, London)
by Rembrandt's pupil Ferdinand Bol [104].
Two globes, one celestial and the other, in
shadow, presumably terrestial, lie before him
on the table behind the open book. His pose,

chin in hand, and his distracted air, suggests *melancholia*, the scholar's malady: it can be compared to that of the figure of Melancholia in Dürer's famous engraving. Melancholy is the inevitable outcome of the scholar's studies, which only serve to bear in upon him the futility of his own efforts, and his own mortality.

Cornelis Bega's painting of a man lost in thought in his disordered study has been entitled *An Astrologer* [105] because of the presence of a globe behind him. However, the book in front of him shows an open right hand, which suggests that his principal interest is palmistry. There was a great popular interest in palmistry in the seventeenth century – gypsy fortune-tellers who read palms were a feature of every fair – and a widespread belief that it was possible to discover a man's fate by studying the lines and mounds on his hands. It was the right hand which was particularly scrutinized. The contemporary literature of palmistry is largely of a popular kind – almanacs and crudely-printed broadsheets. An example is *Const van procognosticeren uyt de Handt, Handtwijzer tot de Chiromantia* (*Art of telling the future from the hand: Handbook for Chiromantia*), which includes clumsy diagrams showing the planets which control the various parts of the hand. There were more pretentious, pseudo-scholarly books: Meyens' *Chiromantia medica, waerbij is ghevoegt een tractaet van de phisionomie* (*Chiromantia medi-*

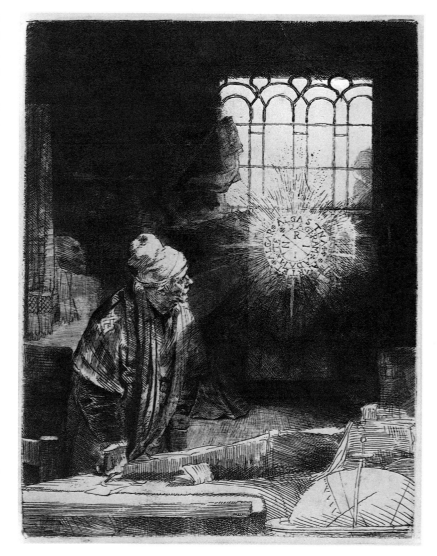

ca, to which is added a treatise on physionomy), published in The Hague in 1665, contains many references to Aristotle and Galen. It is no doubt a book such as Meyens' that Bega's scholar has before him. He tries to foretell the future by astrology and palmistry but, like Bol's astronomer, he seems sunk in melancholy, for he knows that ultimately his efforts are futile and will be rendered meaningless by his own certain death.

Joris van Vliet (c. 1610-after 1635). *A Scholar in his Study*. Etching
Rijksprentenkabinet, Rijksmuseum, Amsterdam
[page 102]

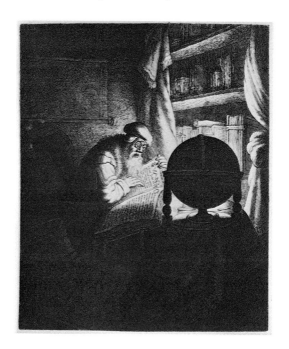

Rembrandt van Rijn (1606-69). *Dr Faustus*, c. 1650. Etching
Rijksprentenkabinet, Rijksmuseum, Amsterdam
[page 102]

Ferdinand Bol (1616-80). *An Astronomer*, 1652. Canvas, 127 × 135 cm
Reproduced by courtesy of the Trustees, National Gallery, London.
[page 102, 103]

Cornelis Bega (c. 1631/2-64). *An Astrologer*, 1663. Panel, 36.9 × 29.6 cm
Reproduced by courtesy of the Trustees, National Gallery, London.
[page 103]

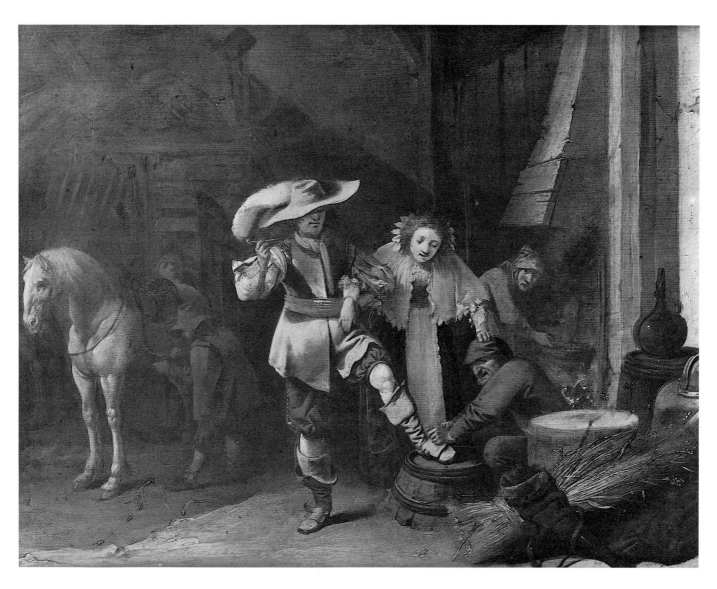

IV. THE LIFE OF SOLDIERS

In the early years of the century the towns of
Holland saw large numbers of soldiers on their
streets. They were occasionally brought in to
quell civil disturbances such as the fighting
between Remonstrants and Counter-Remon-
strants in Amsterdam in 1626. Mostly, how-
ever, they were in search of off-duty pleasures
and there were constant complaints about
their misbehaviour. In contemporary Dutch
literature, soldiers are often represented as
comic figures, the common footsoldiers as
drunken louts and the officers as foppish and
overdressed.

The activities of soldiers, military, amorous
and alcoholic, provided rich subject-matter for
genre painters, and there was a particular
vogue for *cortegaerdjes*, interior scenes show-
ing soldiers, in Amsterdam in the 1620s and

1630s. Its principal exponents were Pieter
Codde and Willem Duyster. The attitude of
genre painters towards soldiers, particularly in
the early part of the seventeenth century, was
largely critical: they were mocked for their
greed, vanity and, more seriously, their ran-
dom acts of cruelty and violence.

Willem Duyster, an Amsterdam painter,
showed soldiers fighting over booty in a barn in
a picture of 1625 [75]. The treatment is clearly
intended to be satirical and it is even possible
that Duyster is illustrating one of the plays by
Bredero, Coster and Rodenburgh which make
fun of military life. Dressed in the most elab-
orate finery, entirely unsuited to a real battle-
field, these heroes squabble like children.
The scene calls to mind a passage in Adriaen
van de Venne's *Tafereel van de Belacherende
Werelt: Hou je stil, ick sie nouw braven | Cappi-
tens, gelijk als graven, | Wt beset en mooy en*

106

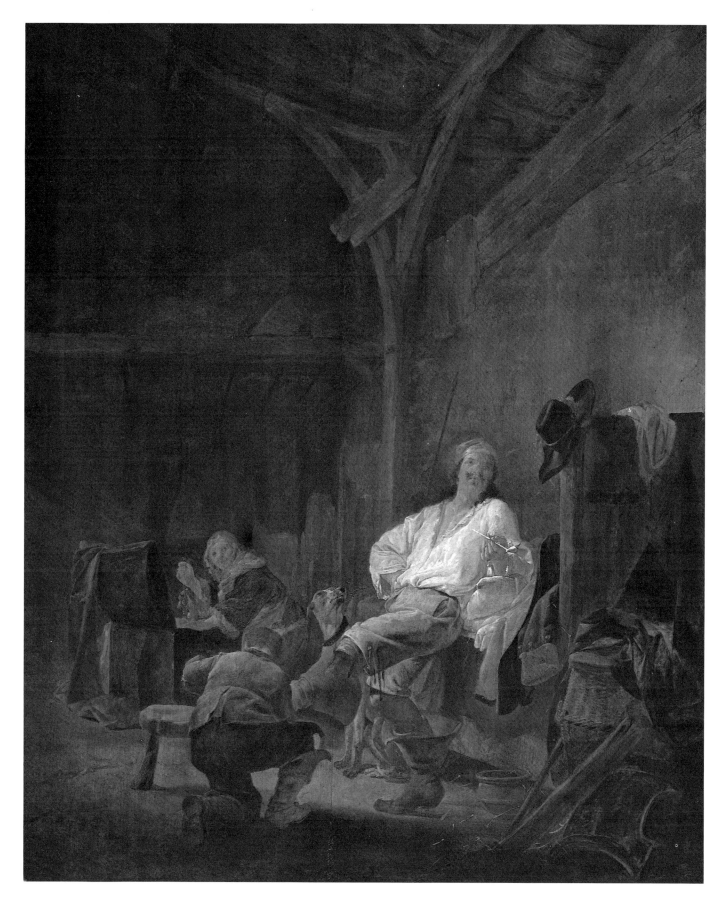

Maerten Stoop (1618-47). *An Officer in billeted Quarters*. Panel, 54 × 45 cm
Rijksmuseum, Amsterdam
[page 108]

wreet, | Meest in softe zijd gakleet, | Dat vol gout en silver blickert, | Nouw de sonn daar snel op flickert. (Stay still, now I can see brave / Captains, like nobles / ranged side by side, beautiful and cruel, / most clad in soft silk / in the latest fashion, with their silver flashing / When the sun shines suddenly upon them.)

Duyster had done his research well: the soldier taking aim is in the correct position for the use of a firelock as shown in the manual on the use of arms, *Wapenhandelinghe van Roers, Musquetten ende Spiesen* (1608), illustrated by Jacob de Gheyn.

Even closer to the spirit of van de Venne's satirical verse is a painting by Pieter Quast [106] which shows a swaggering and over-dressed officer, with a girl on his arm, having his spurs adjusted by an ostler. In fact, there are close links between van de Venne and Quast, who lived in The Hague at the same time. Quast, too, was a book illustrator. Maerten Stoop invites us to laugh at another ridiculous officer in a painting in the Rijksmuseum: this pompous, self-satisfied creature has been billeted on an unfortunate peasant family [107].

The tension, which often escalated into violence, between peasants and soldiers who lived off the land, was a theme treated by genre painters. It was vividly portrayed by David Vinckboons in a pair of paintings: *Boerenverdriet* (*Peasant Grief*) shows richly dressed soldiers (and their camp-followers) who have taken over a peasant household and are eating and drinking all that it contains [74]; *Boerenvreugd* (*Peasant Joy*) is the sequel, showing the peasants evicting – with terrifying violence – their unwelcome guests [74]. There can be no doubt that these and other similar subjects – for example, Gerrit Bleker's *Raid on a Village* (Dublin, National Gallery of Ireland) of 1628 have their origins in actual events during the Eighty Years' War [108]. Armies were encouraged to *teeren op de boer* (live off the land) and gangs of *vrijbuiters* (freebooters) were a familiar phenomenon. The Eindhoven region had changed hands eleven times during the first twenty-five years of the war and the subsequent depredations gave rise to a whole literature of 'Peasants' Laments' and a deep-seated loathing of the soldiery throughout the countryside. *Plakkarts* were issued on a number of occasions in the 1580s by the States General to discipline their own rowdy troops, and

Gerrit Claesz. Bleker (c. 1620-56). *A Raid on a Village*, 1628. Panel, 74 × 135 cm National Gallery of Ireland, Dublin [page 108]

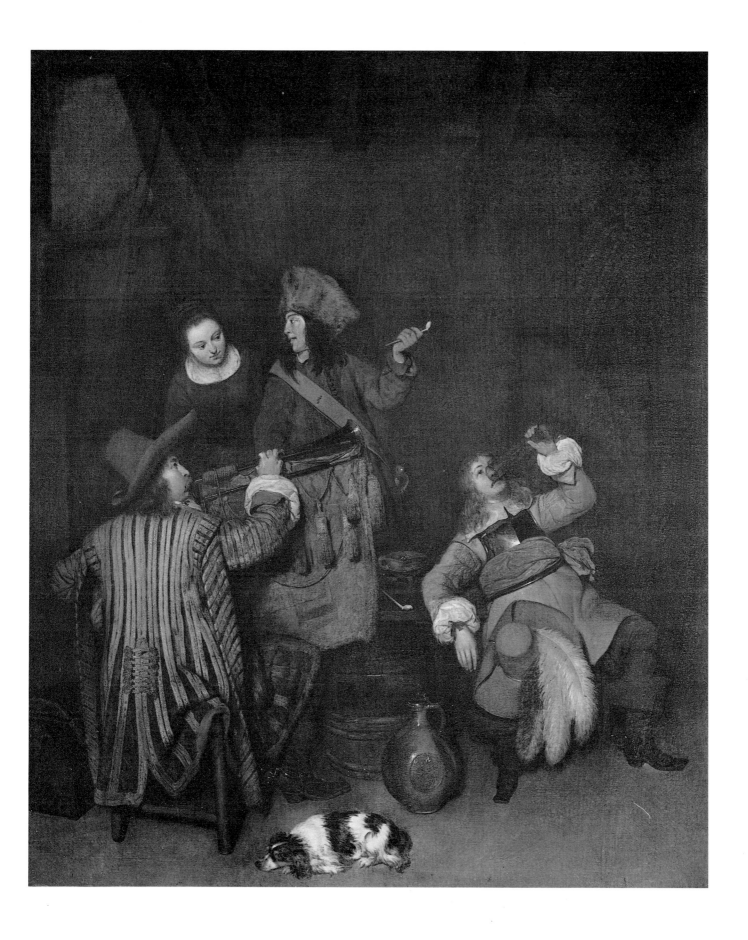

Gerard Terborch. *Soldiers in a Tavern*, 1658. Canvas, 97 × 80 cm. J. G. Johnson Collection, Philadelphia Museum of Art, Philadelphia. [page 111]

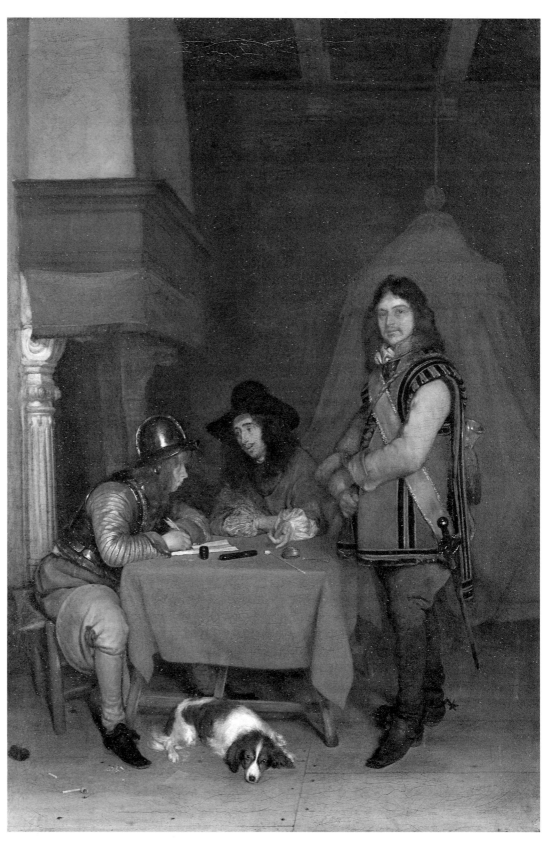

Gerard Terborch. *An Officer Dictating a Letter*. Canvas, 74.5 × 51 cm Reproduced by courtesy of the Trustees, National Gallery, London [page 111]

their ineffectiveness is made clear by the need to issue a *plakkart* in 1638 which went so far as to urge peasants to defend themselves against the soldiers of the States. It instructed that 'the inhabitants take up arms in order to help apprehend each and every soldier in the States' service who conducts himself in an unlawful manner... such as those who go from village to village plundering.'

After the truce of 1609, which was to last for twelve years, the fighting was largely confined

to the south Netherlands, and the Dutch armies were for the most part made up of mercenaries. As the century progressed and the war came to affect the lives of the people of the Republic less directly – the end came with the Treaty of Münster in 1648 – the bitter criticism and satire are not so evident in contemporary art and literature. Terborch's early (c. 1640) painting in the Victoria and Albert Museum is still close to the tradition of the rowdy barrack-room scenes of Duyster. By the time he painted *Soldiers in a Tavern* in 1658, however, the soldiers are far more decorous in their behaviour [109]. Five years earlier, in a painting in The Hague, he is concerned simply with the human predicament of a soldier called from the arms of a woman by a messenger summoning him to rejoin his regiment [76]. Again, in a painting in London, a human drama is enacted: an officer dictates a letter or perhaps an order while a messenger stands by [110]. (The boy who takes down the officer's words is a portrait of Terborch's pupil, Caspar Netscher.)

Soldiers continue to be the subject of mockery in genre painting but it is their ordinary human failings which are touched upon, rather than their professional misbehaviour. Carel Dujardin, for example, shows a young soldier boasting of his martial exploits while a colleague points to his eye in a gesture of disbelief [77]; Carel Fabritius' *Sentry* (1654) is slovenly, loading his rifle while slumped on his bench beside the town gate, hardly in a state of readiness [75]; and Frans van Mieris's officer (c. 1666) has fallen asleep in a tavern under the influence of alcohol [78].

V. STREET SCENES

Markets and stalls

Hendrick Sorgh of Rotterdam specialized in market scenes, showing the lively bustle of the stalls. He painted the housewives and maids buying and bargaining at the fish and poultry markets in his native town in several different versions: his *Fish Market* in the Manchester City Art Gallery dates from 1655 [79] and his *Poultry Market*, now in the museum at Basle, is from around the same time [80]. A far greater artist, Gabriel Metsu, painted the Amsterdam market: two women, one – the stallholder – with her hands on her hips, argue over the price of turnips, a maid who is out shopping receives the attentions of a flamboyantly dressed young man, and a dog and a cock eye one another suspiciously. In the foreground is an immaculately painted vegetable still-life rendered by Metsu in a precisely descriptive manner which is quite different from the freer handling of the figures. It is all set against the elegant backdrop of a row of Amsterdam *gracht* houses [114].

Another painting by Metsu of a woman buying poultry, in the Gemäldegalerie at Dresden, contains an unexpected double meaning. It is apparently an everyday scene, as purely descriptive as the market scenes of Sorgh: a housewife who is out shopping pauses to look at a bird being offered to her for sale by an elderly poultry-seller. The bird is a cock, notorious in folklore for its insatiable sexual appetite, and an old man offering a cock to a young woman would have been understood by contemporaries as a sexual advance. As de Jongh has shown, the words *vogel* (bird) and *vogeleren* (literally, 'to bird') were popularly used at the time for the male organ and the sexual act. This puts a very special connotation on the man's offer in Metsu's painting. If this seems an overly devious interpretation, it is possible to substantiate it with a very clear example of this vulgar *double entendre* in a print which is strikingly similar in composition. It is by Gillis van Breen, and in the inscription underneath the housewife asks about the man's 'bird' which he reaches for with his left hand. He replies that he is keen to 'bird' all the time.

Adriaen van Ostade's *Fish Stall*, painted a few years later, in 1672, has no such undercurrents. It is just what it appears to be: a scene which, rather than showing us the life of the whole market, focuses on an individual stall where the stallholder is cleaning the fish. She is of course an example of virtuous conduct in that she is carrying out her job, however menial, honestly and with proper regard for her customers. The oblique angle of the composition is a particularly ambitious element in this painting from the last years of Ostade's career [113].

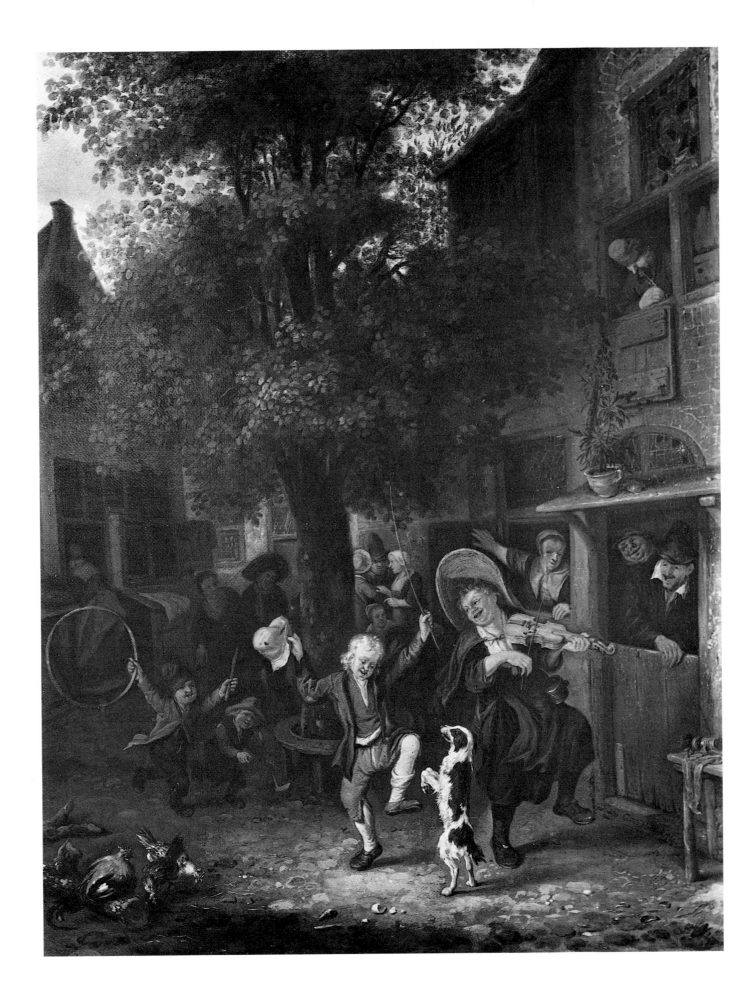

Adriaen van Ostade. *The Fish Stall*, 1672. Canvas, 36.5 × 39.5 cm
Rijksmuseum, Amsterdam.
[page 111]

OPPOSITE:
Cornelis Dusart (1660-1704). *Street Musicians*. Canvas laid down on panel, 57 × 46 cm
Rijksmuseum, Amsterdam.
[page 129]

Gabriel Metsu. *Vegetable Market at Amsterdam.* Canvas, 97 × 84.5 cm
Musée du Louvre, Paris. [page 111]

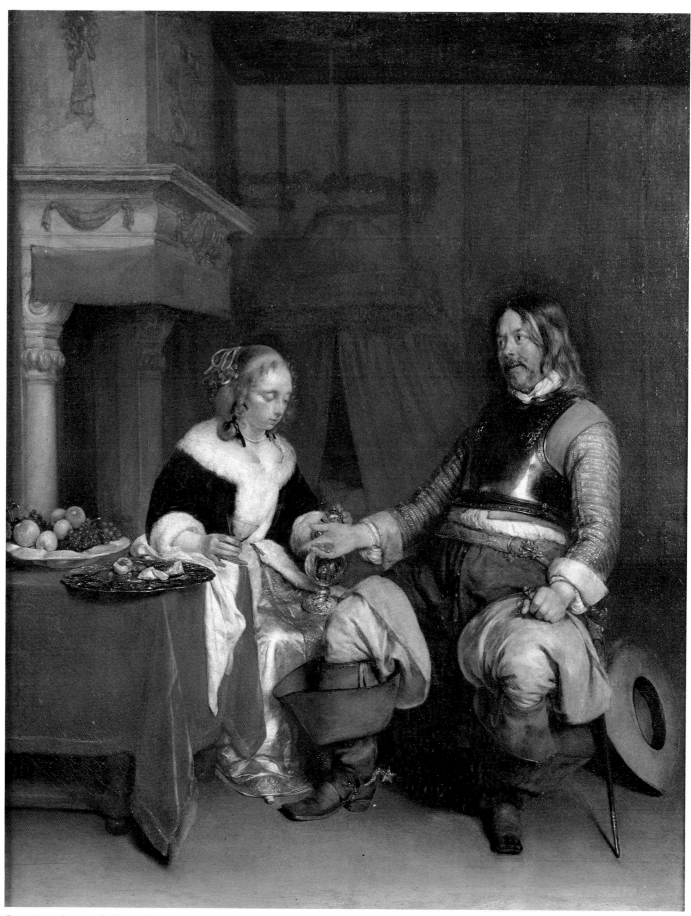

Gerard Terborch. *Soldier offering Money to a Girl* (Le Galant Militaire). Canvas, 68 × 55 cm.
Musée du Louvre, Paris. [page 133]

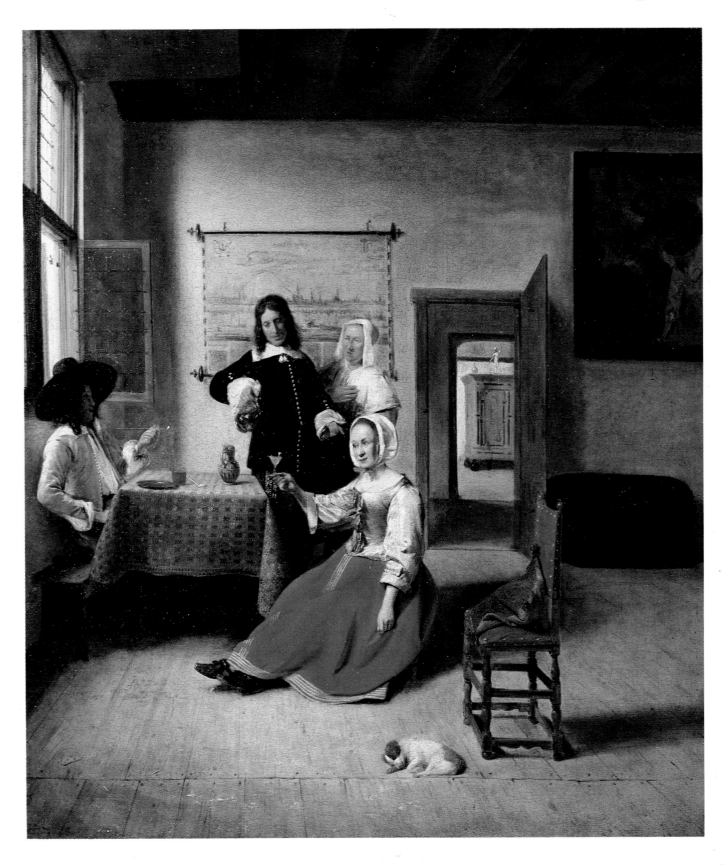

Pieter de Hooch (1629–84). *A Girl drinking with two Men*, 1658. Canvas, 69 × 60 cm. Musée de Louvre, Paris. [page 134]

OPPOSITE:
Frans van Mieris. *The Oyster Meal*, 1661. Panel, 27 × 20 cm. Mauritshuis, The Hague. [page 134]

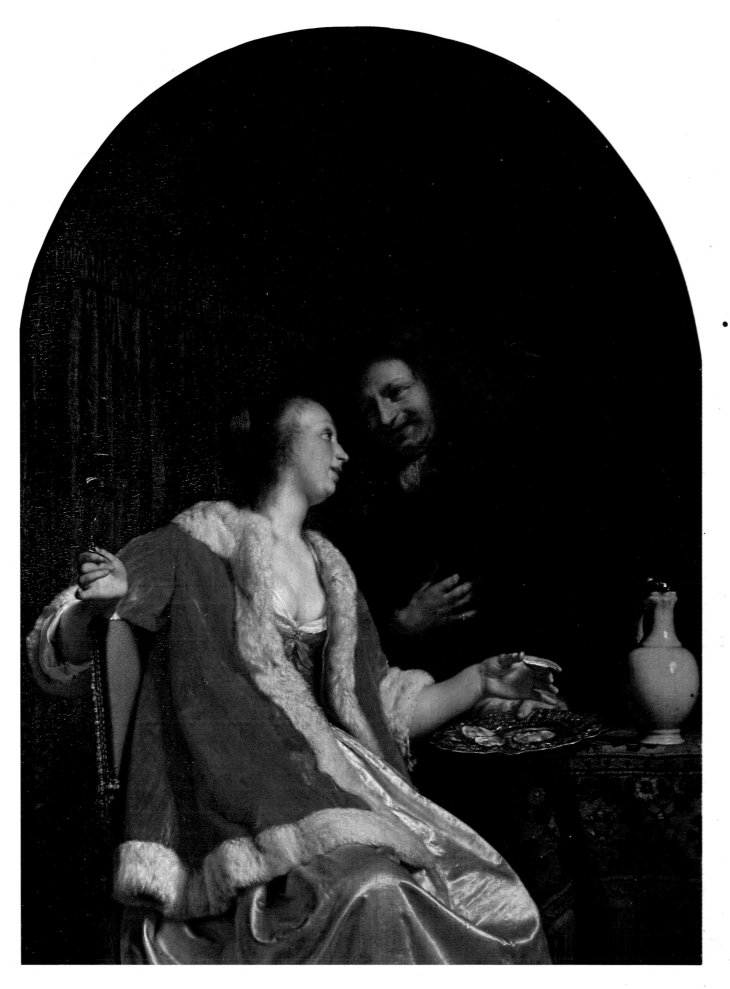

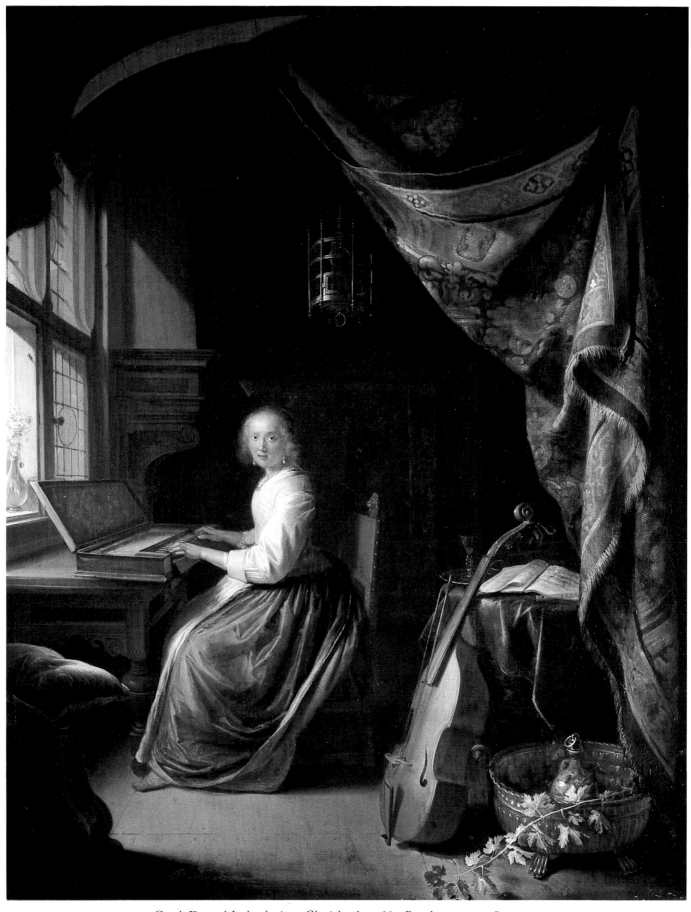

Gerrit Dou. *A Lady playing a Clavichord*, c. 1665. Panel, 37.7 × 29.8 cm.
By permission of the Governors of the Dulwich Picture Gallery, London. [page 137]

Gabriel Metsu. *A Musical Party*, 1659. Canvas, 60 × 52.2 cm. Metropolitan Museum of Art, Gift of
Henry G. Marquand (1890), New York. [page 137]

Gerard Terborch. *Lute-player and an Officer*. Panel, 37 × 32.5 cm.
Metropolitan Museum of Art, Bequest of Benjamin Altman (1913), New York. [page 137]

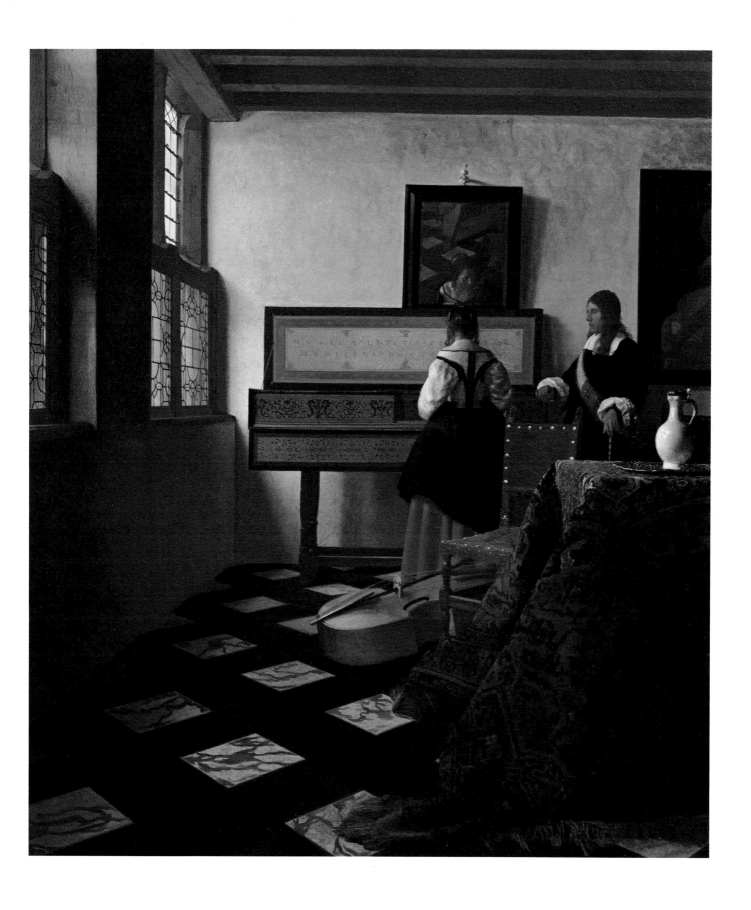

Jan Vermeer. *The Music Lesson*, c. 1664. Canvas, 73.6 × 64.1 cm
Collection of Her Majesty Queen Elizabeth II, Buckingham Palace, London. Copyright reserved
[page 137]

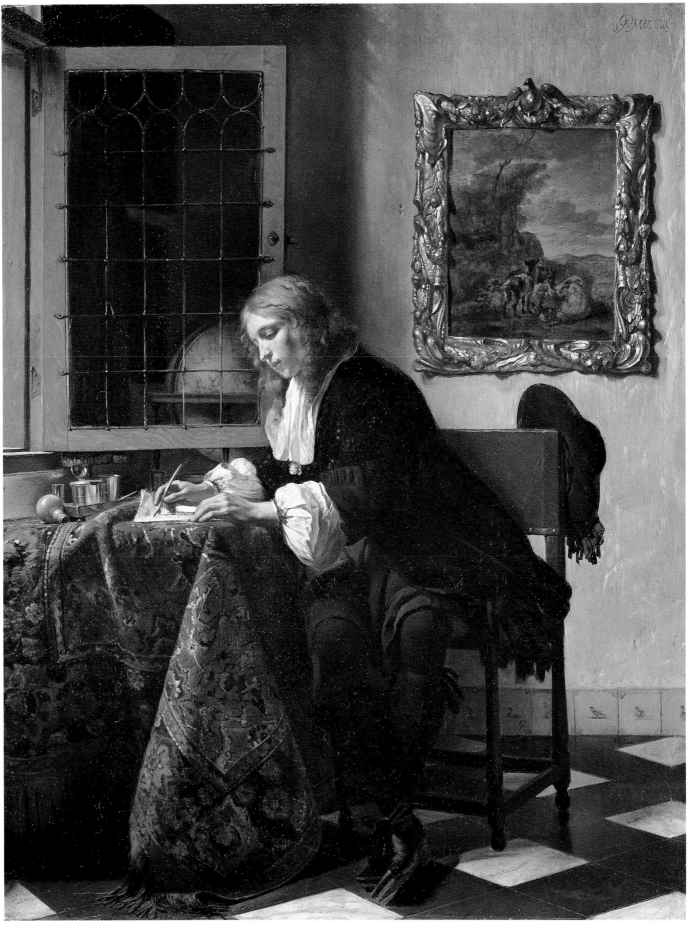

Gabriel Metsu. *Man Writing a Letter*. Panel, 52.5 × 40.2 cm. Pair to the painting on the opposite page.
Beit Foundation, Russborough, near Dublin. [page 140].

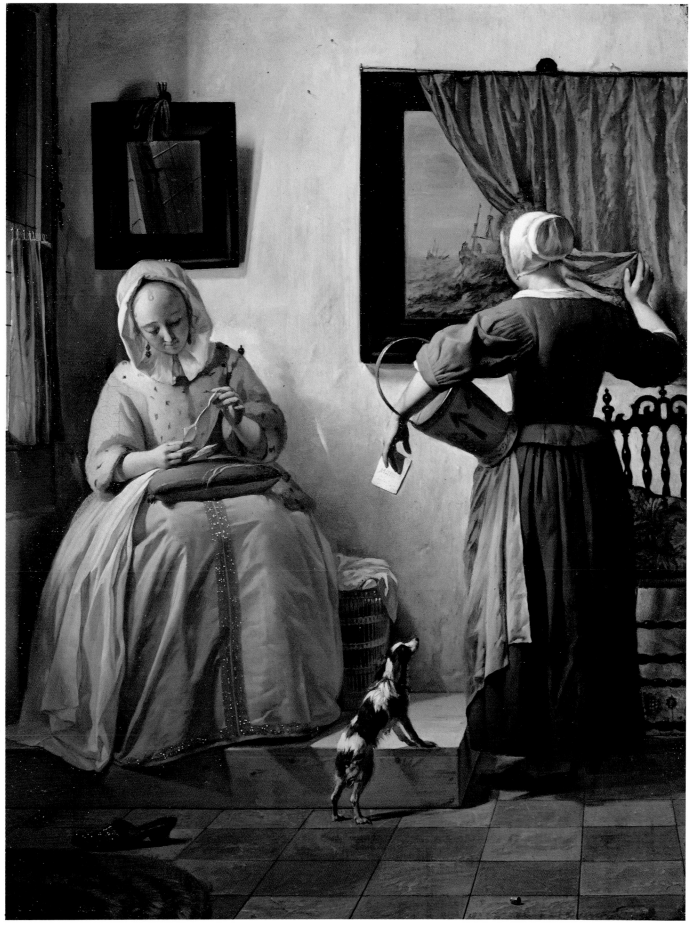

Gabriel Metsu. *Woman reading a Letter*. Panel, 52.5 × 40.2 cm.
Beit Foundation, Russborough, near Dublin. [page 140]

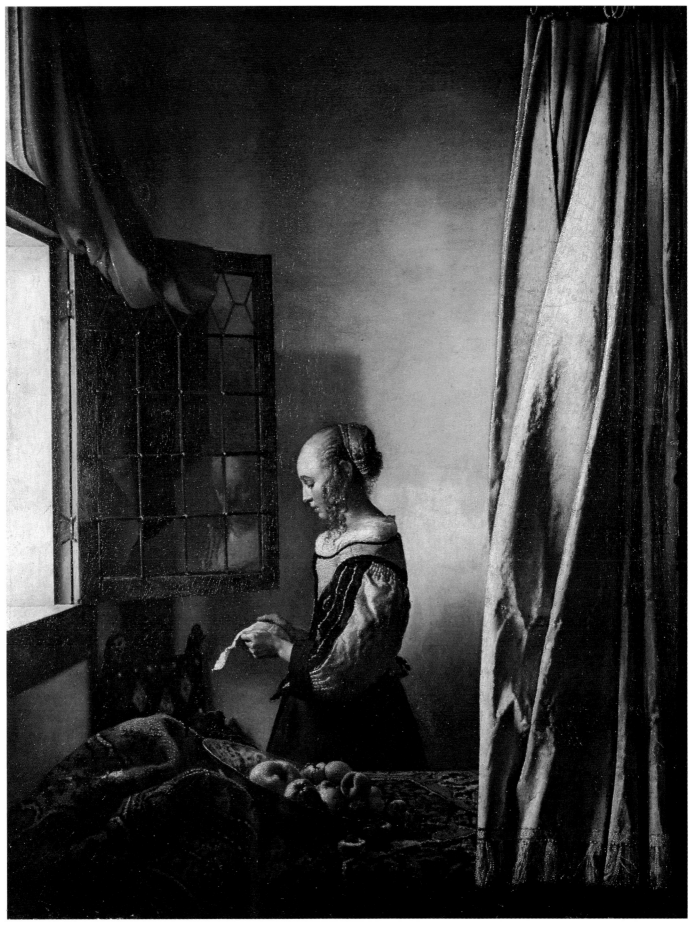

Jan Vermeer. *Girl reading a Letter at an Open Window*, c. 1659. Canvas, 83 × 64.5 cm
Staatliche Kunstsammlungen Dresden, Gemäldegalerie Alter Meister. [page 140]

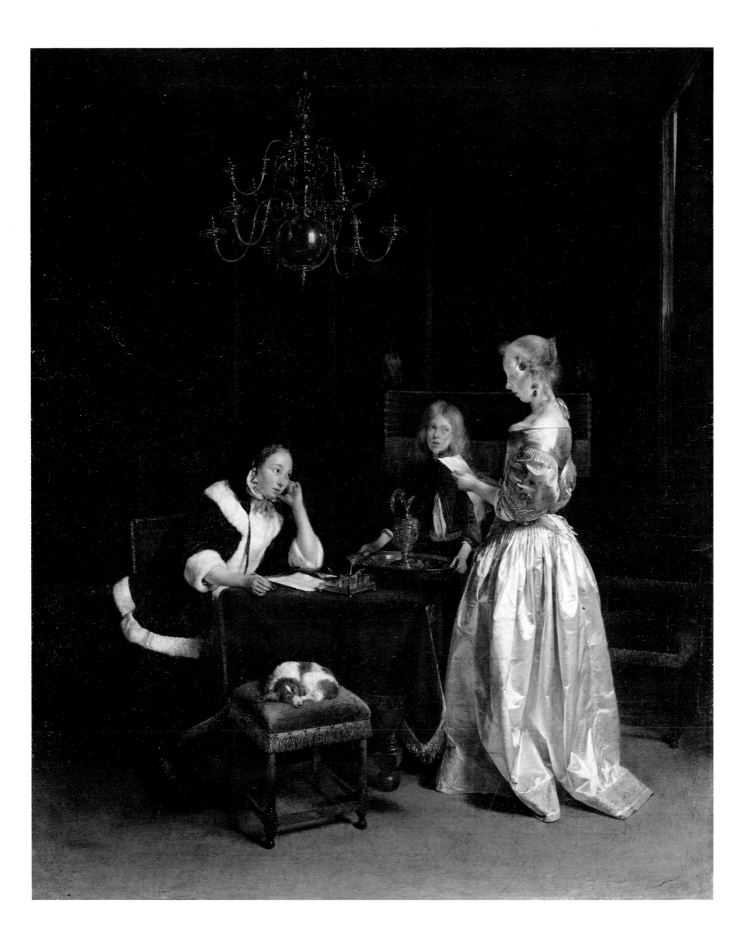

Gerard Terborch. *The Letter*, c. 1660. Canvas, 81.9 × 68 cm
Collection of Her Majesty Queen Elizabeth II, Buckingham Palace, London.
[page 140]

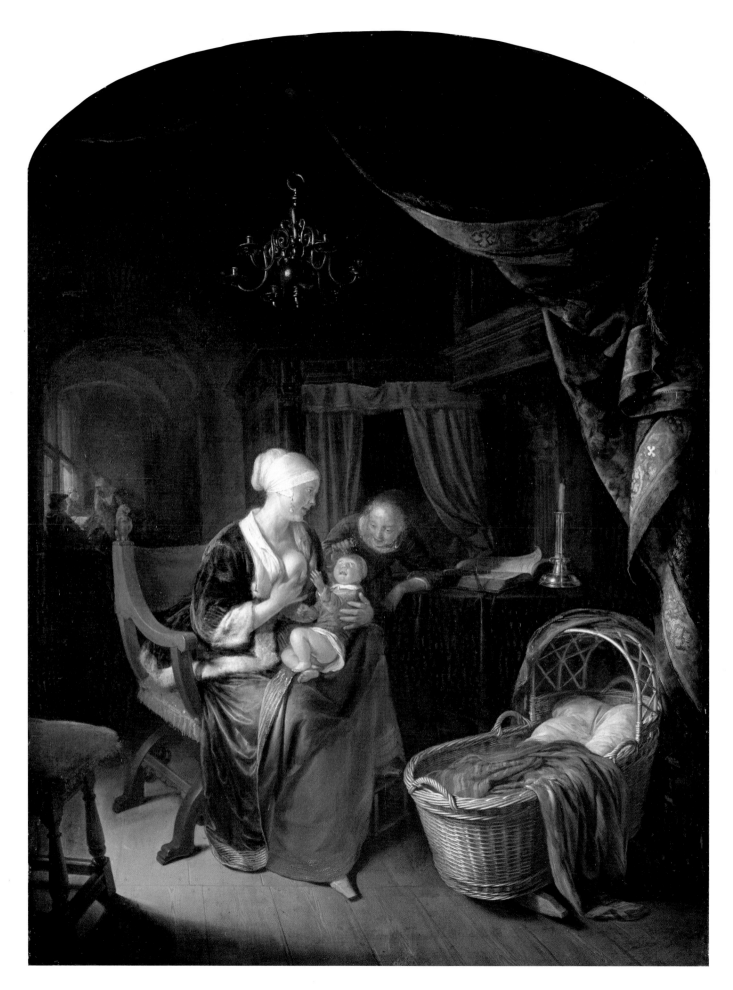

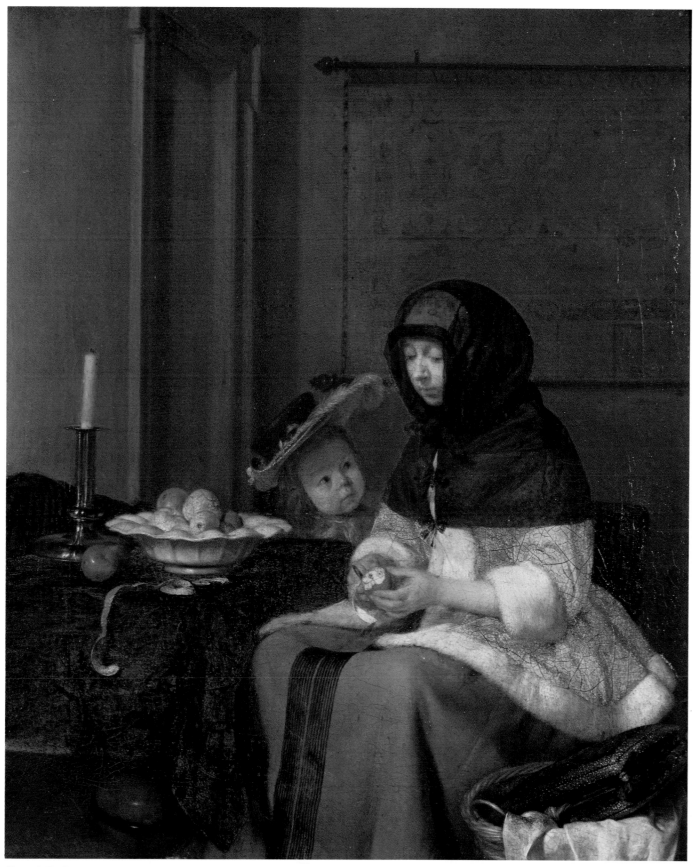

Gerard Terborch. *Woman peeling an Apple watched by a Child*, c. 1660. Canvas laid down on panel, 36 × 30.5 cm. Kunsthistorisches Museum, Vienna. [page 147]

OPPOSITE: Gerrit Dou. *The Young Mother*, c. 1655. Panel, 49.1 × 36.5 cm
Staatliche Museen Preussischer Kulturbesitz, Berlin-Dahlem [page 140]

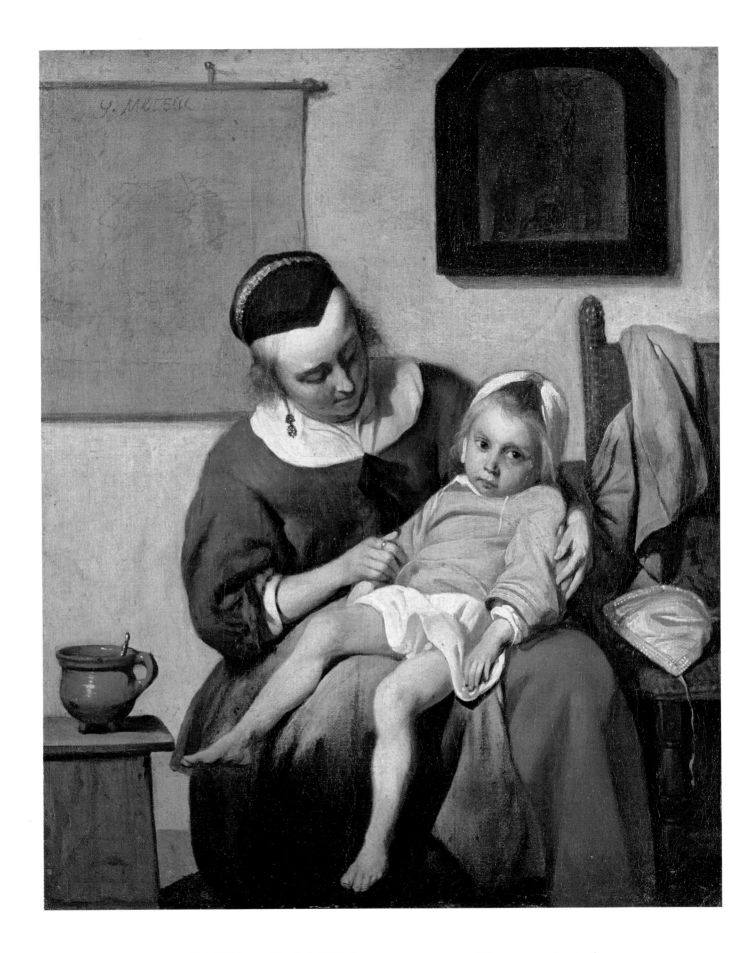

Gabriel Metsu. *The Sick Child*. Canvas, 32.2 × 27.2 cm. Rijksmuseum, Amsterdam
[page 147]

Pedlars, street musicians and beggars

The streets of Dutch towns were crammed with a variety of itinerants selling from their packs, playing musical instruments and begging. Vinckboons' *Blind Hurdy-Gurdy Player* [19] is an early example of a genre painter's response to these subjects. Adriaen van Ostade made a series of etchings of these street types, showing them sympathetically without being in any way patronizing in his treatment [129]. His pupil, Cornelis Dusart, whose closeness to Ostade's style has caused his own real value to be underestimated, also painted these subjects [112].

Jan Steen's street musicians, seen in a painting known as *The Serenade* (Prague, Narodni Galerie), are a good deal more exotic than Dusart's. These are not poor, itinerant musicians but extravagantly dressed and masked players, probably members of a local chamber of amateur players, the *rederijkers*. Steen's theatricality has been commented on before and, although he is not recorded as a member of one of these local amateur theatrical (literally, rhetoricians') troupes – unlike his follower Richard Brakenburgh, who was a member of the Haarlem chamber – he must had very close contact with them. He painted a number of scenes showing *rederijkers* reciting verses, usually unsteadily, under the influence of alcohol. In *The Serenade* the boy with his back to the viewer, who pulls the bell, has a sausage poking out of his pocket which identifies him as the buffoon *Hansworst*. Beside him a man plays a *bombas*, an extraordinary home-made instrument with an inflated pig's bladder as a sound box.

Beggars were attracted from all over northern Europe to Holland by its prosperity. They were to be found in every town and at fairs and festivals. The beggar family had been the subject of an engraving by Lucas van Leyden [129] as early as 1520: this print, because of the presence of the owl, has been thought to show Eulenspiegel from the German tale of *Till Eulenspiegel*, which was published in 1515. Recently, however, it has been argued that it actually illustrates a passage in Sebastian Brant's famous satire the *Ship of Fools* of 1494. Brant – and Lucas – were attacking the practice of false begging, which could be lucrative employment. The shell, the sudarium badge and the staff are marks of the fraudulent pilgrim, while the habit worn by the boy mocks the hypocrisy

Lucas van Leyden. *The Beggar's Family*, 1520. Engraving Rijksprentenkabinet, Rijksmuseum, Amsterdam [page 129]

Adriaen van Ostade. *The Pedlar*. Etching Rijksprentenkabinet, Rijksmuseum, Amsterdam [page 129]

Adriaen van de Venne.
All-arm, 1621. Panel,
37.5 × 30 cm
Rijksmuseum,
Amsterdam
[page 131]

of mendicant monks. The bagpipes, which here stand for foolishness, and the spoons, for licence, underline this sense of the print. It is remarkably close in spirit to an attack on begging by Martin Luther which appeared in the same year (1520): 'Probably one of our greatest needs is to abolish mendicancy everywhere in Christendom. No one living among Christians should go begging. ... No beggars in the street should be let into the house, whatever they call themselves, whether pilgrims, friars or members of mendicant orders... In my view, there is nowhere so much wickedness and deception as in mendicancy.' The debate about true and false begging continued during this century – for example, in the Haarlem humanist and print-maker Dirk Volckertsz. Coornhert's *Zedekunst* (*The Art of Morals*) of 1586 – and into the next.

In Dutch society beggars, especially those who roamed from town to town and therefore fell outside the largely parochial arrangements for public charity, were a sinister – and potentially anarchic – element. They fascinated, and at the same time terrified, respectable citizens

who encountered them in the streets and at fairs. Van de Venne in the *Tafereel van de Belaccherende Werelt* describes gangs of beggars and vagrants at the *kermis* in The Hague and then lists forty-two different categories of beggar – former soldiers, repentant whores, false lepers, escaped convicts, refugees from the war in Flanders, small-holders bankrupted by a failed harvest, and so on. They are all led by *Oud Roem-bout*, who is shown in all his ragged glory on van de Venne's title-page.

Adriaen van de Venne's painted account of beggars is savage. Reduced to utter destitution – the inscription on the grisaille is '*All-arm*' – they fight amongst themselves [130]. It is their hopelessness which van de Venne chooses to emphasize. By comparison, Dou's painting of 1654 at Aschaffenburg, which shows a beggar [131] wistfully eyeing a well-stocked vegetable and herring stall, is anecdotal, even sentimental, in its approach. In the background is the Blauwpoort at Leiden, which Dou also shows in his *Quack Doctor* [24].

Gerrit Dou. *The Beggar*, 1654. Panel, 46.7 × 59 cm
Gemäldegalerie, Aschaffenburg
[page 131]

4. Private and Domestic Life

I. LOVE AND COURTSHIP

Love between men and women has always been a preoccupation of the visual arts, whether acted out by mythological, historical, religious or contemporary characters. The Dutch painters of the seventeenth century were no exception, and the genre painters by preference took for their subjects the loves of contemporary men and women. There is little prudishness in seventeenth-century Dutch art and literature and many frank allusions to sexual love. Constantijn Huygens, secretary of the Prince of Orange, translator of the poetry of John Donne and sophisticated humanist, wrote in addition to many high-flown lyrics in French and Latin, a play in the vernacular, *Tryntje Cornelis* (1657), which, because of its frequent, detailed and coarse references to physical love, was suppressed from the canon

of his works and has only recently been performed in Holland for the first time since the author's lifetime. Jacob Cats, too, for all his high-mindedness, could make extremely crude puns. It is hardly surprising, therefore, that artists also make overt references to sex. Several examples – the *bordeeltje* and the themes of the Doctor's Visit and the Poultry-Seller – have already been discussed.

The essentially misogynist theme known as The Power of Women was particularly favoured by a number of sixteenth-century northern painters and print-makers. In their hands – Lucas Cranach the Younger and Lucas van Leyden both treated the theme often – the power wielded by women over men was seen in the guise of biblical subjects like Samson and Delilah or subjects from classical literature such as Aristotle and Phyllis. In Hendrick Sorgh's pair of paintings in the National Gallery the theme is the same but the language in which it is expressed could hardly be more

Hendrick Sorgh. *A Woman playing Cards with two Men*, 1644. Panel, 26.3 × 36.1 cm. A pair to the painting on the opposite page. Reproduced by courtesy of the Trustees, National Gallery, London [page 133]

132

different. In the first of these oval paintings, both dated 1644, a peasant on his way to market has gone into a tavern. His basket of eggs and his duck are beside him on the floor. He has started playing cards with an attractive young woman, who is scooping up his money: his foolishness in losing to this experienced card-sharp is mocked by the elderly man with the clay pipe who sits between them [132]. In the second painting a man is in a brothel, eating and drinking with a young girl, who looks out of the picture as if to invite our complicity in her triumph over him. At the door is the procuress who will make him pay dearly for the young woman's favours [133].

It is, however, a striking feature of Dutch genre painting that for the most part the relationship between the sexes is dealt with, not in terms of such stereotyped traditional themes, but rather in a far subtler and thoroughly contemporary language which is often profoundly moving. Judith Leyster, in a painting of 1631

in the Mauritshuis [2], shows a seamstress working late into the night by lamplight: she works long hours for a pittance and yet she virtuously ignores the man who offers her money for her love. The same moral dilemma, though the girl's virtue is less secure, is presented by Gerard Terborch [115] in a painting in the Louvre which has come to be known, presumably ironically, as *Le Galant Militaire*. Although we may wonder how the girl came to find herself in this predicament, this does not seem to be a conventional brothel scene. The effectiveness of the painting depends on the girl's indecision as she looks down at the coins in the soldier's hand.

In recent years narrative explanations of Dutch genre paintings have been ridiculed or dismissed and certainly nineteenth-century writers – Goethe's sentimental account of Terborch's so-called *L'Instruction Paternelle* in the *Wahlverwandschaften* is a well-known example – did misinterpret particular pictures. It

Hendrick Sorgh. *A Man and a Woman at a Table*, 1644. Panel, 26.4 × 36.4 cm.
Reproduced by courtesy of the Trustees, National Gallery, London
[page 133]

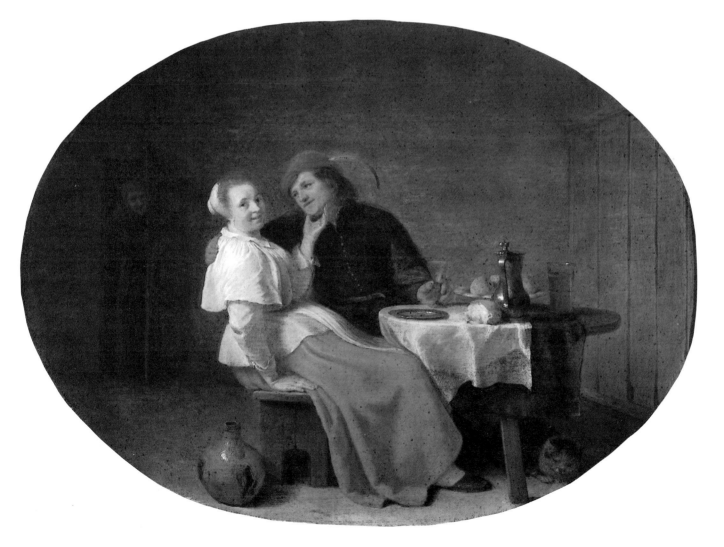

133

must be remembered, however, that the creation of an intriguing human situation, the devising of a credible narrative, was, as nineteenth-century genre painters knew, an important part of the art of their seventeenth-century predecessors. In order to comprehend these situations and follow the sequence of the narratives, no special reference to contemporary ideas or literature is called for. In Pieter de Hooch's *A Girl Drinking with Two Men* (Paris, Louvre) [116] of 1658, the standing man fills the girl's glass – not, it seems, for the first time. An older woman looks on anxiously. The subject of the painting is certainly seduction with the assistance of alcohol but this is hardly a brothel scene and it would be wrong to relate the older woman to the 'procuress' tradition. What De Hooch presents is a human drama which has been deliberately contrived in order to intrigue the viewer.

In Frans van Mieris' *The Oyster Meal* of 1661 (Mauritshuis, The Hague) there is no room for any ambiguity about the situation, nor any doubt about the sequel. The leering older man is seducing the compliant girl with wine and oysters, which were well known in the seventeenth century as aphrodisiacs and the object of much heavy-handed, rib-nudging humour. The couple's destination is the curtained bed behind them [117].

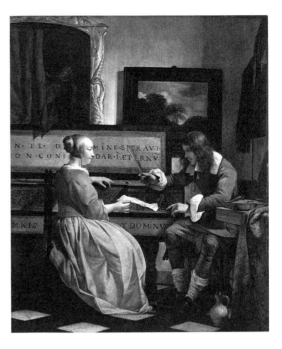

Music and love

The amorous possibilities of music and its role in courtship have long been recognized in painting. A theme previously treated in mythological form – as in Titian's *Venus and a Lute-player*, for example – was dealt with by Dutch genre painters in the context of contemporary life. The metaphor of love as a harmonious duet was particularly popular: in Jan Molenaer's *Young Man playing a Theorbo and Young Woman playing a Cittern* (London, National Gallery) [134] the duet stands for the couple's mutual love – as it had done, for example, in an illustration in a songbook of 1613 entitled *Cupidos Lusthof* (*Cupid's Pleasure-Garden*). In the background of Jan Steen's *Young Woman playing a Harpsicord to a Young Man* (London, National Gallery), which was probably painted in 1659, a boy brings a theorbo for the young man to provide an accompaniment [135]. In this context the proverb '*Acta Virum Probant*' ('Actions prove the man') inscribed on the harpsicord serves as an amusingly ironic commentary on the scene. This device – of a commentary on the scene in the form of an inscription on an instrument – is also used by Gabriel Metsu in his *Man and Woman seated at a Virginal* (National Gallery, London) [134]. The young woman hands the man a sheet of music so that he can take up the violin and join her in a duet: he is keener to press a glass of wine upon her. The inscription

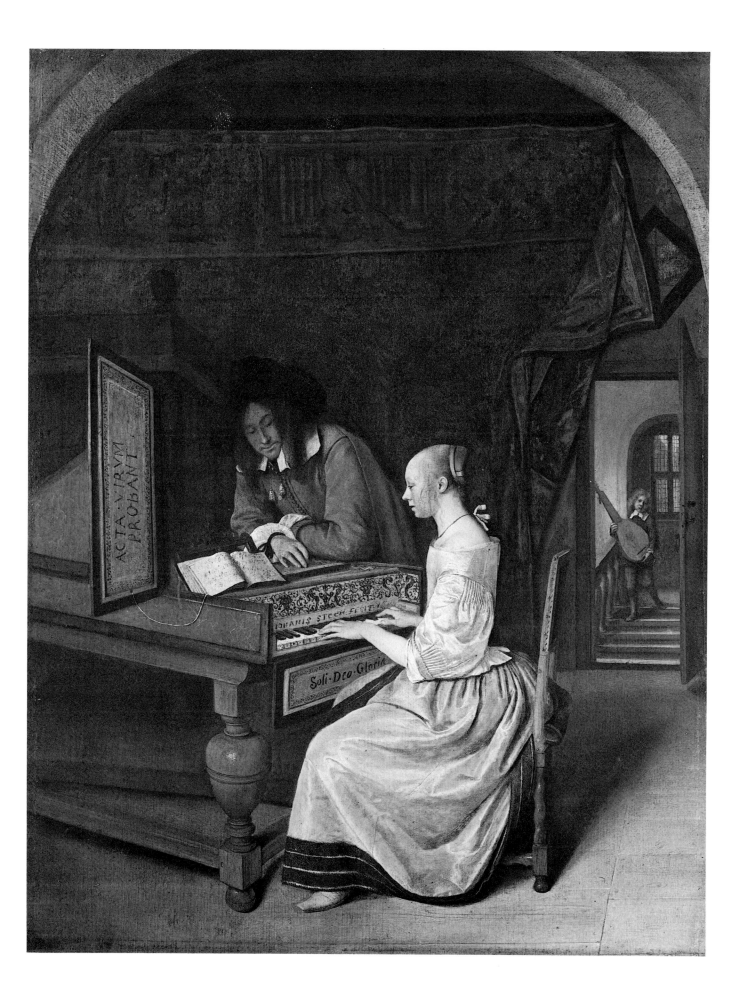

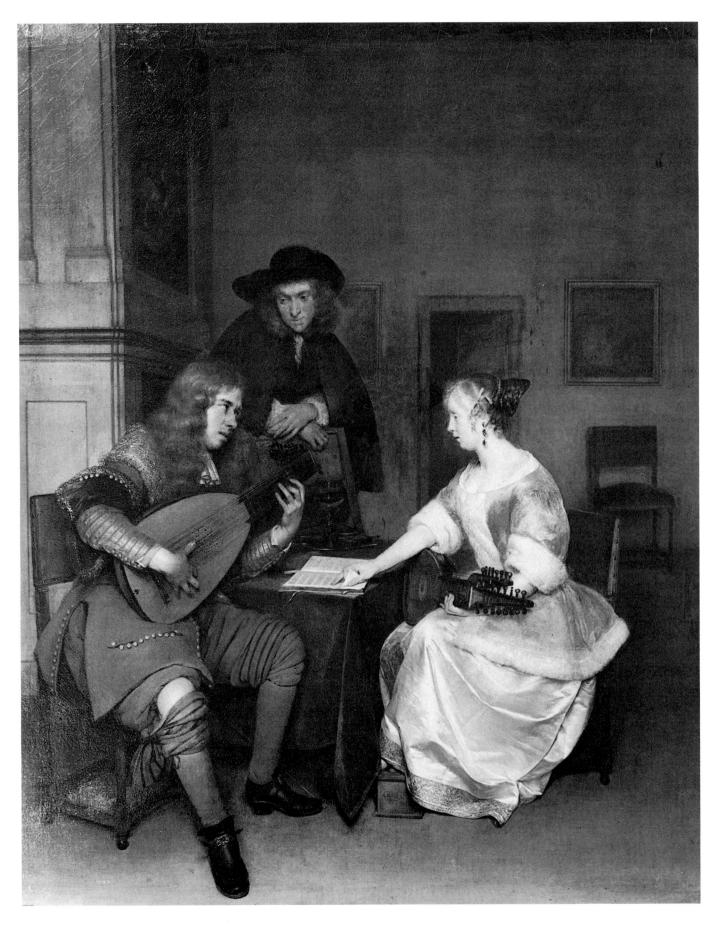

Gerard Terborch. *The Concert*, 1675. Canvas, 78.5 × 66 cm.
The National Trust, Waddesdon Manor, Buckinghamshire. [page 137]

on the virginal, which is of the type made by the famous Andries Rucker of Antwerp, is given a sardonic twist by the couple's flirtation: 'In thee Lord do I put my trust; let me never be ashamed.' (Hanging on the back wall at the left in an auricular gold frame, partially covered by a curtain, is *The Twelfth Night Feast*, an early work by Metsu which today is in the Alte Pinakothek, Munich.)

A related idea is that of the single musician who looks out at the viewer inviting him to pick up the other instrument in the room and join in a duet; as has already been discussed, this notion can be related to an emblem devised by Cats. This is the sense of Dou's *Lady playing a Clavicord* (Dulwich College Picture Gallery), in which a viola da gamba is ready in the foreground to be played by the lady's lover [118]. The wine in the glass and in the cooler are also his to enjoy, and here the prominent birdcage may well stand for the 'sweet slavery' of love. This picture, painted in about 1655, is likely to have been the inspiration for Vermeer's *Young Woman seated at a Virginal* of about fifteen years later [27].

Metsu's *Musical Party* of 1659 (New York, Metropolitan Museum) is distinctly unrestrained in mood. The cellist's swordbelt has been casually tossed aside, books litter the floor and the table, the lady has an unsteady grasp on the neck of her lute and a maidservant brings more wine; nor can there be any mistaking the flirtatiousness of the glance with which the woman passes the music to the richly-dressed man standing behind her [119]. The glance of Terborch's lute-player in his *Lute-player and an Officer* (New York, Metropolitan Museum) is no less explicit. She accompanies the man as he sings from the book which lies on the table; also on the table, suggesting that the time they have to be together is short, is a silver watch [120]. Terborch's couple in *The Concert* (Waddesdon Manor, National Trust), painted in 1675, play a lute duet and as the girl turns the page her eye meets the man's ardent glance. Their music teacher, dressed in the scholar's traditional dark hat and cloak, misses the undercurrent of flirtation, so intent is he on the position of the young man's fingers on the fret [136].

The finest Dutch treatment of the theme of music and love is Vermeer's *The Music Lesson* (London, Royal Collection), painted in around 1663. The man has been thought to be the woman's teacher but in view of the inclusion of a bass viol and a wine jug in the foreground, it is more likely that he is her lover and that her tentative glance toward him – which we can see in the mirror – is one of affection. The subject of the painting hanging on the back wall, less than half visible, is Roman Charity, which shows Pero suckling her aged father Cimon; its inclusion introduces, however obliquely, a distinctly erotic element into the scene. Vermeer's picture, with the infinitely subtle balance of the formal elements of the composition, is one of the very greatest achievements of Dutch genre painting. The low angle of vision, the enclosing grid of roof beams above and tiles below, the delicate modulation of light throwing shadows onto the back wall, the importance accorded to the intricate pattern of the rich Turkish carpet, the visually teasing element of the mirror – all reveal the artist's precise, painstaking and severely intellectual approach [121].

Letter-writing

In the highly literate society of the Dutch Republic letter-writing was, geographically and socially, a widespread activity and the postal service was often praised as the best in Europe. For those letter-writers whom inspiration deserted there were manuals to help them chose the appropriate tone and phrase. The most popular was Jean Puget de la Serre's *Le Secretaire à la Mode*, constantly reprinted in Amsterdam after its first appearance in 1643, and translated into Dutch – as *Fatsoenlicke Zend-Brief-schryver* – in 1651. It is largely devoted to the composition of formal, but not extravagantly phrased, love letters: for example, a man writes to a lady that he has missed her sorely since he saw her last and she replies that she longs to meet him again but is restrained from doing so by her parents. Again, a man praises a woman's beauty and she replies modestly, but giving him significant encouragement. It is clear from de la Serre's manual that in such tentative exchanges a wealth of meaning turns on nuances of wording. In Krul's play *Toneel spel van Rozemond* (*Pampiere*

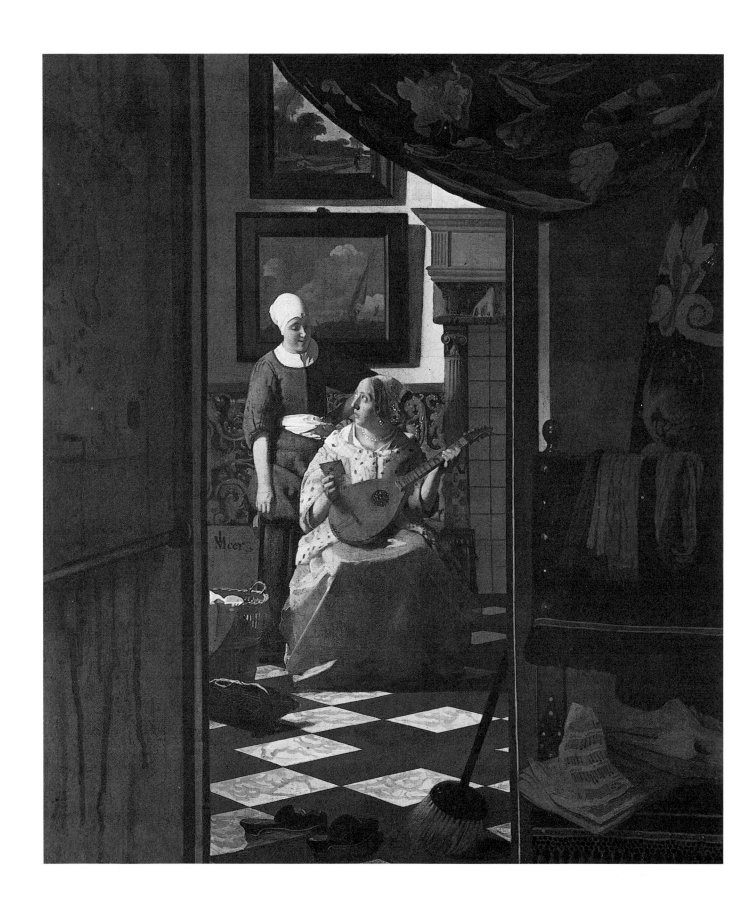

Jan Vermeer. *The Letter*, c. 1667. Canvas, 44 × 38.5 cm. Rijksmuseum, Amsterdam.
[page 140]

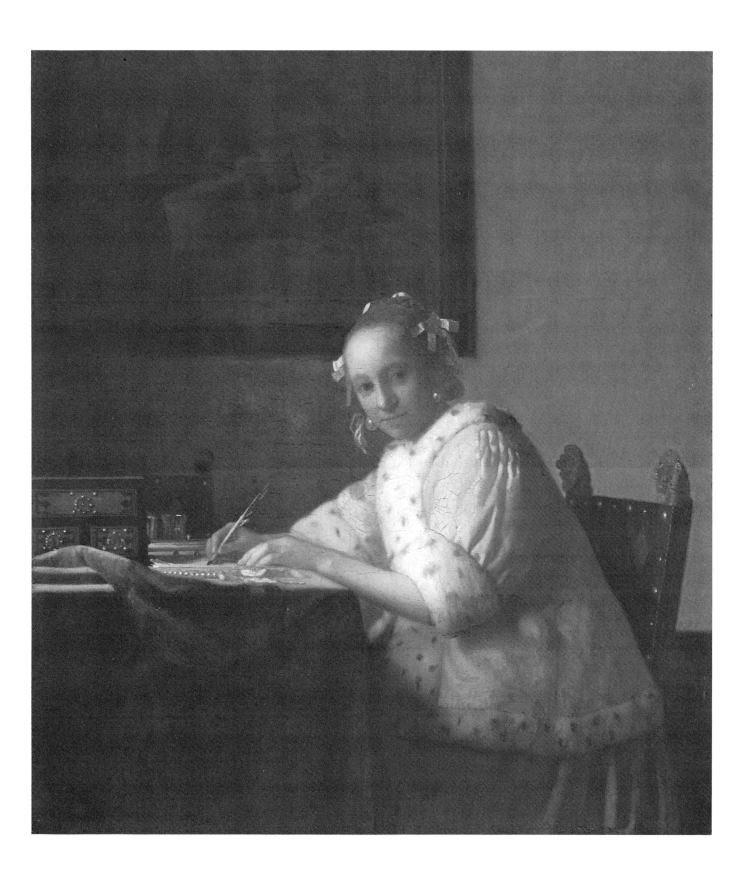

Jan Vermeer. *Woman writing a Letter*, c. 1666. Canvas, 47 × 36.8 cm National Gallery of Art,
Washington. Gift of Harry Waldron Havemeyer and Horace Havemeyer Jr., in memory of their father,
Horace Havemeyer 1962
[page 140]

Wereld, part 3, Amsterdam, 1644), the hero Rozemond tells Cupid of the difficulties he experiences in expressing his feelings towards his beloved in a letter: he is torn between the desire to write to her and torturing jealousy.

In the context of Dutch genre painting, letter-writing is often associated with love. This can be seen in a pair of paintings by Gabriel Metsu in the Beit Foundation at Russborough. In the left-hand painting, a young man is seated by a window writing a letter [122] and in the right-hand one its recipient, a young woman, holds it to the window to read [123]. Metsu has constructed an amorous narrative: the theme of love is underlined by the action of the woman's maid, who pulls aside the curtain to reveal a painting of a seascape. It immediately suggests the metaphor of love being as hazardous as a journey at sea, and the idea can be found in an emblem devised by Krul. In his *Minne-Beelden* he shows a Cupid at the rudder of a boat taking a lover towards his mistress. The motto is '*Al zijt ghy vert, noyt uyt het Hert*' ('Although you may be far away, you are always in my heart').

The same juxtaposition of letter and seascape recurs in Vermeer's *The Letter* [138] in the Rijksmuseum, and we may assume that here too the letter which the maid has handed to her lute-playing mistress is a love letter. Vermeer and Terborch both often treated the subjects of writing and receiving letters. They showed a young woman writing a letter in two closely related compositions: Vermeer's painting (*c.* 1665), is in Washington [139] and Terborch's (1655) is in The Hague. The striking difference is that while Terborch's letter-writer is absorbed in her task and the viewer has a sense of having intruded, Vermeer's has paused and looks out at the viewer, almost as if asking for his help. In Terborch's picture it is as if we have stumbled accidentally into the room, whereas in Vermeer's we are invited to share the writer's difficulty in arriving at exactly the right phrase. The comparison of the two artists' techniques and palettes is endlessly fascinating: Terborch is far more linear and descriptive while Vermeer's remarkable effects depend on the light catching the ribbons in the woman's hair and the lemon-yellow of her fur-trimmed jacket.

Vermeer's painting (from about 1657) of a girl reading a letter at an open window (Dresden, Gemäldegalerie) is in his early 'grainy' style in which light is almost palpably described in dabs of pure pigment. The *trompe-l'œil* curtain and the foreground still-life are self-consciously virtuoso elements which have the effect of excluding the viewer from the subject – the utter absorption of the reading girl, whose face is teasingly reflected in the glass of the window [124].

Terborch a few years later (around 1660) constructed a domestic narrative on the subject of letter-writing. In *The Letter* (London, Royal Collection) the attention of the young servant who, in this distinctly upper-class Dutch household, is removing the elegant basin and ewer, has been caught by the words read out by the standing woman. The letter has just been written by the seated woman, perhaps her sister. It may well be a reply to a suitor: has she been immodest or over-enthusiastic? Unsure, she has asked the other woman to read the letter. The velvet of the foreground chair on which the dog sleeps, the satin of the reading girl's dress, the basin and ewer, the brass candelabra – these, in one sense, are Terborch's real subject and the delicately judged exchange between the two women simply provides its *raison d'être* [125].

II. WOMEN AND THE HOME

Dutch society, as has already been discussed, laid great stress on the importance of family life and the home. Dutch genre painters show every aspect of the life of the wife and mother in the home, the nursing and instruction of children as well as the performance of each and every household task. In one of his most accomplished paintings, Dou shows a young mother breastfeeding her child, who is distracted by an older child waving a rattle – an image of motherhood so highly esteemed by his contemporaries that it was included amongst the carefully chosen paintings presented by the States of Holland to Charles II on his Restoration [126]. Samuel van Hoogstraten had precious little of Dou's immaculate technique but there is in his painting of 1670 in the Museum of Fine Arts at Springfield,

Samuel van Hoogstraten. *Mother with Child in a Cradle*, 1670. Canvas, 104.1 × 96.5 cm
Museum of Art, Springfield, Massachusetts [page 140]

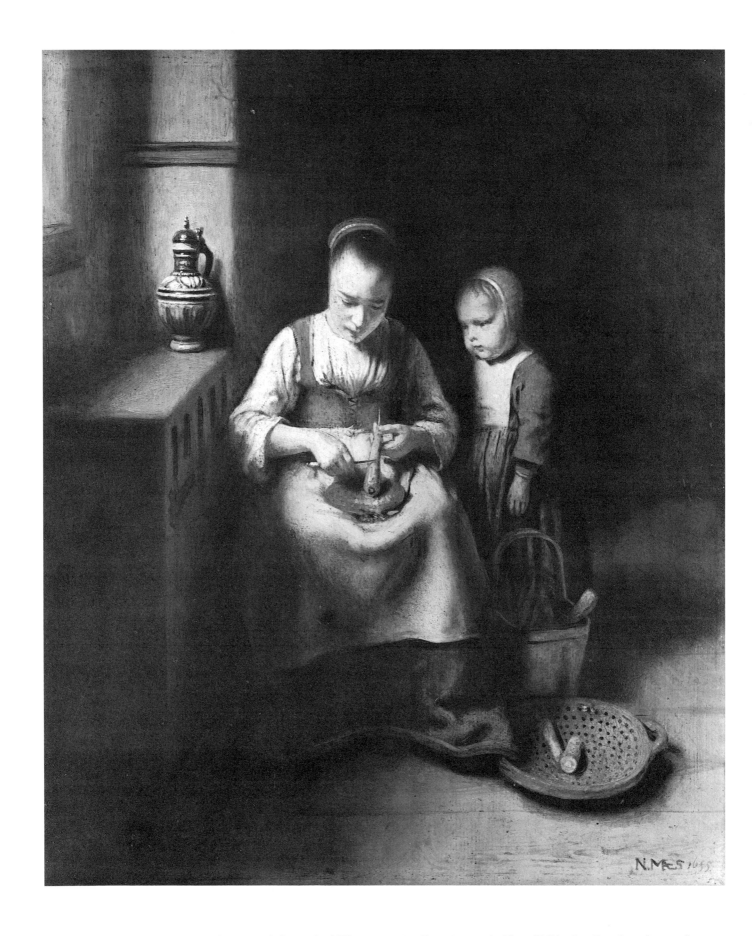

Nicolaes Maes (1634–93). *A Woman scraping Parsnips watched by a Child*, 1655. Panel, 35.6 × 29.8 cm
Reproduced by courtesy of the Trustees, National Gallery, London
[page 147]

142

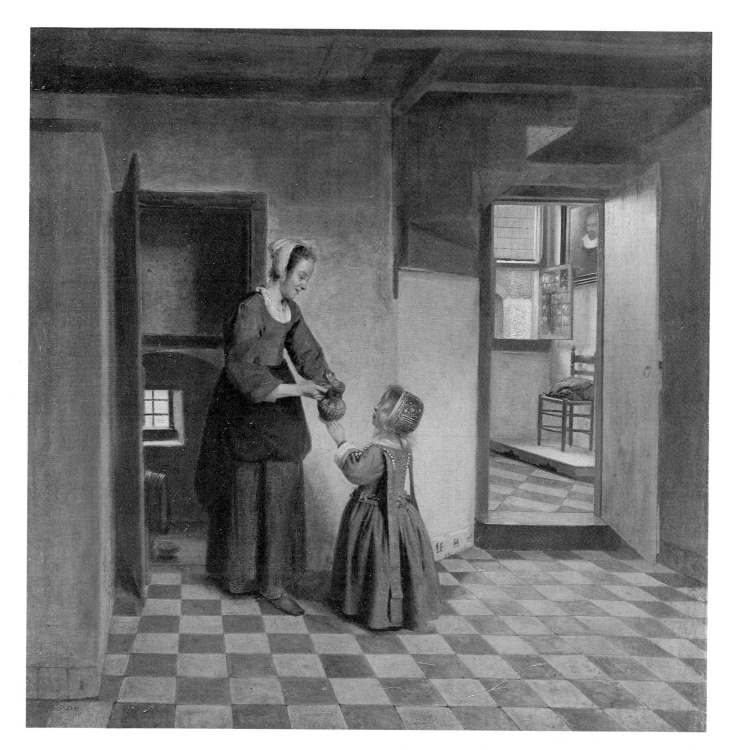

Massachusetts, a degree of sympathetic under-standing in the tentativeness with which the two women peer into the cradle that saves the painting from sentimentality [141].

Calvinist preachers urged parents to beat sin and idleness out of their offspring, but the home was a place for instruction as well as dis-cipline. The mother played a large part in the instruction of her children before they were old enough to be sent to school; and the duty of the mother to care for the education – and the appearance – of her children was stressed by Jacob Cats: '*Leer, jonge moeder, leer, oocke van de minste dieren, | Het Kinder onverstaat naer goede seden stieren; | Niet dat'er eenigh man in vrouwen hooger prijst, | Als dat haer rijpe sorg de kinders onderwijst.*' ('Learn, young mother, learn, even from the humblest animals, | Learn to steer the ignorance of children in the direction of good morals; | There is nothing that any man values more highly in a woman | Than her mature care in teaching children.') When Dutch painters show a mother instruct-

Pieter de Hooch. *Woman with a Child in a Pantry*, c. 1660. Canvas, 65 × 60.5 cm Rijksmuseum, Amsterdam [page 147]

143

Pieter de Hooch. *A Boy handing a Basket to a Woman in a Doorway*, c. 1658. Canvas, 73.7 × 60.2 cm
Reproduced by courtesy of the Trustees, The Wallace Collection, London. [page 147]

144

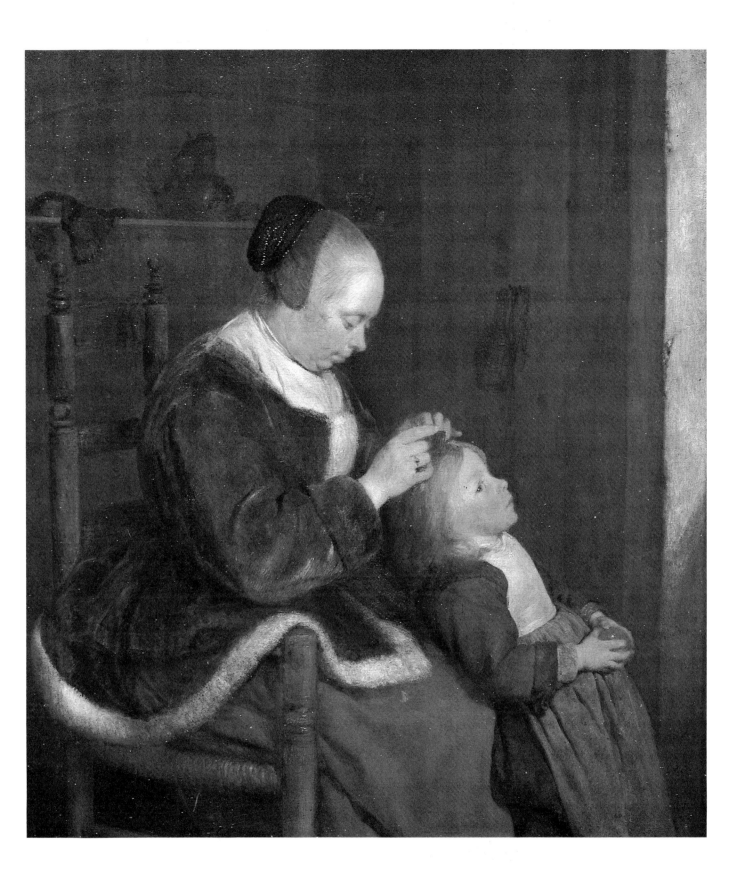

Gerard Terborch. *A Woman combing the Hair of her Child* ('Maternal Care'), c. 1650. Panel, 33.5 × 29 cm
Mauritshuis, The Hague. [page 147]

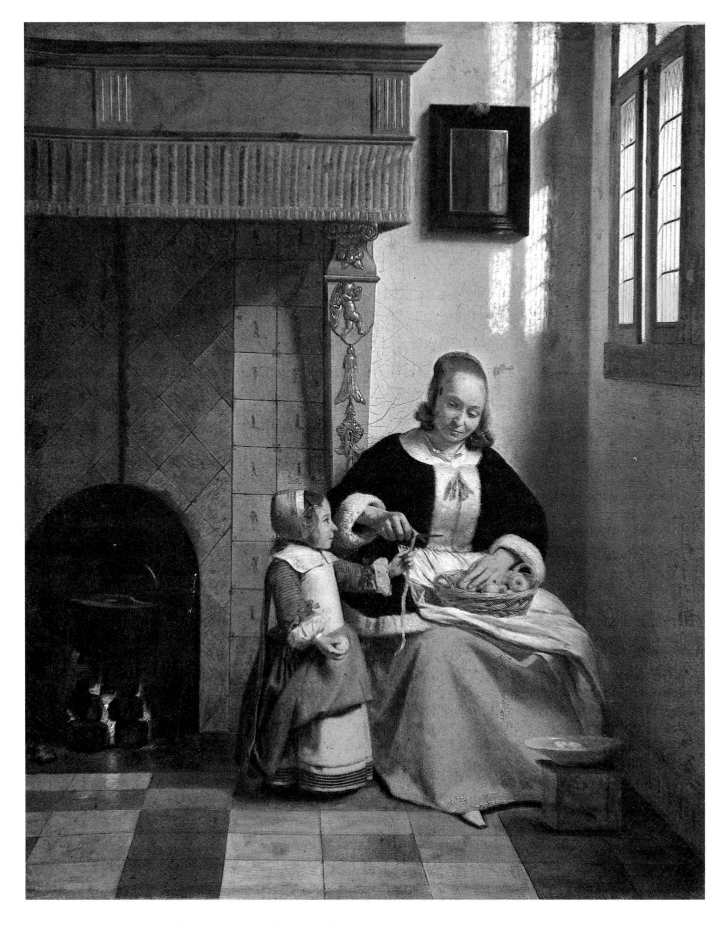

Pieter de Hooch. *A Woman peeling Apples*, c. 1660. Canvas, 70.5 × 54.3 cm. Reproduced by courtesy of the Trustees, The Wallace Collection, London. [page 149]

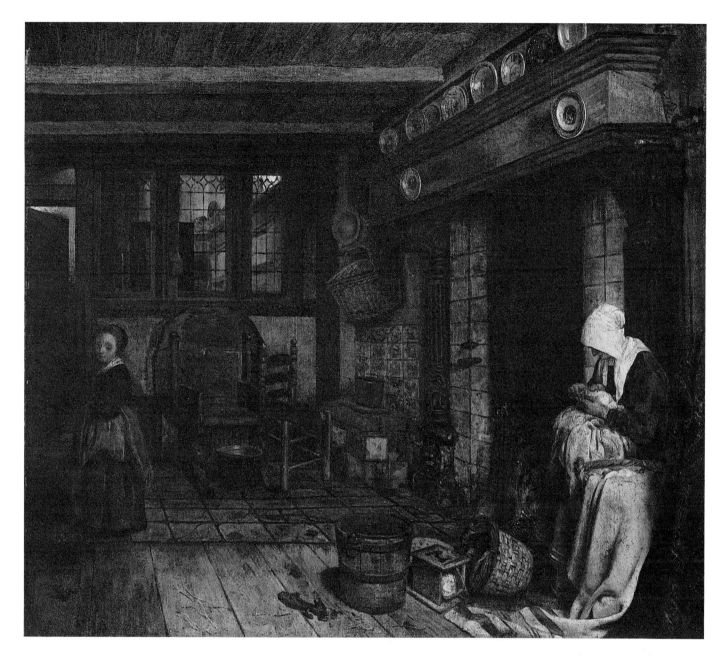

ing her children they mean to convey this sense of a maternal duty being fulfilled. The best method of instruction is by example, and in Gerard Terborch's *Woman peeling an Apple watched by a Child* (Vienna, Kunsthistorisches Museum) the child is learning to perform a simple domestic task by watching her mother [127]. Nicolaes Maes illustrates a similar scene in his *Woman scraping Parsnips with a Child standing beside her* (National Gallery, London), although here it appears to be a housemaid who is the object of the child's fascinated attention [142].

In a painting in the Rijksmuseum, de Hooch shows a child being handed a jug from the pantry by her mother [143] and in another (Wal-

lace Collection, London) a son dutifully carries a basket for his mother [144]. Both are examples of the proper behaviour of young children in the home. Mothers also had the responsibility of caring for their children's appearance and one of the most familiar, as well as the most effective, images of maternal care is that of the mother searching her child's hair for fleas: it is shown, for example, by Terborch in a painting in the Mauritshuis [145]. Yet perhaps the single most moving image of maternal love painted in Holland in the seventeenth century is Metsu's *The Sick Child* (Rijksmuseum), which in its depiction of the mother's tender care has strong and profoundly moving echoes of the subject of the Virgin and Child [128].

Esaias Boursse (1631–72). *A Woman Sewing.* Canvas, 52 × 59 cm Staatliche Museen Preussischer Kulturbesitz, Berlin-Dahlem [page 149]

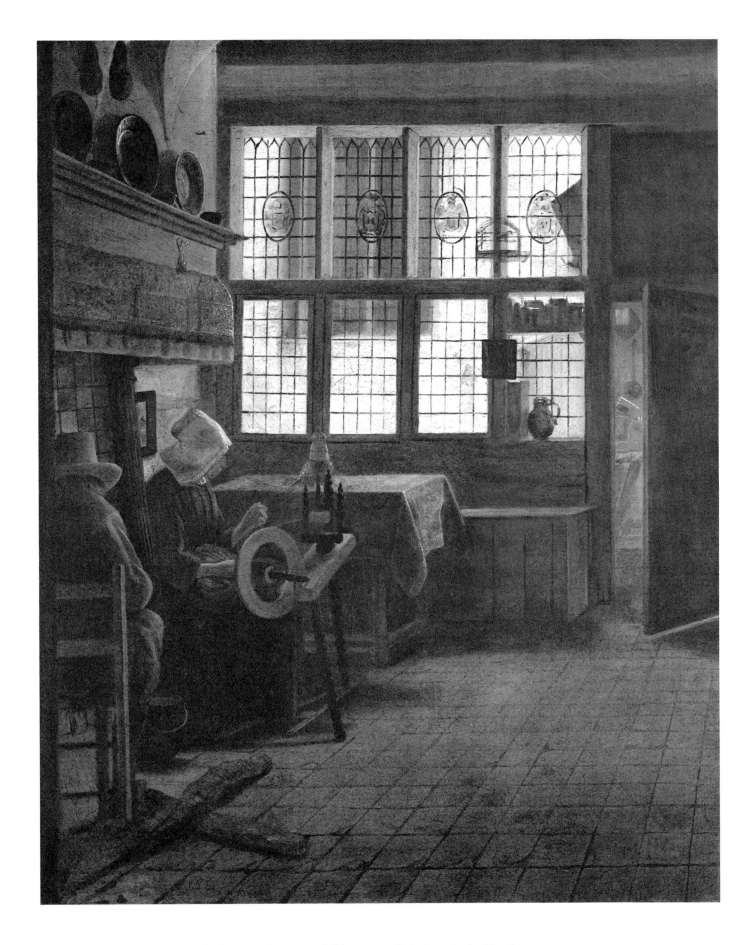

Esaias Boursse. *Interior with Woman at a Spinning-wheel*, 1661. Canvas, 60 × 49 cm
Rijksmuseum, Amsterdam. [page 149]

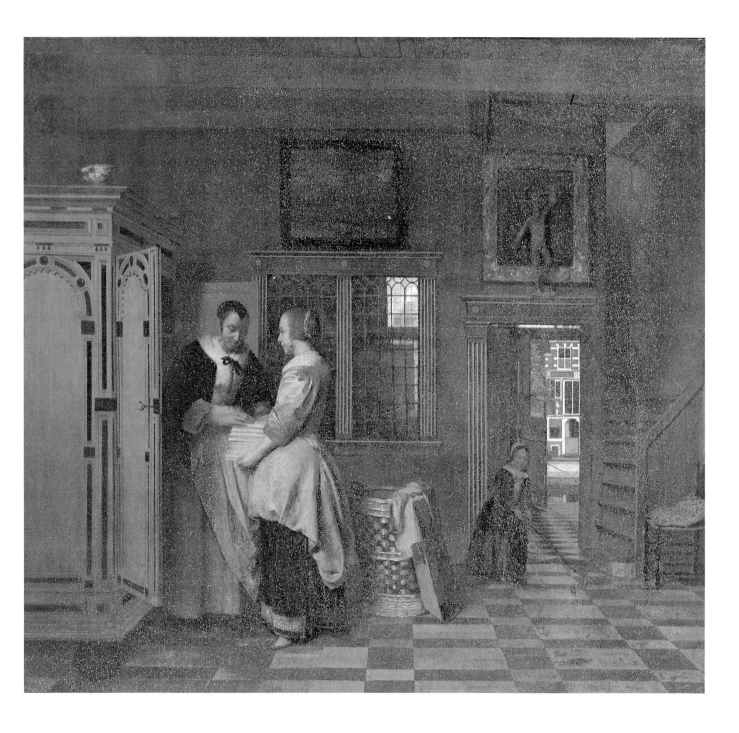

The housewife's daily tasks about the house provided a rich diversity of subjects for genre painters. Pieter de Hooch shows a woman preparing fruit [146]; van Roestraten in 1678 shows a housewife making pancakes [161]; Jacob Duck depicts a woman ironing [162]; Esaias Boursse shows a woman sewing [147], and another spinning [148]. In a picture of 1663, after he had moved from Delft to Amsterdam, de Hooch painted a well-appointed interior, complete with classical statuette, paintings and pilastered windows and doorway, in which a woman and her maid take clean linen from an ornate, inlaid chest. Behind them a child plays with a curved *kolf* stick [149].

It was not only the housewife who was observed in the home by the genre painter. One of Vermeer's most effective compositions, *The Milkmaid* (Rijksmuseum), endows the girl's simple, graceful movement with a monumental quality. Her action appears almost sacramental: she might be performing a secular mass, an impression which evokes rich parallels between genre painting and religious art [163].

Pieter de Hooch. *The Linen Chest*, 1663. Canvas, 72 × 77.5 cm Rijksmuseum, Amsterdam [page 147]

149

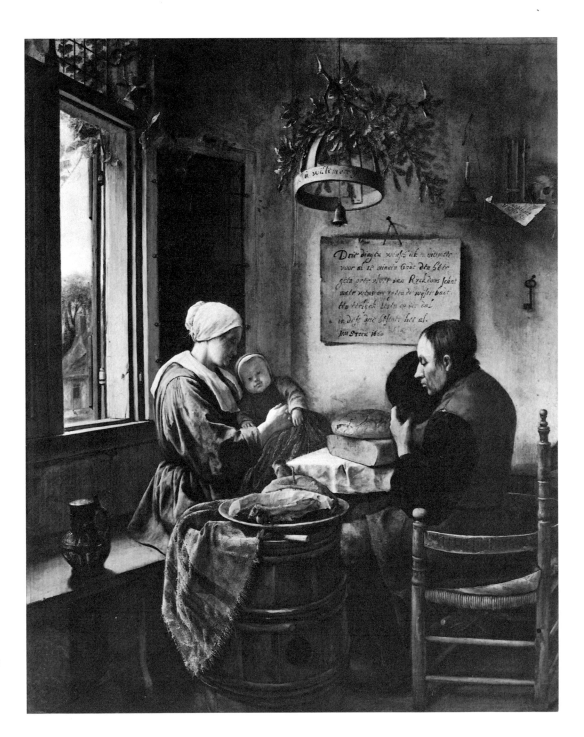

Grace before meat

The theme of Grace before Meat, a genuinely religious subject in a domestic setting, has already been discussed in the Introduction. It shows the family gathered around the dinner table with the father saying grace, and is an image of Christian piety, an expression of thankfulness to the Creator for His provision of even the humblest meal. In a painting of this subject by Jan Steen (private collection) of 1660 [150], the prayer itself is shown on a placard which hangs on the wall behind the

family. It reads: '*Drie dingen wensch ick en niet meer | voor al te minnen Godt den heer | geen overvloet van Ryckdoms schat | maer wens om tegen de wyste badt. | Een eerlyck leven op dit dal | in dese drie bestaet het al.*' ('Three things alone I wish for and no more: | Above all to love God the Father, | Not to covet an abundance of riches | But to desire what the wise pray for, | To live an honest life. | In these three everything is contained.') Steen enriches the sense of the painting by including references to other themes which have been explored elsewhere in this book. The wooden crown (*belkroon*)

Cornelis Bega. *Grace
before Meat*, 1663.
Canvas, 37.5 × 30 cm.
Rijksmuseum,
Amsterdam.
[page 151]

hanging from the ceiling which contains a bell
and is topped by oak leaves refers to the sancti-
ty of marriage: it hung above the bride during
the wedding feast. It carries an inscription
which tells of the family's allegiance to the
House of Orange, and on the shelf at the back –
underlying the sense of this painting, as of all
genre paintings – are the *vanitas* symbols of
candle and skull, as well as a single book which
must be the family Bible.

The extraordinary effectiveness of Steen's
simple, devout image and the utter appropri-
ateness of his broad, even rough, handling can
be seen when his painting is compared with
Cornelis Bega's treatment of the same subject
three years later in a canvas in the Rijksmu-
seum [151]. Beside the Steen, Bega's *Grace be-
fore Meat*, despite its technical control, seems
contrived and sentimental, with none of the
powerful truth of Steen's image.

III. CHILDREN AT SCHOOL AND AT PLAY

School

The proper upbringing of children was a matter of great and constant concern for the Dutch, and a favourite theme among genre painters. In a painting in the Rijksmuseum Dou shows children at a night school: the elderly teacher helps a girl with her reading while a boy nervously waits his turn [164]. Dou's choice of a schoolroom shown in the evening or perhaps early on a winter morning – in 1600 school began at six in the morning in summer and seven in winter and finished at seven in the evening – allows him to paint 'lamps and burning candles', his skill at the representation of which Hoogstraten and others so admired. In more abstract terms they suggest the 'lamp of understanding' passed from teacher to pupil. Dou also includes the scene of a night school on the left wing of his famous triptych, *The Lying-in Room*, which in the eighteenth century was the greatest treasure of the remarkable collection formed by Gerrit Braamcamp in Amsterdam. It was bought from him in 1771 by the Empress Catherine the Great, lost in a shipwreck on its way to Russia, and is known today only in a copy made for Braamcamp, now in the Rijksmuseum. Emmens has brilliantly interpreted the painting as a visual representation, in the deliberately archaic triptych form, of the notion of the three stages of learning devised by Aristotle: nature (which Dou illustrates by the mother feeding her child); training (the night school); and practice (the man sharpening his pen). If we consider Dou's single painting of a night school in the context of the triptych, it too can be seen to stand for training in a general sense as well as the instruction of children in a particular one [165].

Jan Steen takes a far less serious view of schooling. His painting of *The Schoolmaster* [153] is in the satirical tradition of Pieter Bruegel's print *The Ass at School* [153] which illustrates a popular saying: 'Though an ass goes to school in order to learn, he'll still be an ass, not a horse, when he returns.' In Steen's school there is little to be learnt from the short-sighted teacher who is so intent on sharpening his quill that he fails to notice the chaos all around him. Some of the children who wish to learn have gathered around the schoolmistress who corrects their spelling but others fight, sing, make fun of the teachers and even sleep. On the right is the owl, the familiar symbol of foolishness in Steen's work, being handed a pair of glasses by a child.

Adriaen van Ostade's *The Schoolmaster* (Louvre, Paris), painted in 1662, is a convincingly truthful view of a rural common school, of the type about which complaints were often made [168]. Wooden spoon in hand, the master is a brutal disciplinarian, a believer, we may surmise, in the view of the appropriately named theologian Batty who held that the providence and wisdom of God had formed the human buttocks so that they could be severely beaten without causing serious injury. He is testing a cowed boy while two more children wait alongside. Elsewhere in the schoolroom the children are writing their letters on the slates, although one boy at the back looks idly out of the window and another, at the top of the stairs, has been despatched to fetch a basket.

Play

In Netherlandish art the play of children had long been treated as an allegory of adult life. This is implicit in Bruegel's *Children's Games* of 1560 [154]. The children, who range in age from toddlers to adolescents, roll hoops, walk on stilts, spin tops, ride hobby-horses, stage mock tournaments, inflate pigs' bladders and play with dolls and other toys. They have also taken over the large building which dominates the square: it is the town hall and in this way Bruegel makes the point that the adults who direct civic affairs are as children in the sight of God. Eighty individual games have been identified but Bruegel is not simply compiling a visual encyclopaedia of games. He shows the children absorbed in their play with a seriousness displayed by adults in their apparently more important pursuits. It was an idea also familiar in contemporary literature: in an anonymous Flemish poem published in Antwerp in 1530 by Jan van Doesborch, mankind is compared to children absorbed in their foolish games rather than giving proper thought to the service of God. This notion is encountered

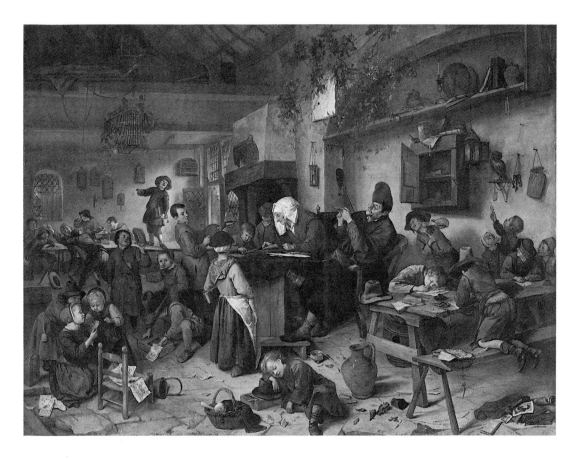

Jan Steen. *The Schoolmaster*. Canvas, 83.8 × 109.2 cm National Gallery of Scotland, Edinburgh [page 152]

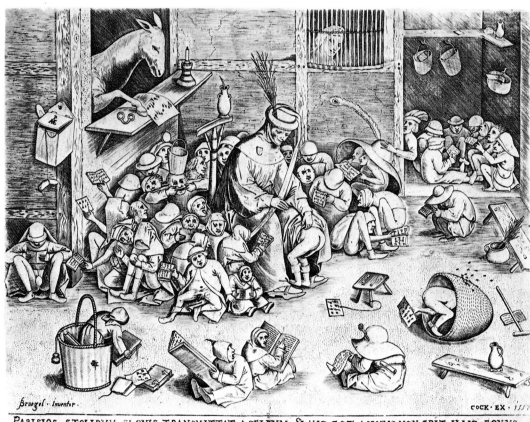

After Pieter Bruegel the Elder. *The Ass at School*. Engraving, 1557, engraved by Pieter van der Heyden Rijksprentenkabinet, Rijksmuseum, Amsterdam [page 152]

Bruegel · Inventor ·

COCK · EX · 1557

PARISIOS STOLIDVM SI QVIS TRANSMITTAT ASELLVM · SI HIC EST ASINVS NON ERIT ILLIC EQVVS ·
Al reÿst den esele ter scholen om leeren ist eenen esele hÿ en sal gheen peert weder keeren

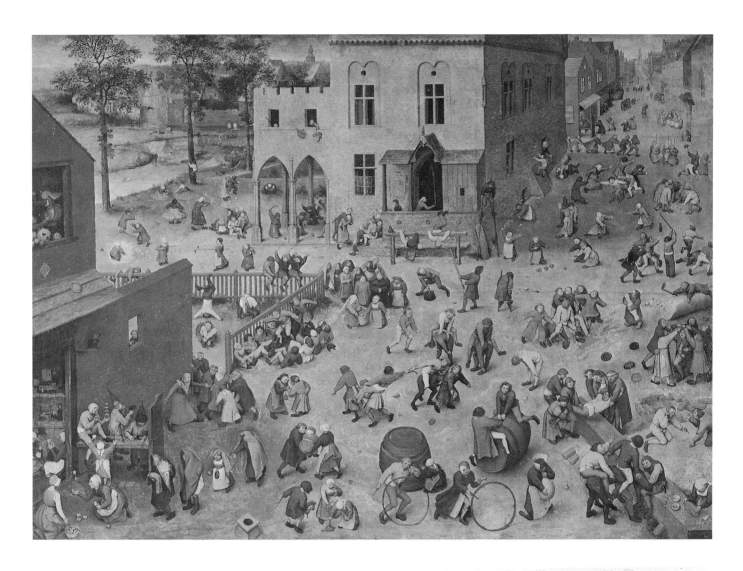

Pieter Bruegel the Elder.
Children's Games, 1560.
Panel, 118 × 161 cm
Kunsthistorisches
Museum, Vienna
[page 152]

After Adriaen van de
Venne. Illustration to
Jacob Cats, *Silenus
Alcibiadis, sive Proteus*,
Amsterdam, 1615
[page 155]

early in the seventeenth century in a section of Jacob Cats' *Silenus Alcibiadis, sive Proteus*, published in Amsterdam in 1622. The appropriate illustration was designed by Adriaen van de Venne and is evidently based on Bruegel's composition: it shows children playing a variety of games against a backdrop of the abbey at Middelburg [154]. The plate is grandiloquently entitled '*Kinder spel gheduijdet tot Sinnebeelden ende Leere der Seden*' ('Children's play shown as images of the spirit and lessons of morals'). In his text Cats interprets each game emblematically, as an illustration of adult folly.

A French visitor to the Netherlands in the late seventeenth century recorded a huge number of children's games which he had observed: '*jouer à la grande boule, à la mouche, pour des chiquemauldes, au palet, des claquettes, des osseletz, à la croce, aux dets (ung ieu defendu), aux tablettes, à pair ou non, aux dames, aux noix, du pot casse, gagner à iecter la pierre*' and so on ('bowls, I spy, flick-fingers, hunt-the-slipper, quoits, clappers, knucklebones, little wind-mill, prisoners' base, slabs, equal-or-not, conkers, marbles and hey-cockalorum').

The delightful pair of paintings by Dirk Hals (Clark Institute, Williamstown) from 1631 mimic adult behaviour on a far less serious level than Bruegel and Cats [166, 167]. The girl who has won the card game by producing an ace will grow to be a woman who will conquer men, while the two girls who play with the cat act out a domestic scene which deliberately recalls mother and child groups.

By contrast, Jan Molenaer's *Children making Music* (National Gallery, London) celebrate the innocent state of childhood: concerned only with the moment, the boys play the fiddle and *rommelpot*, while the girl, in her oversized breastplate, beats time on a helmet with a pair of spoons. Only the empty birdcage on the left introduces an element of melancholy: the bird has flown through the door which has been forgetfully left open – its brief imprisonment was just as fleeting as childhood [155].

Jan Molenaer. *Children making Music*, 1629. Canvas, 68.3 × 84.5 cm Reproduced by courtesy of the Trustees, National Gallery, London [page 155]

The most important family festivals in the Dutch calendar were the Feast of St Nicolas and Twelfth Night. St Nicolas, which takes place on 6 December, is an occasion specifically for children. On the previous night the children would place their wooden shoes in the hearth and during the night the saint and his helper, Zwarte Piet ('Black Peter', so-called from the soot in the chimney), filled them. If the children had been good during the year they would receive sweets and toys but naughty children would find only a dry birch-branch in their clogs. This was also an occasion for the baking (and the consumption by the whole family) of special breads and biscuits. All these elements are contained in Jan Steen's *Feast of St Nicolas* (Rijksmuseum, Amsterdam) [169]: a small girl in the centre clutches the new doll which she has found in the shoe lying in front of her while her older brother cries when he discovers that he has received only a birch twig from St Nicolas. There may be consolation in store, however, as his grandmother beckons him towards her, pulling aside the curtains of the bed, presumably to reveal his presents. A younger child, also holding a doll, is shown the route taken by St Nicolas and Zwarte Piet. In the foreground is a carefully arranged still-life of breads, biscuits, fruit and nuts, seasonal foods to be eaten at the family's St Nicolas dinner. Richard Brakenburgh, in his *Feast of St Nicolas* (Rijksmuseum, Amsterdam) of 1685, follows Steen very closely, but sets the scene in a more affluent middle-class household [157].

Steen's attitude is genial and celebratory. It is true that the Dutch Reformed Church was critical of the indulgence associated with this Catholic feast. In 1607 Delft forbade the sale of gingerbread and pastries in the shapes of human heads which were traditional at the feast of St Nicolas and in 1657 Dordrecht proscribed its celebration altogether. Such local bans had, however, little longterm effect. Steen, as a Catholic, would have been impervious to Calvinist criticism; and indeed, his celebration of the feast may in some sense be a response to such Calvinist disapproval. Essentially, however, his intention is simply to represent this family festival in a joyful, anecdotal manner.

Twelfth Night was another old Catholic feast which survived in the Calvinist Republic in a secularized form, despite opposition from the Reformed Church. On 6 January, the Feast of Epiphany, each family chose a 'king' at breakfast, either by drawing lots or by discovering a bean or a silver coin baked into a loaf or cake. In some places three kings were chosen – the feast is also known as *Driekoningen* – and all three, two dressed in white robes and the third as Melchior in dark robes with his face blacked, would leave the house followed by a procession of children with baskets on their heads and figures representing the Fool and the Glutton, all singing traditional songs about Herod and the Magi. They would then retire to a tavern where they were offered Twelfth Night cakes.

Jan Steen painted a number of domestic Twelfth Night Feasts. In a picture at Woburn the king in his paper crown is at the head of the table, drinking: his riotous followers, including the fool, wearing an inverted funnel on his head, and the pastor, in black, stand behind him. A maid holds up the three-stemmed *Koningskaarsjes* (King's candles) to illuminate the painting hanging on the back wall, which shows the kings following the star to Bethlehem. In the foreground a girl jumps over a row of lighted candles, a custom associated with the feast. In the Cassel painting [157], which is dated 1668, Steen identifies the figures of the *sot* (Fool) and the *pastor* with inscriptions. It seems likely that Steen was inspired to treat this subject by Jacob Jordaens of Antwerp, whose paintings of the festival with large-scale, half-length figures – idealized, red-faced peasant types rather than Steen's credible, if sometimes almost caricatured, individuals – had been widely popular since the 1630s [158].

Steen represented other scenes from the religious calendar, notably the *Procession of the Easter Ox* and, on at least two occasions, the so-called *Pentecostal Flower*. At Whitsun children dressed up in white robes and went from door to door in the village singing the song of the *vrolycke* or *fiere pincxterbloem*, for

Richard Brakenburgh
(1650-1702). *The Feast
of St Nicolas*, 1685.
Canvas, 49 × 64.5 cm
Rijksmuseum,
Amsterdam
[page 156]

Jan Steen. *Twelfth
Night*, 1668.
Canvas, 82 × 107.5 cm
Gemäldegalerie,
Wilhelmshöhe, Cassel
[page 156]

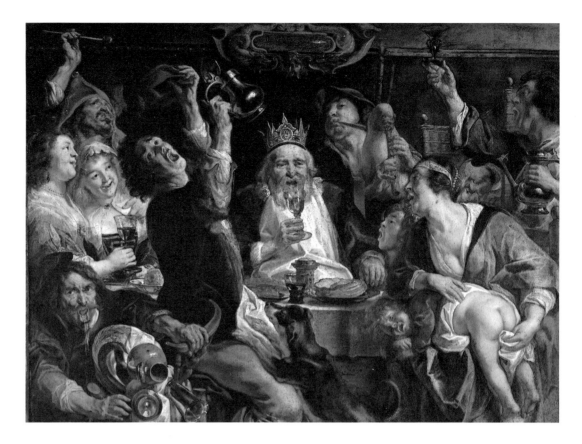

Jacob Jordaens (1593–
1678). *Twelfth Night*
(The King Drinks),
c.1640. Canvas, 156 ×
210 cm
Musées Royaux des
Beaux-Arts, Brussels
[page 156]

which they were rewarded with a coin dropped
into the cup they carried. The money was for
such charitable purposes as the support of or-
phanages and poorhouses. As with so many
Christian festivals, pagan elements survived;
in the Paris painting the little girl wears a
garland of flowers on her head and so is

identified as the Queen of the May, a heathen
custom heartily condemned by the Calvinists
[170]. As with the Twelfth Night Feast, this
was a subject which was also painted by
Steen's close follower Richard Brakenburgh in
his more finished but far less animated manner
[171].

Pieter Bruegel the Elder.
The Peasant Wedding,
c.1567. Panel, 114 × 163
cm
Kunsthistorisches
Museum, Vienna
[page 159]

Wedding feasts

Weddings were celebrated with feasting and dancing and, as with country fairs, a sixteenth-century Flemish tradition for their representation already existed. It found its greatest expression in Pieter Bruegel's *Peasant Wedding* (Vienna, Kunsthistorisches Museum) of around 1567, in which the bride, radiant and composed, sits beneath a canopy, presiding over the table at which her relatives attack their food with gusto, and the bridegroom, if he is indeed the central figure in black, calls for more wine [158]. The scene had originally been devised as a depiction of the sin of Gluttony (*Gula*) but it is unlikely that Bruegel intended more than the gentlest irony when he stressed the enthusiastic indulgence of the guests. In his print of *The Wedding Dance* the inscription – and once again it is impossible to know how much it represents Bruegel's intention – is far less generous in spirit. It mocks the clumsy dancing of the figures and concluded: '*Maer ons bruiyt neemt nu van dansen verdrach, | Trouwens, tis ook best, want sij ghaet vol en soete*' (But our bride has given up dancing and it's all for the best as she's full and sweet' – i.e. pregnant) [159].

Jan Steen's *Wedding Feast* (Wellington Museum, Apsley House, London) of 1667 closely follows Bruegel's painting in spirit [173]. The bride and groom are lost sight of amid their riotous guests. A woman in the centre, just in front of the couple, has a saucepan on her head and a large spoon in her hand – attributes of Gluttony, as can be seen in Bruegel's print of *Gula*. In this way Steen, working within the

realistic mode, makes subtle reference to the earlier allegorical one. His *Peasant Wedding* (Rijksmuseum, Amsterdam) of 1672 is also within the Bruegel tradition, conflating, as it were, the *Peasant Wedding* and the *Wedding Dance*. The bride is seated on the right at the table and her health is being toasted by a crowd of over-eager young men, while her husband is drinking heavily; in the foreground an elderly man, wearing an apron and so presumably the inn-keeper, dances to the music of a fiddler and tries to persuade a young woman to join him on the floor. Here Steen is adding an extra dimension, introducing the Unequal Lovers theme, a traditional northern subject in which old men with young women (and old women with young men) were ridiculed. Certainly, the enthusiasm of the bride's young admirers does not bode well for the success of the marriage. And Steen has introduced a further important and intriguing element: a young couple stand, hand-in-hand, on the left in the foreground, observing the scene. It is as if the wedding feast is a play being performed for their benefit [172]. In Holland in the sixteenth and seventeenth centuries *tafelspelen*, that is, short domestic plays performed around the table or in front of the hearth by amateur players or *rederijkers*, were often devised and performed for newly-weds. Here Jan Steen, with his strongly theatrical sense, has apparently devised a *tafelspel* for the couple on the left, warning them of the pitfalls of marriage. He shows drunkenness, gluttony, amorous attentions paid to the bride by young men, the foolishness of an old man and the immorality implicit in the glance given by the young woman on the ladder to the bedroom upstairs, directed at the man who follows eagerly after her. The young couple are entering a solemn state and they should guard against potential dangers.

Jan Molenaer had used the same device of a *tafelspel* acted out before a young couple forty years earlier in his *Allegory of Marital Fidelity* (Richmond, Virginia, Museum of Fine Arts) of 1633 [173]. Here the young couple on the right is shown a tableau of a musical party, the harmony of the instruments standing for harmony in marriage. In the centre a man is pouring wine into a glass from a long-spouted vessel: this action, because the long, thin spout

After Pieter Bruegel the Elder. *The Wedding Dance*, c. 1566. Engraving by Pieter van der Heyden Rijksprentenkabinet, Rijksmuseum, Amsterdam [page 159]

159

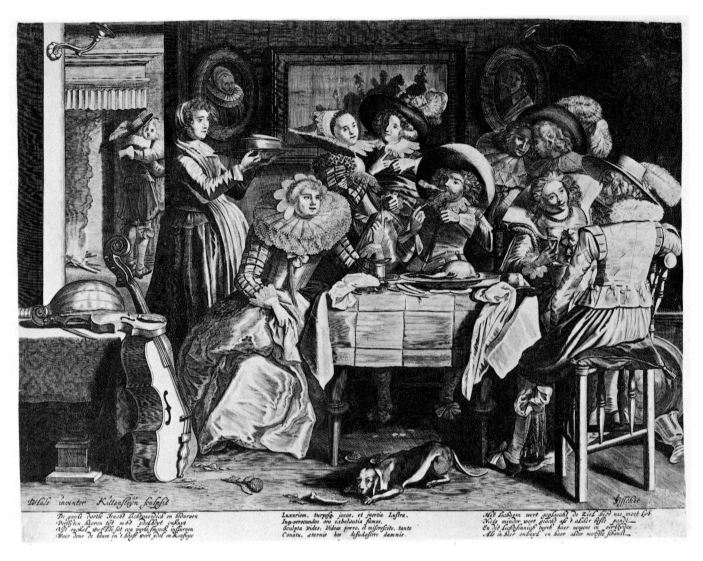

Latin inscriptions beneath the engraving:

Luxuriem, turpefq; jocos, et inertia Lustra,
Ingꝑ verecundas ora exhalantia fumos,
Sculpta vides: videas pravo, et miserescito, tanto
Conatu, aternis hoc desudascere damnis.

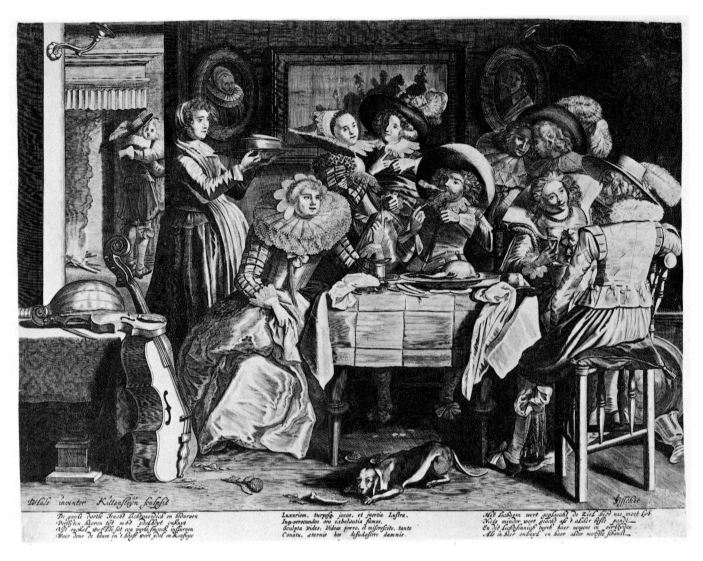

After Dirk Hals. *Merry Company*. Engraving by Cornelis Kittensteyn Rijksprentenkabinet, Rijksmuseum, Amsterdam [page 177]

produces a controlled flow of wine, is a traditional symbol of temperance. (It is used, for example, by Bruegel in his *Temperantia* print.)

As a contrast to the main scene, Molenaer shows a violent fight between two peasants in the background at the left, a representation of *Ira*, the deadly sin of anger. In this way the young people, who have just become betrothed or have just married, are urged to follow a path of temperance and avoid that of anger. Although Molenaer employs realistic elements, it is quite clear from the awkward relationship of the two figure groups – the young couple and the musicians – that no ordinary social occasion is in progress. Steen incorporates his young couple far more successfully within a realistic composition but his didactic purpose is no less serious than Molenaer's.

5. Recreation and Pleasure

I. MERRY COMPANIES

The scenes known as 'merry companies' (*geselschapjes*) enjoyed a relatively short-lived vogue during the first thirty or so years of the seventeenth century. They show groups of elegantly dressed, or rather overdressed, young men and women eating, drinking and making music. The inspiration was Flemish: traditional biblical subjects of carefree feasting and self-indulgence like the Prodigal Son in a Tavern or Mankind before the Flood provided compositional prototypes. These biblical scenes showed extravagance and luxury which, as every viewer would have known, led to inevitable retribution, and to some extent this sense of moral condemnation was carried over to the 'merry companies'. The settings are often deliberately non-realistic: the narrow space

160

Pieter Gerritsz. van Roestraten (c. 1632–1700). *A Woman making Pancakes*, 167(?). Canvas, 77.5 × 65 cm
Museum Bredius, The Hague. [page 149]

Jacob Duck (c. 1600-67). *A Woman Ironing*. Panel, 42.5 × 33.1 cm Centraal Museum, Utrecht. [page 149]

Jan Vermeer. *The Milkmaid*, c. 1660. Canvas, 45.5 × 41 cm. Rijksmuseum, Amsterdam. [page 149]

Gerrit Dou. *The Night School*. Panel, 53 × 40.3 cm. Rijksmuseum, Amsterdam.
[page 152]

After Gerrit Dou. Tryptych: *The Lying-in Room*. Copy after a lost original by Willem Joseph Laquy (1738-98). Canvas, 83 × 70 cm (centre); panel, 80 × 36 cm (each of the wings)
Rijksmuseum, Amsterdam.
[page 152]

Dirk Hals (1591-1656). *A Boy and a Girl playing Cards*, 1631. Panel, 32.6 × 27.7 cm. Pair to the painting on the opposite page. Sterling and Francine Clark Art Institute, Williamstown, Massachusetts. [page 155]

Dirk Hals. *Two Girls playing with a Cat*. Panel, 32.6 × 27.7 cm.
Sterling and Francine Clark Art Institute, Williamstown, Massachusetts.
[page 155]

Adriaen van Ostade. *The Schoolmaster*, 1662. Panel, 40 × 32.5 cm
Musée du Louvre, Paris. [page 152]

Jan Steen. *The Feast of St Nicolas*. Canvas, 82 × 70.5 cm. Rijksmuseum, Amsterdam.
[page 156]

Jan Steen. *The May Queen*. Canvas, 59 × 51 cm. Ville de Paris, Musée du Petit Palais, Paris. Photo Bulloz.

[page 158]

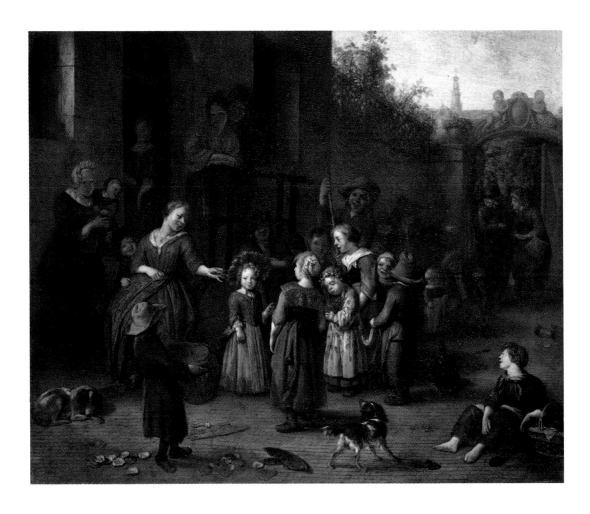

Richard Brakenburgh. *The May Queen*. Canvas, 41.2 × 49 cm
Museum of Fine Arts, Budapest. Photo: Károly Szelényi, Corvina Archiv
[page 158]

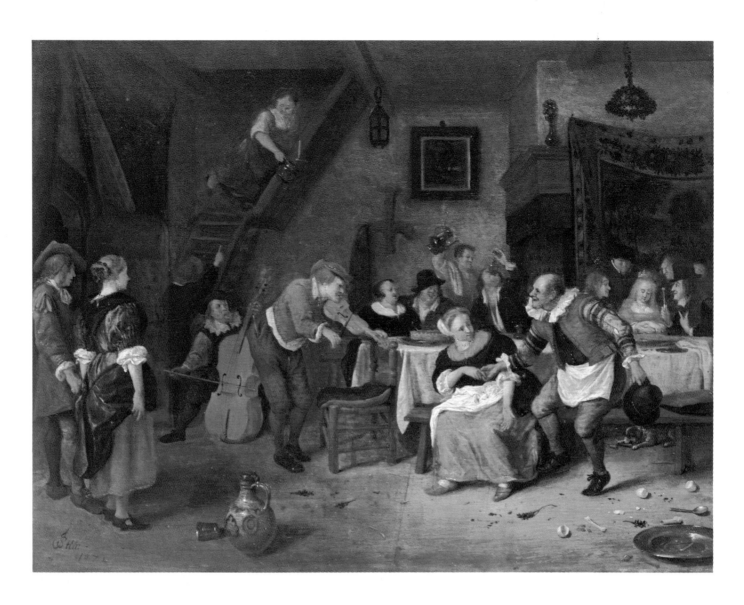

Jan Steen. *A Peasant Wedding*, 1672. Panel, 38.5 × 50 cm
Rijksmuseum, Amsterdam.
[page 159]

OPPOSITE, TOP:
Jan Steen. *A Wedding Feast*, 1667. Canvas, 101 × 156 cm
Wellington Museum, Apsley House, London.
[page 159]

OPPOSITE, BOTTOM:
Jan Molenaer. *Allegory of Marital Fidelity*, 1633. Canvas, 98 × 140 cm
Museum of Fine Arts, Richmond, Virginia.
[page 159]

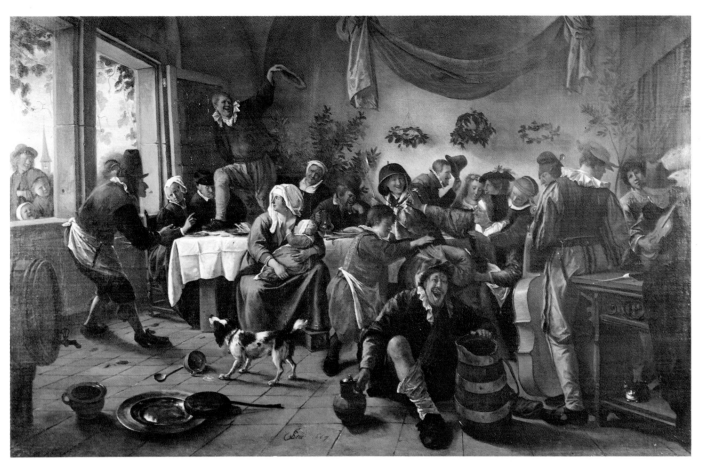

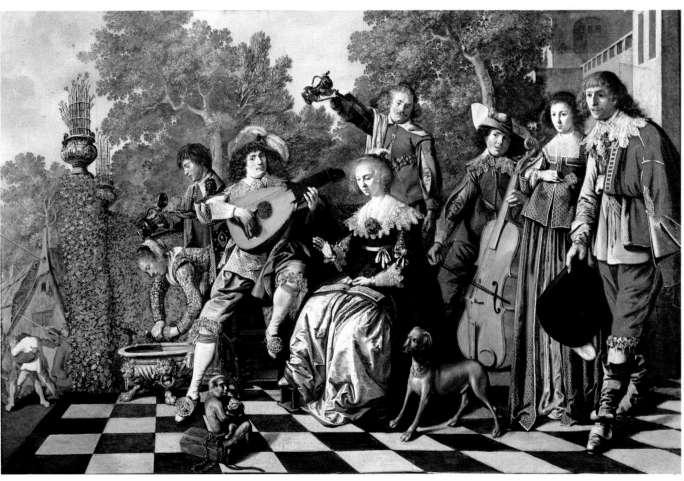

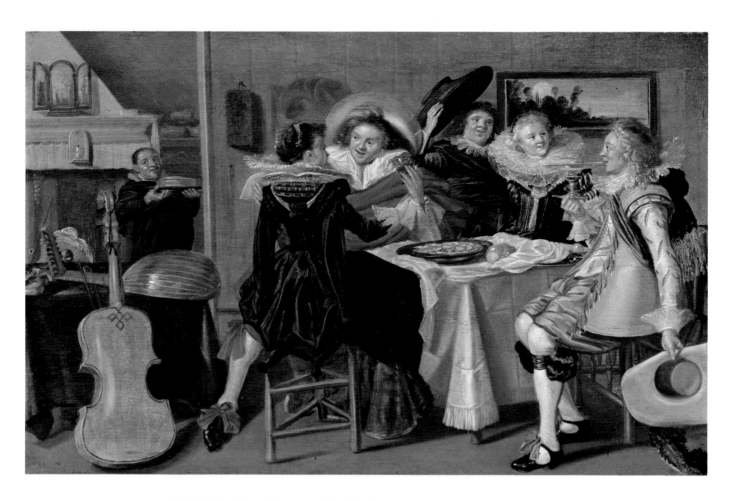

Dirk Hals. *Merry Company*, 1627. Panel
Staatliche Museen Preussischer Kulturbesitz, Berlin-Dahlem.
[page 180]

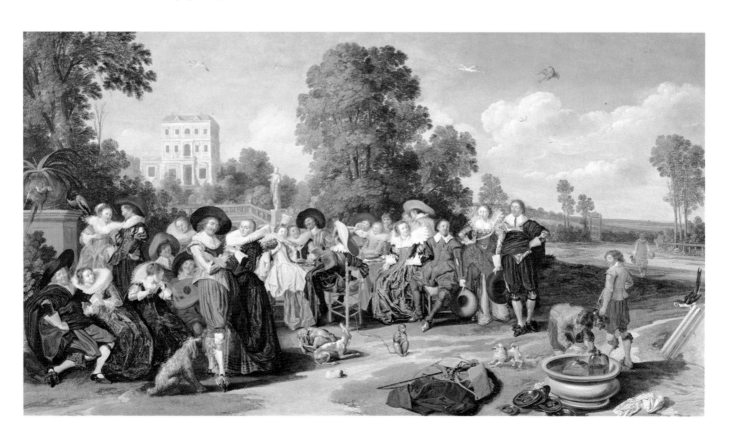

Dirck van Baburen (c. 1595-1624). *The Procuress*, Dutch, f. 1611-d. 1622, oil on canvas, 101 × 107.3 cm.
50.2421, Purchased, Maria T. B. Hopkins Fund. Courtesy, Museum of Fine Arts, Boston. [page 182]

OPPOSITE, BOTTOM:
Dirk Hals. *Garden Feast* (Fête Champêtre), 1627. Panel, 78 × 137 cm
Rijksmuseum, Amsterdam.
[page 179]

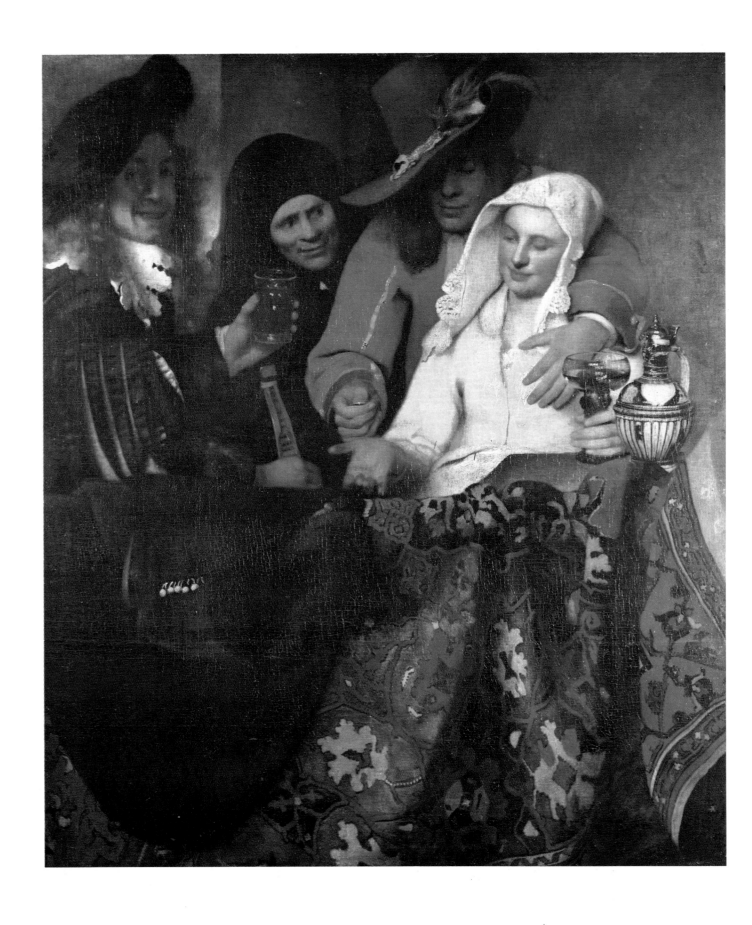

Jan Vermeer. *The Procuress*, 1656. Canvas, 143 × 130 cm. Staatliche Kunstsammlungen, Dresden.
Gemäldegalerie Alter Meister. [page 182]

occupied by the figures and their exaggerated actions and costumes emphasize the emblematic, even theatrical, aspects of these paintings. The Calvinist society of the Republic was deeply disapproving of extravagant dress, conspicuous consumption and idleness and it is this spirit which informs the uncompromising inscription beneath the Kittensteyn print [160] after a Dirk Hals 'merry company':

De gayle dartel jeucht lichtvaerdich en bedurven / Verslyten haeren tijt met ydelheyt onkuys / Uijt enckel weelde sat een vuyle smoock inslurven / Waer deur de beurs en't hooft wert ydel en konfuys. / Het lichaem wert geplaecht de ziel hier nae moet ly[den] / Niets minder wert geacht als 't alder beste pandt / En dit licht-sinnich tuych haer nergens in verblyden / Als in haer onheyl, en haer alder meest schandt. (The hurtful wanton youth, rash and corrupt, / Waste their time in unchaste vanity. / From pure sated luxuriousness they are inhaling a foul smoke / Which leaves both their heads and their purses empty and confused. / The body is being tormented and the soul must suffer as a result. / Nothing is held in less regard than these, the very best pledges / And yet these frivolous fools don't rejoice in anything / But in their own destruction, and their greatest disgrace.)

The extent, however, to which this represents Hals' intentions must remain in doubt. At this early moment in the seventeenth century, it was apparently still necessary to 'justify' a secular subject of this kind with an admonitory moral. The painted 'merry companies', while they may have been intended as criticisms of youthful self-indulgence and high spirits, are good-natured in mood, tinged with amusement rather than puritanical condemnation.

David Vinckboons is a central figure in the evolution and popularization of the 'merry

Willem Buytewech the Elder. *Merry Company.* Canvas, 49.3 × 68 cm Museum Boymans-van Beuningen, Rotterdam [page 178]

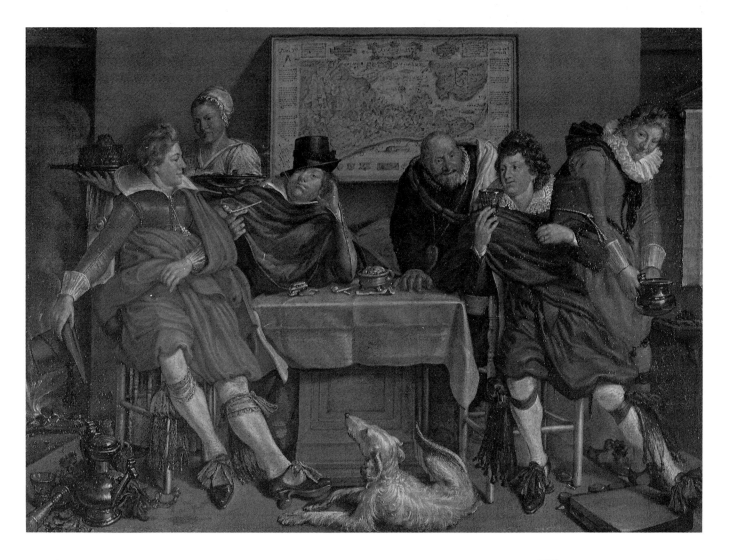

company' scenes but they are particularly as-
sociated with two artists, Willem Buytewech
the Elder and Dirk Hals. Buytewech was born
and trained in Rotterdam but was in Haarlem
from at least 1612, when he joined the guild
there, until 1617 and it was during these years
that, with Hals and Esaias van de Velde, who
also entered the Haarlem guild in 1612, he
developed and refined the subject.

Buytewech was a marvellously inventive
painter, draughtsman and print designer. His
particular contribution to the *geselschapje* was
to make the figures more elegant and sophis-
ticated. In his *Merry Company* in Rotterdam,

Buytewech places his richly dressed, elabo-
rately coiffured, languorous young men in a
tavern: the serving maid is at the back on the
right, on the point of leaving the room, and the
innkeeper who has just demanded payment of
his bill is *Hansworst*, a theatrical buffoon ad-
orned with a sash of sausages [177]. Buyte-
wech had close links with the contemporary
theatre: he designed title-pages for the col-
lected plays of Bredero and for the *Handel der
Amourensheyt* of J. B. Houwaert. He also illus-
trated a scene from Bredero's *Lucelle* and there
is a striking similarity between the figures of
the lovers Lucelle and Ascagnes in his etching
of a scene from the play and his 'merry com-

pany' figures [178]. Buytewech's print also contains a *vanitas* element: it belongs to the tradition of the scene of an amorous couple surprised by Death, a notion entirely appropriate to the play for the third character, who eavesdrops on the couple, is *Lekkerbeetje*, the cook, who is to supply the poison for their mutual suicide. The 'merry companies' also contain *vanitas* undertones – the transience of sensual pleasure is suggested by scattered, fast-fading flowers, swiftly evaporating smoke, the presence of an innkeeper making a reckoning, and so on.

'Merry companies' are not confined to taverns. They can be shown out of doors as in the case of Dirk Hals' *Garden Feast* (Rijksmuseum, Amsterdam), which takes place in the grounds of an elegant country house, dotted with classical statuary. It is related to the medieval notion of the 'love garden'. Here the same fashionably dressed young people eat, drink, play music and flirt with each other. Only the prominently placed pet monkey, who stands for man's baser instincts and lust in particular, strikes a jarring note in this idyllic scene [174].

Love is the theme of Buytewech's intriguing *Merry Company* in the Rijksmuseum, in which two couples stand in front of a fountain set into a wall niche [179]. The coat of arms on the window grating suggested to earlier writers that this was a portrait group but it does not correspond in detail to any known coat of arms and the figures are close to Buytewech's conventional types. Rather than a posed portrait, it is a subtle evocation of love in a 'merry company' format. The fountain refers to the fountain of love, as do the roses held by the seated woman, and the spider's web around

Willem Buytewech the Elder. *Merry Company*. Canvas, 56 × 70 cm Rijksmuseum, Amsterdam [page 179]

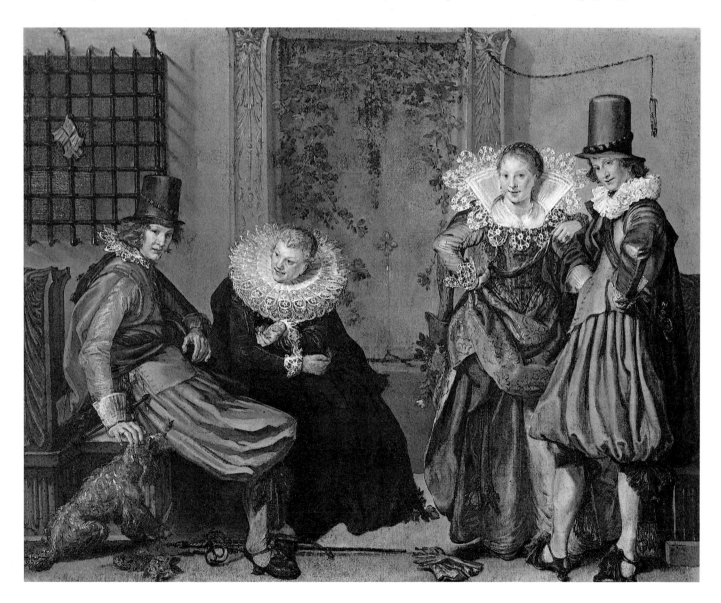

David Vinckboons.
Party in a Garden (Fête
Champêtre). Panel,
28.5 × 44 cm
Rijksmuseum,
Amsterdam
[page 180]

OPPOSITE, TOP:
Anthonie Palamedesz.
(1601-73). *Merry
Company*, 1633. Panel,
54.5 × 88.5 cm
Rijksmuseum,
Amsterdam
[page 180]

OPPOSITE, BOTTOM:
Hendrick Pot (c. 1585-
1657). *A Brothel Scene*,
1630. Panel, 32.3 × 49.6
cm
Reproduced by courtesy
of the Trustees, National
Gallery, London
[page 180]

Esaias van de Velde
(c. 1591-1630). *Party in a
Garden* (Fête
Champêtre), 1615.
Panel, 35 × 61 cm
Rijksmuseum,
Amsterdam
[page 180]

the coat of arms has been linked to an emblem of Jacob Cats, which compares the spider's web to the net cast by Venus over her victims (*Venus warre-net*).

The 'merry company' format was adopted by a number of contemporaries of Buytewech and Dirk Hals [174], all of whose paintings date from between 1615 and 1635. David Vinckboons [180] and Esaias van de Velde [180] have already been mentioned; Anthonie Palamedesz. in Delft [181] and Hendrick Pot in Haarlem also painted 'merry companies'. In the hands, however, of an artist like Pot the 'merry company' scene, so subtle and carefully judged when treated by Buytewech, became an explicit *bordeeltje* (brothel scene). In the National Gallery painting the amorous proceedings are supervised by an elderly procuress who makes an obscene gesture with her pipe. Her age and ugliness are deliberately contrasted with the youth and beauty of the girls [181].

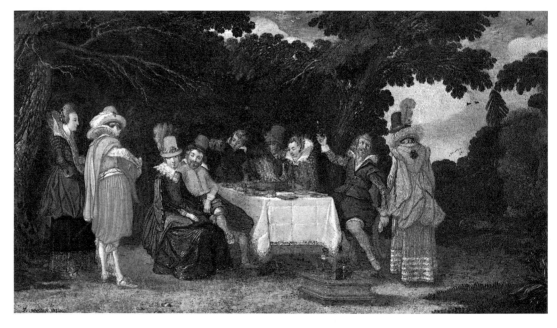

180

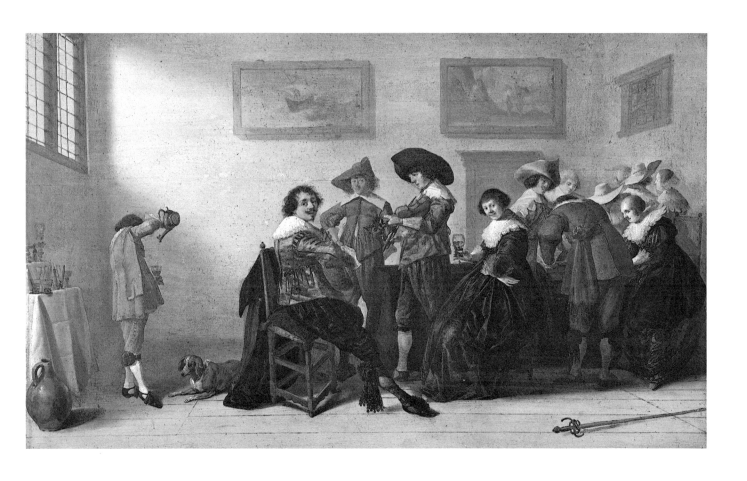

The distinction between these two types of institution is hard to make in Dutch genre paintings – as it was no doubt in actual taverns and brothels in seventeenth-century Holland. The waitresses, at whom the drinkers in taverns often leer, were no doubt sometimes prepared to augment their earnings by prostitution. Taverns often appear to have had conveniently situated upstairs rooms to which the women could take their clients, while brothels often had a large room in which drinks were served and choices made.

The best-known brothels in the north Netherlands in the seventeenth century were the famous *musicos* of Amsterdam which attracted the interest of visitors to the city: 'He who takes a walk in the streets in the dark of an evening', wrote a German traveller, J. H. von Melle, in 1683, 'can observe the so-called music-houses, where for money a lover can satisfy his senses'. Brothels of this kind, where wine was drunk and music played, were in the Pijl and the Halsteeg; their activities were strictly supervised by a city official, the *schout*, assisted by a force of twelve *dienaren* (servants). Prostitutes were permitted to work only three days a week and not at all in the last week of the month, because of the commemoration of the Last Supper. It is an aspect of the libertarianism of Dutch society (at least in the larger towns) that brothels were not only tolerated but institutionalized in this way.

An apparent contradiction within Dutch society, pervaded as it was by stern Calvinist morality, is that large numbers of pictures of both brothels and taverns were painted, for which there must have been a considerable and a constant demand. In Dirck van Baburen's *Procuress* of 1622, the setting for the figure group is scarcely indicated but there is no doubt as to the nature of the transaction taking place [175]. Baburen had spent ten years in Italy and his composition formally derives from the half-length genre subjects painted by Caravaggio and his Roman followers. This type of Caravaggesque genre scene enjoyed a vogue in Utrecht, where its principal practitioners, Baburen, Hendrick Terbrugghen and Gerard van Honthorst

worked. It was short-lived – the early deaths of Baburen and Terbrugghen in 1624 and 1629 removed much of its impetus – and had little impact on the development of Dutch genre painting. In his capacity as an art dealer Vermeer owned *The Procuress* (or a copy of it) and showed it hanging on a back wall in two of his own paintings. His choice of this subject and a large format for his picture of 1656, in Dresden, no doubt reflects his study of this and other Caravaggesque treatments of the theme [176]. Soon afterwards, however, Vermeer abandoned this type of large-scale painting with half-length figures in favour of small-scale full-length compositions.

There was already in the sixteenth century a vigorous Netherlandish tradition of the representation of brothels and taverns. This had originated in the depiction of biblical subjects and, in particular, the story of the Prodigal Son, who had wasted his inheritance in riotous living before being reduced to the condition of a swineherd and eventually seeking his father's forgiveness (St Luke 15 : 11-32). The earliest example of the subject seems to be a woodcut by Lucas van Leyden from around 1520, showing a young man in a tavern with a young woman embracing him and picking his pocket at the same time [183]. In the background is an elderly woman of the procuress type and at the window a fool whose ironic comment on the scene, inscribed on a banderole, is '*Acht, hoet varen sal*' ('Watch the way the wind blows'). This type of subject-matter was taken up especially by the so-called Brunswick Monogrammist, an artist who has been identified as Jan van Amstel of Antwerp. In his hands the brothel and the tavern become the settings for man's foolishness: there men are cheated and – shown standing on their hands, for example – made ridiculous [193].

It is to the theme of the Prodigal Son in the tavern that Rembrandt alludes in his remarkable *Self-Portrait with his Wife Saskia* painted not long after their marriage in 1634. He shows himself in extravagant dress, looking out at the viewer and raising a *pas-glas* filled with beer. He has his arm around Saskia, who perches, a little primly, on his knee: before them is a table set with peacock pie, a great delicacy. Originally the composition was even more closely

related to the theme by the inclusion of a leering lute-player, subsequently painted out by Rembrandt. That he should have chosen to portray himself as the Prodigal Son – presumably a self-conscious reference to his notorious prodigality – and his new wife as one of the instruments of his ruin shows a characteristic freedom in dealing with traditional subjects. He also displays a disregard for the categories of painting – this being history scene, genre subject and double portrait in one [194].

Like Rembrandt, Gabriel Metsu chooses a tavern as a suitable setting for a self-portrait with his wife, Isabella de Wolff, in a painting of 1661 in Dresden. The couple, engaged in conversation, are less boisterous but Metsu also raises his glass in an expansive gesture. Metsu displays far more interest in descriptive detail – his wife's elegant gold braid- and fur-trimmed overdress, the food and *pyp* on the table, the birdcage, and the view out of the open door – than Rembrandt, but the echoes of the Prodigal Son theme are no less strong [184].

It is hardly surprising that a moralizing artist like Adriaen van de Venne should have been attracted to the theme of the brothel; in a painting of 1625 in Budapest the brothel is used, as Jan van Amstel had used it, as a stage for man's gullibility and stupidity. Less expected is the interest shown in brothel subjects by Frans van Mieris, the Leiden *fijnschilder*. His *Soldier and Maid* (Mauritshuis, The Hague) [195] is ostensibly set in a tavern but the glance between the maid and the soldier who tugs at her skirt, her *décolletage*, the amorous couple in the background, the bolster and sheets draped so prominently over the handrail and – most graphically – the copulating dogs, make the true nature of the scene quite explicit. The action of the dogs has somewhat pedantically been related to an emblem by Jacob Cats, '*Gelijk de juffer is, so is haer hondeke*' ('As the girl, so her dog'): such a direct literary reference is hardly necessary in order to grasp the relevance of the animals' actions to the humans. Van Mieris, who had a marked preference for erotic subjects, is similarly explicit in the *Sleeping Courtesan* (Uffizi, Florence) of 1669. The sleeping woman displays her breasts to the spectator while in the back-

ground a procuress arranges the financial details with her next client. Van Mieris' intention is shamelessly titillating, even pornographic: she is exhausted by the demands of her trade. It is not inappropriate that the formal source for van Mieris' painting seems to have been Caravaggio's lost *Magdalen Sleeping*, the composition of which survives in a number of old copies. Jan Steen shows the interior of a brothel in his *Man offering an Oyster to a Woman* (National Gallery, London). An elderly woman has opened the oyster which the young man offers: in the work of certain authors such as Johan van Dans oysters are used to stand for the female genitals. Here the man's action is undoubtedly a sexual advance and combined with the presence of wine, the procuress opening the oysters, the bed in the background and the second couple, there can be no doubt that the girl's love is for sale

Lucas van Leyden. *A Young Man cheated in an Inn*. Woodcut Cabinet des Estampes, Bibliothèque Nationale, Paris [page 182]

183

Gabriel Metsu. *Self-Portrait with his wife Isabella de Wolff*, 1661. Panel, 35.5 × 30.5 cm
Staatliche Kunstsammlungen, Dresden. Gemäldegalerie Alter Meister. [page 183]

[196]. By far the most unrestrained brothel scene is that by Nicolaus Knüpfer, recently purchased by the Rijksmuseum in Amsterdam [197]. It gives a theatrical impression with the figures in extravagant poses, wrestling on the bed and crowded at the window, although it is difficult to imagine that a play with such a scene could have been staged.

Taverns provided an important focus for social life among the lower classes in the north Netherlands and were frequently shown filled with drinkers and gamblers by genre painters, in particular those such as Adriaen van Ostade [185] and Jan Steen, who specialized in scenes from peasant life. Steen's *Tavern Interior* (Amsterdam, Rijksmuseum) intentionally and wittily contrasts two 'games' taking place in the tavern – the old man seizing the skirts of the landlady and the backgammon being played in the background [186]. Arent Diepram's *Bar-room* of 1665 is a particularly vivid illustration of peasant foolishness and self-indulgence. A man, whose coarse features show little if any intelligence, clutches his wineglass and pewter jug, and laughs drunkenly at the spectator. It calls to mind the classical tag '*ridendo dicere verum*' ('in laughing one speaks the truth'), for the truth is that the peasant is a fool, himself a fit object for laughter [187].

Drunkenness, and its consequent violence, as well as profligacy, are often mocked in such paintings, and in Cornelis Saftleven's *Tavern Exterior with Card-players* a monk is prominently included among the players, a jibe at the corruption of the Catholic Church [193]. On the other hand, the tavern is often shown as a meeting place for villagers rather than a den of iniquity. This is particularly evident in the

Adriaen van Ostade.
Tavern Interior, 1674.
Panel, 49.5 × 62.5 cm
Staatliche Kunst-
sammlungen, Dresden.
Gemäldegalerie Alter
Meister
[page 185]

185

Jan Steen. *Tavern Interior*. Canvas, 63 × 69.5 cm Rijksmuseum, Amsterdam [page 185]

scenes set outside taverns. Outings into the countryside were very popular as a recreation amongst Dutch town-dwellers. Parival noted this practice and commented that 'wherever one goes here [that is, into the countryside] one finds as many people as would be seen elsewhere in a public procession.' He continued: 'All these excursions end up at one of the inns which are to be found everywhere... These inns are always packed with visitors, and the confused murmur of many voices is like the sound in a city square. These are inexpensive pleasures which all, even the humblest labourer, can share.' In the summer, tavern gardens were used for eating and drinking in the open air although Jan Steen – for whom the rearing of children is such a recurrent theme – appears to be criticizing the presence of a young child being given beer in a tavern garden by his mother in a painting in Berlin [198]. The grinning fish seller's presence and the father's eating of a fresh herring, while entirely in keeping with the setting, probably refer to the phrase 'to sell someone a herring', with the sense of giving them something unsuitable.

A crowded, noisy tavern is the setting for one of Steen's most elaborate and ambitious compositions, *The Egg Dance* (Apsley House) [6]. In the version of this ancient dance performed in the Netherlands in the sixteenth – Pieter Aertsen had shown it in a painting of 1557 – and seventeenth centuries, a circle was marked out on the floor in chalk, and leaves, flowers and eggs were placed inside it. The dancers had to work the eggs out of the circle with their feet as they were dancing past and whoever got their eggs out first won a basket of them as a prize. The music for this dance is provided by a bagpipe-player, seated in the foreground looking out of the painting, and a fiddler. Elsewhere in the tavern are drinkers (one, in the left background, with a resemblance to Steen himself, raises his glass as he looks out at the viewer), smokers, a herring-seller, children with their toys, amorous couples on the stairs and in secluded corners, and, at the door, an elegantly dressed trio of two men and a woman who seems uncertain whether she should enter such a rowdy establishment.

186

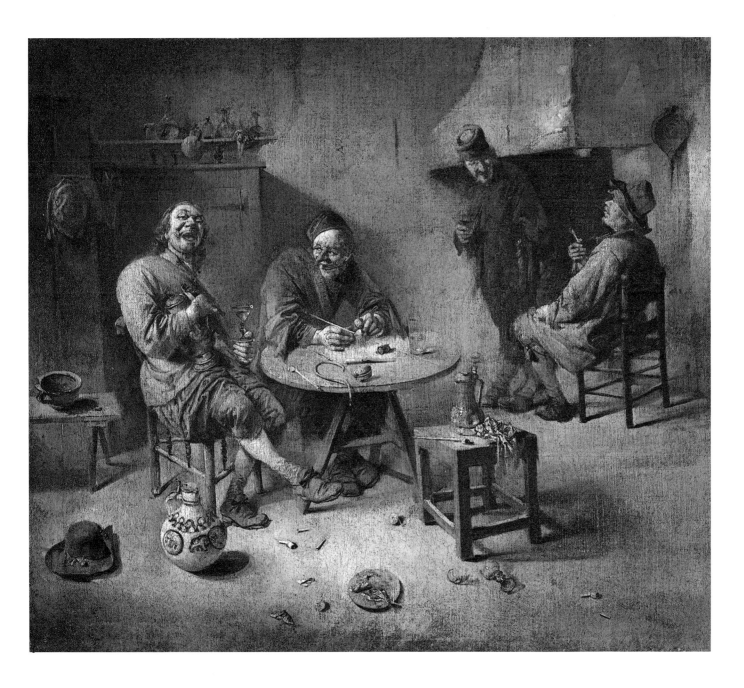

Steen's *The Prince of Orange's Birthday* (Rijks-museum, Amsterdam) also takes places in a crowded tavern interior [199]. The central figure proposes a toast to Prince Willem III who had been born on that day – 14 November – while the innkeeper, who wears an apron, kneels before a portrait of the Prince's dead father, Willem II. The significance of the occasion is underlined by a series of pro-Orange inscriptions which Steen has incorporated within the painting. On a piece of paper in the foreground the toast, which is distinctly belligerent in tone, is written: '*Op de gesonheyt van het nassauss basie in de eene hant het rapier in de andere hant het glaesie*' ('To the health of the little lord of Nassau raise in one hand your

sword and in the other your glass'); on the crown which hangs above the proceedings is the motto '*Salus patriae suprema lex esto*' ('The health of the country is the supreme law'); and finally, above the bed, '*Wij screuwe als leuwe*' ('we roar like lions') referring to the Orange coat of arms which bears a rampant lion. The innkeeper's devotion to the House of Orange is amusingly exaggerated by Steen, while many of his customers appear to ignore the toast; however, in the political context of the 1660s, the celebration of the Prince's birth did represent a commitment to the Orange cause which found much of its support among Steen's chosen subjects, the urban artisan class.

Arent Diepram (1622–70). *Bar-room*, 1665. Canvas, 46 × 52 cm
Rijksmuseum, Amsterdam
[page 185]

187

The traditional country fair, or *kermis*, was religious in its origins. Held on a saint's day, its purpose was to commemorate the founding of a church, and a service formed an important part of the festivities. There were also, of course, more secular activities – eating, drinking and dancing – which naturally provoked accusations of blasphemy and depravity. Such criticisms were not confined to passionate sermons and moralizing pamphlets: in Pieter Bruegel's *Peasant Dance* (Vienna) the lovers, drinkers and dancers are oblivious to the religious banner which hangs on the left and the image of the Virgin nailed to the tree on the right [189]. In certain cases these fairs moved so far away from their original religious inspiration that they came to be regarded as occasions of remarkable licence, when conventional modes of behaviour – and rules of morality – were temporarily suspended. While the political authorities tended to turn a blind eye to this aspect of the *kermis*, they were naturally swift to act when, as sometimes happened, the *kermis* provided a focus for political disturbances and, in particular, food riots. After a number of such disturbances, Charles V issued an edict that no *kermis* should last for longer than one day.

Fairs were condemned by Calvinist preachers on the grounds of their Catholic origins and the opportunities they presented for immoral behaviour. They continued, however, to flourish in the Dutch Republic, becoming entirely secular occasions and increasingly assuming a commercial character. Stall-holders, quack doctors, travelling pedlars and gipsy fortune-tellers could all be found at country fairs while town fairs, held on large open spaces on the edge of the towns, offered even more sophisticated entertainments. The great microscopist Anthoni van Leeuwenhoek recounted that he learnt glass-blowing at fairs and it was at fairs throughout Holland that the engineer Leeghwater, who drained the polders, demonstrated his diving technique. Czar Peter the Great attended the Amsterdam fair when he was in the Netherlands and was particularly impressed by Tetjeroen – quack, juggler, magician and mountebank – who had set up his stall in the Butter Market. The *Hof-kermis* held on the Vijverberg in The Hague was visited by the court; a painting of 1625 by Esaias van de Velde shows Prince Maurits and Prince Frederik Henry there, accompanied by the exiled King and Queen of Bohemia. One of the trades enthusiastically carried on at fairs was the sale of paintings, as Evelyn had noted at the Rotterdam fair. The town guilds of St Luke restricted the right to sell paintings in a particular town to members of the guild, but for the duration of the *kermis* this rule was set aside.

There was a well-established Flemish sixteenth-century tradition of the representation of country fairs which can be seen, for example, in the engraving designed by Pieter Bruegel of the *Fair at Hoboken* (1559), whose mocking inscription has already been discussed above. It is a composite image, showing a variety of village activities which could not have actually taken place simultaneously. The church is at the centre of the composition and a religious procession, which includes the figures of a saint and the Virgin, moves towards it. Elsewhere there is drinking, dancing, archery practice (by members of the local Archers' Guild) and, in the top right-hand corner, two plays are being performed, by a travelling company of players or by the local *rederijkers* [188].

A second print designed by Bruegel shows the *Kermis of St George* [190]. The church is placed in the middle distance, with greater prominence given to the inn, The Three

After Pieter Bruegel the Elder. *The Fair at Hoboken*. Engraving. The print, whose engraver is unknown, is based on a drawing by Bruegel of 1559 in the Courtauld Institute Gallery, London. Rijksprentenkabinet, Rijksmuseum, Amsterdam [page 188]

Crowns, on which hangs a banner with the inscription '*Laet die boeren haer kermis houven*' ('Let the peasants hold their *kermis*'), perhaps a deliberate reference to Charles v's edict of limitation. In the foreground on the left a game akin to croquet is being played – a large ball is knocked through an upright hoop – and in the centre a sword dance is performed. Beyond the church wall St George does battle with a mechanical dragon and to the right actors entertain their audience. In the middle ground on the left a drunken fight has broken out. The whole scene is observed by two men in the foreground, one of whom points towards it and looks at the spectator: his companion, seen from behind, wears a pilgrimage pennant in his hat. These two figures serve to comment on the transformation of a religious event into a riotous secular occasion. Bruegel's depictions of country fairs, whether or not we attribute to him the precise sentiments which appear below the *Fair at Hoboken*, do possess a moral dimension. The juxtaposition of the religious and the all-too-secular, and the rela-tive prominence accorded to them, is force-fully ironic. The tone is not, however, the severely condemnatory one of Calvin and Zwingli, but rather the ironic resignation of Erasmus in the *Praise of Folly*.

In the seventeenth century the *kermis* usually lasted a week, sometimes two weeks and occa-sionally even three weeks, as at Haarlem. In the Hague the May *kermis* lasted two weeks and the September *kermis* one week, but the latter was abolished by a decree in 1643.

In David Vinckboons' *Country Fair* (Bayeri-sche Staatsgemäldesammlungen, Munich) of about 1608, any irony has become so mild as to be scarcely present [191]. The church, in the centre at the back, dominates the proceedings and yet it is difficult to see its position as having any more than a compositional signi-ficance. As in Bruegel's prints, the inn is in the right foreground and there is a group of danc-ers in the centre; the traders' stalls are promi-nently placed, an indication of the increasingly

Pieter Breugel the Elder.
The Peasant Dance.
Panel, 114 × 164 cm
Kunsthistorisches
Museum, Vienna
[page 215]

After Pieter Bruegel the
Elder. *The Kermis of
St George's Day*.
Engraving, engraver
unknown
Rijksprentenkabinet,
Rijksmuseum,
Amsterdam
[page 188, 189]

commercial nature of fairs. Particularly eye-catching, especially in the light of Evelyn's account, is a stall selling paintings. A striking difference between Bruegel's and Vinckboons' treatment of the subject is the latter's inclusion of a group of richly-dressed figures, with bright, quilted doublets, high ruffs, and plumed hats, among the *boeren*. These may not be the local aristocracy, as might be assumed, but a party of rich city-dwellers in the country for the day. Many wealthy Amsterdam merchants bought country houses and estates, some of which carried with them honorary feudal titles.

Vinckboons painted a number of country fairs during his career. *The Country Fair* (Mauritshuis, The Hague) of 1629 has in the background the cruel game of 'pulling the goose', in which a man on horseback has to catch hold of a goose by its neck while it is being pulled across the street on a rope [200]. It was a favourite game of skill, and can frequently be seen in peasant scenes, as well as in the background of landscapes by Salomon van Ruysdael and Jan van Goyen.

Adriaen van de Venne's *Country Fair* (Rijksmuseum, Amsterdam) of 1625 also belongs to this Flemish-derived tradition [200]. Although van de Venne is often a severe social critic, it is difficult to detect any such intention here. The fair is taking place in the shadow of the village church, while in the foreground are two contrasted groups of visitors, a soberly-dressed family party on the left and on the right riders

in extravagant, colourful dress. In van de Venne's black satire, the *Tafereel van de Belacherende Werelt* (1635), he sends his central character, a young peasant called Tamme Lubbert, to the *Haegsche Kermis*. (Lubbert is a traditional name for stupid characters: the patient in Bosch's *Operation for Stone* is identified by an inscription as *Lubbert Das*.) He is amazed by what he sees there – the sights include a tightrope walker, acrobats, and a quack doctor – and van de Venne uses the performers, charlatans and pickpockets of the *kermis* as butts for his savage criticisms of contemporary society.

Later in the century the subject of the Country Fair was taken up by painters of peasant life such as Isack and Adriaen van Ostade, Cornelis Dusart and Jan Steen. In the work of the Ostades no element of criticism or moral condemnation is present; indeed, if anything, country life is softened and romanticized in an idyllic scene like the *Country Fair* of 1667 (Ascott, Bucks) [191].

IV. PASTIMES AND GAMES

In the hard-working society of the Dutch Republic leisure time was scarce and, consequently, intensely enjoyed. Recreation in its many forms was as important a theme for genre painters as work.

Skating and games on the ice

From the end of the fifteenth century until the middle of the nineteenth, Europe experienced far more severe winters than we do today. The Thames and the canals of Venice froze over in the winter and so, every year, did the canals and harbours of the Netherlands. Sir William Temple noted that '...many times their havens are all shut up for two or three months with ice, when ours are open and free'.

The pleasures of the northern winter had already been celebrated by Pieter Bruegel and his followers. Bruegel's print of *Skaters at the Gate of St George* of 1553 shows the pleasures and the perils of skating on the frozen river Scheldt [192]. The popular winter game of *kolf*, an early form of golf (although in fact it is

probably closer to ice hockey), in which the ball is hit by a stick with a curved end, can be seen being played in the top right-hand corner. The title of this lively scene is '*De Slibber-achtigheyt van 's menschen leven*' ('The slipperiness of man's life') and the inscription below compares the way in which the skaters slip and slide with the way in which man goes through his life, which is more transient and fragile than the ice itself.

An early Dutch account of winter pleasures is Adam van Breen's panel of 1611 in the Rijksmuseum [201]. Van Breen worked in The Hague and is associated with the court of Prince Maurits there. His fashionably dressed figures could well be courtiers enjoying the

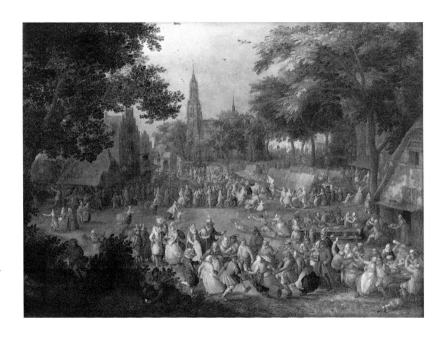

David Vinckboons. *The Country Fair*. Panel, 42.5 × 60 cm
Alte Pinakothek, Munich [page 189]

Isack van Ostade (1621-49). *The Country Fair*. Panel, 81.3 × 66 cm
The National Trust, Ascott House, Buckinghamshire [page 190]

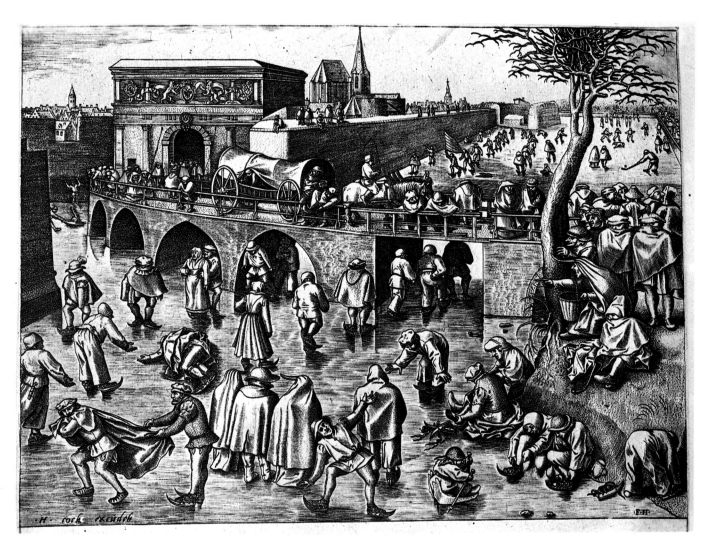

After Pieter Bruegel the Elder. *Skaters at the Gate of St George in Antwerp*. Engraving by Frans Huys. The print is based on a drawing by Bruegel of 1558 which is in a private collection in America. Rijksprentenkabinet, Rijksmuseum, Amsterdam [page 190, 191]

pleasures of the winter: in the middle distance on the right is an elaborately decorated sleigh and on the left is a boat which has been adapted to glide over the ice. Adriaen van de Venne, in the *Winter* panel of his Four Seasons of 1625 (Rijksmuseum, Amsterdam), contrasts a richly dressed young couple skating on the ice and a ragged family on the bank: for the skaters winter means pleasant sport, for the family cold and deprivation.

Hendrick Avercamp is the Dutch artist best known for his treatment of winter scenes. He was trained in Amsterdam, possibly in the studio of David Vinckboons, but spent his working life in the small provincial town of Kampen in Overijssel. His early contact with the Flemish landscape tradition, with its bird's-eye viewpoint and a distinctive, highly individualized, treatment of the figures, determined his style, which changed very little throughout his career. His small, stocky, brightly-dressed figures are glimpsed engaged

in all the varied pursuits of the Dutch winter, some more vigorous than others [201].

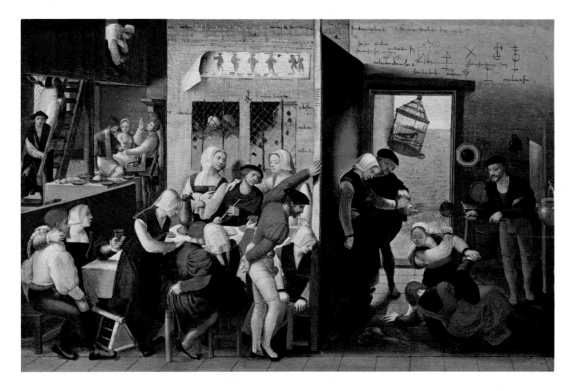

Brunswick
Monogrammist (Jan van
Amstel?). *Brothel Scene*,
c. 1540. Panel, 29 × 45
cm
Staatliche Museen
Preussischer Kultur-
besitz, Berlin-Dahlem
[page 182]

Cornelis Saftleven
(1607–81). *Tavern
Exterior with Card-
players*, 1642. Panel,
63 × 83.5 cm
Rijksmuseum,
Amsterdam
[page 185]

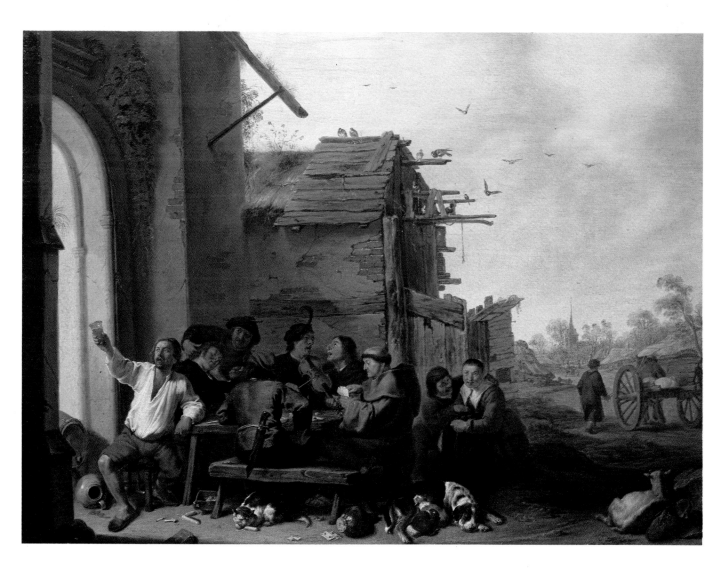

Rembrandt van Rijn. *Self-portrait with Saskia*, c. 1635. Canvas, 161 × 131 cm
Staatliche Kunstsammlungen, Dresden. Gemäldegalerie Alter Meister. [page 182]

Frans van Mieris. *Soldier and Maid*, 1658. Panel, 43 × 33 cm. Mauritshuis, The Hague. [page 183]

Jan Steen. *A Man offering an Oyster to a Woman.* Panel, 38.1 × 31.5 cm. Reproduced by courtesy of the Trustees, National Gallery, London. [page 183]

Nicolaus Knüpfer. *A Brothel Scene*. Panel, 50 × 60 cm
Rijksmuseum, Amsterdam. [page 185]

Jan Steen. *The Garden of an Inn*. Canvas, 68 × 58 cm
Staatliche Museen Preussischer Kulturbesitz, Berlin-Dahlem
[page 186]

Jan Steen. *The Prince of Orange's Birthday.* Panel, 46 × 62.5 cm Rijksmuseum, Amsterdam [page 187]

Jan Steen. *Card-players Quarreling.* Canvas, 90 × 119 cm Staatliche Museen Preussischer Kultur-besitz, Berlin-Dahlem [page 210]

David Vinckboons. *The Country Fair*, 1629. Panel, 40.5 × 67.5 cm
Mauritshuis, The Hague. [page 190]

Adriaen van de Venne. *Country Fair*, 1625. Panel, 33 × 55 cm
Rijksmuseum, Amsterdam. [page 190]

Adam van Breen (active 1611–after 1618). *Winter Scene*, 1611. Panel, 52.5 × 90.5 cm
Rijksmuseum, Amsterdam. [page 191, 192]

Hendrick Avercamp. *Winter Landscape with Skaters*. Panel, 77.5 × 132 cm
Rijksmuseum, Amsterdam. [page 192]

Jan Steen. *Skittle-players outside an Inn*. Panel, 33.5 × 27 cm. Reproduced by courtesy of the Trustees, National Gallery, London. [page 210]

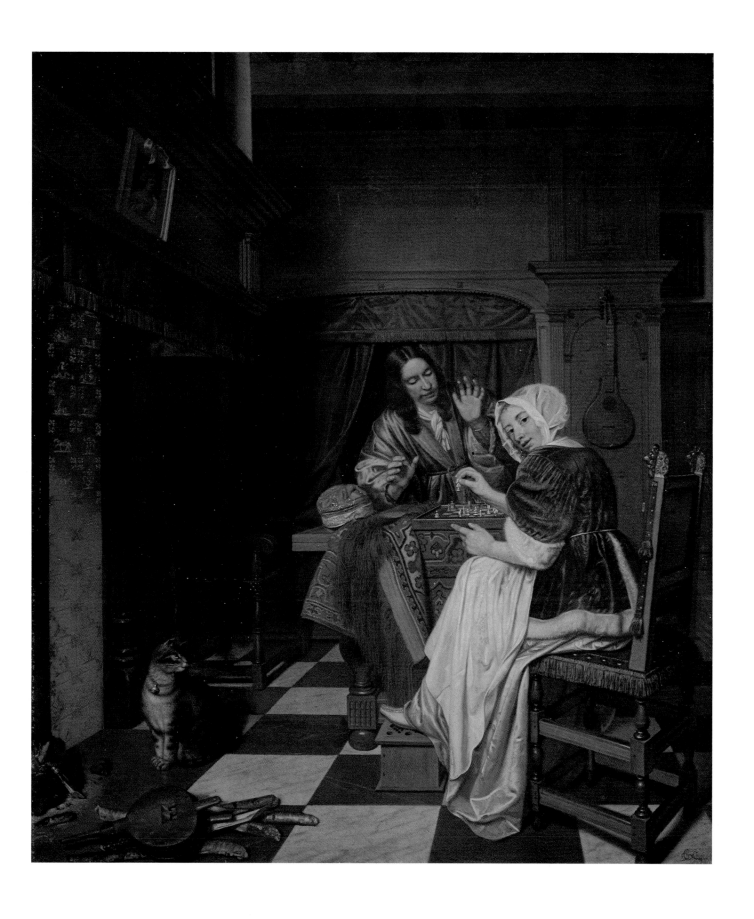

Cornelis de Man (1621-1706). *Chess-players*. Canvas, 97.5 × 85 cm
Museum of Fine Arts, Budapest. Photo: Károly Szelényi, Corvina Archiv. [page 210]

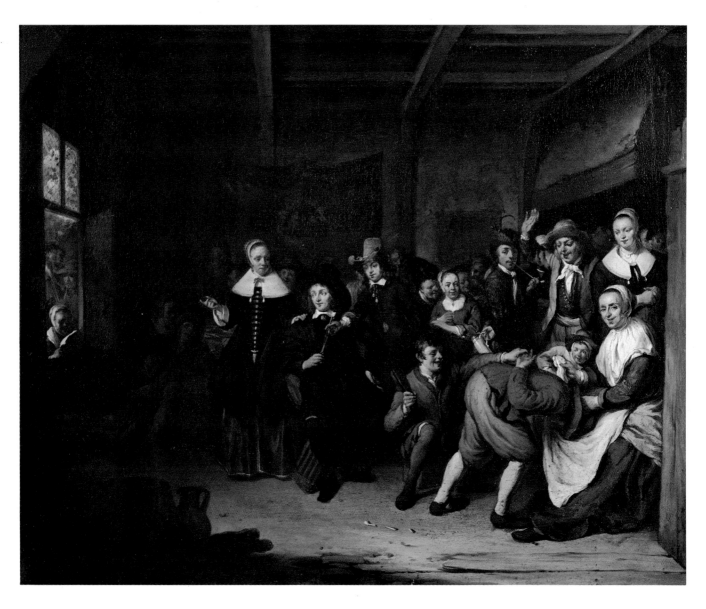

Cornelis de Man. *La Main Chaude*. Canvas, 69 × 84 cm
Mauritshuis, The Hague. [page 211]

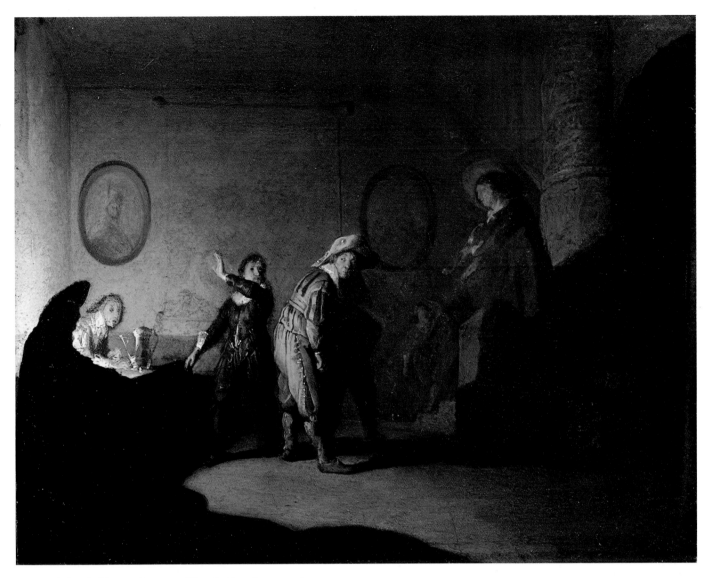

Leiden School. *Playing La Main Chaude*. Panel, 20 × 26 cm
National Gallery of Ireland, Dublin. [page 211]

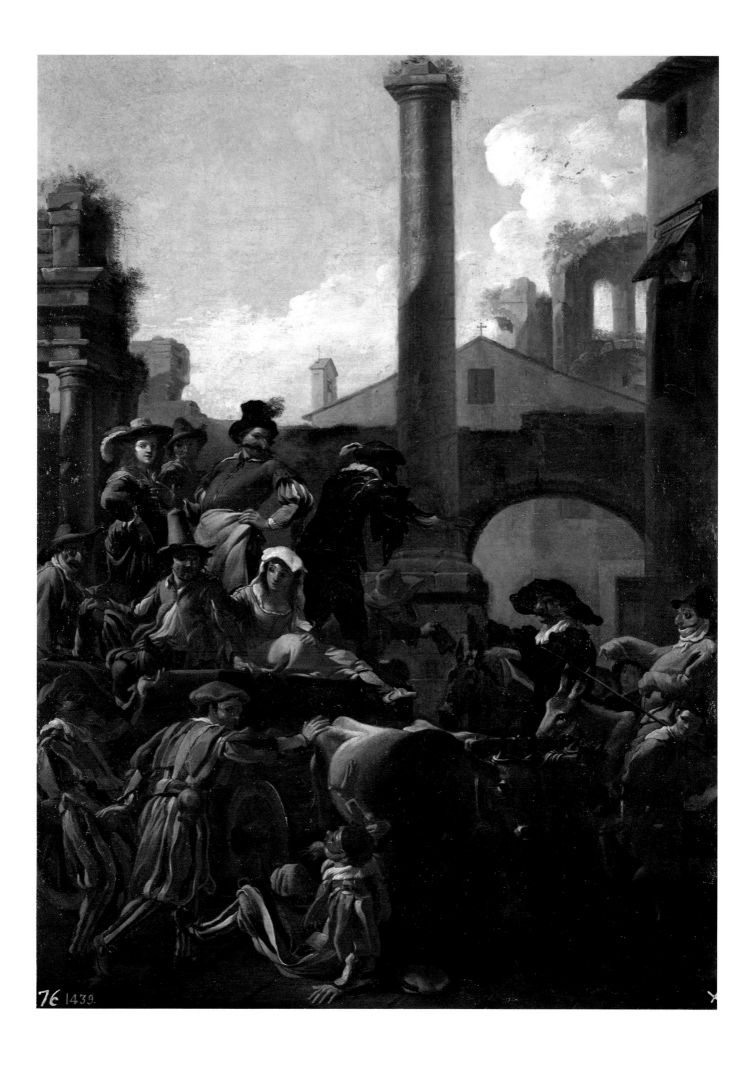

Jan Lingelbach (1622-74). *Marketplace in an Italian Town, with a Dentist*, 1651. Canvas, 68.5 × 86 cm
Rijksmuseum, Amsterdam. [page 214]

OPPOSITE:
Jan Miel (1599-1664). *Masquerade*, 1653. Canvas, 68 × 50 cm
© Museo del Prado, Madrid. [page 213]

Adriaen van Ostade. *The Artist in his Studio*, 1663. Panel, 38 × 35.5 cm
Staatliche Kunstsammlungen, Dresden. Gemäldegalerie Alter Meister. [page 214]

Adriaen van Ostade. *The Courtyard of an Inn with a Game of Shuffleboard*, 1677.
Panel, 33.7 × 47 cm
Wellington Museum, Apsley House, London
[page 210]

Willem Duyster. *Backgammon-players.*
Panel, 41 × 67.6 cm
Reproduced by courtesy of the Trustees, National Gallery, London
[page 210]

209

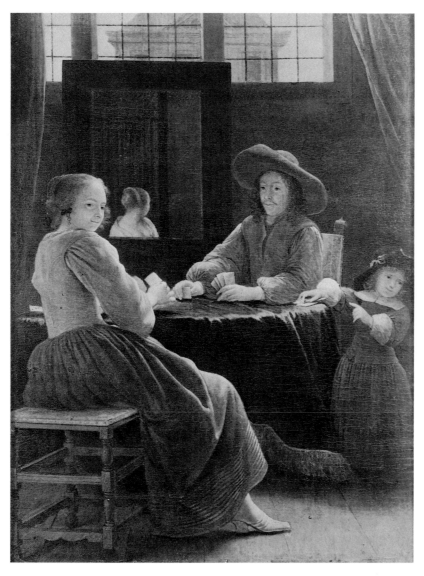

Cornelis de Man. *Card-players*. Canvas laid down on panel, 43.2 × 33 cm
The National Trust, Polesden Lacey, near Dorking
[page 210]

two related traditions for the representation of scenes of gaming: they were seen as typifying idleness, the foolish misuse of time, or alternatively, games of chance were thought of as symbols of human mortality – man's life was as chancy as the fall of the dice. Willem Duyster's backgammon-players [209], so absorbed in their game, are engaged in a thoroughly futile pursuit: their time – and, by extension, their whole lives – evaporate like the smoke puffed into the air by the men with pipes. On the castiron stove on the right are the figures of a religious scene, probably *The Adoration of the Magi*: a clear contrast is intended with the very secular gaming.

Cornelis de Man gives different emphasis to his chess game between a man and woman. The woman looks toward the spectator with a sensual smile, encouraging us to equate the game with the game of love [203]. Chess had been depicted as a lovers' game in the Middle Ages: in an engraving by Master E.S. from the middle of the fifteenth century, a chess game is shown at the centre of an enclosed love-garden occupied by three amorous couples.

Cornelis de Man also painted a card-game in progress: as well as a couple there is a young child who has distracted the woman's attention, causing her to look away [210]. It is difficult to know whether de Man means to show anything more than a quiet domestic occasion but the painting has been associated with an emblem devised by Johan de Brune, the motto of which – above a card-playing couple – is '*U zelven hoort, geen ander woord*' ('You hold the heart, no more words'). The woman holds the ace of hearts, which she shows to the viewer: the text explains that the woman, who commands the man's heart, will always win.

In other circumstances, games of chance can lead to drunken brawls, as in Jan Steen's theatrically violent *Card-players Quarrelling* [199]. The man on the left, who is restrained by his wife and child from drawing his sword, is dressed in the costume of Capitano, a character in the *commedia dell'arte* who is boastful and cowardly. His fine clothes are deliberately contrasted with the rags of the peasant who has drawn his knife. The whole drama can be

Shuffleboard and skittles

Taverns were a focus for Dutch social life and some enterprising landlords provided games for their customers. In a painting of 1667 by Adriaen van Ostade a game of shuffleboard (*sjoelbak*) is in progress: the long polished table along which a coin (or a disc) is propelled by a sharp blow with the inside of the player's hand has been set up by the tavern-keeper in his garden beneath a roof to protect it (and the players) from the elements [209]. This particular inn also boasts a bowls court. Skittles was another popular game played in inn gardens: Jan Steen shows a game in progress outside The White Swan [202].

Backgammon, chess and cards

In taverns and at home card-games and backgammon were popular pastimes. There were

thought of as an illustration of the sin of Anger.

Parlour games

Parlour games, played by young people and involving an important element of flirtation, were also depicted by genre painters. In a picture in the Mauritshuis, Cornelis de Man shows young men and girls playing a game known as *La main chaude*. The young man has put his head in a woman's skirts: he then puts his right hand on his back and the game is to guess who has touched his hand and at the same time smacked his behind [204]. The game was painted by a number of artists, including Jan Molenaer and an unidentified artist from the Leiden circle of Rembrandt, in a painting in Dublin [205]. It offered fascinating possibilities for the artist, who in his posing of the young man in the woman's lap could suggest woman's dominance of men by compositional reference to the biblical story of Samson and Delilah (Samson slept in Delilah's lap while the Philistines cut his hair). The potential dangers of this seemingly innocent game were seen by the Calvinist Johan de Brune: emblem 32 in his *Emblemata* shows the game taking place under the motto: '*Een hoeren schoot is duyvels boot*' ('A whore's lap is the devil's boat').

A second parlour game, no doubt equally condemned by contemporaries for its amorous possibilities, was *Vrouwtje kom ten hoof* (Lady, come into the garden), which was painted by Godfried Schalcken [211]. The artist depicts himself as the young man on the floor wearing only an open shirt and breeches, according to Arnold Houbraken who, in his life of Schalcken, describes this as one of the artist's best paintings, in the manner of Dou. Just as Dou's slowness in painting details was legendary so, Houbraken says of Schalcken's work on this picture, 'it is said that he took a month to paint the tapestry curtain'. The game is one of 'forfeits', in which the players have to take off articles of clothing: in French it went by the name *Le Roi Detroussé*. Houbraken says that it was a great favourite among young people in Dordrecht where Schalcken was living from 1665, when he left Dou's studio, until 1691, just before he set out for England. This picture was painted around 1675.

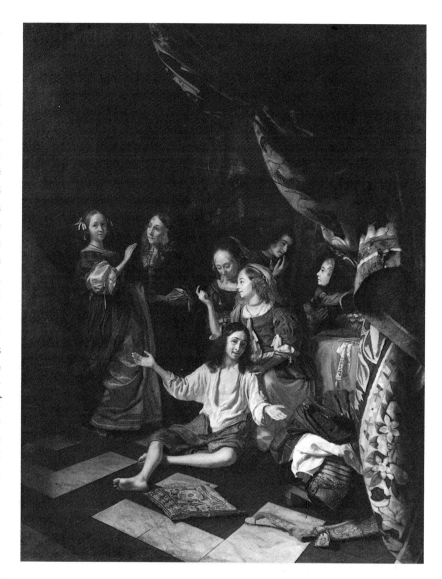

6. Foreign Scenes

Dutch painters travelled widely in Europe during the seventeenth century. They went to work in England, where, particularly in the years following the Restoration of Charles II, a large community of Dutch artists was established in London; to France, where they settled in Paris and in Lyon; to Germany, where, for example, Jan Weenix and Adriaen van der Werff were employed at the court of the Elector Palatine in Düsseldorf; and even to Brazil, where the painters Frans Post and Albert van Eeckhout travelled in the entourage of Prince Johan Maurits. The route which led painters from the Netherlands to Italy and particularly to Rome was, however, especially well trodden and had been since the early sixteenth century. For many Dutch artists travel to Italy was akin to a pilgrimage, a chance to worship at the

Godfried Schalcken (1643-1706). '*Lady, Come into the Garden*' ('Vrouwtje kom ten Hoof'). Panel, 63.5 × 49.5 cm Collection of Her Majesty Queen Elizabeth II, Buckingham Palace, London. Copyright reserved. [page 211]

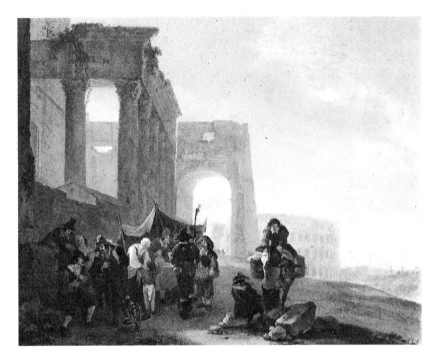

Jan Both (c. 1615–52). *Street Scene with Roman Ruins*. Canvas, 67 × 83.5 cm
Rijksmuseum, Amsterdam
[page 214]

Margutta and the Via Paolina at the foot of the Spanish steps and drinking together in chosen taverns. In 1623 they formed a fraternal association, the *Schildersbent* (literally, 'band of painters'), which involved initiation rites (characterized by drunken feasting), the adoption of nicknames and the performance of dramas and tableaux. The *Bent* gained a notorious reputation for rowdy behaviour and came into frequent conflict with the Accademia di San Luca: it was finally suppressed in 1720.

In the context of genre painting, one group of Dutch artists who went to Rome is of particular interest, the so-called *bamboccianti*. They were given this curious title after the nickname in the *Schildersbent* of their leader, Pieter van Laer, *Il Bamboccio*. It was a cruel nickname, in keeping with the robust and unsubtle humour of the *Schildersbent*: it literally means 'grotesque or ill-formed baby' and mocks van Laer's hunchback. The word *bambocciata* was coined by Italian writers to describe a form of painting unknown to the Roman public – the street scene – for which no existing critical term was appropriate.

shrines of classical Antiquity and the High Renaissance, and also to become familiar with more recent developments in Italian art. Others were lured to Italy by its landscape, particularly that of the Roman Campagna, dotted with the visible remains of the classical past. In Rome Netherlandish artists established a distinct colony, living principally on the Via

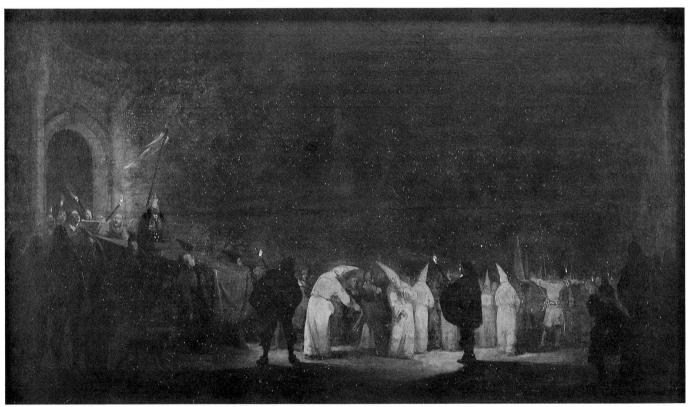

Gerard Terborch. *Procession of Flagellants*. Panel, 41 × 71.5 cm
Museum Boymans-van Beuningen, Rotterdam [page 214]

Of Pieter van Laer's training in his native Haarlem nothing is known, although his earliest work suggests the influence of Esaias van de Velde. Van Laer, travelling with his brother Roelant who was also a painter, was in Rome by 1625 or 1626. He brought to Italy the already established Dutch genre format of small-scale paintings of full-length figures shown going about their business in the streets. When in Rome van Laer took for his subjects the life he saw about him – particularly the beggars, pedlars, gipsies and gamblers who thronged the city, and the peasants of the countryside around it. Although the scale of Caravaggio's paintings and, for the most part, its subject-matter, is a far cry from van Laer's small-scale canvases and panels, the Italian painter's naturalism – which had so shocked and excited contemporaries – was a powerful impetus towards the development of *bambocciate*, which also employed his dramatic lighting techniques. In their use of Caravaggesque chiaroscuro some of the *bamboccianti*, notably Jan Lingelbach and Michael Sweerts, went far further than van Laer himself.

Van Laer's *Gipsy Encampment* (Vaduz, Collection of the Prince of Liechtenstein) is an excellent example of his style: the bustling, preoccupied figures, notably the men in the foreground absorbed in their game of *morra*; the domestic details, such as the woman stoking the brazier and, in the top left-hand corner, the laundry hanging out to dry; the numerous animals, in this case dogs and donkeys; and the use of the shadows and bright highlights, such as the white shirt of the *morra* player, the headscarf of the woman and the flames of the brazier. An early Italian biographer of van Laer, Giovanni Battista Passeri, described his Italian street scenes as a 'window onto life', and in a scene like this one it is clear what he meant.

In the twelve or thirteen years which he spent in Rome, van Laer achieved great success with an aristocratic Roman public. In 1636 paintings by him were valued at 30 to 35 *scudi*, an extraordinarily high price, far more than many established Roman painters commanded; and among his distinguished patrons were Marchese Vincenzo Giustiniani, who also collected paintings by Caravaggio and his followers, and

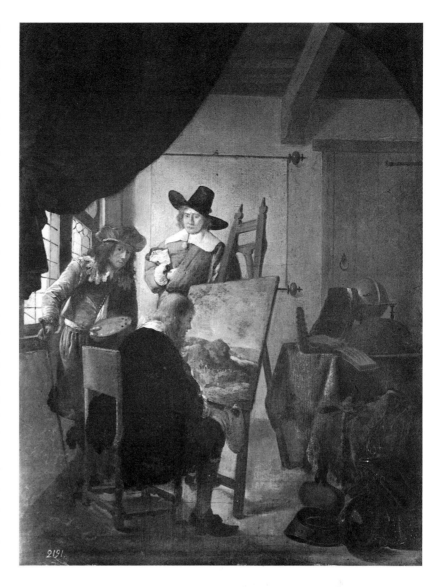

Poussin's great friend Cassiano del Pozzo.

Van Laer's closest Netherlandish follower was a fellow-member of the *Schildersbent*, Jan Miel, from Beveren near Antwerp, who painted a pair of street scenes in van Laer's manner as early as 1633. Miel, who was particularly attracted by rowdy scenes of carnivals and masquerades (like his painting of 1653 in the Prado, Madrid) [206], was to spend his entire career in Italy, eventually deserting *bambocciate* for decorative history painting which suited his talents far less well.

Jan Lingelbach from Amsterdam seems to have arrived in Rome in 1644, five years after van Laer's departure, and yet, presumably through contact with Miel and the native Roman painter of *bambocciate*, Michelangelo Cerquozzi, he came under the powerful influence of van Laer's style. Indeed, he followed it

Job Berckheyde
(1630-93). *The Artist in his Studio*, 1659
Hermitage, Leningrad
[page 214, 215]

213

so closely that there has been considerable subsequent confusion about the attribution of individual paintings and only recently have the *oeuvres* of the two artists begun to be disentangled. Lingelbach's *Italian Marketplace* of 1651, probably painted soon after he had returned to Amsterdam, shows an itinerant dentist performing an extraction while on horseback. An enthralled crowd has gathered. It is a traditional Netherlandish subject (see Chapter 3), transported to an Italian town and set against a background of a classical sarcophagus and columns. The artist strongly emphasises light and shadow in order to lead the eye towards the distant, sunny Italian landscape [207].

Dutch landscape painters travelled out of Rome into the Campagna to fill their sketchbooks with views of the countryside, its classical ruins and its inhabitants, and this rich material they mined for many years after their return home. Jan Both, who was back in his native Utrecht by 1641 after several years in Rome, is best known as a painter of Italianate landscapes but in his *Street Scene with Roman Ruins* (Rijksmuseum, Amsterdam) he collaborated with his brother Andries, a figure painter, on a characteristic *bambocciata* – a pedlar and stallholders plying their trades against a grand backdrop of classical monuments. The Colosseum can be seen in the distance [212].

Quite different in character from the *bambocciate*, and certainly the single most remarkable painting of a foreign scene by a Dutch painter during the seventeenth century, is Gerard Terborch's *Flagellants' Procession* (Rotterdam, Museum Boymans-van Beuningen) [212]. This eerie night-time scene was probably glimpsed by the much-travelled artist in Rome in the 1630s. Some years later, in 1645, Evelyn witnessed a similar procession: 'On Good Friday... at night was a procession of several who most lamentably whipped themselves till the blood stained their clothes, for some had shirts, others upon the bare back, having visors and masks on their faces; at every three or four steps dashing the knotted and ravelled whipcord over their shoulders, as hard as they could lay it on; whilst some of religious orders and fraternities sung a dismal tone, the lights and crosses going before, making altogether a horrible and indeed heathenish pomp.' We have no way of knowing whether Terborch shared Evelyn's Protestant revulsion but he was certainly impressed by the extraordinary pictorial possibilities of the scene, with touches of red and flashes of yellow in the grey evening light.

7. The Painter in his Studio

It would be surprising if genre painters, for whom the occupations of others provided such rich raw material, had not also represented their own profession at work. Sometimes these scenes took the form of a self-portrait or an allegory of painting, but Adriaen van Ostade, in his painting of 1663 in Dresden, treats the artist at work in his studio as a genre subject, like any other occupation. His face is seen in profile only: he sits in front of his easel, maulstick and palette in his left hand, brush in his right. Resting his arm on the maulstick, he paints a landscape on a panel. Above it, pinned to his easel, is a drawing done from nature to which he refers from time to time. On a three-legged stool to his right are brushes, paints, oils and varnishes. Elsewhere is the clutter of the studio – drawings strewn on the floor, canvases stacked against the wall, books, a plaster head, a lay figure and, more exotically, reindeer horns and an ox skull. The quiver full of arrows is a studio prop. The scene is set in the same type of rustic barn in which Ostade places so many of his domestic and tavern scenes: this is a rural peasant painter and not an urban bourgeois one [208].

Ostade made an etching of a very similar studio, although here he added two apprentices grinding colours and cleaning brushes. The artist has his sketchbook propped up on a table beside him. The inscription underneath is unexpectedly high-flown: the artist can achieve fame, as did the renowned Greek painter Apelles, by deceiving the eye.

Job Berckheyde, in a painting of 1659 in the Hermitage, Leningrad, shows a very different interior, perhaps that of his own studio in Haarlem. Such clutter as there is in this room

is carefully arranged; the lute, globe and books on the table are to be painted in a still-life. The piled-up armour is a studio prop to be donned by a model who would then be posed for a figure such as Mars in a history painting. This is unexpected if the scene is meant to be Berckheyde's own studio, since he was almost exclusively a painter of topographical scenes. The actual subject of Berckheyde's painting is the visit to the studio of a prospective client; seated in front of the easel, he is being shown a landscape by the deferential painter, who may be a self-portrait [213].

Gerrit Dou was particularly interested in the subject of painters in their studios. Early in his career he showed a young painter standing before his easel on which there is a large canvas of a biblical subject (Private collection, London). Dou's painting dates from around 1630, when he was in Rembrandt's studio, and the painter has been identified as his master. It is, however, hard to see Rembrandt's well-known features in this pinched and apprehensive face. The studio contains canvases stacked against the wall and, prominently in the right foreground, a pile of studio props; on the wall, an umbrella and a circular portrait; and behind the painter a small table on which rest books, a violin and a candle. At the door is a prosperously dressed man, presumably the patron for whom the picture on the easel has been painted.

Dou returned to the subject in a painting of 1649 in the Bayerische Staatsgemäldesammlungen, Munich. The elderly painter is placed within one of Dou's 'niches'. On the ledge of the niche lie a plaster head, a dead peacock, a shell, a brass jug and an open book, all suitable elements for a *vanitas* still-life. Above the artist hangs a winged cupid, placed there so that he can paint it from below, judging the foreshortening of the limbs.

Two years earlier, in 1647, Dou had painted his self-portrait in a similar format [216]. The objects around him are the apparently casual clutter of the studio; in fact, they are all carefully chosen and arranged. Hercules, protector of the arts, is present in the sculpture of *Hercules and Cacus* by Leonhard Kern. The lute, violin and music-book refer to the parallels – in terms of harmony and proportion – that

were often made between painting and her sister art of music; the globe represents the visible world which is the painter's subject. The snuffed-out candle on the left is a *vanitas* element, a reminder that all human endeavour, that of the painter as much as anyone else, is futile in face of human mortality.

Of all depictions of the artist in his studio by Dutch genre painters, the most intriguing – as well as the most perfect – is Vermeer's *Art of Painting* (Vienna, Kunsthistorisches Museum) [215]. Vermeer, the subtlest of realistic painters, employs an allegorical mode to express his ideas. The artist's model is dressed as the muse of History, Clio. She wears a crown of laurel and holds a trumpet and a volume of Thucydides, just as Cesare Ripa described her in his *Iconologia*, which Vermeer would have known in the Dutch edition of 1644. Vermeer's meaning is that the muse of history should be the inspiration of the artist – a high-minded sentiment familiar from van Mander and other theorists but hardly one that Vermeer (with the exception of a few very early paintings) ever put into practice. The presence of the map on the back wall refers to the idea that the painter's work will enhance the fame – and Clio's laurel wreath and trumpet are also attributes of fame – of his country. One of the town views which are on either side of the map shows Delft and the painting was prophetic of the fame brought to the town by Vermeer – and above all by his genre paintings.

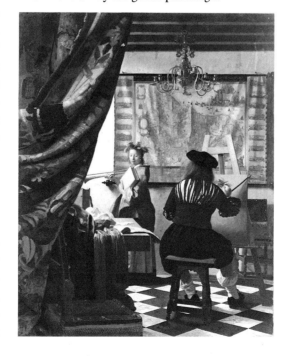

Jan Vermeer. *The Art of Painting.* Canvas, 120 × 100 cm Kunsthistorisches Museum, Vienna [page 215]

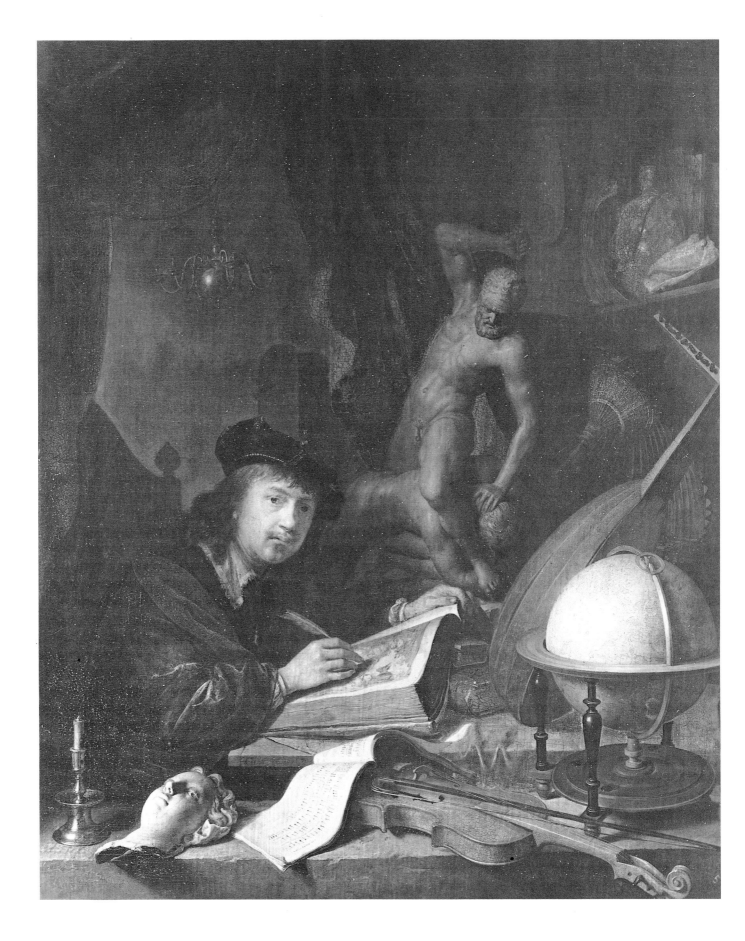

Gerrit Dou. *The Artist in his Studio*, 1647. Panel, 43 × 34.5 cm
Staatliche Kunstsammlungen, Dresden. Gemäldegalerie Alter Meister. [page 215]

Notes

These short notes are intended to provide a guide to the sources consulted and, in some cases, suggestions for further reading. Full details can be found in the Bibliography. References to individual paintings in standard mongraphs (which are given in the literature sections of the Appendix) and museum catalogues (listed separately in the Bibliography) have not been given in the Notes.

Preface

The exhibition catalogues referred to are: Cat. London 1978/9; Cat. Amsterdam 1976. For the work of Emmens and de Jongh, see the Bibliography.

I. INTRODUCTION

Themes and Interpretations

This section is based on the interpretation of Dutch genre painting elaborated in the work of Emmens and de Jongh: see under these authors in the Bibliography; and Cat. Amsterdam 1976. For the historiography of this approach, see Renger 1978.

For a useful discussion of the term genre, see Comer/Stechow. Diderot, Quatremère de Quincy and Kügler are quoted in Comer/Stechow.

Junius on Aertsen: Hadrianus Junius, *Batavia*, Antwerp, 1588, pp. 239-40.

Bellori on Van Laer: Giovanni Pietro Bellori, *Le Vite de' Pittori, Scultori et Architetti Moderni*, Rome, 1672, p. 21.

Michiel on the Grimani Breviary: ed. T. Frimmel, *Der Anonimo Morelliano: Marcantonio Michiels Notizia d'Opere del Disegno*, Vienna, 1888, p. 104.

Campin's Merode Altarpiece: M. Schapiro, 'Muscipula Diaboli: The Symbolism of the Merode Altarpiece', *The Art Bulletin*, 27, 1945, pp. 182-7.

Lucas van Leyden: see Cat. Amsterdam 1978.

Bruegel: For a good modern discussion of Bruegel, with a useful bibliography, see Gibson. For the paintings, see Grossmann. For a more extended account of various aspects of his iconography, see Stridbeck. For a convenient modern edition of the prints, see Klein. For a stimulating discussion of his attitudes towards peasants, see Alpers 1972/3.

For the significance of the market and kitchen scenes of Aertsen and Beuckelaer: see Emmens, vol. 4, pp. 189-221; for an opposing view, see Moxey 1976.

For the *homo bulla* theme, see de Jongh 1971, pp. 81-90; Cat. Amsterdam 1976, pp. 44-7; and for its continuation in the eighteenth and nineteenth centuries, see Snoep-Reitsma.

For a bibliography of Dutch emblem books, see Land-wehr. For studies of Dutch emblem books, see Monroy; Praz; and Porteman.

For Steen's *Grace before Meat*, see Sutton 1982/3, pp. 29-31. For sunflower symbolism, see Emmens, vol. 3, pp. 99-115.

For Dou's *Quack Doctor*, see Emmens, vol. 4, pp. 5-22; Cat. Amsterdam 1976, pp. 87-9; Gaskell.

Fromentin: for an annotated modern edition, ed. H. Gerson, *The Masters of Past Time: Dutch and Flemish Painting from Van Eyck to Rembrandt by Eugene Fromentin*, 2nd edition, Oxford, 1981.

For smoking, see Cat. Amsterdam 1976, pp. 55-7.

For Maes' *Sleeping Kitchenmaid*, see Cat. Amsterdam 1976, pp. 145-7.

For Vermeer's *Girl Asleep at a Table*, see Blankert 1978, pp. 28-9, 156 (with full bibliography).

For music-making and love, see de Jongh 1971; Cat. Amsterdam 1976.

For the paintings by Netscher, see Cat. Amsterdam 1976, pp. 197-9; Cat. London 1978/9, p. 30.

The Transformation of Dutch Society

For this section I have found the following particularly useful: Parker 1977, 1979; Cipolla; Boxer; Grigg; van Dillen; Lis and Soly; den Tex; J. de Vries 1974, 1976; Roorda 1961, 1967, 1971; Zumthor; van Deursen; de Vrankrijker.

For the Flemish immigration, see Briels.

The Family and the Home

For this section I have consulted, on the history of the family in general: Ariès; Stone; Laslett; Mitterauer and Sieder; Flandrin; Anderson; and on the Dutch family in particular: van Deursen; van der Woude; Haks (with valuable up-to-date bibliography); Schotel 1903.

Parival is quoted by Zumthor, p. 100 (children) and p. 137 (cleanliness).

Temple: *The Works of Sir William Temple, Bart.*, London, 1815, 4 vols., vol. 2, pp. 472-3.

De la Barre is quoted by Zumthor, p. 136.

For domestic songbooks, see Schotel 1903, pp. 179-83.

Jan Luicken and his son Caspar were immensely prolific: among their best-known publications are *Jesus en de Ziel* (1678), *Voncken der Liefde Jesus* (1687), *Spiegel van het Menschelijk Bedrijf* (1694), *De Byekorf des Gemoeds* (1709), *Het Leerzaam Huisraad* (1711), and *Des menschen Begin, Midden en Einde* (1712). For a study of their work, see P. van Eeghen and J. P. van der Kellen, *Het werk van C. en J. Luiken*, Amsterdam, 1905.

Theory: Gerard de Lairesse on 'Modern Painting'

The edition of Lairesse used is the English translation of
1778; see Lairesse 1778, pp. 96-112.
For a discussion of Van Mander's and Van Hoogstraten's
categories of painting, see Miedema 1975.
Philips Angel on *cortegaerdjes*: Angel, p. 42.

Practice: Towns and their Painters

For biographies of individual artists, see Appendix.
For Haarlem, see Cat. New Brunswick 1983.
For Delft, see M. Eisler, *Alt Delft*, Amsterdam/Vienna,
1923; Cat. Delft 1981; W. Liedtke, *Architectural Painting
in Delft*, Doornspijk, 1982.
For the Utrecht Caravaggisti, see Cat. Utrecht, 1952;
Nicolson 1979.

Postscript

For the debate about 'iconographic erosion', see L. de Vries
1977; Sutton 1980, pp. 41ff.; de Jongh 1980, pp. 184-5.

2. PROVERBS

For Bruegel's *Netherlandish Proverbs*, see Grossmann,
pp. 55 (note 91), 191; Gibson pp. 65ff.
For Jordaens' treatments of Flemish proverbs, see
d'Hulst, pp. 176-81.
For Dutch proverbs, see Harrebomée.

3. THE WORLD OF WORK

The Work of Men

Particularly useful were: van Deursen, vol. 1; de Vranrij-
ker.

The Professions

For doctors and dentists in the United Provinces in the
seventeenth century, see van Andel (with bibliography).
For the theatricality of Steen's figures, see Gudlaugsson
1945.

Alchemists, Astrologers and Astronomers

For Bruegel's print of *The Alchemist*, see M. Winner, 'Zu
Bruegels *Alchemist*', in ed. O. von Simson and M. Winner,
Pieter Bruegel und seine Welt, Berlin, 1979, pp. 193-202.
For astronomers, see Cat. Amsterdam 1976, pp. 83-5.
'Dr Faustus': van de Waal, pp. 133-81 (esp. Appendix 3).
Const van procognosticeren uyt de Handt...: Schotel 1873/4,
vol. 1, p. 143.

The Life of Soldiers

For literary accounts of the misbehaviour of soldiers, see
Playter, chapter 1.
Boerenverdriet: see Fishman.

Street Scenes

For Metsu's *Poultry-seller*, see Cat. Amsterdam 1976,
pp. 166-9.
For Steen and the *rederijkers*, see Heppner; Gudlaugsson
1945; L. de Vries; Sutton 1982/3, pp. 25-8.
For Lucas van Leyden's beggars, see Silver; Cat. Amster-
dam 1978, pp. 70-1; Cat. Washington 1983, pp. 206-7.

4. PRIVATE AND DOMESTIC LIFE

Love and Courtship

For the Power of Women theme, see Cat. Amsterdam
1978, pp. 49-61.
For letter-writing, see Bray; Cat. Amsterdam 1976,
pp. 36-9; Alpers 1983, pp. 192-207.

Women and the Home

For general references, see notes to *The Family and the
Home*, above.
Cats: Cats, vol. 1, p. 395.
Mother searching her child's hair for fleas: Gudlaugsson
1960, nos. 95, 96; Cat. The Hague 1974, nos. 24, 25; Cat.
Amsterdam 1976, pp. 40-3.
Grace before Meat: Sutton 1982/3, pp. 29-31.

Children at School and at Play

For Dou's *The Lying-in Room* triptych: Emmens, vol. 4,
pp. 5-22.
Batty: mentioned by Stone, p. 122.
Bruegel's *Children's Games*: Grossmann, p. 191; Gibson,
pp. 85-9 (with reference to the poem published by van
Doesborch).
Dutch children's games: Schotel 1903, pp. 62-78.
Cats' *Kinderspel...*: de Jongh 1971, pp. 42-4.
French account of Dutch children's games: Schotel 1903,
p. 77.

Family Festivals and Wedding Feasts

St Nicolas and Twelfth Night: ter Gouw, pp. 171-85;
Schotel 1903, pp. 193-213, 356-63; Zumthor, pp. 180-92.
Jan Steen's *Twelfth Night Feast* (Woburn); Cat. London
1976, no. 107.

Jordaens' *Twelfth Night Feasts*: d'Hulst, pp. 179-80.
Steen's *Pentecostal Flower*: Sutton 1982/3, pp. 9-11.
Bruegel's print of *The Wedding Dance*: Klein, pp. 115-17.
The Unequal Lovers theme: see A. G. Stewart, *Unequal Lovers: A Study of Unequal Couples in Northern Art*, New York, 1977.
Tafelspelen: Kren 1980, pp. 77ff.
Molenaer's *Allegory of Marital Fidelity*: van Thiel 1967/8.

5. RECREATION AND PLEASURE

Merry Companies

For a discussion of Kittensteyn's print after Dirk Hals: de Jongh 1971, pp. 6-8.
For Dirk Hals' *Garden Feast*: Cat. Amsterdam 1976, pp. 124-5.
For Buytewech's *Merry Company* (and its relationship to the Cats emblem): Cat. Amsterdam, pp. 64-7.
For Pot's *bordeeltje*: Cat. London 1978/9, p. 13.

Taverns and Brothels

For a discussion of Baburen's *The Procuress*: Cat. Philadelphia 1984, no. 1.
For the Prodigal Son theme: Renger 1970.
For Rembrandt's *Self-Portrait with Saskia*: Mayer-Meintschel.
Steen's *Man offering an Oyster to a Woman*: Cat. London 1978/9, p. 32.
Knüpfer's *Brothel Scene*: Kuznetsow.
Parival: quoted by Zumthor, pp. 163-4.
Steen's *Egg Dance*: Cat. London 1976, no. 108.

Fairs in Town and Country

Fairs: Zumthor, pp. 188-92.
Bruegel's *kermis* prints: Klein, pp. 107-13.

Pastimes and Games

Pastimes and games: Schotel 1903, pp. 169-92, 341-47.
Bruegel's *Skaters at the Gate of St George*: Klein, pp. 103-5.
For the symbolism of gaming scenes: Cat. Amsterdam 1976, pp. 108-11.
For Duyster's backgammon-players: Cat. London 1978/9, p. 26.
For de Man's chess game: Cat. Amsterdam 1976, pp. 154-7; for his card-players: ibid, pp. 150-3; for *la main chaude*: ibid, pp. 158-61.
For Schalcken's *Vrouwtje komt ten hoof*: Cat. Amsterdam 1976, pp. 222-3.

6. FOREIGN SCENES

For the *bamboccianti* and the *Schildersbent*: Hoogewerff 1952; Janeck 1968; Kren 1983 (with valuable bibliography).
Evelyn's account of a flagellants' procession in Rome is quoted by Gudlaugsson 1960, I, p. 37.

7. THE PAINTER IN HIS STUDIO

For this subject: Cat. Nijmegen 1964; Cat. Delft 1964/5.
Dou's self-portraits: Gaskell.
Vermeer's *Art of Painting*: van Gelder.

Appendix

BIOGRAPHIES OF THE ARTISTS

The early sources referred to in these short biographical notes on the artists whose work is discussed in this book are: Van Mander: Carel van Mander, *Het Schilderboek*, Haarlem, 1604; Van Gool: Johan van Gool, *De nieuwe schouburgh der Nederlandsche kunstschilders en schilderessen*, 2 vols., The Hague, 1750/1; Houbraken: Arnold Houbraken, *De Groote Schouburgh der Nederlandse Konstschilders en Schilderessen*, 3 vols., Amsterdam, 1718-21; de Piles: Roger de Piles, *Cours de Peinture*, Paris, 1708; Sandrart: ed. A. Peltzer, *Joachim van Sandrart's Academie der Bau, Bild und Mahlerey-Kunste von 1675*, Munich, 1925; Weyerman: C. Weyerman, *De Levensbeschryvingen der Nederlandsche Kunstschilders*, 4 vols., The Hague, 1729-69.

ARENT ARENTSZ. 1585/6-1631

He was the son of a sail-maker who lived on the Zeedijk in Amsterdam in a house called De Cabel. He married at Sloten near Amsterdam in 1619, and worked in Amsterdam where he had a house built on the Prinsengracht which he named De Cabel after his family house. He was known as Cabel. It has been recently discovered that he was buried in the Old Church at Amsterdam in 1631.

These are the few known facts of Arentsz.'s life. Nothing is known of his artistic training. His work, which consists exclusively of landscapes with figures, is dependent on that of Hendrick Avercamp. That it was Avercamp rather than Arentsz. who was the innovator of this type of landscape can reasonably be assumed from the fact that Arentsz.'s earliest extant dated work is from 1629, later than the earliest related works by Avercamp.

HENDRICK AVERCAMP 1585-1634

He was born in Amsterdam, but in 1586 the family moved to Kampen in the province of Overijssel. His father was an apothecary. Dumb from birth, he was known as *stomme van Campen* (the mute of Kampen). He may have been *de stom* who was recorded as living in the house of the painter Pieter Isaacsz. in Amsterdam in 1607. He is recorded in Kampen in 1613 and appears to have remained there for the rest of his life.

Avercamp painted landscapes with figures, particularly ice scenes, and also made a large number of water-colour drawings of winter scenes, fishermen and peasants. His style is based on that of the Flemish followers of Pieter Bruegel the Elder and he may well have been a pupil of one of those Antwerp painters who settled in Amsterdam, possibly David Vinckboons. Avercamp's earliest dated painting is from 1608: there are a few other dated paintings but as his style does not significantly change, the construction of a chronology of his surviving paintings is problematic.

Among Avercamp's followers and imitators were his nephew, Barent, whose work has often been confused with his own, and Arent Arentsz., known as Cabel.

Literature: Welcker; Cat. Amsterdam 1982.

DIRCK VAN BABUREN c. 1595-1624

He was born in the province, if not actually within the city, of Utrecht, probably in about 1595. He is first mentioned in 1611, in the records of the guild of St Luke in Utrecht, as a pupil of Paulus Moreelse, who is best known as a portrait painter but who also painted a number of religious and mythological subjects. Subsequently Baburen travelled to Italy, perhaps as early as 1612. With his friend David de Haen, he was commissioned to decorate the Pietà chapel in San Pietro in Montorio in Rome between 1615 and 1620. The altar painting, *The Entombment*, which is still in place, was said in 1875 to bear the date 1617, but this is no longer visible. It is closely related to Caravaggio's treatment of the subject, which then hung in the Chiesa Nuova and is today in the Vatican Gallery. In Rome Baburen enjoyed the patronage of the Marchese Vincenzo Giustiniani and Cardinal Scipione Borghese. He returned to Utrecht, probably in 1620, certainly by 1622. From 1622 until his death two years later, Baburen had a close working relationship (and perhaps even shared a studio) with Hendrick Terbrugghen. He was buried in the Buurkerk, Utrecht.

In Rome Baburen was influenced by the work of Caravaggio and his followers, especially Bartolommeo Manfredi. He was an important iconographic innovator, treating certain religious and secular subjects (such as Saint Sebastian attended by Saint Irene and a scene from Hooft's play *Granida and Daifilo*) for the first time in the Netherlands. He also played a key role in the development of certain Caravaggesque genre subjects, painting half-length single figures of lute-players and singers, as well as concerts and groups of card-players.

Literature: Slatkes.

CORNELIS BEGA c. 1631/2-64

He was born in Haarlem and is said by Houbraken to have been a pupil of Adriaen van Ostade. In 1653 he travelled with the Haarlem painter Vincent Laurensz. van de Vinne

in Germany and Switzerland. He entered the Haarlem guild in the following year and remained in the town until his death there in August 1664.

Bega painted peasant scenes of a type derived from Adriaen van Ostade. His style, however, is very different from that of Ostade, his forms being characterized by firm, linear outlines and the surfaces being far more highly finished. He also made about thirty-five etchings of scenes from peasant life. There are dated works from 1650 onwards.

JOB BERCKHEYDE 1630-93

He was born in Haarlem and was a pupil there of Jacob de Wet, a Rembrandtesque history painter. In the years after 1650 he travelled, with his younger brother Gerrit (born in 1638), who was his pupil, in Germany. They visited Cologne, Bonn, Mannheim and Heidelberg where they worked at the court of the Elector Palatine. From Heidelberg they returned to Haarlem where they lived for the rest of their lives, sharing a house with an unmarried sister.

Both brothers were architectural painters, specializing in topographically accurate views of Haarlem, Amsterdam and elsewhere. Job Berckheyde also painted some biblical scenes, which reveal the influence of his master, and a few landscapes with figures. Self-portraits in his studio are his only domestic interiors.

GERRIT BLEKER active 1625, died 1656

His date of birth is unknown, but he was probably born in Haarlem, where he worked throughout his life. Nothing is known of his training. He took on three apprentices in 1640 and in 1643 he served as an official in the Haarlem guild. He may have been the father of the history painter, Dirck Bleker.

Gerrit Bleker painted landscapes with figures which show the strong influence of Elsheimer and of Cornelis Moeyaert. For the most part they show biblical scenes. He also etched biblical and rural subjects.

PIETER DE BLOOT c. 1602-58

His family came from Antwerp, but settled in Rotterdam when he was a child. Nothing is known of his training, but his peasant scenes reveal the strong influence of Adriaen Brouwer. He also painted biblical scenes and Van Goyenesque landscapes.

FERDINAND BOL 1616-80

He was born in Dordrecht, the son of a surgeon, and may have studied there with Jacob Gerritsz. Cuyp. In 1635 Bol was still in Dordrecht and already signing himself 'painter'.

Shortly afterwards he moved to Amsterdam and there entered the studio of Rembrandt at the age of about twenty and so probably more as an assistant than as a pupil. He left Rembrandt's studio in about 1637 and his earliest independent works, especially his portraits, show the strong influence of Rembrandt. Subsequently his portraiture is closer in style to that of Bartholomeus van der Helst, although his figure paintings remain strongly Rembrandtesque. Bol also made sixteen etchings in Rembrandt's style between the years 1642 and 1651. He enjoyed considerable success in Amsterdam, particularly with his portraiture. He painted group portraits and history pieces for public buildings in Amsterdam, Leiden and elsewhere, and, notably, for the Amsterdam Town Hall. His few genre paintings, such as *The Astronomer*, are treated in the same manner as his history paintings (and indeed the dividing line between history and genre is not very clear in paintings of this type). In 1669 Bol was married for the second time – to a rich widow – and thereafter appears to have given up painting for the leisured life of a prosperous member of Amsterdam's regent class, serving as a member of the board of governors of a charitable institution and acquiring a fine house on the Keizersgracht. Among Bol's pupils were Cornelis Bisschop and Gottfried (later Sir Godfrey) Kneller.

Literature: Blankert 1982.

ANDRIES BOTH 1612/13-41

He was born in Utrecht, the son of a glass-painter, Dirck Both. In 1624/5 he was a pupil, with his (presumably slightly younger) brother Jan, of Abraham Bloemaert. Andries subsequently travelled to Rome, where he is first recorded in 1635. He was still there in 1641. On his way back to the Netherlands later that year he visited Venice, where he was drowned.

In Holland, before his departure for Italy, Andries Both painted small genre scenes in a free, caricatural manner. They show figures in interiors – for example, drinkers in inns. In Rome he came under the strong influence of Pieter van Laer, *Il Bamboccio*, and himself began to paint *bambocciate*, which are characterized by his fat, grinning peasant types. He also painted figures in landscapes by his brother Jan, and Jan in his turn etched figures by Andries.

JAN BOTH c. 1615-52

He was born in Utrecht, the son of the glass-painter Dirck Both. He trained at first with his father and then, according to Sandrart, he and his elder brother Andries were pupils of the history painter Abraham Bloemaert. He says that the brothers travelled to France and then to Rome. Andries is recorded in Rome in 1635, and Jan in 1638. While there he was commissioned (with Claude Lorrain) to paint land-

scapes to decorate Philip IV of Spain's Buen Retiro Palace in Madrid. He probably returned to Utrecht in 1641 (after Andries' death in that year in Venice) and remained there for the rest of his life. He served as an *overman* of the Utrecht painters' association in 1649.

Almost all of Jan Both's works are landscapes based on the Italian countryside, particularly that of the Roman Campagna. Some contain mythological and religious subjects and there are a few topographically accurate views of Rome and Tivoli. Sandrart mentions that Andries painted figures in Jan's landscapes. Jan was also an etcher of landscapes and of figure subjects after Andries.

Literature: Burke.

RICHARD BRAKENBURGH 1650-1702

Born in Haarlem, he was, according to Weyerman, a pupil of the animal painter Hendrick Mommers. He is also said to have been a pupil of Adriaen van Ostade and of Jan Steen (who was in Haarlem between 1661 and 1669). Brakenburgh entered the Haarlem guild in 1687 and remained in the town throughout his career. As well as being a painter, he was a poet and a prominent member of the Haarlem *rederijker* chamber known as *De Witte Angieren*. Among other works, he wrote their *Nieuwjaarsdigt* performed on 1 January 1697. Brakenburgh painted genre scenes based very closely on those of Jan Steen, although his style is more precise in detail (he is particularly careful in recording details of dress) and far less animated. His palette is more sombre and conservative than that of Steen. He also etched genre scenes and painted portraits.

ADAM VAN BREEN active 1611-29

Very little is known of the life of the artist, who painted ice scenes in the style of Adriaen van de Venne. He married in The Hague in 1611 and entered the guild there in the following year. In 1617 he was rewarded by the States General for his dedication to them of a book which he had illustrated, *Les évolutions militaires suivant l'idée du Prince du Nassau*. He is last recorded in The Hague in 1618 and then in Amsterdam in 1628. He may be the Dutch artist of this name who is recorded at the court in Christiania between 1624 and 1646. He was also an engraver.

QUIRINGH VAN BREKELENKAM active 1648, died 1667/8

The place and date of his birth are not known, although he may have been born at Zwammerdam, his sister's birthplace, which is about twenty kilometres from Leiden. He was probably born in about 1620. He entered the Leiden guild in the year of its foundation, 1648, and apparently remained in the town for the rest of his life.

Brekelenkam painted peasant scenes and domestic interiors as well as a few still-lifes.

WILLEM BUYTEWECH c.1591/2-1624

He was born in Rotterdam, the son of a shoemaker. His teacher or teachers are unknown. He settled in Haarlem around 1611 and joined the guild in the following year. By 1617 he had returned to Rotterdam where he worked for the remainder of his short life.

Buytewech, known by contemporaries as 'Geestige' (ingenious or inventive rather than witty) Willem, was a highly original genre painter and print-maker. He is a crucial figure in the development of the 'merry company' scene, which in his hands became immensely elegant in composition and sophisticated in allusiveness. He etched illustrations to the works of Gerbrand Bredero and J.B. Houwaert. He also etched a series of small-scale landscapes, the *Various Landscapes* of 1616.

Literature: Haverkamp-Begemann.

PIETER CODDE 1599-1678

He was born and worked in Amsterdam, where he lived at first on the Jodenbreestraat and later on the Keizergracht. In 1637 he completed a large militia group, *The Corporalship of Captain Reynier Reael and Lieutenant Cornelis M. Blaeuw* (Rijksmuseum, Amsterdam), which had been left unfinished by Frans Hals. He was influenced by Hals; his work, which largely consists of small-scale genre scenes, is also close in style to that of Anthonie Palamedesz. of Delft and of Willem Duyster. Duyster may have been his pupil.

Codde's genre scenes show barrack-rooms, elegant interiors, carnivals and dances. He later came to concentrate increasingly on portraiture, handled on a similarly small scale and with close attention to detail, especially of dress.

Literature: Playter.

CORNELIS DECKER active 1640, died 1678

Very little is known about his life. He is mentioned as a member of the Haarlem guild in 1643 and appears again in the guild records in 1661.

For the most part Decker painted landscapes in a style derived from that of Jacob van Ruisdael's Haarlem period. He also painted, perhaps before he came under the strong influence of Ruisdael, a number of peasant interiors, which often show weavers at work.

OLIVIER VAN DEUREN 1666-1714

He was born in Rotterdam. The style of his very rare paintings derives from that of the Leiden *fijnschilders* and he may

have been a pupil of Frans van Mieris the Elder or of Caspar Netscher. Van Deuren served as a *hoofdman* of the Rotterdam guild on five occasions between 1697 and 1713. He appears to have spent all his life following his apprenticeship in Rotterdam and died in the town in 1714.

ARENT DIEPRAM 1622-70

Very little is known about this painter, who was baptized and died in Rotterdam. Houbraken gives an account of an Abraham Diepram who he says was a pupil of Hendrick Sorgh in Rotterdam and of Adriaen Brouwer, presumably in Antwerp. This artist, according to Houbraken, joined the Dordrecht guild in 1648 and later worked in Arnhem.

There are a number of paintings signed 'A Diepram' which clearly show the influence of Brouwer, but as Brouwer died in 1638 it is unlikely that he was Arent Diepram's third master as Houbraken claims. Houbraken is likely, in part at least, to be mistaken.

All the paintings signed by 'A Diepram' are of peasant subjects, painted in a rough, broad manner and in a restricted dark palette.

LAMBERT DOOMER 1622-1700

He was born in Amsterdam. His father, Harmen, who came from Anrath in Germany, was a furniture and frame maker. He supplied frames to Rembrandt (who painted portraits of Harmen Doomer and his wife Baertge Martens) and Lambert studied in Rembrandt's studio, presumably *c*.1640-5. In 1645 or 1646 Doomer left Amsterdam for Nantes; he travelled in France (with Willem Schellincks) in 1646, making numerous topographical studies. He also journeyed extensively in the Netherlands in the 1650s and 1660s and in 1663 he travelled along the Rhine. All these journeys are recorded in topographical drawings. In 1669, following his marriage in the previous year, Doomer moved to Alkmaar although he was still a frequent visitor to Amsterdam; in 1672, for example, he was in the city as a member of a commission set up to judge the authenticity of a group of paintings sold by the Amsterdam dealer Gerrit van Uylenburch to Frederick Wilhelm of Prussia. In 1695 Doomer moved back to Amsterdam and bought a house on the Rozengracht: he remained there until his death.

Doomer is best known for his topographical drawings in pen and wash, of which more than two hundred survive. There are only about thirty known paintings by him. The landscapes and the biblical, mythological and genre scenes all display the strong influence of Rembrandt while his portraits – which include group portraits of Alkmaar regents – are closer in style to Van der Helst and Flinck.
Literature: Schulz 1974.

GERRIT DOU 1613-75

He was born in Leiden, the son of a glass-engraver, Douwe Jansz. According to Houbraken he was first sent to study drawing with the engraver Bartholomeus Dolendo (1622-3), then studied with the glass-engraver Pieter Kouwenhorn, and finally worked in his father's studio. From 1625 until 1627 he was a member of the glaziers' guild. In 1628 Dou entered the Leiden studio of Rembrandt and remained with him until Rembrandt moved to Amsterdam in 1631 or 1632. He was one of the founder members of the Leiden painters' guild in 1648 and rarely left Leiden. One of the most successful of all Dutch seventeenth-century painters, Dou had a European reputation. In 1660 the States General of the United Provinces and the East India Company included some of his paintings among those presented to Charles II on his Restoration. Later the King tried unsuccessfully to tempt the artist to work in England.

Dou was principally a genre painter but he also painted small-scale portraits and a few illusionistic still-lifes (*bedriegertjes*). His genre scenes, for the most part interiors with figures, are characterized by their high degree of finish and the still-life details, which enrich their sense, sometimes with an amorous or *vanitas* meaning. Dou's earliest training as a glass-engraver can be discerned in the miniaturistic technique of his small paintings, which are often on panel. There are many accounts in the early lives of Dou of his painstaking method of painting, which involved working for long hours with the finest of brushes in a dust-free studio.

Dou was the founder of the so-called *fijnschilder* school of Leiden. His principal followers, who continued this technique, were Frans van Mieris the Elder and Godfried Schalcken. He had many other pupils and imitators, among them Dominicus van Tol, Jacob Toorenvliet, Gabriel Metsu, Pieter van Slingeland, Karel de Moor and Matthys Naiveu.

Dou's work was enthusiastically sought after not only in his own lifetime but in France in the eighteenth century and in England in the nineteenth.
Literature: Martin 1913.

CORNELIS DUSART 1660-1704

He was born in Haarlem and was a pupil there of Adriaen van Ostade, many of the contents of whose studio he apparently inherited. Dusart joined the Haarlem guild in 1679 and appears to have remained in the town for the rest of his life.

Dusart was a close follower of Adriaen van Ostade, painting, drawing and etching rowdy scenes from peasant life. However, the fact that his subject-matter is so closely derived from that of his master has tended to obscure his remarkable technical virtuosity and his unerring colour sense. He was a gifted draughtsman and executed a particularly attractive

series of decorative water-colours of peasant life. He made fourteen or fifteen etchings and a large number of mezzotints.

WILLEM DUYSTER c. 1599-1635

He was born in Amsterdam, where he may have been a pupil of Pieter Codde. From 1620 his family lived in a house on the Koningsstraat known as *De Duystere Werelt* (The Dark World), from which they took their family name. He appears to have lived in Amsterdam for the rest of his life. Duyster painted barrack-room scenes and genre interiors in a style close to that of Pieter Codde and of his brother-in-law Simon Kick. They are on a small scale with full-length figures whose extravagant dress is rendered with careful attention to detail. He also painted a number of portraits. *Literature*: Playter.

CAREL FABRITIUS 1622-54

He was born in Midden-Beemster (near Purmerend), where his father Pieter Carelsz. was a schoolmaster. His father was also an amateur painter and may have been the first master of Carel and two of his brothers, Barent and Johannes, who were also painters. In 1641 Carel was working as a carpenter in Midden-Beemster but later that year he entered Rembrandt's studio in Amsterdam. (A fellow-pupil was Samuel van Hoogstraten.) He was there until 1643 when he returned to Midden-Beemster. By 1650 he had settled in Delft and he entered the guild in 1652. He died in Delft in the explosion of the municipal arsenal which destroyed a large part of the town.

Fabritius' known works are few, but in them he emerges as a brilliant and experimental painter. Contemporaries commented on his interest in illusionistic perspective: his *View of Delft* (1652; National Gallery, London) is the only surviving painting which attests to this. He also painted portraits, head studies, a religious scene and one genre piece, *The Sentry*. He was influential on the development of other painters in Delft although he was probably not, as has been claimed in the past, Vermeer's teacher. His only known pupil, Matthias Spoors, also died in the 1654 explosion. *Literature*: Brown.

DIRK HALS 1591-1656

He was born in Haarlem, the younger brother of the portrait painter Frans Hals, who no doubt gave him his first training. He lived and worked in Haarlem but is recorded briefly in Leiden in the 1640s.

Dirk Hals' style – the forms built up with bold, broad strokes – is based on that of his brother. His subject-matter, however, is very different (although Frans Hals did paint a

'merry company' set in a garden, a picture of about 1610 which was in the Berlin Museum until destroyed in World War 11): Dirk painted small-scale genre scenes, particularly of the 'merry company' type, similar to those of Willem Buytewech and Esaias van de Velde.

GERARD VAN HONTHORST 1590-1656

He was born in Utrecht into a wealthy Catholic family. Both his father and his grandfather were painters: his grandfather had been dean of the Utrecht guild in 1579 and his father was a painter of tapestry cartoons. Honthorst studied in Utrecht with Abraham Bloemaert, the town's leading history painter. He went to Rome, perhaps as early as 1610, where he developed a style based on that of Caravaggio and his immediate Roman followers – in particular, Bartolommeo Manfredi. Honthorst enjoyed a considerable reputation in Rome (where he was known as *Gherardo della Notte* because of his paintings illuminated by candlelight); among his patrons there was the Marchese Vincenzo Giustiniani, in whose palace he lived for a time and for whom he painted the monumental *Christ before Pilate* (National Gallery, London). He also received a number of commissions for Roman churches. Honthorst was back in Utrecht late in 1620; he joined the guild in 1622 and often served as one of its officers in the 1620s. By 1625, at about the time Sandrart came to study with him, Honthorst had established a great reputation in the Netherlands and had twenty-four pupils in his studio. He increasingly concentrated on portraits and genre scenes, as well as allegorical and mythological subjects, rather than the religious scenes which he had painted for his Roman patrons. In 1627 Rubens visited him in Utrecht. In the following year Honthorst went to England for six months at the invitation of Charles 1 and painted the large allegorical canvas *Mercury Presenting the Liberal Arts to Apollo and Diana* (now at Hampton Court Palace), as well as portraits of the king and queen and members of their court. In 1635 he sent to Denmark the first of a long series of classical and historical paintings commissioned by King Christiaen IV. In 1637 Honthorst entered the guild at The Hague and remained in the city until 1652 as painter to the Stadholder, for whose palaces at Rijswijk and Honselaersdijk he produced portraits and allegorical paintings. He also contributed to the decoration of the summer palace near The Hague, the Huis ten Bosch. In 1652 Honthorst returned to Utrecht, where he died four years later.

Honthorst was one of the few Dutch artists to possess a great international reputation. He played an important part in bringing knowledge of the work of Caravaggio and his followers to the Netherlands and also introduced to the North the Italian manner of illusionistic decoration. His portraits are a development of the court style of Michiel Mierevelt. Genre painting represents a relatively small aspect of his

large *oeuvre*: especially in the years following his return from Italy, he painted single half-length figures of musicians and drinkers as well as a number of Caravaggesque scenes of lovers, gamblers and singers, also shown in half-length lit by flickering candlelight in an interior. They are closely related to similar scenes and figures by Baburen and Terbrugghen, and it seems likely that it was Baburen who was the first to paint these subjects in Utrecht.

Literature: Judson.

PIETER DE HOOCH 1629-84

He was born in Rotterdam and is said by Houbraken to have been a pupil of the Haarlem painter Nicolas Berchem at the same time as Jacob Ochtervelt (who also came from Rotterdam). De Hooch is first recorded in Delft in 1652 and in the following year, is mentioned as a painter and servant (*dienaar*) in the employ of a linen merchant, Justus de la Grange. This was probably a commercial arrangement under the terms of which de la Grange supported the artist in return for a proportion of his production. (A number of other Dutch painters, among them Nicolas Berchem and Emanuel de Witte, entered into similar contracts.) In 1654 de Hooch married Jannetge van der Burch, probably the sister of the painter Hendrick van der Burch. In the following year he entered the Delft guild and is recorded in the town until 1657. In fact he was probably there until 1660, when he moved to Amsterdam: he is first positively recorded in Amsterdam in 1661, when his daughter was baptized in the Westerkerk. He is recorded living in the city – in modest circumstances – until 1672. After that the next documentary mention is of his burial in the Sint Anthonis Kerkhof in Amsterdam in March 1684. He is described as coming from the *Dolhuys*, the municipal asylum.

De Hooch's earliest genre scenes are in the manner of the Amsterdam barrack-room painters, Willem Duyster and Pieter Codde, but there are no dated paintings before 1658. These are in his full-fledged 'Delft style' – open, light-filled domestic scenes populated by a few, carefully-placed figures, with well-judged perspective and carefully observed naturalistic detail. During his years in Amsterdam de Hooch's style gradually changed. He painted family portraits as well as genre scenes. The interiors became more ornate, reflecting his new, richer and more cosmopolitan clientele, and his technique coarsened. The subtly modulated palette of the Delft years becomes progressively more acidic while his draughtsmanship is sometimes careless and his figures clumsy. It may be that the illness which caused him to be confined in the *Dolhuys* affected his skill in later years.

Literature: Sutton 1980a. (For van der Burch, whose work has in the past been confused with that of de Hooch, see Sutton 1980b.)

SAMUEL VAN HOOGSTRATEN 1627-78

He was born in Dordrecht. In his theoretical treatise, *Inleyding tot de Hooge Schoole der Schilderkonst* (*Introduction to the High School of the Art of Painting*), published in the year of his death, Hoogstraten writes that he was a pupil first of his father, Dirck Hoogstraten, a painter and engraver, and then after his father's death in 1640, of Rembrandt in Amsterdam. (In the studio at the same time were Carel Fabritius, Abraham Furnerius and Constantijn van Renesse.) He was back in Dordrecht in 1648, in which year he was baptized as a Mennonite; in 1651 he travelled to Vienna and worked there for Emperor Ferdinand III. He went to Rome in the following year and then returned to Vienna. He was back in Dordrecht in 1654. In 1656 his marriage to Sarah van Balen, an outsider, led to his expulsion from the town's Mennonite community. Hoogstraten was in London in September 1662 and still there at the time of the Great Fire (September 1666), which he witnessed. He joined Pictura, the painters' society in The Hague, in 1668, and in that year one of his plays was performed there. By 1673 he had returned to his native town, where he served as one of the provosts of the Mint, and he devoted his last years to the writing of the *Inleyding*.

Hoogstraten painted a remarkable variety of subjects: portraits, architectural fantasies and biblical as well as genre scenes. His pupil Houbraken records that he also painted landscapes, marines and animal, flower and still-life pictures. Houbraken also mentions his master's great interest in perspective and illusionism, and a peep-box by Hoogstraten showing a domestic interior has survived (National Gallery, London). He was a poet and a dramatist as well as a painter.

NICOLAUS KNÜPFER *c.* 1585/6-1655

He was probably born in Leipzig where in 1603 he was a pupil of Emmanuel Nysen. Subsequently he spent some time in Magdeburg. In 1630 he travelled to Utrecht, where he entered the studio of Abraham Bloemaert. He entered the guild in Utrecht in 1637 and remained in the town for the rest of his life.

Knüpfer achieved considerable fame in his lifetime, receiving numerous commissions including one for three battle-pieces from the king of Denmark. Most of his work consists of history paintings – scenes from classical history, mythology and allegories, and above all scenes from the Old and New Testaments – but he also painted a few portraits and genre scenes.

Literature: Kuznetsow.

ISAAC KOEDIJK c. 1616/18-68

He was probably born in Amsterdam. When he married in Leiden in 1641 he was said to be twenty-four; but in a document of 1664 he is said to be forty-six. In addition to being a painter he was active as a merchant and is recorded as such in both Leiden and Amsterdam. Financial difficulties led him to travel to the Dutch East Indies in 1651; he returned to the Netherlands in 1659 and subsequently lived in Haarlem and Amsterdam. He probably died in Amsterdam.

Koedijk was an imitator (and perhaps a pupil) of Gerrit Dou. He painted biblical and genre scenes in Dou's *fijnschilder* manner: only a handful of his paintings are known today.

PIETER VAN LAER 1599-after 1642

Pieter Boddingh van Laer was born in Haarlem. It is not known with whom he trained but his earliest work reveals the influence of Esaias van de Velde. Van Laer's elder brother, Roelant, was also a painter and the two travelled to Italy together, arriving in Rome in 1625 or 1626. Soon after his arrival, Pieter van Laer joined the *Schildersbent* and was given the Bent name *Bamboccio* (in Dutch, *Bamboots*), literally meaning a rag doll or puppet. It referred to his awkwardness: he had a physical deformity, apparently a hunchback. Sandrart recounts that he and van Laer, accompanied by Claude Lorrain and Nicolas Poussin, rode to Tivoli together to draw landscapes from nature. Van Laer achieved considerable success in Rome: among his patrons was Cardinal Francesco Maria Brancaccio, and his 1636 series of landscape etchings is dedicated to the viceroy of Naples, Ferdinando Ajan de Ribera. Van Laer is last recorded in Rome in 1638. He travelled back to the Netherlands via Vienna, where he tried unsuccessfully to sell a painting to the Emperor. He was in Haarlem in 1639: in that year he visited Sandrart in Amsterdam and the two painters went to see Gerrit Dou in Leiden. He is mentioned for the last time in his sister's will, drawn up in 1642, when he left Haarlem. His subsequent fate is unknown: his earliest biographer Schrevelius says he set out for Rome and somewhat melodramatically compares his disappearance to that of the philosopher Empedocles, who fell into the crater of Mount Etna.

Van Laer is best known for his *bambocciate*, to which he gave his name: small-scale Italian street scenes showing beggars, pedlars and musicians. They are painted on dark Italian grounds and bring the techniques of Caravaggio and his Roman followers to small multi-figured genre compositions. An early Italian biographer of van Laer, Giovanni Battista Passeri, describes such scenes as 'a window onto life'. Van Laer is, however, also mentioned in early biographies and inventories as an animal and landscape painter

and recently his pioneering importance in the development of these subjects in Haarlem has been recognized. He was influential on Philips Wouwermans, Paulus Potter and Adriaen van de Velde. Van Laer also painted a number of history paintings and portraits and the recent discovery of a songbook to which he contributed emblematic and satiric drawings and verses adds yet another dimension to this remarkable artist.

Literature: Janeck. (For van Laer as an animal and landscape painter, see A. Blankert in *Oud Holland*, 83, 1968, pp. 117-34 and J. Michalkowa in *Oud Holland*, 86, 1971, pp. 188-95.)

JUDITH LEYSTER 1609-60

Born in Haarlem, she was the daughter of a Flemish brewer who had settled in the town. She was probably in the studio of Frans Hals in the years around 1630. She entered the Haarlem guild, the first woman known to have been admitted, in 1633, and in 1635 is recorded to have had three apprentices in her studio in the town. In May 1636 she married the painter Jan Molenaer, who may also have been a pupil of Hals, at Heemstede, near Haarlem. In 1637 they were living in Amsterdam and probably remained there until 1648 when they bought a house at Heemstede, where she stayed for the rest of her life.

For the most part Judith Leyster painted genre subjects but also a number of portraits, still-lifes and bird pictures. She was a skilled water-colourist and made botanical illustrations, notably a series illustrating different varieties of tulips. Her technique as a painter, with bold, vigorous strokes and bright highlights, depends on that of Hals: her copy of Hals' *Luteplayer* (private collection, Paris) is remarkably close to his handling and palette. Her genre paintings show figures, children as well as adults, in interiors, making music, playing, eating and drinking. She often signed her work with an L and a star, a punning reference to her family name.

Literature: Hofrichter.

JAN LINGELBACH 1622-74

Lingelbach was born in Frankfurt-am-Main, but by 1634 his family had settled in Amsterdam, where his father David (and later his brother Philip) ran the *Nieuwe Doolhof*, a highly successful pleasure garden. Lingelbach's teacher is unknown. Houbraken says that he left Amsterdam in 1642 to travel to France and that two years later he went on to Rome where he worked until 1650. This account is supported by the few surviving documents: Lingelbach is recorded from 1647 until 1649 as living in Rome. There he came under the powerful influence of the style of Pieter van Laer, *Il Bamboccio*, who had given his name to a new type of small-scale genre painting showing Italian street life, the *bambocciate*.

Although van Laer had himself returned to Haarlem by 1639, a number of artists, including Jan Miel and Michelangelo Cerquozzi, continued to work in his manner. So closely did Lingelbach follow the style of the other so-called *bamboccianti* that there has been much confusion about the attribution of individual paintings and only recently have the *oeuvres* of these artists begun to be disentangled. According to Houbraken (who even gives the day, 8 May), 1650 was the year in which Lingelbach left Rome to return to Amsterdam. No documents record his presence there until 1653, when he married and was granted citizenship. He continued to live in Amsterdam until his death, when he was buried in the city's Old Lutheran Church.

On his return to Holland, Lingelbach abandoned *bambocciate* and was increasingly influenced by the work of the prolific and successful Philips Wouwermans, in particular by his landscapes with figures working and riding. He also painted Italianate landscapes and seaports in the manner of Jan Baptist Weenix and his son, Jan. He collaborated with a number of artists, painting figures in landscapes by, amongst others, Jan Hackaert, Philips Koninck, Frederick de Moucheron and Jan Wijnants.

Literature: Bürger-Wegener; Kren 1982.

NICOLAES MAES 1634-93

He was born in Dordrecht. According to Houbraken, he learnt drawing from *een gemeen Meester* (an ordinary master) and painting from Rembrandt. Maes was probably in Rembrandt's studio in Amsterdam in around 1650. He was back in Dordrecht in 1653 and remained there until 1673 when he moved to Amsterdam. Houbraken recounts that Maes made a special trip to Antwerp in order to study the work of Rubens, Van Dyck and others at first hand; while there he met a number of artists including Jacob Jordaens. This trip seems to have taken place between 1660 and 1665.

A number of large-scale history paintings, among them *Christ Blessing the Children* (National Gallery, London), have been attributed to Maes. If they are by Maes, and in the case of the London painting there are closely related drawings by him, they must date from the period immediately after he left Rembrandt's studio, as his earliest signed and dated painting, *Abraham dismissing Hagar and Ishmael* of 1653 (Metropolitan Museum of Art, New York) shows him already working in a small format and in a style close to that of his genre paintings. By 1654 Maes was painting domestic interiors which are characterized by a deep chiaroscuro and a precise treatment of still-life detail: both in subject-matter and style they are related to contemporary developments in Delft, although the exact relationships between the work of Maes and that of Carel Fabritius (who died in 1654) and Pieter de Hooch (whose earliest dated painting is from 1658) is difficult to establish. In 1656 Maes

began to paint portraits in a style derived from Rembrandt and after 1660 he confined himself to portraiture. His small-scale, bust-length portraits were, according to Houbraken, in great demand and survive in large numbers today. The later ones show a distinctly Flemish influence (notably of Van Dyck's portraiture), no doubt a consequence of Maes' trip to Flanders.

Literature: Valentiner.

CORNELIS DE MAN 1621-1706

He was born in Delft. Houbraken, who deals very cursorily with Pieter de Hooch and omits any mention of Vermeer, devotes a whole page to de Man. He says that after joining the Delft guild in 1642, de Man travelled for nine years, staying in Paris, Lyon, Lombardy, Rome and Venice before returning to Delft in 1654 or 1655. De Man often served as an officer of the Delft guild and as a regent of the Municipal Orphanage, for which he painted an *Allegory of Charity* (Prinsenhof, Delft) in 1682. He remained in Delft until his death.

De Man's trip to Italy had little effect upon his art. His very varied *oeuvre* includes landscapes and marine paintings, church interiors as well as individual and group portraits. After a number of early peasant scenes, he began, around 1665, to paint domestic interiors which show a clear debt to the work of the two younger painters, de Hooch and Vermeer. In these interiors he is concerned to describe detail – of clothes, carpets, panelling and furniture – which he does in a dry, linear manner.

Literature: Brière-Misme.

GABRIEL METSU 1629-67

Born in Leiden, he was the son of a Flemish painter, Jacques Metsue, who had settled in the town. He was presumably a pupil of his father and, in all probability, of Gerrit Dou, Leiden's leading genre painter. Metsu was one of the foundation members of the Leiden guild in March 1648. He spent some time outside Leiden in the 1650s but did not settle permanently in Amsterdam until 1657. He remained there until his death.

Though there are some dated paintings, the chronology of Metsu's work is difficult to reconstruct. Robinson (see Bibliography) has stressed Metsu's eclecticism, his tendency to interpret existing stylistic trends in Dutch genre painting rather than to originate such trends. He points to the influences of, among others, Dou (in Metsu's earliest works), Steen, Knüpfer, J.B. Weenix, Terborch, Vermeer and de Hooch. However, while he may be correct in stating that Metsu's subject-matter owes something to some of these artists, his exquisite, refined technique, particularly in the representation of texture, is highly original. In addition to

his many genre scenes of interiors with figures, streets and markets, Metsu painted a number of religious subjects and a few still-lifes.
Literature: Robinson.

FRANS VAN MIERIS THE ELDER 1635-81

He was born in Leiden, the son of a goldsmith. Houbraken says that he was a pupil first of a glass-painter, Abraham van Toorenvliet, then of Gerrit Dou, then of Abraham van den Tempel and finally, again, of Dou. Dou is said to have called Van Mieris 'the Prince of my Pupils'. Van Mieris entered the Leiden guild in May 1658 and served as a *hoofdman* in 1664 and 1665, and as dean in 1665. Although, like Dou, he achieved a European reputation and received commissions from the Archduke Leopold and Duke Cosimo III of Tuscany, he rarely left Leiden.
Van Mieris was a leading member of the Leiden school of *fijnschilders*, pupils and imitators of Gerrit Dou, who followed him in the high degree of finish in their paintings. He painted genre scenes and portraits, as well as some religious, classical, literary and allegorical subjects.
Van Mieris was imitated by his sons, Jan and Willem, and by his grandson, Frans the Younger (1689-1763), who carried the tradition into the second half of the eighteenth century.
Literature: Naumann.

WILLEM VAN MIERIS 1662-1747

Born in Leiden, he was the second son of Frans van Mieris the Elder. His only master, according to Johan van Gool, was his father, who died when Willem was eighteen. He entered the Leiden guild in 1683 and spent his life in the town, serving as dean of the guild in 1699.
Willem van Mieris' style is very closely based on that of his father. He painted many genre scenes, as well as religious, mythological and literary subjects, and portraits. He made numerous copies of his father's paintings.
His son, Frans van Mieris the Younger, continued to work in his father's and grandfather's style.

JAN MIENSE MOLENAER *c.*1610-68

He was born in Haarlem and was probably a pupil there of Frans Hals. Molenaer's first dated paintings are of 1629. In 1636 he married the painter Judith Leyster, who had been in Hals' studio, and in the following year they were living in Amsterdam. In 1648 they returned to Heemstede, near Haarlem. In his early years Molenaer was in court on a number of occasions for debt and brawling: the move to Amsterdam may have been precipitated by a court action in which his property was confiscated. He died at Heemstede

in 1668, eight years after the death of his wife.
Molenaer's paintings are almost all of genre subjects, sometimes – as in the case of the *Allegory of Marriage* (Richmond, Virginia) and the *Vrouw Wereld* (Toledo, Ohio) – of considerable iconographic sophistication. He also painted a few portraits and religious scenes.
Molenaer's early style is close to that of Hals and of his wife, Judith Leyster. Later he painted a number of peasant interiors in a style which reveals his study of the work of Adriaen van Ostade.

MATTHYS NAIVEU 1647-1721

He was born in Leiden, where he was a pupil of Abraham Toorenvliet and then (in 1667/69) of Gerrit Dou. Naiveu entered the Leiden guild in 1671 and served as an officer in 1677. In that year he is first recorded in Amsterdam where he settled. He became a citizen in 1696 and died in the city. Naiveu was a genre painter in Dou's *fijnschilder* manner: he painted domestic interiors and portraits, including family portraits set in elaborately described domestic settings. His palette is more colourful than that of Dou and there are strong analogies with the work of Slingeland, another Dou pupil.

CASPAR NETSCHER 1635/6-84

At one point in his account of the life of Netscher, Houbraken says that he was born in Prague, but later that his birthplace was Heidelberg. Roger de Piles writes that Netscher was born in Prague. Houbraken recounts that Netscher was taken as a child to Arnhem where he was a pupil of Hendrick Coster, a painter of fowl and kitchen still-lifes, and that subsequently he studied with Terborch in Deventer. Netscher left the Netherlands for Rome around 1658 but got no further than Bordeaux where he stayed at least until 1661. He joined Pictura, the painters' society in The Hague, in 1662 and remained in the town, where he was in great demand as a portrait painter, until his death. He declined an invitation from Charles II to settle in England.
Up until the late 1660s Netscher painted genre scenes in a manner based on that of Terborch, as well as religious and classical subjects, but in the 1670s he concentrated on small-scale portraits in a fashionable French-influenced style.
Netscher's son, Constantijn, closely imitated him, enjoying a successful career as a portrait painter.

JACOB OCHTERVELT 1634-82

He was born in Rotterdam. According to Houbraken, he was a pupil of the landscape painter Nicolas Berchem in Haarlem at the same time as Pieter de Hooch. Ochtervelt was back in Rotterdam by 1655 when he married. He re-

mained in the town until 1674 when he moved to Amsterdam, where he seems to have achieved a degree of prosperity. He died in Amsterdam in 1682.

Ochtervelt painted genre scenes, principally domestic interiors of the wealthier residents of Rotterdam and Amsterdam. His rooms rarely contain more than one or two figures, often rather schematically treated, with an acute feeling for their precise disposition and for the description of the rich fabrics of their clothes. He also painted portraits and, in his earliest years, a few landscapes.

Ochtervelt's early interiors display the influence of de Hooch; there are also stylistic links with the work of Terborch.

Literature: Kuretsky.

ADRIAEN VAN OSTADE 1610-85

He was born in Haarlem, where he lived and worked all his life. His father, who was probably a weaver, had moved to Haarlem, an important centre of textile production, from the small village of Ostade, near Eindhoven. According to Houbraken, Adriaen van Ostade was a pupil of Frans Hals at the same time as the Flemish painter of peasant scenes, Adriaen Brouwer. Ostade joined the Haarlem guild in 1634, served as a *hoofdman* in 1647 and 1661 and as dean in 1662. He appears to have been prosperous and was a prominent member of the town's civic guard.

Ostade painted, etched and drew scenes of peasant life. His early style reflects the influence of Brouwer rather than of Frans Hals. He was remarkably prolific: more than eight hundred paintings, over fifty etchings and several hundred drawings and water-colours survive. He also treated a few biblical subjects and painted several portraits.

Among Ostade's pupils were his younger brother, Isack, Cornelis Dusart and Cornelis Bega.

His work was enthusiastically collected in France in the eighteenth century and in England in the nineteenth.

Literature: Schnackenburg.

ISACK VAN OSTADE 1621-49

A younger brother and pupil of Adriaen van Ostade, he was born in Haarlem. He entered the Haarlem guild in 1643 and remained in the town until his early death.

Isack's earliest work is closely dependent on Adriaen's often gloomy peasant interiors but later he became more interested in daylight effects and painted outdoor scenes, many in winter.

Literature: Schnackenburg.

JOHANNES VAN OUDENROGGE 1622-53

He was born in Leiden and was a pupil there of the little-known Adriaen van Witvelt. He is recorded in Leiden between 1645 and 1648 but had moved to Haarlem by 1651, when he joined the guild there.

He painted peasant scenes – country inns, labourers and artisans at work and barn interiors – in the manner of Adriaen van Ostade.

ANTHONIE PALAMEDESZ. 1601-73

He was born in Delft. He is said to have been a pupil of the portrait painter Michiel Mierevelt in Delft and of Dirk Hals in Haarlem. In 1621 Palamadesz. entered the Delft guild and subsequently often served as one of its officers. He died in Amsterdam.

Palamadesz. painted 'merry company' scenes in the manner of Dirk Hals, as well as concerts indoors and outside, and guardroom scenes.

HENDRICK POT *c.* 1585-1657

He was probably born in Haarlem, and was a pupil of Carel van Mander there before 1603. He served as an officer of the Haarlem guild in 1626, 1631, 1634 and 1648, and as dean in 1635. In 1625 Pot served for the first time as a sergeant in the town's civic guard and in 1628 he was a regent of the poorhouse. In 1633 he can be seen as a lieutenant in a civic guard painting by Frans Hals of the Archers' Company of St Adrian; and in 1639 in another, of the archers' company of St George. In 1632 he visited London, where he painted the portraits of Charles I and his queen, Henrietta Maria, but was back in Haarlem in 1633. In about 1650 he moved to Amsterdam, where he died.

Pot painted small-scale guardrooms, brothel and 'merry company' scenes of a type evolved by Willem Buytewech and Dirk Hals. He also painted small-scale full-length portraits which are similar to his genre figures.

PIETER QUAST 1605/6-47

He was born in Amsterdam and was living there in 1632 when he married. In 1634 he joined the guild at The Hague and was still resident in the town in 1643. By 1644 he was back in Amsterdam, where he died three years later.

Quast's work consists of genre and satirical subjects; his figures are often strongly caricatural. He was also a printmaker and book-illustrator, and was influenced by Adriaen van de Venne, who had settled in The Hague by 1625.

CORNELIS SAFTLEVEN 1607/8-81

He was born in Gorinchem, the son of the painter Herman Saftleven II (none of whose work survives) and brother of the painter Herman Saftleven III (1609-85). Shortly after his birth, the family moved to Rotterdam. Around 1632/4 Cornelis is said to have spent some time in Antwerp: although there are no documents covering this period of his career, the closeness of his work to that of Brouwer and Teniers supports the likelihood of such a stay. In 1634/5 he was in Utrecht. In 1637 he was back in Rotterdam, where he apparently remained for the rest of his life, serving in 1667 as dean of the Rotterdam guild.

Cornelis Saftleven painted peasant scenes, biblical subjects and portraits. He also painted a number of satirical subjects in which animals play out human roles.

Literature: Schulz 1978

GODFRIED SCHALCKEN 1643-1706

He was born at Made, nor far from Dordrecht, to which town his parents moved in 1654. Houbraken says that he was first a pupil of Samuel van Hoogstraten (in Dordrecht) and then of Gerrit Dou (in Leiden). He was back in Dordrecht by 1665 and appears to have remained there until 1691. In that year he joined Pictura, the painters' confraternity in The Hague, though still resident in Dordrecht. Schalcken travelled to England in 1692 and may have stayed until 1698: while there he painted several portraits of King William III. He was back in The Hague in 1698 and settled there, remaining in the town until his death, although he spent some time in Düsseldorf in about 1703 in the service of the Elector Palatine, Johann Wilhelm.

Schalcken was very successful, enjoying a European reputation during his lifetime, particularly with *fijnschilder* genre scenes shown by artificial light and his small-scale portraits (some of which are also illuminated by candle-light). His early style is heavily dependent on that of Dou. He also painted religious and mythological subjects as well as a few allegorical and literary ones.

Schalcken's candle-lit paintings were closely imitated by Arnold Boonen (1669-1729) and continued to be imitated into the nineteenth century. Petrus van Schendel (1806-70) was one of the last of his imitators.

HENDRICK SORGH 1610/11-70

He was born in Rotterdam. According to Houbraken, Sorgh was a pupil of David Teniers the Younger (in Antwerp) and Willem Buytewech the Elder in Rotterdam. His early work reveals, however, little obvious relationship to that of Teniers (except for its subject-matter of peasant life) or of Buytewech (who died in 1624). Sorgh lived and worked in Rotterdam; in 1659 he served as a *hoofdman* of the guild. Many of Sorgh's paintings show peasant interiors and – particularly in his later years – street markets. His early work apparently shows the influence of the Flemish peasant painter Adriaen Brouwer and later – in the 1650s – he came under the influence of Cornelis Saftleven. He also painted some small-scale portraits, river views and a few mythological and religious subjects.

JAN STEEN 1625/6-79

He was born in Leiden and inscribed as a student in the University there in November 1646. Houbraken says that he was a pupil of Van Goyen (whose daughter he married); Weyerman recounts that his first master was Nicolaus Knüpfer at Utrecht and that he then studied with Adriaen van Ostade at Haarlem and Jan van Goyen in The Hague. In 1648 Steen joined the newly-formed guild in Leiden. In the following year he was living in The Hague and in October he married Margaretha van Goyen there. Steen's father, a brewer, leased a brewery for him in Delft from 1654 until 1657. From 1656 until 1660 he was living in Warmond, near Leiden; there is no firm evidence that Steen actually lived in Delft. He had settled in Haarlem by 1661 when he joined the guild there, but apparently returned to Leiden when he inherited a house in the town. He remained in Leiden until his death, serving as a *hoofdman* in the Leiden guild in 1672 and 1673 and as dean in 1674.

An enormously prolific painter, Steen concentrated upon lively genre scenes, although he also painted portraits and religious and mythological scenes. His work, which is markedly uneven in quality, is characterized by a robust humour, a sense of theatre and an often moralistic intention. Steen made no prints and no drawings by him survive.

Literature: de Groot 1952; Martin 1954; de Vries 1976; de Vries 1977; Sutton 1982/3

MAERTEN STOOP *c.*1620-47

He was probably born in Rotterdam, but his father, the glass-painter Willem Stoop, had settled in Utrecht by 1633. His elder brother was the painter Dirk Stoop. Maerten entered the Utrecht guild in 1638/39 and died in the town.

He painted genre scenes with a strongly moralizing aspect. His work displays the influence of Nicolaus Knüpfer, who had settled in Utrecht by 1630.

GERARD TERBORCH 1617-81

He was born in Zwolle and studied there with his father Gerard Terborch the Elder, a painter who had lived in Italy in his youth. In 1632 Gerard the Younger was in Amsterdam and in 1633 in Haarlem in the studio of the landscape

painter Pieter Molijn. He probably joined the guild in Haarlem in 1635. In that year he went to England; in the late 1630s and 1640s he travelled widely in the Netherlands and also, according to Houbraken, visited Germany, Italy, France and Spain. From 1646 to 1648 Terborch was in Münster, painting portraits of the participants in the peace negotiations which were to bring an end to the long war between Spain and the United Provinces. He recorded the successful conclusion of the negotiations in his remarkable group portrait, *The Swearing of the Oath of Ratification of the Treaty of Münster on the 15 May 1648* (National Gallery, London). In 1653 Terborch was in Delft and in the following year married in Deventer, where he remained for the rest of his life, becoming a town councillor and in 1667 painting a group portrait of the councillors in the Town Hall (where the painting still hangs).

Terborch collaborated with Pieter Molijn, painting portraits in Molijn's landscapes. His earliest genre scenes are barrack-rooms and interiors in the manner of Codde and Duyster. It was not until the 1650s that he evolved his very distinctive genre painting style, showing richly-dressed figures in elegant, if sparse, interiors. These scenes reveal debts to developments in Delft in the 1650s, and in particular to the work of Pieter de Hooch, so that the recent discovery of documentary proof that Terborch visited Delft in 1653 is of the greatest significance.

Among Terborch's pupils was Caspar Netscher.

Literature: Gudlaugsson 1960; Cat. The Hague 1974.

HENDRICK TERBRUGGHEN *c.* 1588-1629

He was born into a wealthy and distinguished Catholic family who lived in the province of Overijssel. His father, Jan, moved to Utrecht in about 1591, the year in which Prince Maurits defeated the Catholic faction in Deventer. Hendrick was trained in the studio of the leading Utrecht history painter, Abraham Bloemaert, until about 1604 when, at the age of only fifteen or so, he travelled to Italy. He was there for about ten years, principally in Rome, where he met Rubens. In 1614 he was in Milan on his way back to the Netherlands. He married in Utrecht in 1616 and entered the guild there in 1616 or 1617. He remained in Utrecht for the rest of his life and was buried in the city's Buurkerk.

Terbrugghen was the first Dutch Caravaggist painter to return to the Netherlands. None of the paintings he made in Italy – which, according to Houbraken, included a picture for the high altar of Naples Cathedral – are known. His style is an individual interpretation of that of Caravaggio and, perhaps even more importantly, of Caravaggio's Roman followers. His genre scenes show half-length musicians and drinkers, alone or in groups; they are often illuminated by candle-light which creates deep shadows in the folds of their flamboyant and voluminous costumes. Terbrugghen's style

is characterized by remarkable fluency in modelling the soft edges of his forms and an unusual palette which includes light blues, lemon, purple and cerise. He also painted a number of biblical, mythological and literary scenes.

Literature: Nicolson 1958; Nicolson 1960; van Thiel 1971.

ADRIAEN VAN DE VELDE 1636-72

He was the son of the marine painter Willem van de Velde the Elder and brother of Willem van de Velde the Younger. He was born in Amsterdam and was probably a pupil of his father. Subsequently, according to Houbraken, he studied with Jan Wijnants in Haarlem. Although he painted Italianate landscapes, nothing is known of a trip to Italy. He is recorded in Amsterdam in 1657 (when he married) and apparently spent the rest of his life there. Six of his children were baptized in hidden Catholic churches in Amsterdam and a document of 1671 confirms that Adriaen was a Catholic.

Most of his paintings are landscapes, often with prominent figure or animal groups: among them are a number of coast and winter scenes. He also painted portraits and genre scenes and a few religious, mythological and allegorical subjects (among them a series of five paintings of the Passion for the Catholic Spinhuiskerk in the Spinhuissteeg, Amsterdam). He made about twenty-five etchings, the dated ones ranging from 1653 to 1670, and collaborated with a number of landscape painters, adding animals and figures to landscapes by Jacob van Ruisdael, Philips Koninck, and others.

ESAIAS VAN DE VELDE *c.* 1591-1630

He was born in Amsterdam, the son of a painter, Anthonie van de Velde, who had travelled north from Antwerp, nephew of the calligrapher Jan van de Velde the Elder and cousin of the engraver Jan van de Velde. He may have been a pupil in Amsterdam of Gillis van Coninxloo, who died in 1607. He is first recorded in Haarlem in 1609; he entered the guild there in 1612 and remained until his move to The Hague in 1618, where he joined the guild in the same year and stayed for the rest of his life.

Esaias van de Velde painted 'merry company' scenes, cavalry battles and scenes of travellers ambushed by bandits; however, his principal activity is as a landscape painter and he occupies a key place in the development of realistic landscape in Haarlem. He also made about fifty etchings.

ADRIAEN VAN DE VENNE 1589-1662

He was born in Delft. He was a pupil of the goldsmith Simon de Valck in Leiden and of Jeronimus van Diest, a grisaille painter, in The Hague. His father moved to Middelburg, in Zeeland, in 1605. Adriaen's older brother Jan

established a printing, publishing and art-dealing business there – his single most successful author was Jacob Cats, who also lived in the town – and Adriaen illustrated books for him. While in Middelburg he also painted highly coloured, multi-figured compositions related in style to Jan Bruegel the Elder, showing town and country views with figures, fairs and contemporary political events (sometimes presented in an allegorical form). After his brother's death in 1625, Adriaen moved to The Hague and entered the guild there in the same year. In The Hague he turned (presumably under the influence of Van Diest) to the painting of grisailles illustrating popular sayings or commenting – often with bitter satire – on human folly. They carry inscriptions in prominent banderoles.

Van de Venne made many designs for prints (engraved by Crispijn de Passe and others) and for book illustrations. He illustrated many of Cats' works, and was also a poet.

JAN VERMEER 1632-75

He was born in Delft, the son of Reynier Jansz. Vos or Vermeer, who was a successful silkweaver, art-dealer and innkeeper. Nothing is known of Vermeer's training but when in 1653 he married the daughter of a prosperous Catholic family in Delft, Leonaert Bramer, a history painter who had spent a number of years in Italy, testified on his behalf. This might well indicate that Bramer was Vermeer's master; but if so, his influence is not apparent in the younger painter's early work. Vermeer also entered the Delft guild in 1653; his earliest dated work is of 1656. He lived and worked in Delft, serving as an officer in the guild in 1662/3 and 1670/1. On the death of his father in 1652, Vermeer inherited a large inn on the town's principal square, where he and his family – there were eleven children of the marriage – lived. He also continued his father's art-dealing business. Balthasar de Monconys, a French traveller who was in Delft in 1663, was told by Vermeer that he had no paintings of his own for sale; however, de Monconys did see pictures by the artist which belonged to a baker, and thought them overpriced. Vermeer had an important patron in Jacob Dissius, a Delft printer, whose collection included twenty-one Vermeers when it was sold in Amsterdam in 1696. In the year after Vermeer's death his widow declared herself bankrupt, blaming the family's financial troubles on the slump which began in the *Rampjaar* of 1672.

Only about thirty paintings by Vermeer survive and it is likely that these constitute the greater part of his entire *oeuvre*. This small output may be a consequence of Vermeer's other commercial activities or of his painstaking technique. His first paintings are large-scale mythological and biblical scenes executed in a manner related to that of the Utrecht Caravaggisti. Later, under the influence of Pieter de Hooch and Gerard Terborch (who was in Delft in

1653), he turned to small-scale genre scenes. He also painted two town views, *Het Straatje* (Rijksmuseum, Amsterdam) and the *View of Delft* (Mauritshuis, The Hague). In his latest paintings Vermeer's technique becomes increasingly highly-finished. Towards the end of his life he painted two allegories, the *Art of Painting* (Kunsthistorisches Museum, Vienna) and the *Allegory of Faith* (Metropolitan Museum, New York), both of which draw heavily on Cesare Ripa's *Iconologia* (which had appeared in a Dutch edition in Amsterdam in 1644) for their symbolism. The iconography of the *Allegory of Faith* is Catholic and it seems likely that Vermeer became a Catholic at the time of his marriage.

Although certain of Vermeer's paintings were prized in the eighteenth and early nineteenth centuries, his name was little known and he was rediscovered in the second half of the nineteenth century largely as a result of a series of articles published by the French critic Etienne Joseph Théophile Thoré (whose pen name was William Bürger) in the *Gazette des Beaux-Arts* in 1866.

Literature: Blankert 1978 (with all previous literature).

JAN VICTORS 1619/20-76 or later

Born in Amsterdam, he was probably a pupil of Rembrandt in the late 1630s. He lived and worked in Amsterdam until 1676 when he went to the Dutch East Indies, where he died soon afterwards.

Until nearly the mid-1650s Victors' paintings, mostly religious subjects and portraits, were strongly Rembrandtesque. From around 1650 he began to paint peasant genre scenes which are far more original in style. They show village life, with strongly individual figures, rendered in a sombre palette of browns, yellow and greens, occasionally enlivened by highlights of red and white.

DAVID VINCKBOONS 1576-c.1632

He was born in Mechelen (Malines). His father, Philip, a painter, moved to Antwerp and subsequently to the north Netherlands. The family settled in Amsterdam in 1591. David Vinckboons was a pupil of his father, who painted in water-colour, but, according to Van Mander, he was self-taught in all the other media in which he worked – oil painting, glass painting, etching and engraving. He lived and worked in Amsterdam.

Vinckboons played an important role in bringing certain secular subjects from Flanders to the north and in originating others. He painted 'merry company' scenes, fairs and subjects from peasant life. His landscapes also provide an important link between Flemish landscape painting and the rise of realistic landscape in Haarlem early in the seventeenth century.

Literature: Goosens.

ADRIAEN VAN DER WERFF 1659-1722

He was born at Kralingen, near Rotterdam. According to Houbraken, he was a pupil first of Cornelis Picolet in Rotterdam and then of Eglon Hendrick van der Neer, also in Rotterdam; he is said to have set up as an independent painter at the age of seventeen (that is, in 1676). Van der Werff spent his whole life in Rotterdam apart from a number of trips to Düsseldorf to deliver paintings to the Elector Palatine and to paint his portrait. The Elector made him a knight in 1703. He had a great contemporary reputation – Houbraken describes him as the greatest living Dutch painter – and among his many distinguished patrons were the King of Poland, the Duke of Brunswick and the French regent.

Van der Werff's earliest work, painted under the influence of Eglon van der Neer, is in the Leiden *fijnschilder* tradition: as well as genre scenes and religious and mythological subjects, he painted many small-scale portraits in this manner. As his fame grew, he largely abandoned portraiture in favour of history painting and his style became progressively smoother and more finished under the influence of French classical taste.

Van der Werff's brother, Pieter (?1665-1722) was his principal pupil and assistant, imitating him closely and painting many copies of his works.

EMANUEL DE WITTE *c.* 1617-92 ·

He was born in Alkmaar and entered the guild there in 1636 but is recorded as living in Rotterdam in 1639 and 1640. In 1641 he was in Delft and joined its guild in the following year. He had moved to Amsterdam by 1652 and probably remained in the city for the rest of his life. Particularly towards the end of his life there is evidence that de Witte was in considerable financial difficulties and at various times after 1660 he put himself under contract to art dealers to paint in return for his upkeep. Houbraken says that he committed suicide and that his body was discovered in an Amsterdam canal which had been frozen over since his disappearance.

According to Houbraken, de Witte was a pupil of the still-life painter Evert van Aelst in Delft, but there is no evidence for this in his early works which are figure paintings showing the influence of the Utrecht school. He began to paint church interiors in Delft in around 1650, at about the same time as two Delft contemporaries, Gerrit Houckgeest and Hendrik van Vliet. Houbraken says that he was 'famed for his knowledge of perspective'. In addition to church interiors, de Witte painted domestic interiors (sometimes with portrait groups), harbour views, maritime paintings and, after 1660, market scenes in which portraits are sometimes included.

Literature: Manke.

JOACHIM WTEWAEL 1566-1638

He was born in Utrecht, the son of a glass-engraver with whom he worked until he was eighteen. Wtewael was then apprenticed to the painter Joos de Beer. After two years with de Beer, Wtewael spent four years in Italy and France in the entourage of Charles de Bourgneuf de Cucé, bishop of St Malo. He returned to Utrecht around 1590, where he remained for the rest of his life. He was a wealthy flax-merchant as well as a successful painter.

Wtewael's highly finished and stylized manner is closely related to 'Haarlem Mannerism', a style based upon the work of Bartholomaus Spranger, which dominated painting in Haarlem for the decade after its importation by Carel van Mander in 1583. However, while Haarlem artists soon abandoned Spranger's tortuous and elegant court art for more naturalistic styles, Wtewael and his Utrecht contemporary Abraham Bloemaert practised their individual interpretations of it well into the seventeenth century. Wtewael responded to later developments such as the introduction of Caravaggesque styles into Utrecht in the 1620s but never wholly gave up Spranger's manner.

Wtewael principally painted religious and mythological subjects but also market scenes – in a modified version of his history painting style – and a number of portraits.

Literature: Lowenthal.

Bibliography

ALPERS 1972/3: S. Alpers, 'Bruegel's Festive Peasants', *Simiolus*, 6, 1972/4, pp. 163-76.

ALPERS 1975/6: S. Alpers, 'Realism as a Comic Mode: Lowlife Paintings seen through Bredero's Eyes', *Simiolus*, pp. 115-44.

ALPERS 1983: S. Alpers, *The Art of Describing*, London, 1983.

AMMAN/SACHS: Ed. B. A. Rifkin, *The Book of Trades by Jost Amman and Hans Sachs*, New York, 1973.

AMSTERDAM 1976: P. J. J. van Thiel et al., *All the Paintings of the Rijksmuseum in Amsterdam*, Amsterdam/Maarssen, 1976.

VAN ANDEL: M. A. van Andel, *Chirurgyns, Vrye Meesters, Beunhazen en Kwakzalvers*, 2nd. edition, The Hague, 1981.

ANDERSON: M. Anderson, *Approaches to the History of the Western Family 1500-1914*, London, 1980.

ANGEL: P. Angel, *Der Lof der Schilderconst*, Leiden, 1646.

ARIÈS: P. Ariès, *Centuries of Childhood: A Social History of Family Life*, London, 1962.

BERLIN 1978: *Picture Gallery, Staatliche Museen Pruessischer Kulturbesitz, Berlin. Catalogue of Paintings, 13-18th century.* Berlin-Dahlem, 1978.

BLANKERT 1978: A. Blankert, *Vermeer of Delft: Complete Edition of the Paintings*, Oxford, 1978.

BLANKERT 1982: A. Blankert, *Ferdinand Bol (1616-1680): Rembrandt's Pupil*, Doornspijk, 1982.

BOXER: C. R. Boxer, *The Dutch Seaborne Empire*, London, 1965.

BRAY: B. Bray, *L'Art de la lettre amoureuse: des manuels aux romans (1550-1700)*, The Hague/Paris, 1967.

BRIELS: J. Briels, *De Zuidnederlandse Immigratie 1572-1630*, Haarlem, 1978.

BRIÈRE-MISME: C. Brière-Misme, 'Un émule de Vermeer et de Pieter de Hooch, Cornelis de Man', *Oud Holland*, 52, 1935, pp. 1-26, 97-120.

BROWN: C. Brown, *Carel Fabritius*, Oxford, 1981.

DE BRUNE: J. de Brune, *Emblemata*, Amsterdam, 1624.

BÜRGER-WEGENER: C. Bürger-Wegener, *Johannes Lingelbach 1622-1674*, Diss., Freie Universität, Berlin, 1976.

BURKE: J. D. Burke, *Jan Both*, New York, 1976.

CATS: J. Cats, *Alle de wercken*, 2 vols., Amsterdam, 1700.

CIPOLLA: Ed. C. M. Cipolla, *The Fontana Economic History of Europe: The Sixteenth and Seventeenth Centuries*, Glasgow, 1974.

COMER/STECHOW: C. Comer and W. Stechow, 'The History of the Term Genre', *Bulletin of the Oberlin Art Museum*, 33, 1975/6, pp. 89-94.

COMMELIN: C. Commelin, *Beschrijving van Amsterdam*, Amsterdam, 1693.

VAN DEURSEN: A. T. van Deursen, *Het Kopergeld van de Gouden Eeuw*, 4 vols., Assen, 1981.

VAN DILLEN: J. G. van Dillen, *Van Rijkdom en Regenten: Handboek tot de Economische en Sociale Geschiedenis van Nederland Tijdens de Republiek*, The Hague, 1970.

DRESDEN 1979: *Gemäldegalerie Alte Meister Dresden. Katalog der ausgestellten Werke*, Dresden, 1979.

DUBLIN 1981: National Gallery of Ireland, *Illustrated Summary Catalogue of Paintings*, Dublin, 1981.

EMMENS: J. A. Emmens, *Verzameld Werk*, 4 vols., Amsterdam, 1981.

FISHMAN: J. S. Fishman, *Boerenverdriet: Violence between Peasants and Soldiers in Early Modern Netherlands Art*, Ann Arbour, 1982.

FLANDRIN: J.-L. Flandrin, *Families in Former Times: Kinship, Household and Sexuality*, Cambridge, 1979.

GASKELL: I. Gaskell, 'Gerrit Dou, His Patrons and the Art of Painting', *The Oxford Art Journal*, 5, 1982, pp. 15-23.

VAN GELDER: J. G. van Gelder (with commentary by J. Emmens), *De Schilderkunst van Jan Vermeer*, Utrecht, 1958.

GIBSON: W. Gibson, *Bruegel*, London, 1977.

GOOSSENS: K. Goossens, *David Vinckboons*, 2nd ed., Soest, 1977.

TER GOUW: J. ter Gouw, *De Volksvermaken*, Haarlem, 1871.

GRIGG: D. Grigg, *Population Growth and Agrarian Change*, Cambridge, 1980.

DE GROOT: C. W. de Groot, *Jan Steen: Beeld en Woort*, 1952.

GROSSMANN: F. Grossmann, *Pieter Bruegel: Complete Edition of the Paintings*, 3rd ed., London, 1973.

GUDLAUGSSON: S. J. Gudlaugsson, *De Komedianten bij Jan Steen en zijn tijdgenoten*, The Hague, 1945.

GUDLAUGSSON: S. J. Gudlaugsson, *Katalog der Gemälde Gerard ter Borchs*, The Hague, 1960.

THE HAGUE 1977: Mauritshuis, *The Royal Cabinet of Paintings: Illustrated General Catalogue*, The Hague, 1977.

HAKS: D. Haks, *Huwelijk en Gezin in Holland in de 17de en 18de Eeuw: Processtukken en moralisten over aspecten van het laat 17de en 18de-eeuwse gezinsleven*, Assen, 1982.

HARREBOMÉE: P. J. Harrebomée, *Spreekwoordenboek der Nederlandse taal*, 3 vols., Utrecht, 1858-70.

HAVERKAMP-BEGEMANN: E. Haverkamp-Begemann, *Willem Buytewech*, Amsterdam, 1959.

HEPPNER: A. Heppner, 'The Popular Theatre of the Rederijkers in the work of Jan Steen and his Contemporaries', *Journal of the Warburg and Courtauld Institutes*, 5, 1939/40, pp. 22-48.

HOFRICHTER: F.F.Hofrichter, *Judith Leyster, 1609-1660*, Diss., Rutgers University, New Brunswick.

HOOGEWERFF: G.J.Hoogewerff, *De Bentvueghels*, The Hague, 1952.

D'HULST: R.A.d'Hulst, *Jacob Jordaens*, London, 1982.

JANECK: A.Janeck, *Untersuchung über den holländischen Maler Pieter van Laer genannt Bamboccio*, diss., Würzburg, 1968.

DE JONGH 1967: E.de Jongh, *Zinne- en Minne-beelden in de Schilderkunst van de Zeventiende Eeuw*, Amsterdam, 1967.

DE JONGH 1968/9: E.de Jongh, 'Erotica in vogelperspectief. De Dubbelzinnigheid van een reeks 17de eeuwse genrevoorstellingen', *Simiolus*, 3, 1968/9, pp. 22-74.

DE JONGH 1971: E.de Jongh, *Realisme en Schijnrealisme in de Hollandse Schilderkunst van de Zeventiende eeuw*, in *Rembrandt en zijn tijd* (Exhibition catalogue), Brussels, 1971, pp. 143-194.

DE JONGH 1980: E.de Jongh, 'Review of P.Sutton, Pieter de Hooch', *Simiolus*, 11, 1980, pp. 181-5.

JUDSON: J.R.Judson, *Gerrit van Honthorst*, The Hague, 1959.

KIRSCHENBAUM: B.Kirschenbaum, *The Religious and Historical Paintings of Jan Steen*, Oxford, 1971.

KLEIN: H.A.Klein, *Graphic Worlds of Pieter Bruegel the Elder*, New York, 1963.

KREN 1980: T.Kren, 'Chi non vuol Baccho: Roeland van Laer's burlesque painting about Dutch artists in Rome', *Simiolus*, 11, 1980, pp. 63-80.

KREN 1982: T.Kren, 'Jan Lingelbach in Rome', *The J.P.Getty Museum Journal*, 10, 1982, pp. 45-62.

KREN 1983: T.Kren, *Jan Miel: A Flemish Painter in Rome*, Ann Arbour, 1983.

KRUL: J.H.Krul, *Pampiere Wereld*, Amsterdam, 1644.

KURETSKY: S.Kuretsky, *The Paintings of Jacob Ochtervelt*, Oxford, 1979.

KUZNETSOW: J.L.Kuznetsow, 'Nicolaus Knüpfer', *Oud Holland*, 88, 1974, pp. 169-219.

LAIRESSE 1707: G.de Lairesse, *Het Groot Schilderboek*, Amsterdam, 1707.

LAIRESSE 1778: G.de Lairesse, *The Art of Painting*, translated by J.F.Fritsch, London, 1778.

LANDWEHR: J.Landwehr, *Emblem Books in the Low Countries 1554-1949: A Bibliography*, Utrecht, 1970.

LASLETT: Ed. P.Laslett, *Household and Family in Past Time*, Cambridge, 1972.

LIS/SOLY: C.Lis and H.Soly, *Poverty and Capitalism in Pre-Industrial Europe*, Brighton, 1979.

LONDON 1960: N.MacLaren, *National Gallery Catalogues: The Dutch School*, London, 1960.

LONDON 1982: C.M.Kauffmann, *Catalogue of Paintings in the Wellington Museum*, London, 1982.

LOWENTHAL: A.Lowenthal, *The Paintings of Joachim An-thonisz Wtewael 1566-1638*, Ann Arbor, 1983.

MANKE: I.Manke, *Emanuel de Witte*, Amsterdam, 1963.

MARTIN 1913: W.Martin, *Gerrit Dou (Klassiker der Kunst)*, Stuttgart/Leipzig, 1913.

MARTIN 1954: W.Martin, *Jan Steen*, Amsterdam, 1954.

MAYER-MEINTSCHEL: A.Mayer-Meintschel, 'Rembrandt und Saskia im Gleichnis vom Verlorenen Sohn', *Staatliche Kunstsammlungen Dresden Jahrbuch*, 1970/1, pp. 39-54.

MIEDEMA: H.Miedema, 'Over het realisme in de Nederlandse schilderkunst van de zeventiende eeuw – naar aanleiding van een tekening van Jacques de Gheyn II,' *Oud Holland*, 89, 1975, pp. 2-18.

MITTERAUER/SIEDER: M.Mitterauer and R.Sider, *The European Family*, Oxford, 1982.

MONROY: E.F.von Monroy, *Embleme und Emblembücher in den Niederländen, 1560-1630*, Utrecht, 1964.

MOXEY: K.P.F.Moxey, 'The "Humanist" Market Scenes of Joachim Beuckelaer: Moralizing Exempla or "Slices of Life"?' *Koninklijk Museum voor Schone Kunsten Antwerpen, Jaarboek*, 1976, pp. 109-87.

MURRIS: R.Murris, *La Hollande et les Hollandais au XVIIe at XVIIIe siècles vus par les Français*, Paris, 1925.

NAUMANN: O.Naumann, *Frans van Mieris the Elder*, 2 vols., Doornspijk, 1981.

NICOLSON 1958: B.Nicolson, *Hendrick Terbrugghen*, London, 1958.

NICOLSON 1960: B.Nicolson, 'Second Thoughts about Terbrugghen', *Burlington Magazine*, 102, 1960, pp. 466-70.

NICOLSON 1979: B.Nicolson, *The International Caravaggesque Movement*, Oxford, 1979.

PARIS 1979: *Catalogue sommaire illustré des peintures du Musée de Louvre: l' Ecoles Flamande et Hollandaise* (by A.Brejon de Lavergnée, J.Foucart and N.Reynauld), Paris, 1979.

PARIVAL: J.-N.Parival, *Les Délices de la Hollande*, Leiden, 1678.

PARKER 1977: G.Parker, *The Dutch Revolt*, London, 1977.

PARKER 1979: G.Parker, *Europe in Crisis 1598-1648*, Glasgow, 1979.

PLAYTER: C.B.Playter, *Willem Duyster and Pieter Codde: The "Duystere Werelt" of Dutch Genre Painting, 1625-1635*, Diss., Harvard University, 1972.

PORTEMAN: K.Porteman, *Inleiding tot de Nederlandse Emblemataliteratuur*, Groningen, 1977.

PRAZ: M.Praz, *Studies in Seventeenth-Century Imagery*, 2nd ed., Rome, 1975.

RENGER 1970: K.Renger, *Lockere Gesellschaft: Zur Iconographie des Verlorenen Sohnes und von Wirtshausszenen in der niederländischen Malerei*, Berlin, 1970.

RENGER 1978: K. Renger, 'Zur Forschungsgeschichte der Bilddeutung in der Holländische Malerei', in Cat. Braunschweig 1978, pp. 34-8.

ROBINSON: F. W. Robinson, *Gabriel Metsu: A Study of his Place in Genre Painting of the Golden Age*, New York, 1974.

ROORDA 1961: D. J. Roorda, *Partij en Factie: De Oproeren van 1672 in de Steden van Holland en Zeeland, een Krachtmatig tussen Partijen en Facties*, Groningen, 1961.

ROORDA 1967: D. J. Roorda, 'Party and Faction', *Acta Historiae Neerlandica*, vol. 2, 1967, p. 197ff.

ROORDA 1971: D. J. Roorda, 'Sociale Mobiliteit onder Regenten van de Republiek', *Tijdschrift voor Geschiedenis*, 84, 1971, pp. 360ff., pp. 321-5.

SCHNACKENBURG: B. Schnackenburg, *Adriaen van Ostade. Isaack van Ostade. Zeichnungen und Aquarelle*, 2 vols., Hamburg, 1981.

SCHOTEL 1869: G. D. J. Schotel, *Het Maatschappelijke Leven onzer Voorouders in de Zeventiende Eeuw*, Rotterdam, 1869.

SCHOTEL 1873/4: G. D. J. Schotel, *Vaderlandsche Volksboeken en Volkssprookjes van de Vroegste tijden tot het einde der 18de Eeuw*, 2 vols., Haarlem, 1873/4.

SCHOTEL 1903: G. D. J. Schotel, *Het Oud-Hollandsch Huisgezin der Zeventiende Eeuw*, 2nd ed., Leiden 1903.

SCHULZ 1974: W. Schulz, *Lambert Doomer: Sämtliche Zeichnungen*, Berlin/New York, 1974.

SCHULZ 1978: W. Schulz, *Cornelis Saftleven: Leben und Werke*, Berlin/New York, 1978.

SILVER: L. A. Silver, 'Of Beggars: Lucas van Leyden and Sebastian Brant', *Journal of the Warburg and Courtauld Institutes*, 39, 1976, pp. 253-7.

SLATKES: L. J. Slatkes, *Dirck van Baburen, c. 1595-1624, a Dutch painter in Utrecht and Rome*, Utrecht, 1965.

SNOEP-REITSMA: E. Snoep-Reitsma, 'Chardin and the Bourgeois Ideals of his Time', *Nederlands Kunsthistorisch Jaarboek*, 24, 1973, pp. 147-243.

SPIEGHEL: H. L. Spieghel, *Hertspieghel en andere Zede-Schriften*, Amsterdam, 1694.

STONE: L. Stone, *The Family, Sex and Marriage in England 1500-1800*, 2nd ed., London, 1979.

STRIDBECK: C. G. Stridbeck, *Bruegelstudien*, Stockholm, 1956.

SUTTON 1980a: P. Sutton, *Pieter de Hooch*, Oxford, 1980.

SUTTON 1980b: P. Sutton, 'Hendrick van der Burch', *Burlington Magazine*, 122, 1980, pp. 315-26.

SUTTON 1982/3: P. Sutton, 'Jan Steen: Comedy and Admonition', *Philadelphia Museum of Art Bulletin*, 78, 1982/3.

TEMPLE: Ed. G. Clark, *Sir William Temple: Observations upon the United Provinces of the Netherlands*, Oxford, 1972.

DEN TEX: J. den Tex, *Oldenbarnevelt*, 2 vols., Cambridge, 1973.

VAN THIEL 1967/8: P. van Thiel, 'Marriage Symbolism in a Musical Party by Jan Miense Molenaer', *Simiolus*, 2, 1967/8, pp. 91-9.

VAN THIEL 1971: P. van Thiel, 'De Aanbidding der Koningen en ander vroeg werk van Hendrick ter Brugghen', *Bulletin van het Rijksmuseum*, 19, 3, 1971, pp. 91-116.

VALENTINER: W. R. Valentiner, *Nicolas Maes, Klassiker der Kunst*, Stuttgart/Leipzig, 1924.

VAN DE VEEN: J. van de Veen, *Zinne-beelden oft Adams appel*, Amsterdam, 1642.

VISSCHER: Ed. L. Brummel, *Sinnepoppen van Roemer Visscher (Amsterdam, 1619)*, The Hague, 1949.

DE VRANKRIJKER: A. C. J. de Vrankrijker, *Mensen, Leven en Wercken in de Gouden Eeuw*, The Hague, 1981.

DE VRIES 1974: J. de Vries, *The Dutch Rural Economy in the Golden Age 1500-1700*, New Haven/London, 1974.

DE VRIES 1976: J. de Vries, *The Economy of Europe in an Age of Crisis 1600-1750*, Cambridge, 1976.

DE VRIES 1976: L. de Vries, *Jan Steen*, Weert, 1976.

DE VRIES 1977: L. de Vries, *Jan Steen "De Kluchtschilder"*, diss., Groningen, 1977.

VAN DE WAAL: H. van de Waal, *Steps towards Rembrandt: Collected Articles 1937-1972*, Amsterdam/London, 1974.

WELCKER: C. J. Welcker, *Hendrick Avercamp en Barent Avercamp*, 2nd revised edition, Doornspijk, 1979.

VAN DER WOUDE: A. M. van der Woude, 'Variations in the size and structure of the household in the United Provinces of the Netherlands in the seventeenth and eighteenth centuries', in Laslett, op. cit.

ZUMTHOR: P. Zumthor, *Daily Life in Rembrandt's Holland*, London, 1962.

In the case of travelling exhibitions, only the location of the first showing is given

CAT. AMSTERDAM 1976: *Tot Lering en Vermaak, Betekenissen van Hollandse Genrevoorstellingen uit de Zeventiende Eeuw*, Rijksmuseum, Amsterdam, 1976.

CAT. AMSTERDAM 1978: *Lucas van Leyden – Grafiek*, Rijksmuseum, Amsterdam, 1978.

CAT. AMSTERDAM 1982: *Hendrick Avercamp and Barent Avercamp: Paintings from Museums and Private Collections*, Waterman Gallery, Amsterdam, 1982.

CAT. BRAUNSCHWEIG 1978: *Die Sprache der Bilder. Realität und Bedeutung in der niederländischen Malerei des 17. Jahrhunderts*, Herzog Anton Ulrich-Museum, Braunschweig, 1978.

CAT. DELFT 1964/5: *De Schilder in zijn Wereld van Jan van Eyck tot Van Gogh en Ensor*, Delft, 1964/5.

CAT. DELFT 1981: *De Stad Delft: Cultuur en Maatschappij van 1572 tot 1667*, Stedelijck Museum Het Prinsenhof, Delft, 1981.

CAT. THE HAGUE 1974: *Gerard ter Borch*, Mauritshuis, The Hague, 1974.

CAT. LONDON 1976: *Art in Seventeenth-Century Holland*, National Gallery, London, 1976.

CAT. LONDON 1978/9: *The National Gallery Lends Dutch Genre Paintings*, National Gallery, London, 1978/9.

CAT. NEW BRUNSWICK 1983: *Haarlem: The Seventeenth Century*, The Jane Voorhees Zimmerli Art Museum, Rutgers, The State University of New Jersey, New Brunswick, 1983.

CAT. NIJMEGEN 1964: *Het Schildersatelier in de Nederlanden 1500-1800*, Nijmegen, 1964.

CAT. PHILADELPHIA 1984: *Masters of 17th century Dutch Genre Painting*, Philadelphia Museum of Art, 1984.

CAT. UTRECHT 1952: *Caravaggio en de Nederlanden*, Centraal Museum, Utrecht, 1952.

CAT. WASHINGTON 1983: *The Prints of Lucas van Leyden and his Contemporaries*, National Gallery of Art, Washington, 1983.

Index

Page references to illustrations are in italic type